THE THAMES AND HUDSON MANUALS

GENERAL EDITOR: W.S. TAYLOR

*David M Meslany*

*apr 76*

# Rendering with Pen and Ink

*C.M. Coombs*

Robert W. Gill

The Thames and Hudson
Manual of Rendering with
Pen and Ink

with 166 illustrations

Thames and Hudson T&H London

© 1973 Thames and Hudson Ltd, London

Reprinted 1976

Printed in Great Britain by
Jarrold and Sons Ltd, Norwich

# Contents

# 1   Introduction

Perspective drawings have long been recognized, by designers and laymen alike, as among the most important of technical drawings. It is often difficult to appreciate points of design or the actual appearance of a building or object from plans and elevations. A correctly constructed perspective presents as nearly as possible the actual appearance in terms of line on a two-dimensional surface. Thus it is very important in the work of artists, architects, engineers, industrial designers, interior designers and landscape specialists, making it possible to view the design as a finished product before committing it to manufacture.

Perspective projection is a technique which has not yet reached its full development. There are in use a number of methods of perspective construction other than those shown in this book, each having its advantages as well as its disadvantages. The chapter on perspective projection deals with matters common to all techniques in rendering, e.g. pencil, poster colour, watercolour and pen and ink. This is also true of the various chapters on drawing objects. However, it is my intention to concentrate on rendering with pen and ink and allied materials.

Hard and fast rules cannot be laid down for rendering with pen and ink as each rendering has its own unique set of problems. There are, however, some problems which remain constant: for instance, drawing objects which can be identified as accessories. Trees, shrubs, grass, water, rocks, transport, furniture, ornaments and, of course, people come under this classification in architectural and interior renderings. The chapters on these various items are intended to guide the student in developing his own techniques.

The drawings shown are limited generally to the techniques and styles used by the author, and it should be pointed out to the student that merely to copy is of little use as everyone should develop his own techniques, styles and individuality according to his own abilities.

Some of the objects shown may appear strange to some draughtsmen but everything has at some time or other been required of the author while engaged in preparing drawings for architects, engineers, designers, manufacturers, advertising and industry generally.

The reference material included will help the student to reduce time spent in gathering information, by giving him one main source. It is of course impossible to cover every subject fully, but a bibliography is provided on pp. 364–5 listing some useful books.

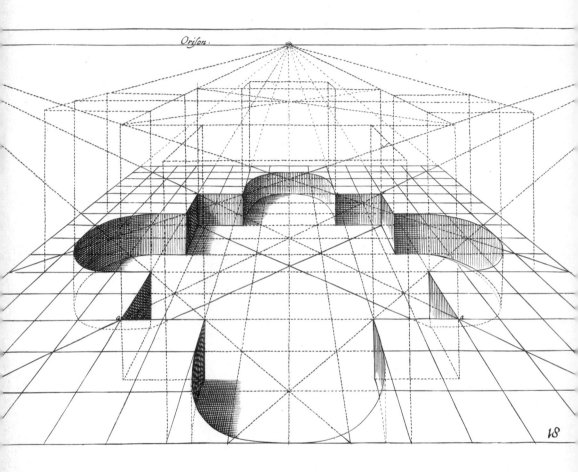

# 2 Perspective drawing

In all things we see we are aware of the existence of 'perspective' – an optical effect which makes things close to us appear larger than the same objects viewed at some distance. It is this effect which gives a sense of distance and solidity to a view of a building or object. One of the best examples is railway lines, which seem to converge as they recede. This effect is also obvious when people seen at a distance appear smaller than those seen close at hand. From these examples it can be seen that the railway lines, and imaginary lines drawn through the heads and feet of the people, will eventually meet; the point where they meet is called the 'vanishing point'. This point is located on the eye line, which is also the horizon line.

More and finer detail can be seen on the object seen close to than on the same object viewed from a distance. Colours and tonal contrasts also diminish in intensity as they recede from the viewer. But whereas the fading of fine detail and the reduction of colour and tone can be judged only by the eye, and depend on the sensitivity of the observer, linear recession can be calculated exactly. Nevertheless, the perspective formula is monocular; it does not present the sense of space and recession experienced by a person with reasonable eyesight. Such vision is binocular, and can be approximately reproduced in stereoscopic photography.

The mathematical laws of perspective were developed at the beginning of the fifteenth century by a Florentine architect, Filippo Brunelleschi (1377–1446). New spatial concepts in Italian painting were based on a scientific foundation, and on this foundation perspective was developed. Masaccio, Piero della Francesca, Alberti and Uccello were deeply involved with the mathematical basis of art; both Uccello and Piero della Francesca formulated theories of perspective.

There are a number of ways of constructing or setting up a perspective drawing, and the underlying theories are long and rather involved when verbal descriptions are attempted. There are a number of very good books devoted to the various methods and theories of perspective drawing (see p. 364). So it is proposed not to explain the various methods in detail here but to concentrate only on the two main methods covering most requirements under normal conditions.

It is impossible to begin the preparation of a perspective drawing without first being supplied with, or preparing for oneself, plans and elevations, and where necessary sections,

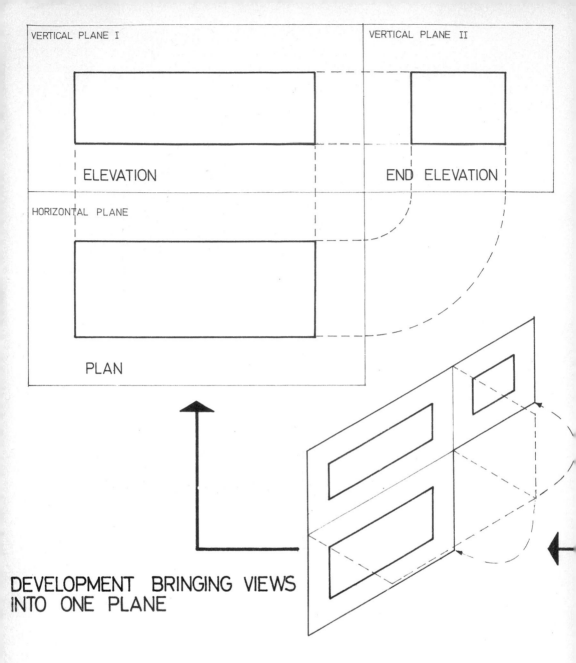

VERTICAL PLANE I

VERTICAL PLANE II

ELEVATION

END ELEVATION

HORIZONTAL PLANE

PLAN

DEVELOPMENT BRINGING VIEWS
INTO ONE PLANE

*Fig. 1 The development of an orthographic projection of a simple solid object.*

of the building or object. The plans, elevations and sections are drawn by using a method of projection known as *orthographic projection.*

## ORTHOGRAPHIC PROJECTION

Orthographic projection is the method of drawing three-dimensional objects in two dimensions by means of related views called plans, elevations and sections. This simply means a parallel or perpendicular projection. Most building,

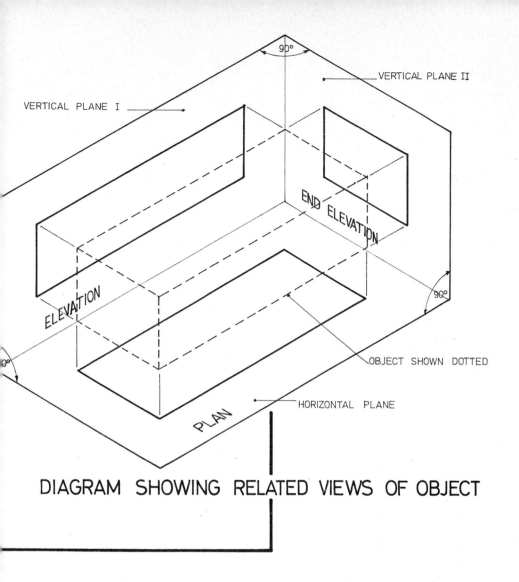

90°

VERTICAL PLANE II

VERTICAL PLANE I

END ELEVATION

ELEVATION

90°

OBJECT SHOWN DOTTED

0°

HORIZONTAL PLANE

PLAN

DIAGRAM SHOWING RELATED VIEWS OF OBJECT

furniture and fitting designs are prepared in this way. But before becoming involved too deeply with the perspective method it is necessary to point out that there are a number of cases where it is neither necessary nor in fact advisable to use perspective projection in showing three-dimensional objects or parts of objects. In assembly diagrams, details of joints and many similar cases where a three-dimensional view of an object is necessary for technical reasons, it is often an advantage to be able to obtain accurate measurements from the drawing. In such cases the use of *metric projections* is preferable.

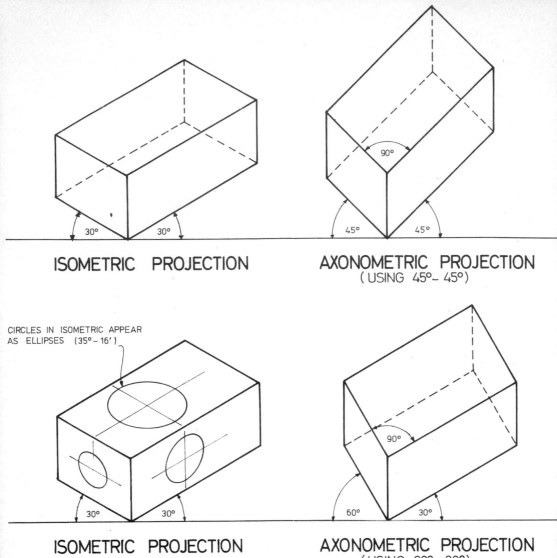

ISOMETRIC PROJECTION

AXONOMETRIC PROJECTION
( USING 45°– 45°)

CIRCLES IN ISOMETRIC APPEAR
AS ELLIPSES (35° – 16')

ISOMETRIC PROJECTION

AXONOMETRIC PROJECTION
( USING 60°– 30°)

*Fig. 2 The three most-used
metric projections, with
variations.*

## METRIC PROJECTIONS

Metric projections are methods of drawing buildings or
objects so as to give a three-dimensional appearance yet in
such a way as to allow length, breadth and height to be
measured. They are set up from orthographic projections
and can be drawn to any scale required. The most-used
projections are: isometric, axonometric and oblique.

*Isometric projection* is particularly suitable for mechanical
assembly drawings, complicated machine parts and cut-
away views of objects because it gives a realistic effect. The

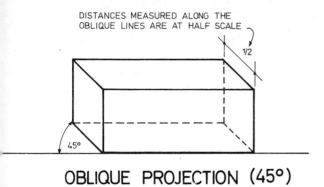

DISTANCES MEASURED ALONG THE
OBLIQUE LINES ARE AT HALF SCALE

½

45°

OBLIQUE PROJECTION (45°)

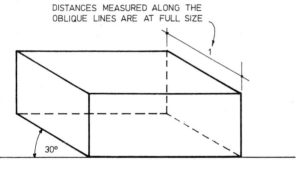

DISTANCES MEASURED ALONG THE
OBLIQUE LINES ARE AT FULL SIZE

1

30°

OBLIQUE PROJECTION (30°)

drawing is made with a T-square and a 30° set square. The base lines of the object are drawn at 30° to the horizontal. Length, breadth and height are drawn to actual scale in forming the three-dimensional view of the object

*Axonometric projection* has the advantage of containing a true plan of the object and is therefore more easily set up from existing drawings. It is particularly suitable for showing diagrammatic interiors of buildings. Axonometric projections can be made at any angle to the horizontal, but for convenience they are usually drawn at either 45°/45° or 30°/60°. (Figure 2*b* shows an axonometric projection of a simple object using both 45°/45° and 30°/60° angles.)

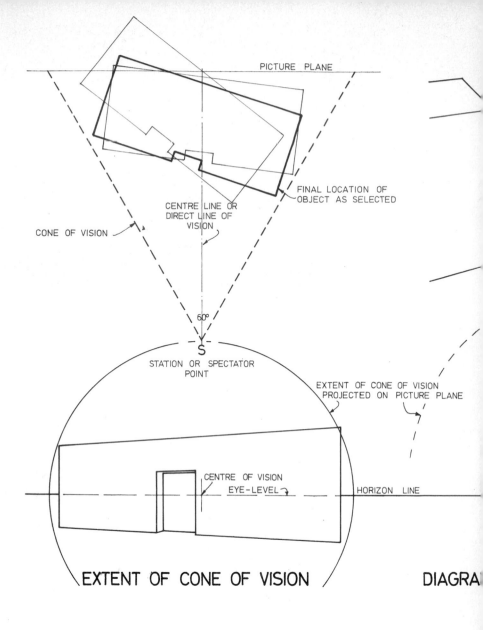

PICTURE PLANE

FINAL LOCATION OF OBJECT AS SELECTED

CENTRE LINE OR DIRECT LINE OF VISION

CONE OF VISION

60°

S

STATION OR SPECTATOR POINT

EXTENT OF CONE OF VISION PROJECTED ON PICTURE PLANE

CENTRE OF VISION
EYE-LEVEL

HORIZON LINE

EXTENT OF CONE OF VISION

DIAGRA

In *oblique projection*, as in isometric projection, the plan is distorted. There are two variations of the method: (1) the oblique lines are drawn at 45° to the horizontal, and distances along them are measured at half the scale of that used for the horizontal and vertical lines; (2) the oblique lines are drawn at 30° to the horizontal, and distances along them are measured at the same scale as that used for the horizontal and vertical lines.

The use of metric projections is limited and is usually not acceptable, for various reasons, to an architect or designer, or to his client, whose main interest is in the actual appear-

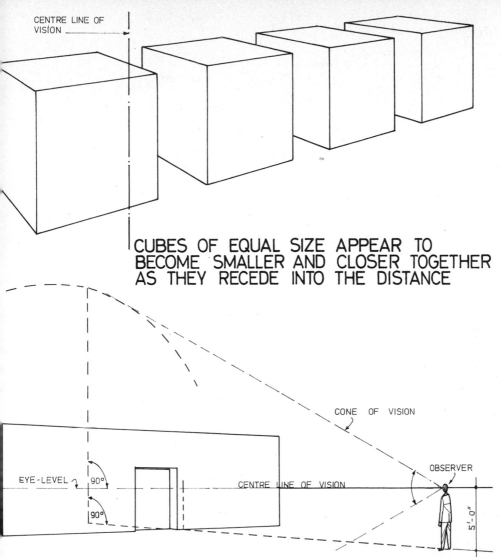

CUBES OF EQUAL SIZE APPEAR TO BECOME SMALLER AND CLOSER TOGETHER AS THEY RECEDE INTO THE DISTANCE

CENTRE LINE OF VISION

CONE OF VISION

OBSERVER

EYE-LEVEL 90°

CENTRE LINE OF VISION

90°

5'-0"

...OWING RELATIONSHIP BETWEEN OBSERVER & OBJECT

ance of the completed building or object. To show this it is necessary to prepare a perspective projection, but before starting to set this up, it is necessary to understand some of the terms used. The next four figures should help to explain them.

*Cone of vision*

The cone of vision is required to obtain the limits of the drawing. The field of vision is known to be more than 180°, but it is not possible to see clearly over this whole range. The normal maximum range within which it is possible to see

*Fig. 3  Cone of vision I.*

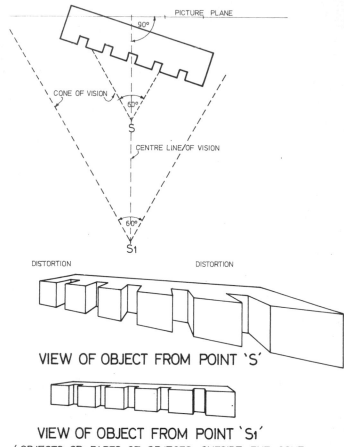

PICTURE PLANE

90°

CONE OF VISION

60°

S

CENTRE LINE OF VISION

60°

S1

DISTORTION                    DISTORTION

VIEW OF OBJECT FROM POINT 'S'

VIEW OF OBJECT FROM POINT 'S1'

( OBJECTS OR PARTS OF OBJECTS OUTSIDE THE CONE
OF VISION ARE SUBJECT TO DISTORTION )

*Fig. 4 Cone of vision II.*

clearly and easily is accepted as being less than 90° and is seldom shown as more than 60°. For the purpose of perspective drawing it is usually limited to 60° or less. This means that any object or part of an object which we would not normally see clearly because of its lying outside this cone of vision will be distorted if we try to draw it.

To obtain a wider coverage with the cone of vision it is necessary to move back from the object; it is *not* enough simply to widen the cone of vision. Figures 3 (p. 15) and 4 (above and opposite) show graphically how the cone of vision is used in the preparation of a perspective projection.

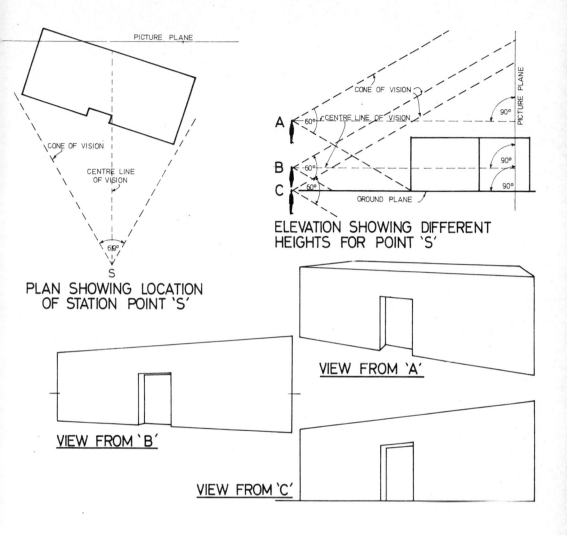

PICTURE PLANE

CONE OF VISION

CENTRE LINE OF VISION

60°

S

**PLAN SHOWING LOCATION OF STATION POINT 'S'**

CONE OF VISION

A   60°   CENTRE LINE OF VISION   90°   PICTURE PLANE

B   60°   90°

C   60°   90°

GROUND PLANE

**ELEVATION SHOWING DIFFERENT HEIGHTS FOR POINT 'S'**

**VIEW FROM 'A'**

**VIEW FROM 'B'**

**VIEW FROM 'C'**

When deciding on the position from which to view the building or object it is necessary to fit the whole – or the part which it is intended to include in the drawing – inside the cone of vision. This fact governs the distance from which one should view the object. The centre line of this cone is known as the *centre line of vision* or the *direct line of vision*. This line is represented in plan by a vertical line and in elevation by a horizontal line. This means that the direct line of vision is parallel to the ground plane. The apex of the cone of vision is known as the *station point*, the *spectator point* or the *viewing point*.

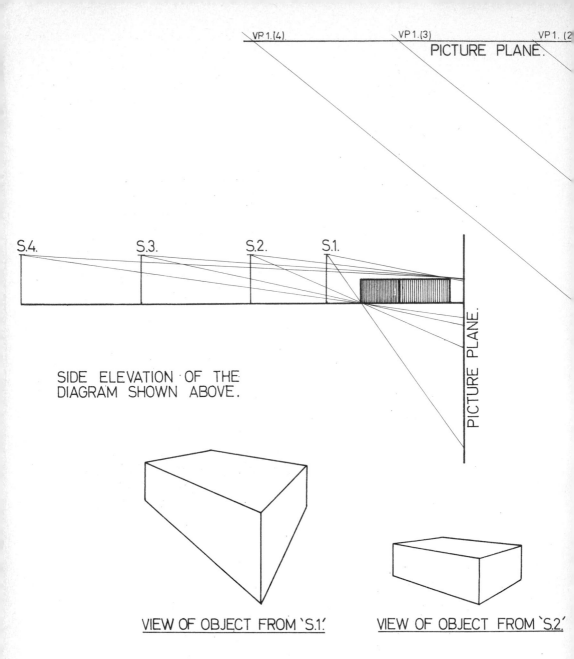

PICTURE PLANE.

S.4.         S.3.         S.2.         S.1.

PICTURE PLANE.

SIDE ELEVATION · OF THE DIAGRAM SHOWN ABOVE.

VIEW OF OBJECT FROM 'S.1.'         VIEW OF OBJECT FROM 'S.2.'

*Fig. 5 Station point.*

The position of the station point should always be considered in relation to the nature of the subject. A large building or a landscape would normally be expected to occupy the entire range of the cone of vision whereas a small subject, such as a piece of furniture or small equipment, would not fill the field of vision unless viewed at very close range. The station point should therefore be arranged so that a convincing picture is obtained. When the position of the station point is chosen too near a small object it tends to give a dramatic appearance in the perspective projection. When the position is chosen too near a large object it results in part

18

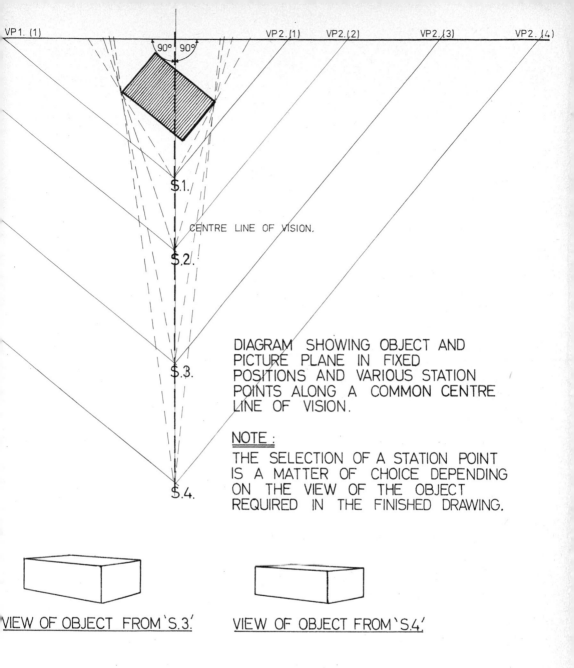

90° 90°

S.1.

CENTRE LINE OF VISION.

S.2.

S.3.

DIAGRAM SHOWING OBJECT AND PICTURE PLANE IN FIXED POSITIONS AND VARIOUS STATION POINTS ALONG A COMMON CENTRE LINE OF VISION.

NOTE :
THE SELECTION OF A STATION POINT IS A MATTER OF CHOICE DEPENDING ON THE VIEW OF THE OBJECT REQUIRED IN THE FINISHED DRAWING.

S.4.

VIEW OF OBJECT FROM 'S.3.'        VIEW OF OBJECT FROM 'S.4.'

of the object being distorted, as shown in fig. 4. Correcting this is simply a matter of moving further back, but this changes the view of the object (see fig. 5). The station point is usually accepted as being at normal eye-level, which is, for perspective purposes, 5 ft above the ground. This however can be varied to suit the particular requirements of the object or the draughtsman, providing the object still falls within the cone of vision.

The selection of a suitable station point is a matter of judgment and experience, and each subject should be examined on its merits.

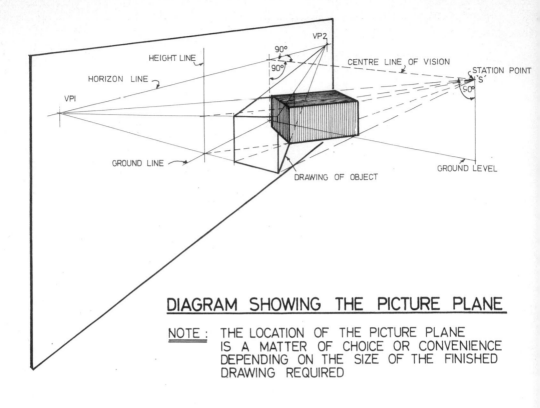

## DIAGRAM SHOWING THE PICTURE PLANE

NOTE : THE LOCATION OF THE PICTURE PLANE
IS A MATTER OF CHOICE OR CONVENIENCE
DEPENDING ON THE SIZE OF THE FINISHED
DRAWING REQUIRED

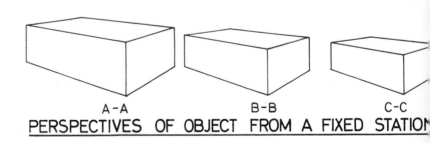

A-A          B-B          C-C
## PERSPECTIVES OF OBJECT FROM A FIXED STATION

*Fig. 6 Picture plane: the choice
of position.*

Picture plane

The picture plane is an imaginary plane on which the pers-
pective is supposed to be drawn. Figure 6 (above) shows
a theoretical drawing of an object being projected on to the
picture plane. To relate this to perspective projection it
should be realized that this plane is shown as a line in plan and
is *always* at right angles to the direct line of vision. Usually, in
end elevation, the picture plane is also shown as a line at
right angles to the ground plane.

The exception to this rule can be seen in fig. 16 (p. 41).
As shown in the diagram, the location of the picture plane
controls the ultimate size of the picture, where it will be seen

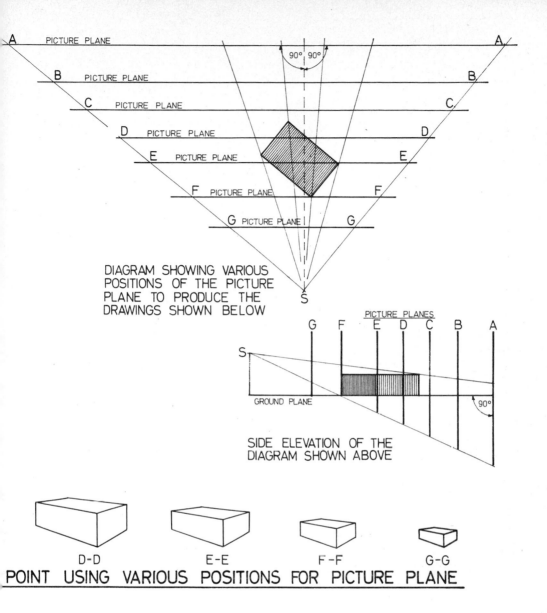

A    PICTURE PLANE                                                    A
                              90° | 90°
B        PICTURE PLANE                                              B
C          PICTURE PLANE                                          C
D            PICTURE PLANE                                      D
E             PICTURE PLANE                                  E
F              PICTURE PLANE                              F
G              PICTURE PLANE                          G

DIAGRAM SHOWING VARIOUS
POSITIONS OF THE PICTURE
PLANE TO PRODUCE THE              S
DRAWINGS SHOWN BELOW

                                        PICTURE PLANES
                            G   F    E   D   C    B    A
              S

                GROUND PLANE                            90°

SIDE ELEVATION OF THE
DIAGRAM SHOWN ABOVE

      D-D              E-E              F-F              G-G

POINT USING VARIOUS POSITIONS FOR PICTURE PLANE

that the closer to the observer the picture plane is placed the smaller the perspective drawing will be.

However, it is only the size of the drawing which is affected, the view of the object remaining constant. The draughtsman should thoroughly understand this point as it is through this fact that he can control the drawing size from the beginning and should be able to fit a perspective to any size required without difficulty. The position on the sheet of paper where it is intended to draw the perspective is the picture plane. This can be understood by referring to fig. 6, where the actual construction of the perspective can be seen on the picture plane behind the object.

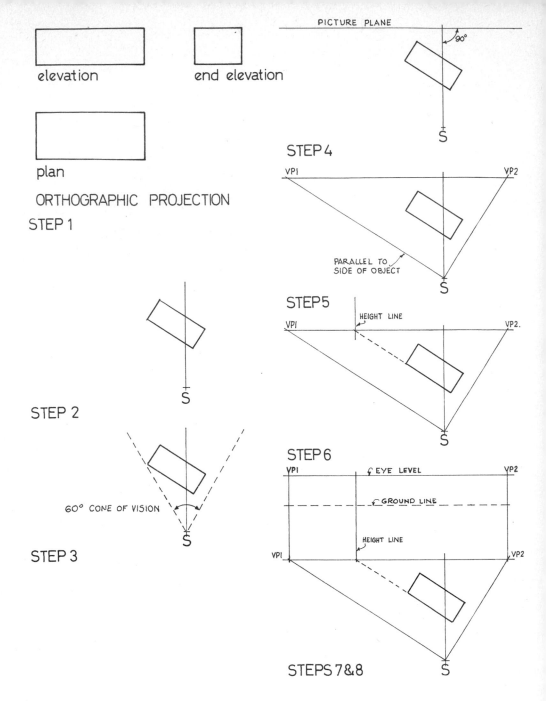

PICTURE PLANE

90°
S

elevation

end elevation

plan

ORTHOGRAPHIC PROJECTION

STEP 1

STEP 4

VPI                                                    VP2

PARALLEL TO
SIDE OF OBJECT

S

STEP 2

S

STEP 3

60° CONE OF VISION

S

STEP 5

HEIGHT LINE

VPI                                                    VP2.

S

STEP 6

VPI        EYE LEVEL                        VP2

GROUND LINE

HEIGHT LINE

VPI                                                    VP2

HEIGHT LINE

STEPS 7 & 8                              S

*Fig. 7 Two-point perspective.*    *Height line*

The height line is the line in the perspective projection used
for all vertical heights, which are measured using the same
scale as the plan from which the projection is being made.
The location of this line is found by projecting a line as the
continuation of one of the sides of the plan of the object
back or forwards to meet the picture plane. From this point
where the two lines intersect a vertical line is drawn to cross

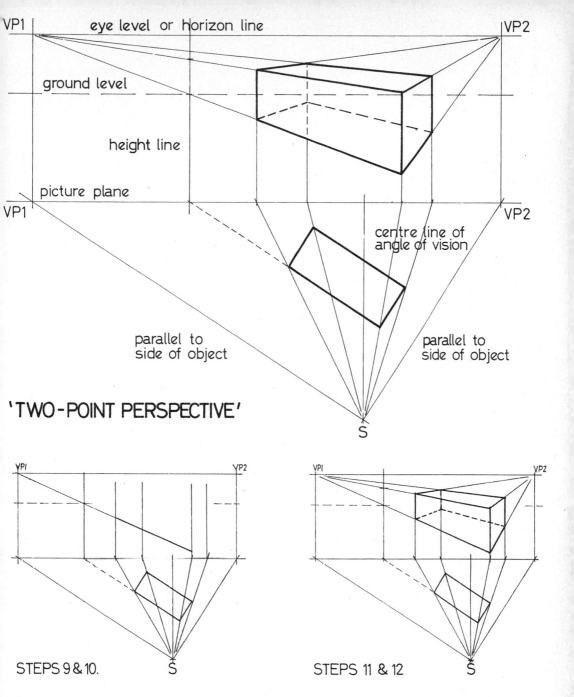

VP1 | eye level or horizon line | VP2

ground level

height line

picture plane

VP1 | | VP2

centre line of
angle of vision

parallel to
side of object

parallel to
side of object

# 'TWO-POINT PERSPECTIVE'

S

VP1 | VP2

STEPS 9 & 10.    S

VP1 | VP2

STEPS 11 & 12    S

the eye-level or horizon line. The height line is usually considered more accurate if placed on the side of the plan which has the longer distance to the vanishing point.

*Eye-level or horizon line*

The eye-level, which coincides with the horizon line in the perspective projection, is a horizontal line drawn at a convenient point above or below the plan of the picture plane.

The location of this line on the paper is entirely at the discretion of the draughtsman, and the main consideration is the space and equipment available to him. As all lines projected on plan have to be projected vertically to this line it is wise to select a position in which this can be done with the least effort. This line represents the height of the observer's eye and all heights are measured in relation to this line.

### Ground line

The ground line in perspective projection is the line of the ground in relation to the eye-level. Under normal circumstances, as already mentioned, this is considered to be 5 ft below the eye-level or the horizon line. The ground line is located in the perspective projection by measuring down the height line from the horizon line a scale distance of 5 ft. This point, when joined to the vanishing point and projected through to the drawing, forms the general ground line of the object in perspective. It should be remembered that all height measurements of the object should be measured from the *ground line* up.

### Vanishing points

Vanishing points are points located on the picture plane and the horizon line to which the lines of the perspective projection of the object will converge. All lines on plan in one direction will converge in the perspective to the vanishing point in the same direction. The number of vanishing points in a perspective projection varies from one (fig. 8, p. 26) to two in a 'two-point perspective' of a simple rectangular object (fig. 7, pp. 22–3), or more for a complicated object. The vanishing points are found by drawing lines from the station point parallel to the sides of the simple rectangular object to meet the picture plane in plan. The point where they meet is the vanishing point. The angle between the two lines from the station point must always be a right angle. Where angles of the object are not right angles it is necessary to select one side only and set up a line parallel to this side; the other line can then be at right angles to this line. The same should then be done for the second side, giving a second pair of vanishing points for the second side. This sounds rather complicated, but if it is done in the correct sequence it is much easier than it sounds. The best way to learn to make perspectives, however, is to study the essential principles from the examples shown, and then practise their application.

The method that is probably most satisfactory for general use is illustrated in fig. 7. This method of perspective projection is known as 'two-point perspective' and is most commonly used for exteriors of buildings. To use it, proceed as follows:

1 Using a convenient scale, draw the plan and elevations of the object, in this case a rectangular prism or block.

2 Decide on a point from which it is wished to view the

object. This is the position of the eye of the spectator, point S. The position of point S is a matter of judgment in the light of experience, but a little imagination will help the beginner to locate the required position approximately.

*3* Place the plan and point S so that they are in a vertical line, this line representing the direct line of vision. It is advisable at this point to check that the object viewed from point S falls within the usually accepted 60° cone of vision. Any part of the object which falls outside this cone will usually be subject to distortion.

*4* Select somewhere along the direct line of vision a point through which the picture plane is drawn at right angles. The picture plane is an imaginary vertical plane on to which is projected the required view of the object.

*5* Draw lines from point S parallel to the sides of the object as far as the picture plane. The points where these lines cross the picture plane are VP1 and VP2. These are the vanishing points along the eye-level to which in the perspective the outlines of the sides of the object will converge.

*6* Draw another line (shown dotted) in continuation of one or other of the sides of the object as far as the picture plane. This gives a point on the picture plane for the position of the height line.

*7* Locate at some convenient distance above the picture plane a horizontal line; this line represents the eye-level of the spectator or the horizon line and to it are projected the perpendiculars from the picture plane from VP1, VP2 and the point for the height line.

*8* Locate the ground line; this line represents the normal level of the ground below the eye-level of the spectator. This line will be approximately 5 ft below the eye-level for a spectator standing on level ground looking at the object. The height can vary if the spectator's position is above or below the object.

*9* Locate the points of the object on the picture plane. These points are located by drawing lines from point S through the various points of the object as far as the picture plane. Project perpendiculars from these points to approximately the eye-level or horizon line.

*10* Locate the base of the object by drawing a line from VP1 through the point where the height line and the ground line intersect and continue until it crosses the perpendiculars from the two front points of the object. This locates the length of the object in perspective.

*11* Obtain the height of the object in perspective. From the ground line measure up the height line the height of the object, using the same scale as used in the preparation of the plan and elevations. From VP1 draw a line through this point to the same perpendiculars as used in the preceding step, which will give the top line of the front of the object in perspective.

*12* Join up the various lines to VP1 and VP2 to show the object in perspective.

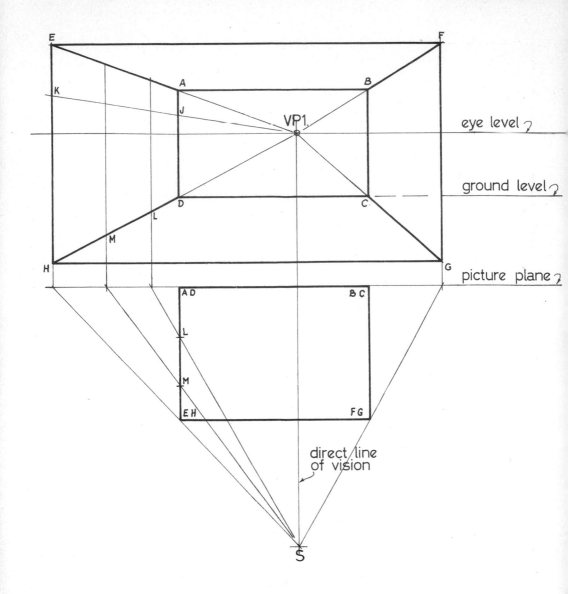

*Fig. 8 One-point or parallel perspective.*

Another method of projection, which is more suitable for interior views or for buildings seen in a straight elevational view, is known as *one-point* or *parallel* or *interior* perspective; the principle is illustrated in figs. 8 and 9. The basis for this method is the same as already described for two-point perspective.

In fig. 8, AD, BC, EH, FG is the plan or part plan of a room, and S is the position of the eye of the spectator looking directly into the room. The picture plane is taken in the same plane as the end wall of the room, i.e. the plane ABCD. On plan, lines are drawn from S through the near corners of the room, EH and FG, to meet the picture plane. The elevation of the end wall ABCD is now drawn to scale immediately above the plan; the height of the eye-level is determined and a horizontal line drawn across it.

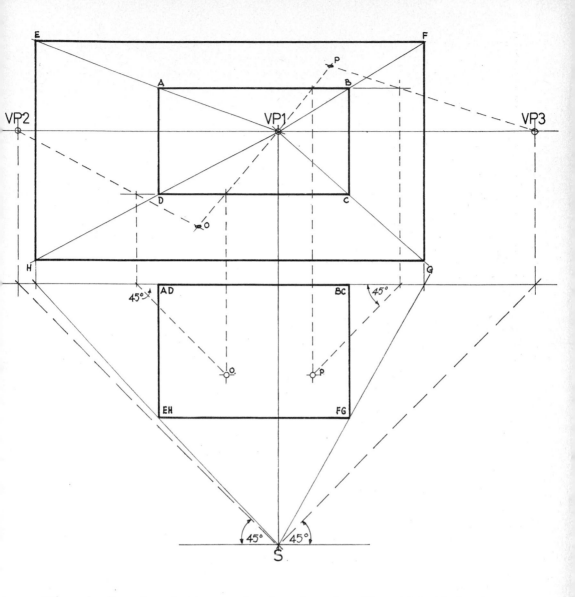

Fig. 9 Method for locating points on ceiling or floor.

Where the direct line of vision, continued up from the plan, cuts the eye-level is the vanishing point VP1 for all 'lines' running parallel to the direct line of vision. Therefore, by drawing lines from VP1 through A, B, C and D to meet the projections of EH and FG to the picture plane, the sides, floor and ceiling of the room in perspective are located.

Figure 8 shows how vertical and horizontal lines on the side walls are drawn. On plan, points L and M represent vertical lines on the left-hand wall of the room, e.g. mullions or panelling. By drawing through these points from S to the picture plane and projecting perpendiculars upwards, the lines can be drawn in their correct position on the side wall in perspective. KJ is a horizontal line on the same wall. The height of the line above the floor or the distance below the ceiling is known and is marked to scale along the corner of

the room, AD, on the picture plane; the line can then be drawn in perspective from VP1.

Figure 9 shows the location of two points O and P on the floor and ceiling respectively. Their positions are marked on the plan and lines are drawn from them at 45° to the picture plane; for convenience, one is taken to the left and one to the right. By referring to fig. 9 it will be seen how vanishing points VP2 and VP3 are obtained for lines running at 45° across the plan. From the point where the line from O on the plan cuts the picture plane a perpendicular is projected upwards to cut the bottom line of the end wall extended; through this intersection a line is drawn from VP2 to contact a line from VP1 through a point where a perpendicular from O on the plan cuts the end wall floor line, thus locating O in the perspective. Point P is found in a similar manner, the line of the ceiling level of the end wall being used in the construction where the floor level was used in the preceding example.

In perspective drawing, the construction lines should be very light, but clearly and accurately drawn. The slightest error can easily become greatly exaggerated and upset the whole drawing. Always set up the main lines of the building or object first and work progressively from large to small detail.

## PERSPECTIVES OF SHADOWS

Design drawings and perspective drawings can be 'rendered', that is, coloured or otherwise treated in a number of different ways, employing various media or techniques, with the object of explaining the design more clearly than is possible by a line drawing only. One of the first aids in this is the drawing of shadows to bring out the three-dimensional forms and the relationships of the various planes of the building or object illustrated.

Generally speaking there are two sources of light, which cast different types of shadows. These are sunlight, which for practical purposes is assumed to be straight parallel lines, and artificial light, which in its most simple form radiates from a point. The shadows cast by artificial light are usually larger than those cast by sunlight, and give a more dramatic appearance.

### Shadows cast by sunlight

Since rays of sunlight are considered to be parallel, the lines of light must have a common vanishing point in perspective. In order to find the perspective shape of shadows cast by sunlight it is necessary first to find the vanishing point of the lines of light and the lines representing their plans. The vanishing point of the plan lines will occur in the horizon

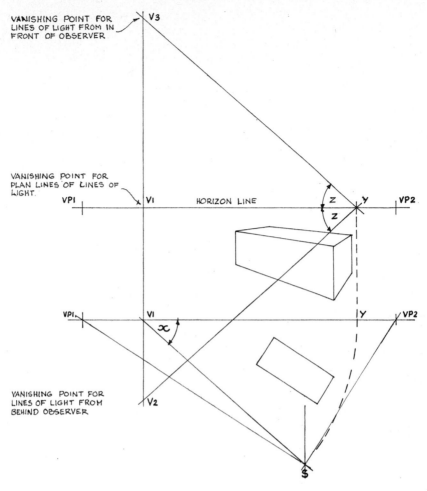

VANISHING POINT FOR LINES OF LIGHT FROM IN FRONT OF OBSERVER → V3

VANISHING POINT FOR PLAN LINES OF LINES OF LIGHT.

VP1    V1    HORIZON LINE    z  y    VP2
                             z

VP1    V1    x    Y    VP2

VANISHING POINT FOR LINES OF LIGHT FROM BEHIND OBSERVER    V2

S

x = ANGLE OF LIGHT RAYS TO PICTURE PLANE
Z = ANGLE OF LIGHT RAYS TO GROUND PLANE

line. When these vanishing points have been found it is comparatively simple, though sometimes a lengthy procedure, to draw the shadows.

The direction of the rays is usually given by the angle they make with the picture plane in plan and their true inclination to the ground plane. The most straightforward method is as follows (fig. 10, pp. 29–31).

To locate the vanishing point for the lines of light coming from behind the observer towards the object let the rays of light be at an angle $x$ to the picture plane and inclined at angle $z$ to the ground plane.

To locate the vanishing point of the lines of light V2 in perspective, draw a line from the spectator point S to meet the picture plane at angle $x$ at point V1. Project point V1 up

*Fig. 10a Obtaining vanishing points for constructing shadows. (continued overleaf).*

29

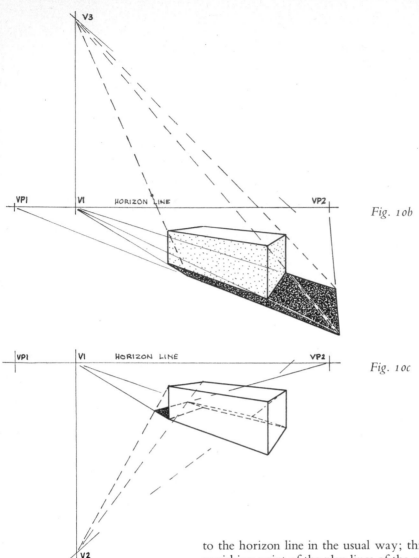

*Fig. 10b*

*Fig. 10c*

to the horizon line in the usual way; this point is now the vanishing point of the plan lines of the rays of light. Locate point Y in the picture plane and the horizon line by making distance V1 to S equal to the distance V1 to Y. From point Y in the picture plane draw a line at angle *z* to meet a vertical line drawn through V1 locating V2: point V2 is the vanishing point for the lines of light. Points V1 and V2 are now the vanishing points required to enable us to draw the shadows cast by parallel sunlight rays coming from behind the observer at an angle *x* to the picture plane and an angle *z* to the ground plane.

Point V3 can be located in the same way for the vanishing point of light lines the source of which is in front of the observer. From point Y on the horizon line draw a line at angle *z* to meet the vertical line through V1 and V2 at point V3. Point V3 is the vanishing point for the lines of light and V1 is the vanishing point for the plan lines of the rays of light. V1 and V3 are now the two vanishing points required to draw shadows cast by parallel sunlight rays from in front

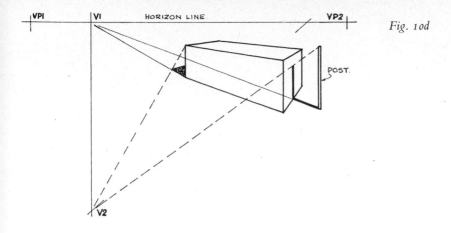

Fig. 10d

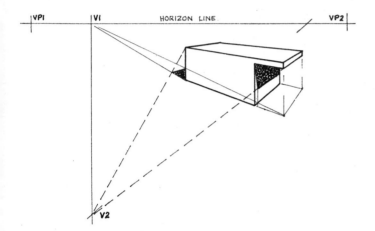

Fig. 10e

of the observer at an angle $x$ to the picture plane and an angle $z$ to the ground plane.

Using the method previously described to locate V1 and V3 it is now possible to construct the shadows cast by a simple object as shown in fig. 10b. As the light rays come from in front of the observer the shadows cast by the object will fall towards the observer.

Figure 10c shows the shadow cast by an object when the light rays come from behind the observer. Figure 10d shows the shadow cast by a post or similar on the vertical surface of the object. Figure 10e shows the shadow cast on a vertical surface of the object by a projection on the object. From these simple examples it should now be possible, given the required angles, to construct correct shadows of buildings and objects.

The method for finding the vanishing points of lines of light in a one-point perspective is exactly the same as for a two-point perspective, and for this reason it is not considered necessary to go into further detail.

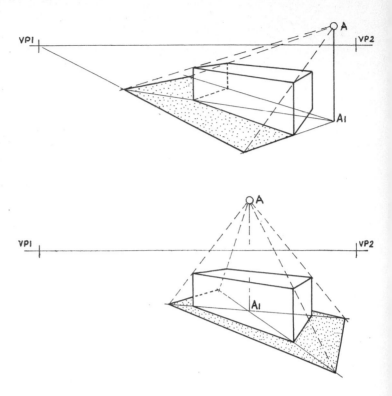

*Fig. 11 Shadows cast by artificial light.*

The construction for drawing shadows cast by artificial light is very similar to that previously described for sunlight, except that vanishing points are replaced by two points representing the actual source of light and its plan position in the ground plane. Typical examples are given in fig. 11 (above) of shadows cast by objects lit by artificial light sources. Point A represents the source of the light and point A1 represents its plan position in the ground plane. In the examples shown the shadows are constructed by drawing lines from point A1 in the ground plane through the plan points of the object, i.e. the plan lines of light. Lines are then drawn from point A, the source of light, through the points of the object to meet the plan lines of light. The shadow is drawn by joining up these intersections as shown.

## PERSPECTIVES OF REFLECTIONS

The main point to remember is that no matter what position the reflecting surface or the object occupies, the reflection of each point of the object will appear to be at the same distance from, and exactly opposite on the other side of, the reflecting surface. This is explained pictorially in fig. 12 and is really all that need be known to draw reflections in perspective. The principle of the use of diagonals as in fig. 12*b* is elaborated in figs. 18 and 19 (pp. 44 and 45).

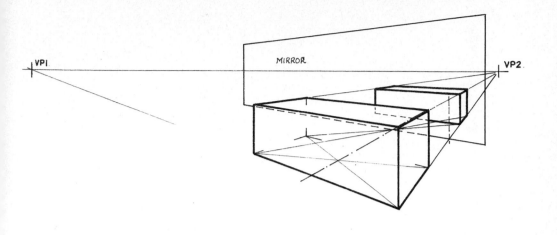

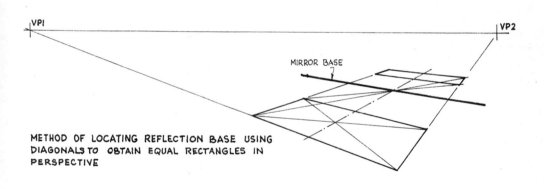

METHOD OF LOCATING REFLECTION BASE USING
DIAGONALS TO OBTAIN EQUAL RECTANGLES IN
PERSPECTIVE

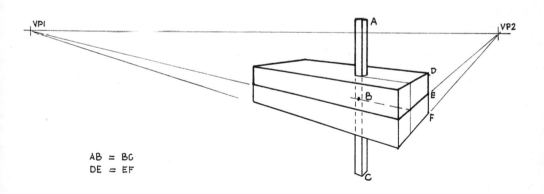

AB = BC
DE = EF

Fig. 12 *Perspectives of
reflections.*

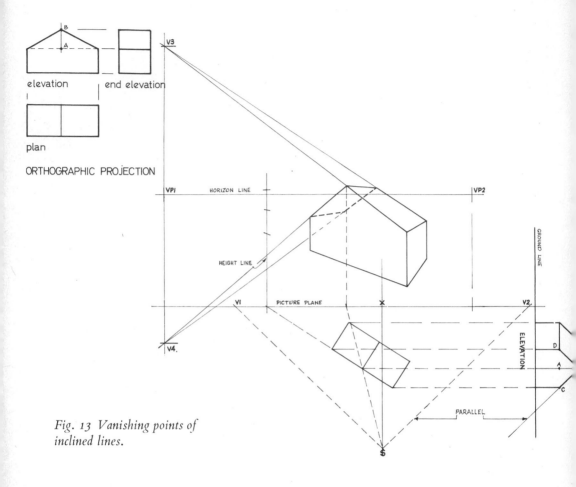

Fig. 13 Vanishing points of
inclined lines.

## VANISHING POINTS OF INCLINED LINES

To find the vanishing points of lines inclined to both the ground and picture planes, such as roof lines etc., it is first necessary to select a convenient point on the picture plane and draw a perpendicular line to be used as a ground line (fig. 13a, above). Project across from the plan and produce an elevation as shown.

Parallel to the roof line BC draw a line from station point S to meet the picture plane at V2. From station point S draw a line parallel to roof line BD to meet the picture plane at V1. Draw a perpendicular line through VP1 and locate V3 the same distance from VP1 as V2 is from X (X is the point where the centre line of vision meets the picture plane). Locate V4 the same distance from VP1 as V1 is from X. V3

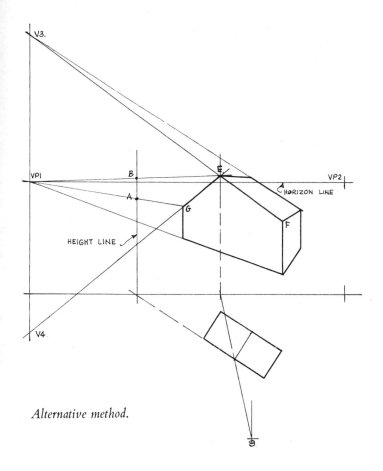

*Alternative method.*

and V4 are now the vanishing points for the sloping lines of the roof.

Where a number of parallel sloping lines are required it is advisable to use the method shown in fig. 13*a*, but if only one or two are needed, the points at the end of the line could be located and the sloping line drawn between the two points, as in fig. 13*b*. In this case the height of the rise of the roof is measured on the elevation and set out on the height line of the perspective. Locate the position of the top of the rise as shown. Project a line from VP1 through B to locate E. Join up points E–F and E–G and continue both until they meet a perpendicular line drawn through VP1. The points at which EF and EG, when projected, meet the perpendicular are V3 and V4 respectively. As in the previous method, these are the vanishing points for the sloping roof lines.

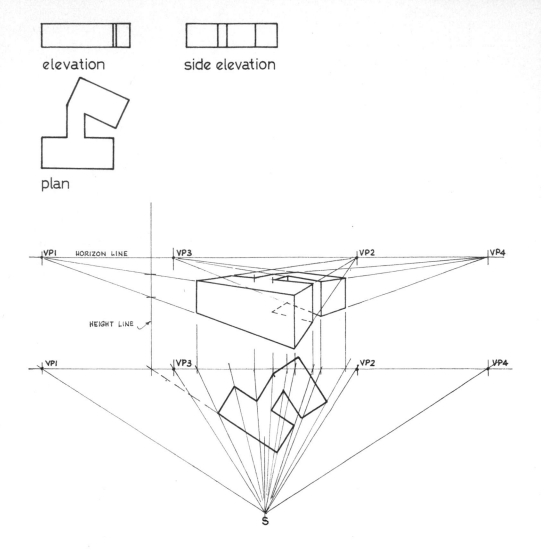

*Fig. 14 Obtaining two or more sets of vanishing points.*

## PERSPECTIVES REQUIRING MORE THAN ONE SET OF VANISHING POINTS

Where objects or parts of objects are placed at different angles to each other on the ground plane as shown in fig. 14a (above), it is sometimes necessary to use more than one set of vanishing points to set up an accurate perspective. The object shown in fig. 14a can be treated as two separate objects with each part having its own set of vanishing points. VP1 and VP2 are the vanishing points for the front part and VP3 and VP4 are the vanishing points for the back part. When these points are found all that is necessary is to apply the basic perspective method previously described.

Figure 14b shows the method for drawing a perspective of a hexagon. Each pair of sides has its own set of vanishing points. VP6 is not shown in this particular case as it would fall a long way off the diagram and for this example it is only necessary to use VP5.

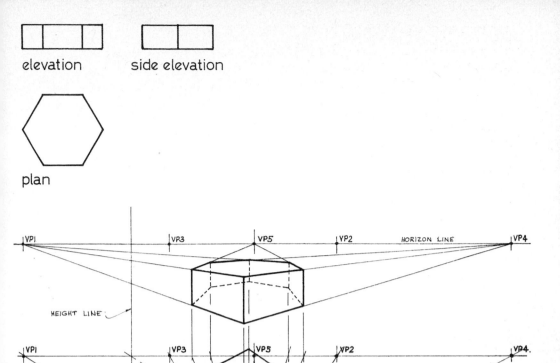

elevation   side elevation

plan

## OBJECTS INCLINED TO THE GROUND PLANE

In previous constructions, perspectives requiring only two vanishing points have been dealt with. If the object is inclined to the ground plane it will be necessary to locate a third vanishing point for the vertical lines, as shown in fig. 15a (p. 38). The simple rectangular object chosen will show the principle without becoming too involved. The plan and elevation have been prepared with the sides inclined to both the ground plane and the picture plane. From point S1 draw a line parallel to the side of the object to meet the picture plane at V4, and another line at right angles from point S1 to meet the picture plane at V3. From point S draw a line parallel to the sides of the plan meeting the picture plane at V1 and V2. Through point S draw a perpendicular and at a convenient point draw a ground line at right angles. At a distance *a* below the ground line draw a second line parallel

37

# 'WORM'S EYE' VIEW

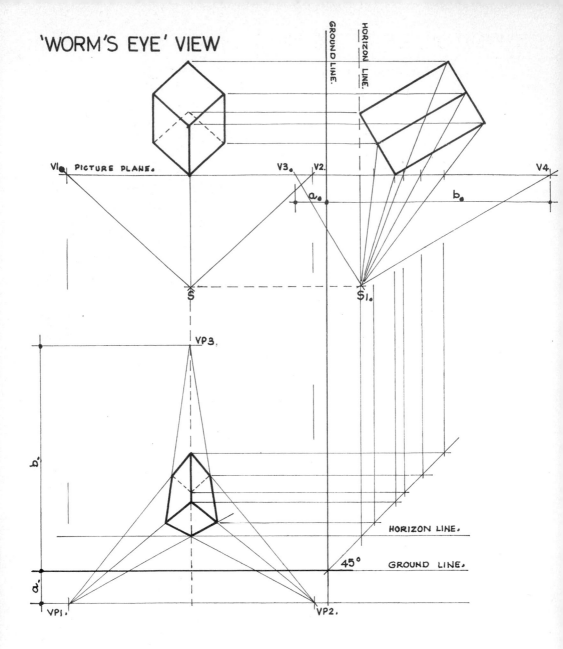

*Fig. 15 Objects inclined to the ground plane.*

to the ground line and project down from V1 to obtain VP1 and from V2 to obtain VP2. Above the ground line measure up distance *b* to obtain VP3. VP1, VP2 and VP3 are the vanishing points required to draw the perspective of the object inclined to the ground plane and the picture plane, which can now be done by using simple projection.

First it is necessary to locate the various points of the object on the picture plane by drawing lines from various points back to S1. At the first intersection of the vertical with the horizontal ground line draw a line at 45°. From the various points on the picture plane drop perpendicular lines

# 'AERIAL' OR BIRD'S EYE VIEW

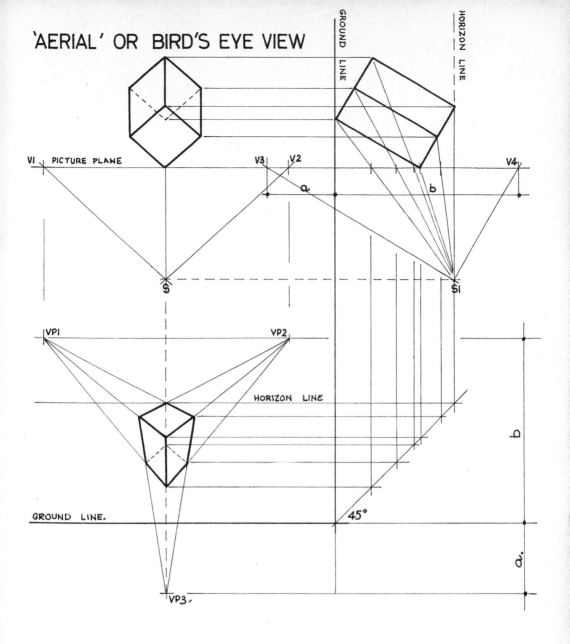

to meet the line drawn at 45°. From these points draw horizontal lines towards a line perpendicular from point S. Using VP1, VP2 and VP3 to join up these points it is possible to complete the outline of the object in perspective. The completed drawing shows the object from underneath, or what is known as a 'worm's-eye' view.

To produce a drawing of an object viewed from above – a 'bird's-eye' view – the principle used is similar. Figure 15*b* shows the method, which differs from the previous construction only in that the station point is above the object. When the plan and elevation have been prepared the

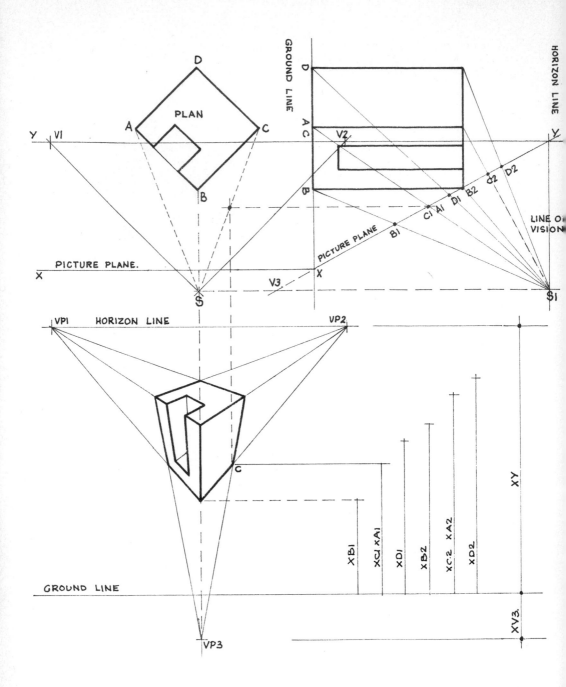

*Fig. 16 Alternative 'aerial' view.*

projections are similar to fig. 15a, and by joining up the points obtained the outline of the object can be drawn.

In the example shown in fig. 16 (above) it is possible to work directly from a normal ground plan and elevation. It is necessary first to locate the station point both in plan (S) and in elevation (S1). Draw the line of vision from the eye or station point (S1) to the object so that the centre of vision will fall within the perspective view as shown. Next draw

the picture plane in the chosen position at right angles to the line of vision (in elevation) to intersect the ground line at X. The line X–X represents the picture plane in plan at the point where it meets the ground line.

Since the lines parallel to AB and BC in the object are horizontal, their vanishing points will lie in the horizon line. To find the position of the horizon line, draw a horizontal line from $S_1$ in the elevation to meet the picture plane at Y and from Y draw a line Y–Y parallel to the picture plane in plan. Now from station point S draw $SV_1$ and $SV_2$ parallel to AB and BC respectively to meet Y–Y at $V_1$ and $V_2$.

To find the vanishing point of the vertical lines of the object, draw a line through $S_1$ perpendicular to the ground line in the elevation to meet the picture plane produced at $V_3$. Now in the perspective view draw a ground line in a convenient position. The vanishing point $V_3$ of the vertical lines of the object will lie in a line through S perpendicular to the picture plane. Produce this line to intersect the ground line in the perspective view. Locate $V_3$ at a distance $XV_3$ below the ground line and project lines down from $V_1$ and $V_2$ to meet the horizon line at $VP_1$ and $VP_2$, the vanishing points for all lines parallel to AB and BC.

It is now possible to draw the perspective view of the object by using the three vanishing points and by locating the necessary points by simple projection. To locate these points a further construction will be necessary. To find point C in perspective, it is necessary to join $S_1$ to C in the elevation, intersecting the picture plane at $C_1$. Now draw a horizontal line from $C_1$ to represent the picture plane in plan at the level of $C_1$ and join SC to intersect this line. From the point of intersection project a line down to the ground line in the perspective view and measure up from the ground line a distance equal to $XC_1$. This point will be the position of C in perspective. Each of the other points required can now be found in exactly the same way.

## PERSPECTIVES OF CIRCLES AND CYLINDERS

To draw a perspective of a circle it is necessary to construct a square around the circle (fig. 17, p. 42). Using the method previously described for two-point perspective, it is possible to set up the square containing the circle as required. At this point it is necessary to draw lines AC, FH, BD etc., on plan. Project up to the picture plane in the usual way and locate these lines on the perspective. From point S project up to the picture plane through the point of intersection of the circle on line AC and locate this point in the perspective. Each of the other intersection points can be found in the same way. When all of the required points have been located it is possible to draw in freehand the outline of the circle in perspective.

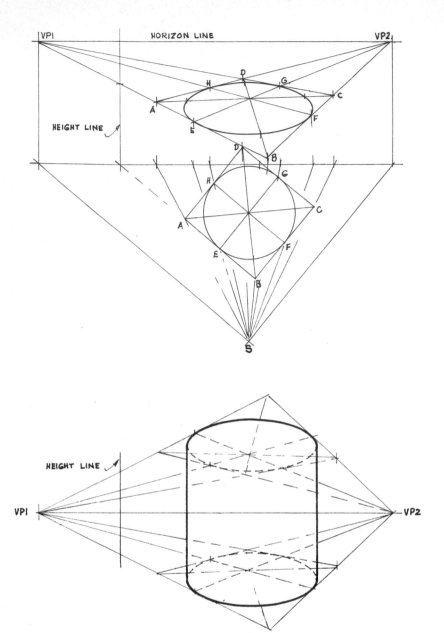

Fig. 17 *Perspectives of circle and cylinder.*

When required to draw a larger or more accurate perspective of a circle it is necessary to use a larger number of diagonals. These are obtained in the same way as previously described and from the example shown, in which only eight points are used to obtain the outline, it can be seen that the more points which are located the more accurate the perspective.

Using the same method it is possible to set up perspectives of cylinders. The basis is as before – a circle in plan projected to obtain a perspective view. Then, by measuring up the height line the required height, it is possible to locate the top

plane of the cylinder. The shape of the circle in perspective can now be outlined by the method previously described or by projecting up from the base.

Many short-cuts can be used in the preparation of a perspective view of an object, but before the student attempts these he should have at least a working knowledge of the rules or he is likely to end in a hopeless tangle.

While this chapter is not meant to be a complete study of perspective drawing, it covers the information generally required in the practice of preparing architectural perspectives, interior perspectives, civil engineering perspectives, furniture and fittings in perspective and most other objects normally encountered.

## APPROXIMATION METHODS

With experience it will be discovered that details can often be approximated in perspective within the general framework of a correctly constructed drawing. These approximations, when applied with intelligence, can save a considerable amount of time and produce equally satisfying results. The aim of perspective drawing is to give as true a picture of the object as possible. Only practice and experience can provide the knowledge which enables these improvisations to be made.

One of the most useful short-cuts in perspective drawing is the use of diagonal lines to divide an object into equal parts in perspective. Any object which is divided into a number of equal sections or parts can be set up quickly and accurately by setting up the whole object and then using a diagonal line from point A to point B, as shown in fig. 18a (p. 44). Divide the vertical line AC into the same number of parts as sections required and project lines back to the vanishing point. Where these lines and the diagonal line intersect, draw perpendicular lines dividing the object into (in this case) four equal sections in perspective.

The alternative method, shown in fig. 18b, is to set up one of the sections only. From the midpoint of the first vertical draw a line back to VP2 as shown. Draw the diagonal AB and project to intersect the top line of the object at C. From C draw a vertical line and repeat the procedure to find points D and E. From this example it will be seen that the same result is obtained as in fig. 18a.

The use of diagonal lines in showing floor tiles in a perspective will save considerable time and tedious work. Figure 19a (p. 45) shows the method of laying out a tiled floor in a one-point perspective. DCGH is the outline of the floor area. DC, as has been found previously, is a measured line which means we can measure along this line for the size of the tiles, which in this exercise are assumed to be 1 ft square. Divide CD into 1-ft divisions and project lines

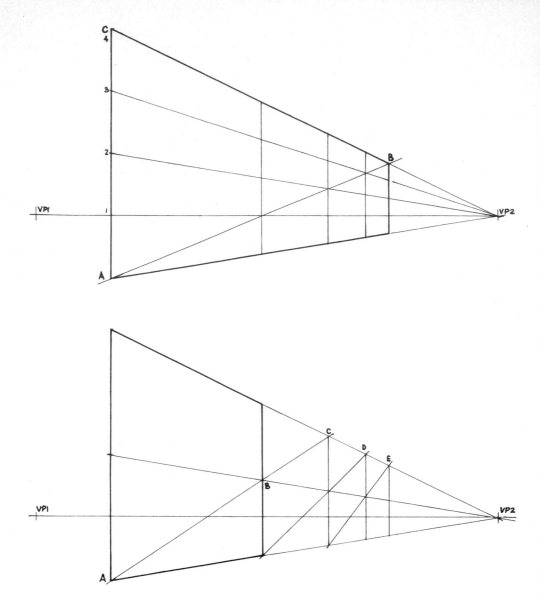

Fig. 18 *Approximation method.*

from VP1 through each of these divisions to meet GH. From the plan the length of side HD can be found, in this case 11 ft. Point X is then found, DX being equal to the plan length of HD. Draw XH, and through each point of intersection draw horizontal lines as shown. By checking, it will be found that the correct number of tiles for the floor is shown.

The alternative method shown in fig. 19*b* is not as accurate as the previous method but is useful for many purposes. Divide the bottom line into equal parts as required and draw lines back to VP1 as shown. Using your judgment, draw a second line CD parallel to the bottom line AB to represent the first row of tiles. Select any convenient tile, draw the line EF and continue it until it intersects all the lines joining AB to VP1. Through each intersection draw horizontal lines. Using this method it will be seen that the tiles appear in

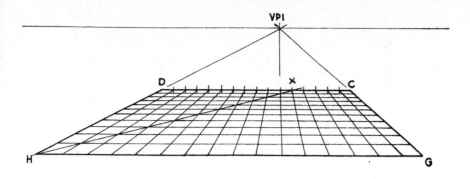

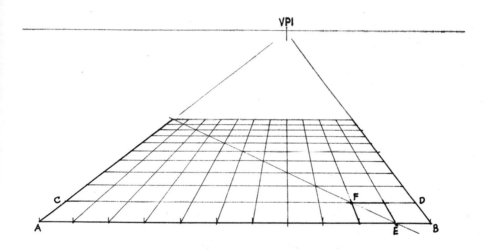

Fig. 19 Alternative
approximation method.

correct perspective. Either of these two methods can be used in most cases where it is not essential to set up the floor or ceiling patterns from the plan. The examples shown are very simple, but it will be seen from them that the use of the diagonal can simplify many problems and save many hours of needless work.

There are a number of further short-cuts which the student will discover for himself as he becomes more familiar with perspective drawing, but short-cuts should be thoroughly examined before they are put into extensive use, and checked against the usual methods of construction. Mistakes in perspective drawing become magnified many times and can cause catastrophic results and considerable waste of time if not checked and rectified as the work proceeds.

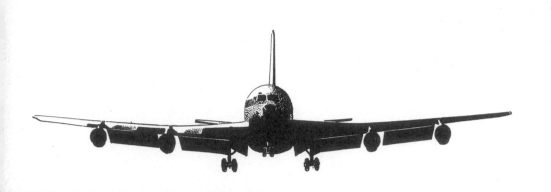

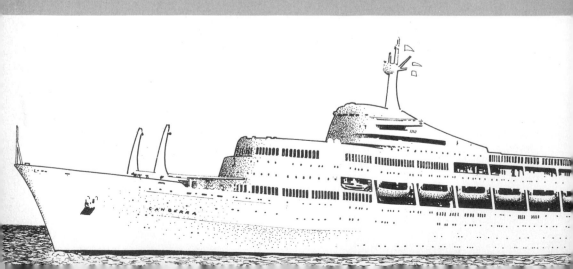

# 3 Drawing transport

In the preparation of a perspective drawing of a building or a bridge or the interior of a room it is necessary to show things normally associated with the subject to give atmosphere, scale and a view of the subject as it will look to a person observing it from a chosen viewpoint. To achieve this natural look one needs to acquire some skill and understanding in drawing objects such as people, trees, shrubs, lawns, rocks, water, paths, cars, buses, for use in exterior perspectives, and furniture, fabrics, carpets, plants, ornaments and other miscellaneous items found in rooms of different types for interior perspectives. Everyone will develop his own style in drawing these varied objects, and it is not intended to lay down rules for drawing them. There are, however, rules for the construction of these things which will help the draughtsman to produce credible representations having the correct relationship to the drawing as a whole, and not to produce, for example, cars of enormous size standing precariously on one wheel in front of a building peopled by midgets.

These rather obvious mistakes can be eliminated by treating the object – a car, in this case – as part of the plan being used to set up the perspective. In this way it is possible to locate the outline of the plan of the car in the perspective correctly. From this point on the car can be treated as the object and a reasonable drawing of a car can be obtained.

Figure 20 shows a simple method of drawing a box-like object with pieces removed to form the trunk and top. The box usually sits on four wheels which, like the trunk and top, are placed in a more or less similar position on all cars. One point to remember is that a car is only a prop, so to speak, and therefore should not be loaded with unnecessary detail. Usually it is necessary to show only the grille, headlights, fender and in some cases a number plate on the front of the car, or tail-lights, fender and number plate on the rear of the car. Interiors, where necessary, can also be simplified. It is worth looking at some of the excellent drawings which are done by specialists for the daily press, advertising various makes of cars on the market. These drawings are fully detailed and are in themselves finished objects presented for a special reason. For most draughtsmen engaged in perspective drawing cars have an entirely different function and usually form only a supporting role in the perspective drawing of a building or group of buildings.

Perhaps the most difficult part of a car in which to obtain a convincing result is the wheel. The wheel, being round,

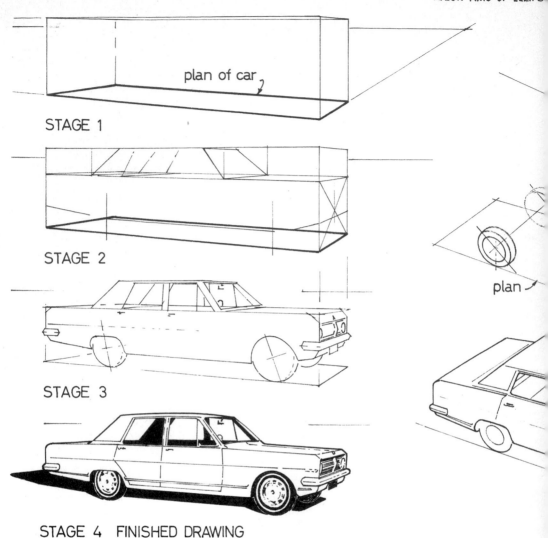

STAGE 1

plan of car

STAGE 2

STAGE 3

STAGE 4   FINISHED DRAWING

plan

*Fig. 20 A car, drawn as a
simple box-like object.*

for the purposes of perspective drawing is seldom if ever seen in true elevation, and because of this is usually represented as a series of ellipses. To draw the wheel it is first necessary to locate approximately the axle on which the wheel is fitted. The main axis of the ellipse for the wheel is then drawn at right angles to the axle line and the minor axis at right angles to the major axis. When these two axes are obtained it is then possible to draw the ellipse, which is usually small enough to be drawn freehand with satisfactory results which will improve with practice and experience. The amount of detail drawn on the basic wheel is a matter of individual decision, but as a rule it should be kept simple.

As with other objects, the use of shadows will improve the drawing and some fairly broad interior detail in shadow

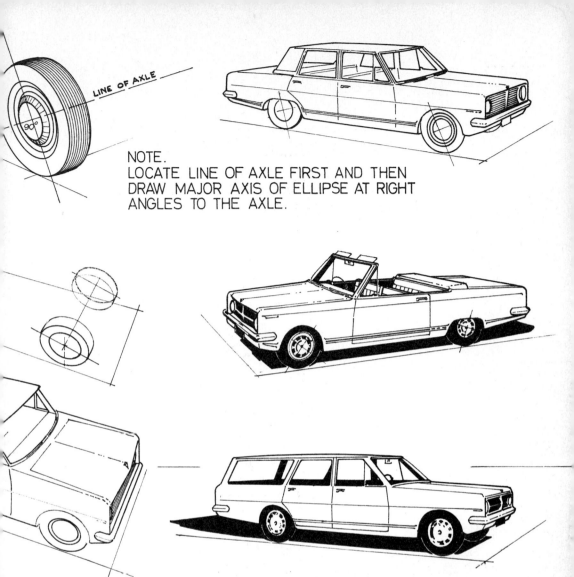

NOTE.
LOCATE LINE OF AXLE FIRST AND THEN
DRAW MAJOR AXIS OF ELLIPSE AT RIGHT
ANGLES TO THE AXLE.

EXAMPLES OF A FEW OF THE MORE
COMMON TYPES OF MOTOR CARS

will achieve a reasonably solid and convincing representa-
tion of a car. It is usually a good rule to draw 'a car' rather
than to attempt to draw a specific make and model of a car
as this can be a trap into which the 'car enthusiast' can easily
fall, and which results in a drawing of a car with a building
as a background. It will be realized that these rules are
intended to be general rules only and will change somewhat
under special circumstances.

This is not, therefore, intended to be a 'how to draw cars',
but only a guide to drawing cars as a 'prop' to create atmo-
sphere and scale. For those whose interest runs to drawing
cars there are a few excellent reference books available which
treat the subject reasonably fully. One good and inexpensive
book is listed in the bibliography (p. 365).

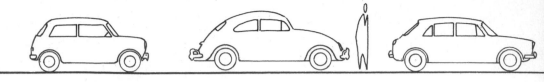

ELEVATIONS OF VARIOUS SIZES OF PASSENGER CARS

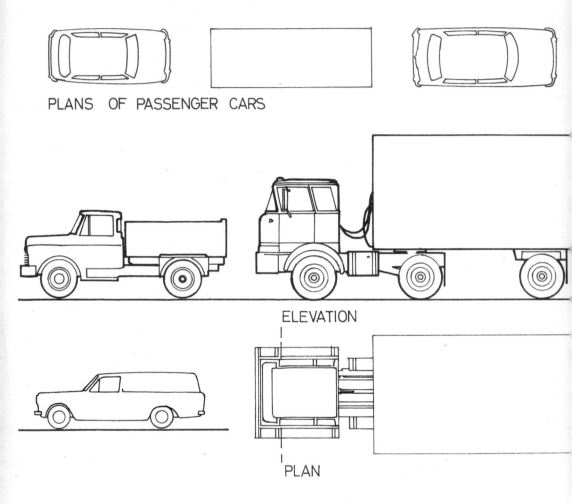

PLANS OF PASSENGER CARS

ELEVATION

PLAN

*Fig. 21 Scale plans and elevations.*

This shows various types of cars, from the small mini car through to the larger American type. The larger commercial vehicles shown give a comparison of size between them and the ordinary passenger car, the plan of which should help in the projection of these vehicles when required in perspective drawing.

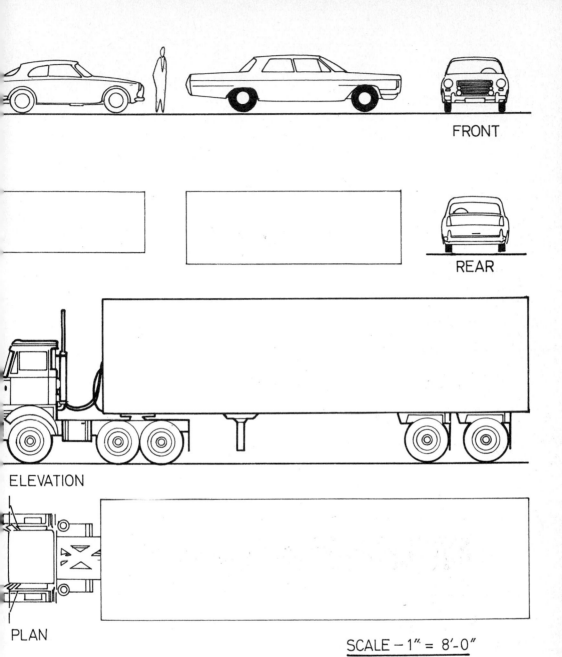

FRONT

REAR

ELEVATION

PLAN

SCALE — 1″ = 8′-0″

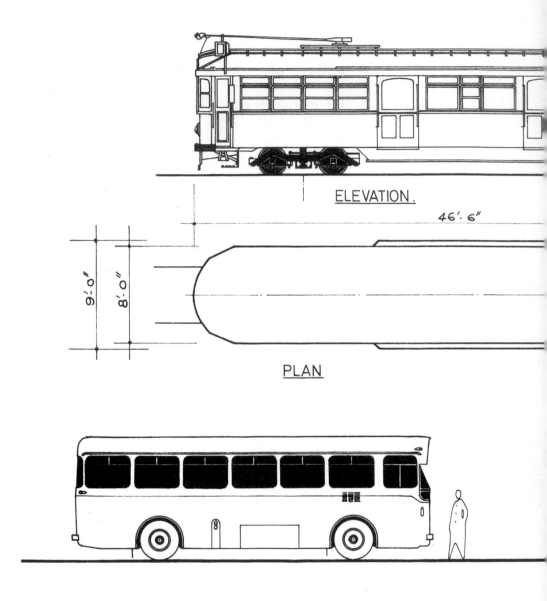

ELEVATION.

46'. 6"

9'. 0"

8'. 0"

PLAN

*Fig. 22  Typical Melbourne tram and bus.*

These are drawn to a scale of $\frac{1}{8}$ in. to 1 ft, which will be of use when preparing a perspective of a city building. The examples shown are of particular vehicles, but the size will help in a general way for most vehicles of this type throughout the world. Styling and access will, of course, vary considerably.

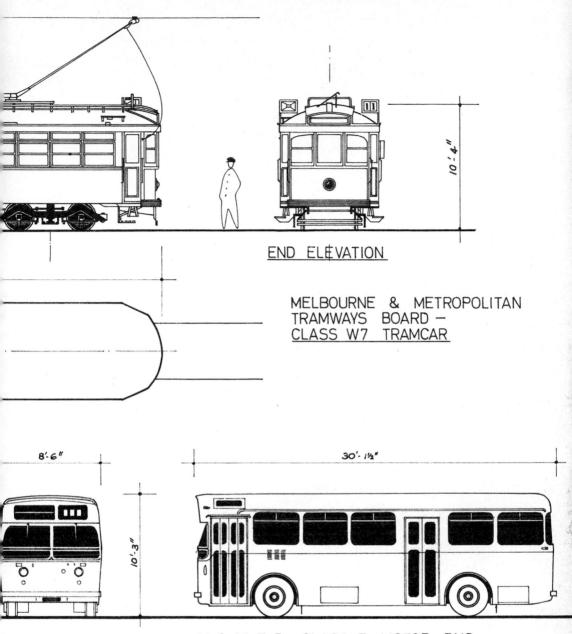

END ELEVATION

MELBOURNE & METROPOLITAN
TRAMWAYS BOARD —
CLASS W7 TRAMCAR

M & M.T.B. CLASS F. MOTOR BUS

*Fig. 23 'Rub-down' cars and buses.*

There are a number of useful aids available to the draughtsman in the form of 'rub-down' drawings of cars and buses. These consist of plans, front elevations, rear elevations and side elevations. Examples of these from Letraset are shown here. The Letraset sheet consists of twice the quantity shown. Their range includes line drawings of cars, buses and larger commercial vehicles in both $1:100$ ($\frac{1}{8}$ in.) and $1:200$ ($\frac{1}{16}$ in.) scales. Each symbol is overprinted with a clear carrier film to facilitate transfer as a complete unit.

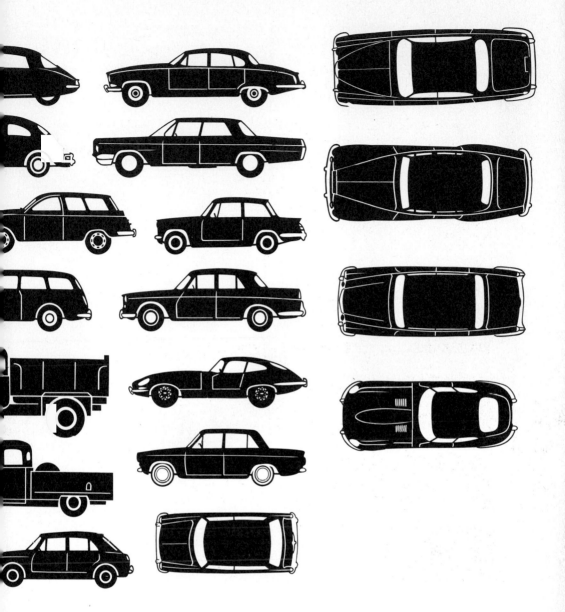

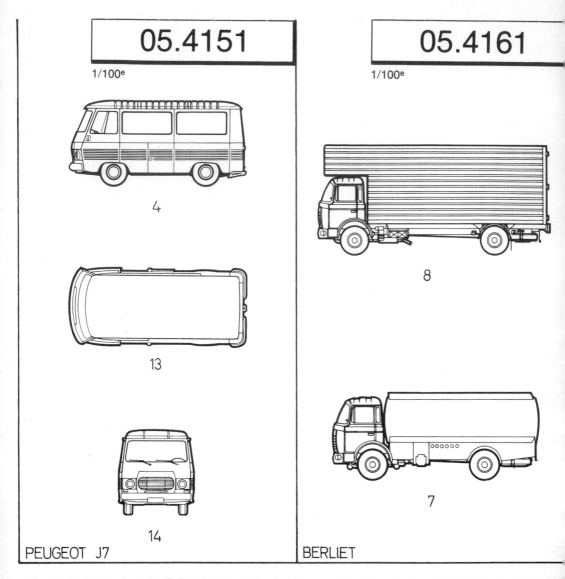

| 05.4151 | 05.4161 |
|---|---|
| 1/100e | 1/100e |

4

13

14

PEUGEOT J7

8

7

BERLIET

THE LETTER-PRESS RANGE OF RUB-DOWN CARS & TRUCKS CONSISTS OF THIRTEEN SHEETS OF DIFFERENT MAKES AND TYPES OF VEHICLES AT SCALES OF EITHER 1 : 100 OR 1 : 50.
THE SHEETS ARE ONE SIZE ONLY : 17.5 × 25 cm. (EXAMPLES SHOWN ARE FROM 1 : 100 SHEETS).

THE FOLLOWING MAKES AND TYPES MAKE UP THE RANGE :

| | | |
|---|---|---|
| 05.4012 – CITROEN DS. | 05.4052 – MINI MORRIS. | |
| 05.4022 – PEUGEOT 404. | 05.4062 – PEUGEOT 504 | |
| 05.4032 – RENAULT 16. | 05.4072 – VOLKSWAGEN 1500. | |
| 05.4042 – SIMCA 1501. | 05.4082 – MERCEDES 25 | |

*Fig. 24 'Rub-down' drawings of cars and commercial vehicles.*

This is an example from the range of such drawings (both plans and elevations) put out by Letter-Press. Each sheet consists of the type of drawing shown in fig. 24 in the quantity shown by the number under each drawing. Each sheet, with the exception of 05.4161 which shows two types of commercial vehicles, is devoted to an individual make and model of a European car. The Letter-Press architectural

## 05.4071

1/100ᵉ

8

17

19

KSWAGEN 1300

## 05.4081

1/100ᵉ

9

18

MERCEDES 250

.4122 - FIAT 850.
.4132 - FIAT 124.
.4142 - FIAT 125.
.4152 - PEUGEOT J7.
.4162 - BERLIET.

NUMBERS UNDER EACH DRAWING INDICATE THE QUANTITY
OF EACH INCLUDED IN EACH 1 : 100 SHEET.

symbol sheets are 17.5 cm. × 25 cm. (6$\frac{7}{8}$ in. × 9$\frac{7}{8}$ in. approx.) and are available in both 1 : 100 and 1 : 50 ($\frac{1}{8}$ in. and $\frac{1}{4}$ in.) scales.

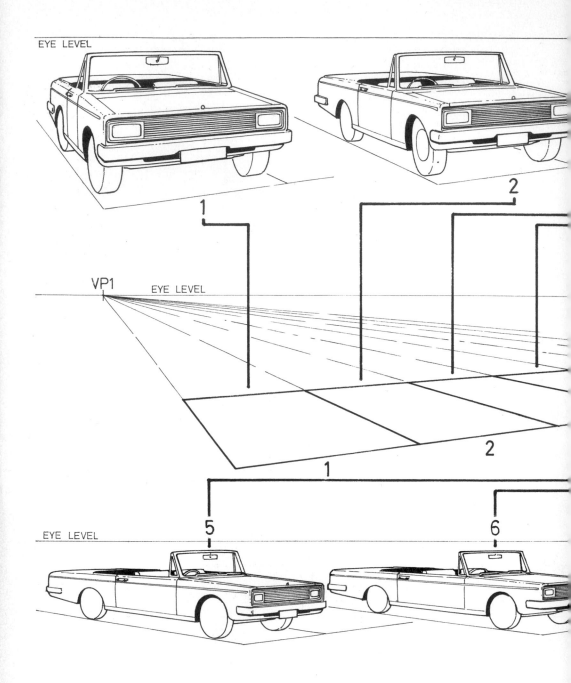

EYE LEVEL

VP1   EYE LEVEL

1   2   5   6

EYE LEVEL

*Fig. 25 A car in eight different positions seen from the same station point.*

This diagram should help the student to appreciate the varying appearance of a car when it is placed in different positions in the drawing. Many mistakes are made because of inaccurate assessment of the proportions of the front to the side of the vehicle.

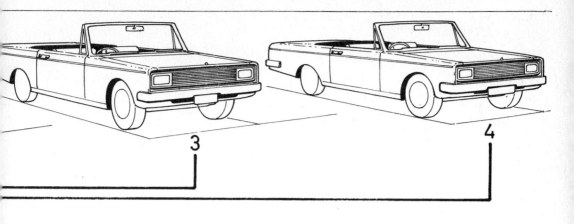

3

4

TO VP2

4    5    6    7    8

7         8

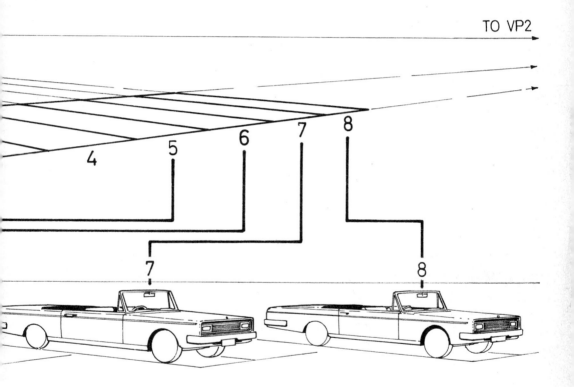

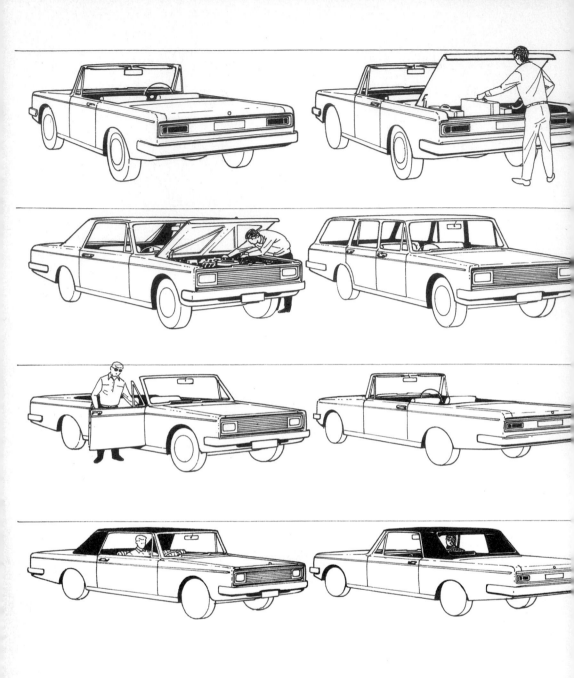

Fig. 26 Drawings of cars in various positions, with figures added.

The figures which have been added to some of the drawings help to give a natural look to the vehicles and can often be used to increase interest in the over-all drawing in which they are included.

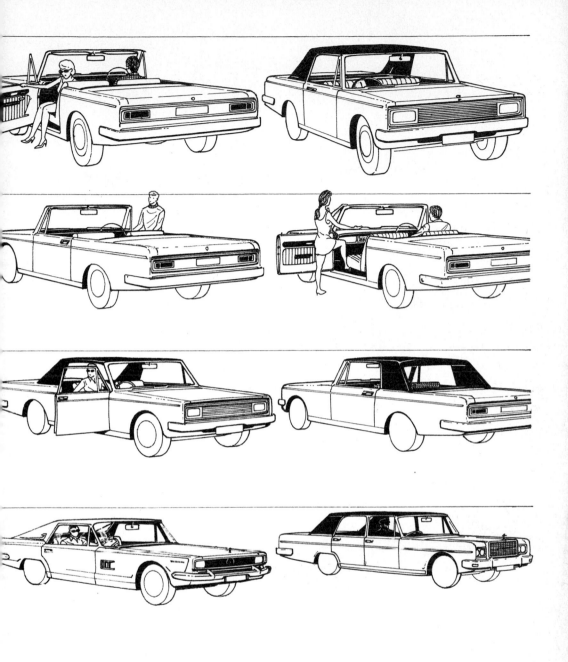

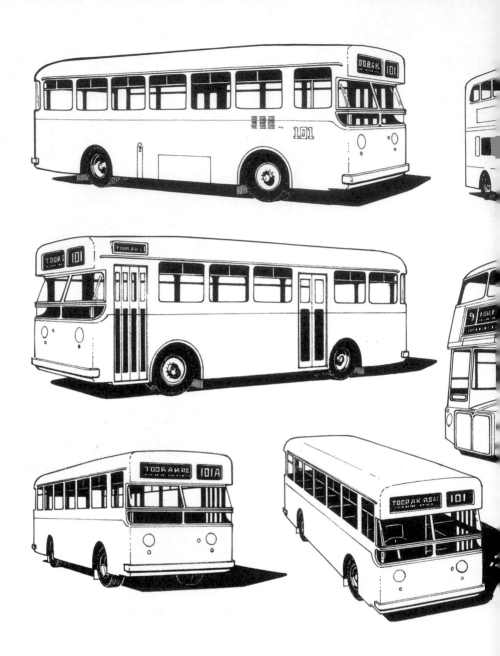

*Fig. 27 Examples of commercial road transport.*

The drawings of the single-deck bus have been set up from the information in fig. 22 (pp. 52–3). The double-decker is based on a London Transport bus shown in fig. 23. The rest of the vehicles shown in this figure are not intended to be any specific make of vehicle but to be indicative of various types seen on highways throughout the world.

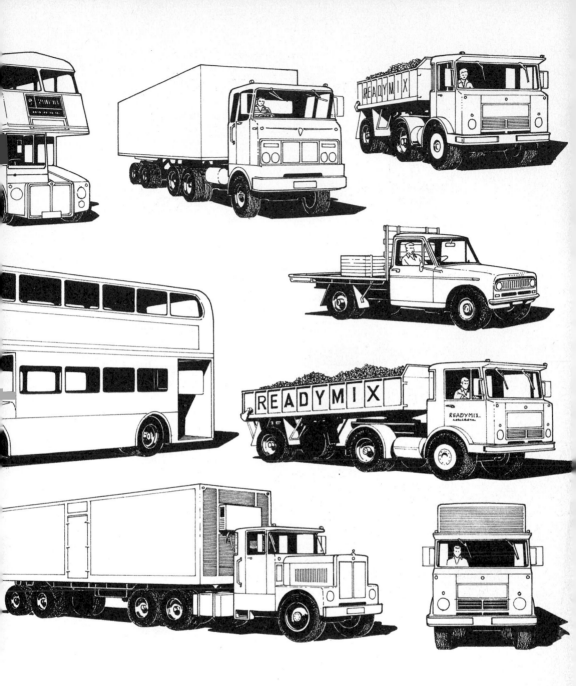

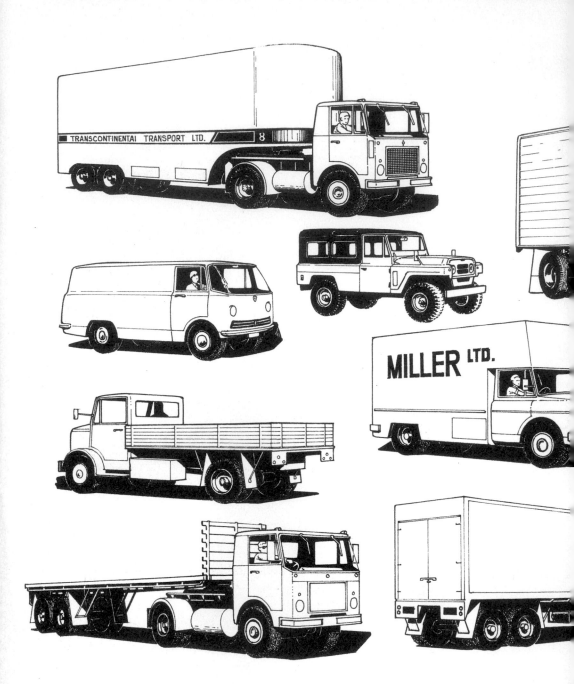

*Fig. 28 Further examples of commercial road transport.*

This includes some special vehicles such as large bulk tankers, refrigerated vans, furniture vans etc. It will be noticed that these can be fitted into a 'box' similar to that used when drawing a car. The single-deck bus is, of course, simple as there is practically no cut-out for the engine-top or trunk. This is true for many of the newer buses, but some of the older types still have an engine-top exposed. Trucks are usually either square-fronted or have an exposed engine-top and are treated in a similar fashion to the bus.

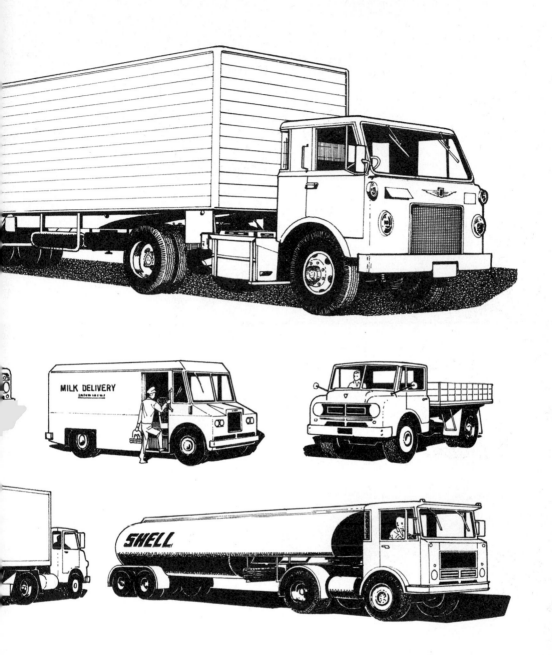

MILK DELIVERY

SHELL

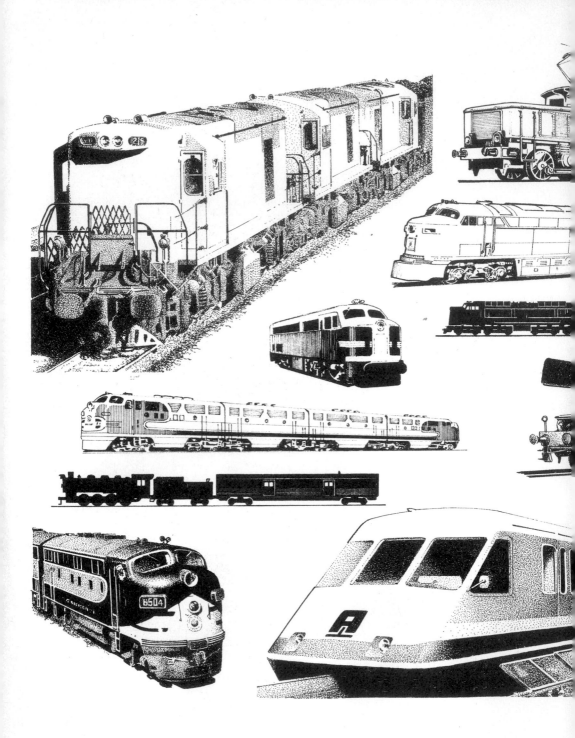

*Fig. 29 Various types of railway locomotives and a few goods wagons.*

The diesel locomotive should be approached in a similar fashion to the passenger bus and in general is fairly simple to draw in outline but, as can be seen from the examples shown, it has a considerable amount of detail which is time-consuming unless treated in a simplified fashion. It is fortunate for

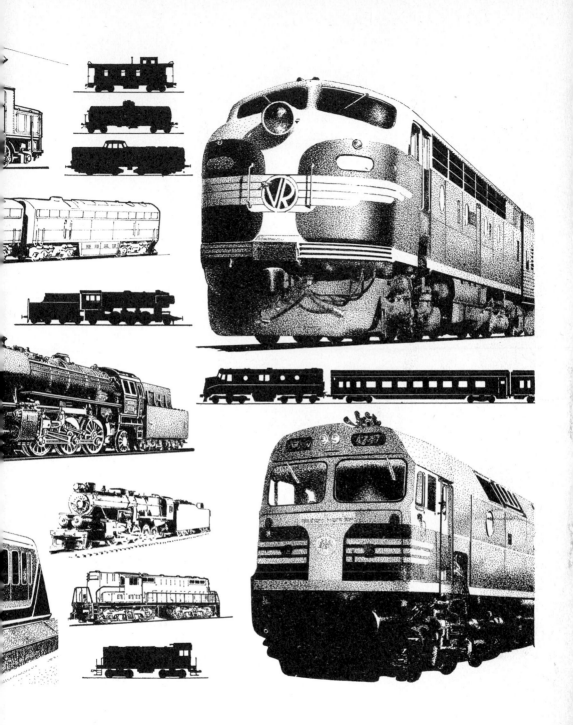

the draughtsman that the steam locomotive is quickly giving
way to diesel and the electric locomotive as it is difficult to
treat the driving mechanism of a steam locomotive in a
simplified fashion; see, for instance, the example of a Class
23 German Federal Railways 2–6–2 passenger locomotive.

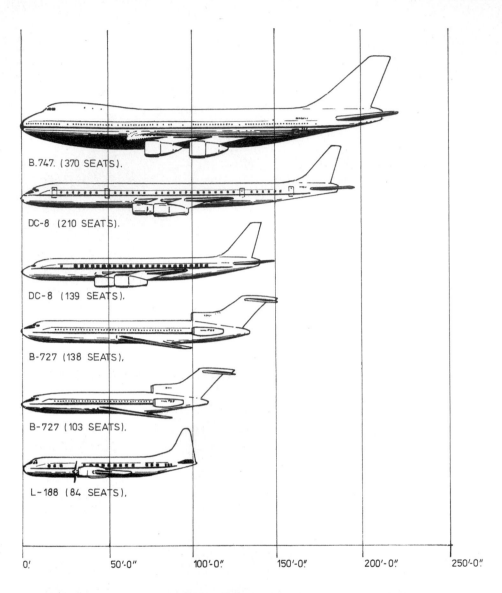

B.747. (370 SEATS).

DC-8 (210 SEATS).

DC-8 (139 SEATS).

B-727 (138 SEATS).

B-727 (103 SEATS).

L-188 (84 SEATS).

0'    50'-0"    100'-0"    150'-0"    200'-0"    250'-0"

COMPARISON DRAWINGS OF A FEW OF THE MORE
COMMONLY SEEN PASSENGER PLANES.

*Fig. 30  Aircraft.*    The aeroplane is one of the more difficult objects likely to be
encountered by the draughtsman. This figure compares the
size of some of the larger passenger planes.

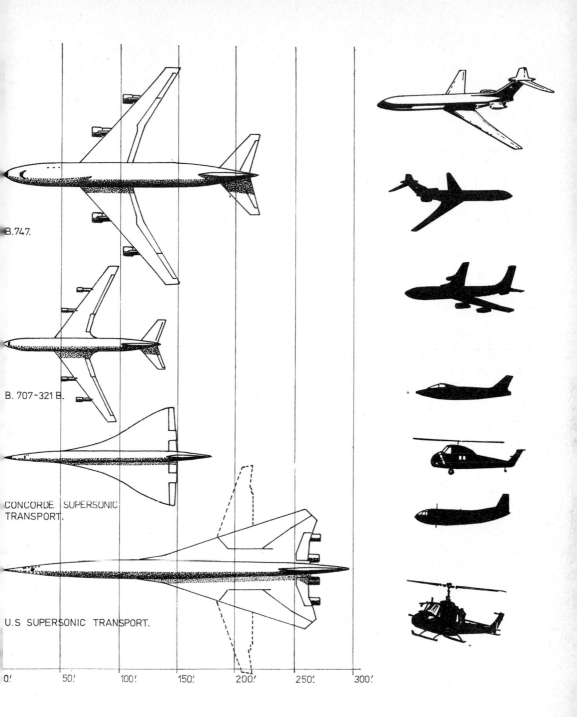

B.747.

B. 707-321 B.

CONCORDE SUPERSONIC
TRANSPORT.

U.S SUPERSONIC TRANSPORT.

0'　　　50'　　　100'　　　150'　　　200'　　　250'　　　300'

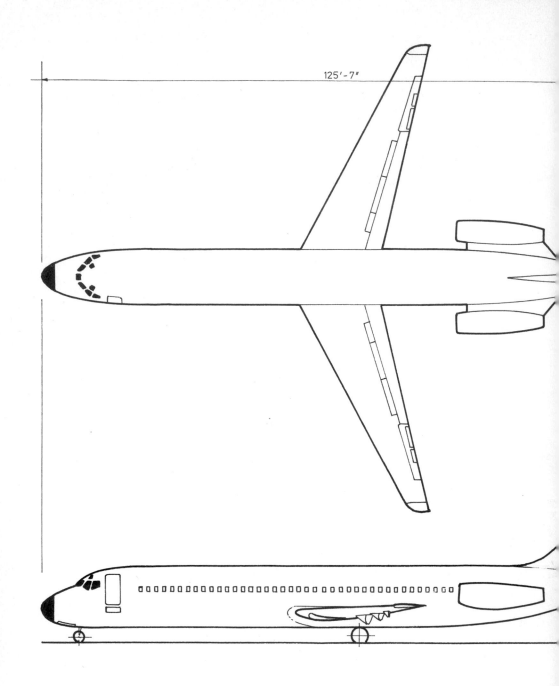

125'-7"

Fig. 31 Scale plan, front and side elevations of a Super DC-9.

This may help the draughtsman to get the feel of a passenger aircraft for general use. However, if more detailed information is required most airways companies are very co-operative and generous with information.

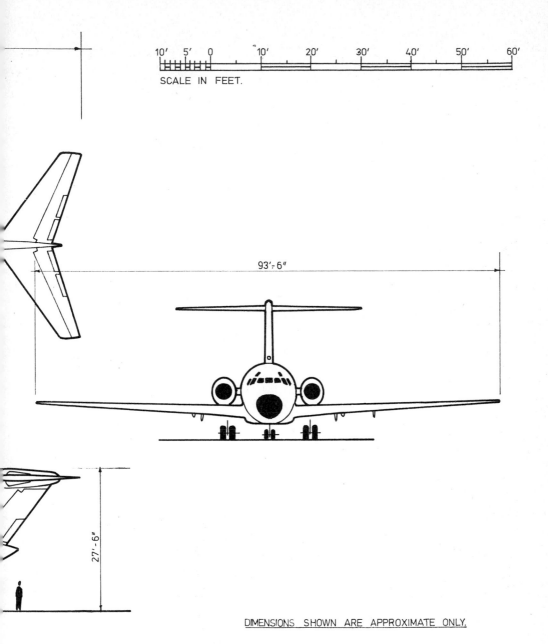

SCALE IN FEET.

93'-6"

27'-6"

DIMENSIONS SHOWN ARE APPROXIMATE ONLY.

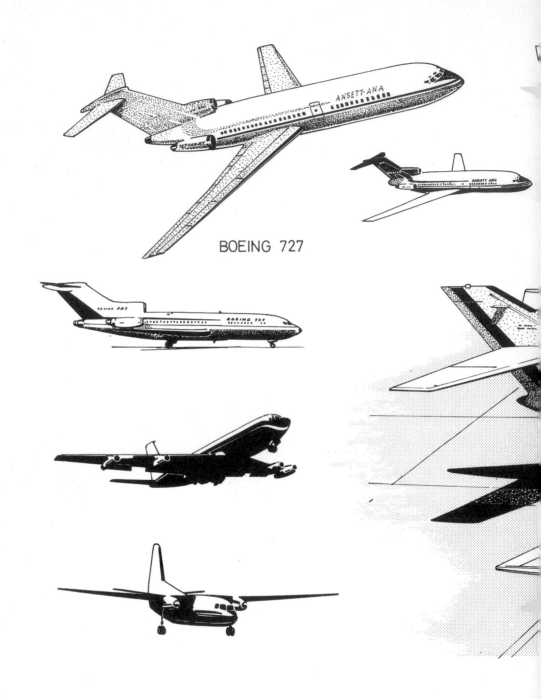

BOEING 727

Fig. 32 *A few aircraft in perspective.*

This may be useful when preparing drawings.

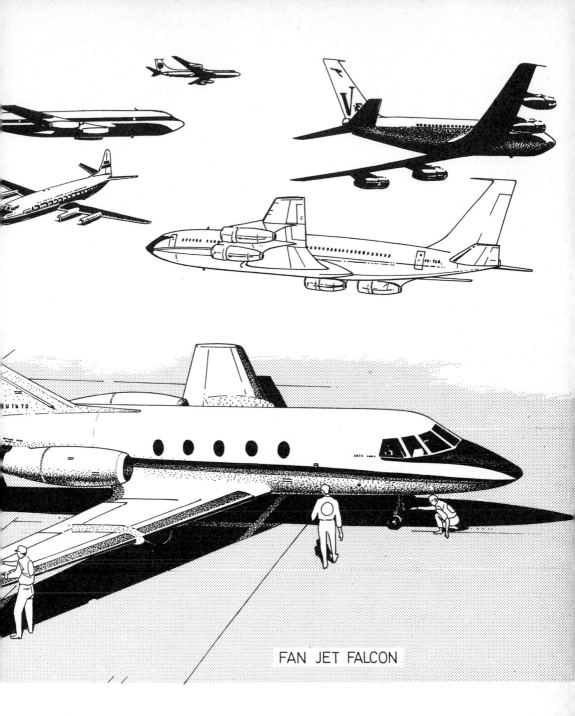

FAN JET FALCON

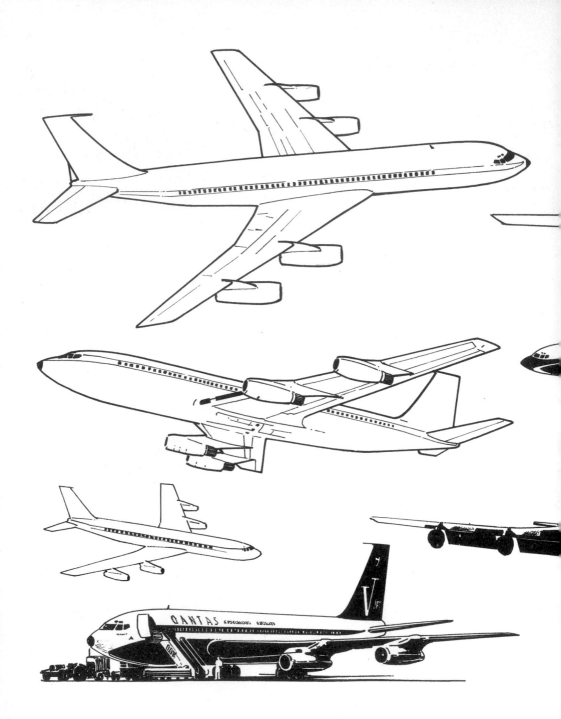

*Fig. 33 Various views of a Boeing 707, a Cessna 150 and a Cessna 172.*

This figure is devoted to two types of aircraft only. The first is a Boeing 707 shown in various positions and from various angles. The second is a Cessna, which is a much smaller aircraft and a very different design from its larger relative, the Boeing. These examples should help not only in the drawing of these aircraft but in drawing any aircraft of the types shown.

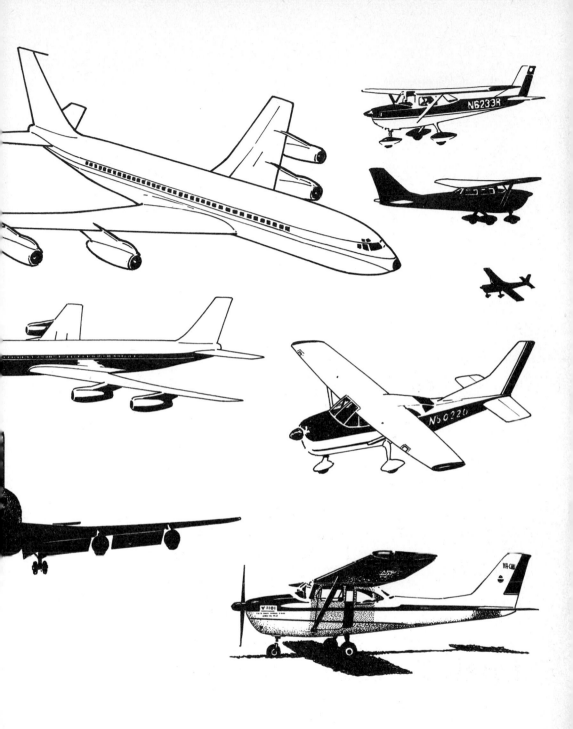

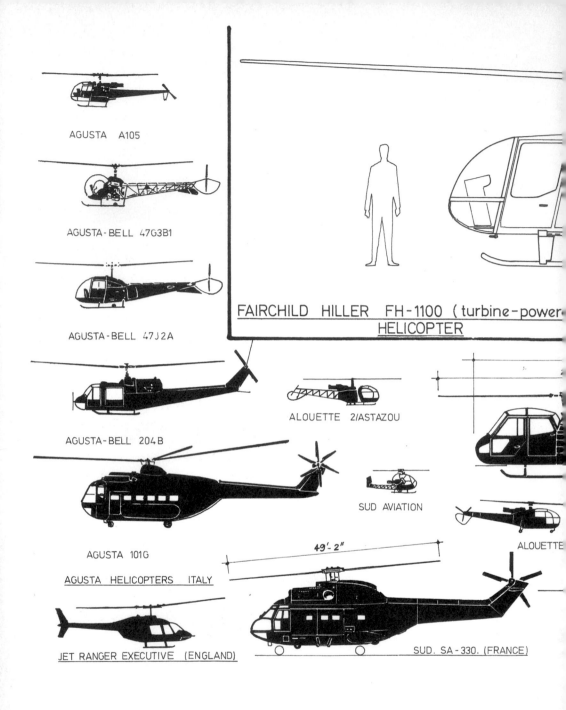

AGUSTA   A105

AGUSTA-BELL  47G3B1

AGUSTA-BELL  47J2A

AGUSTA-BELL  204B

AGUSTA  101G

AGUSTA  HELICOPTERS  ITALY

JET RANGER EXECUTIVE  (ENGLAND)

FAIRCHILD  HILLER  FH-1100  ( turbine-power
HELICOPTER

ALOUETTE  2/ASTAZOU

SUD  AVIATION

ALOUETTE

49'-2"

SUD. SA-330. (FRANCE)

*Fig. 34  Helicopters.*

The large-scale drawing is an elevation of a Fairchild Hiller FH-1100 turbine-powered helicopter. The smaller silhouette drawings are of various types and makes of helicopters from different parts of the world.

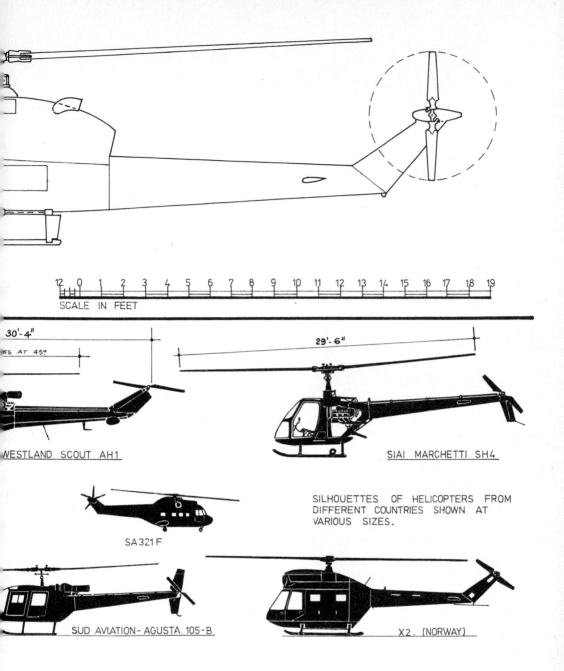

SCALE IN FEET

12 0 1 2 3 4 5 6 7 8 9 10 11 12 13 14 15 16 17 18 19

30'-4"

ES AT 45°

WESTLAND SCOUT AH1

29'-6"

SIAI MARCHETTI SH4

SA 321 F

SILHOUETTES OF HELICOPTERS FROM DIFFERENT COUNTRIES SHOWN AT VARIOUS SIZES.

SUD AVIATION-AGUSTA. 105-B.

X2. (NORWAY)

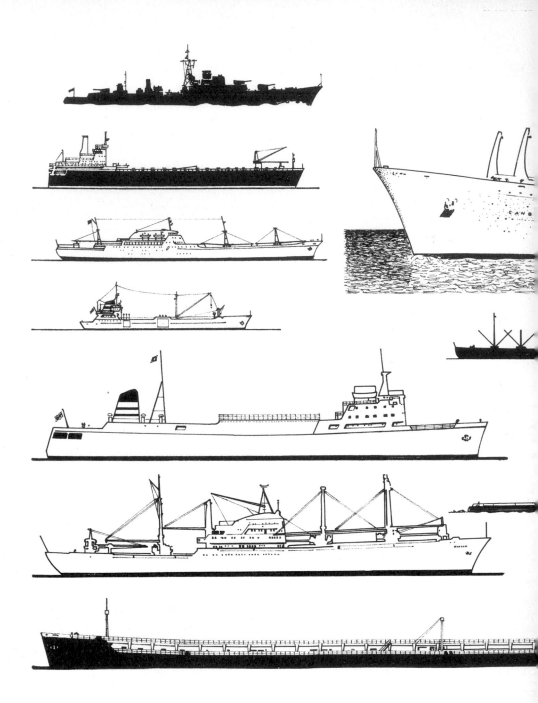

Fig. 35 Passenger and cargo
vessels, a destroyer and a
submarine.

All of these are shown for shape rather than size and are
obviously not drawn to a constant scale. Ships can be
treated as large boxes with shaped ends which can be set up
by starting with a simple box; by plotting the curves, an
accurate shape can be obtained. It should be noted that the
use of a centre line is indispensable.

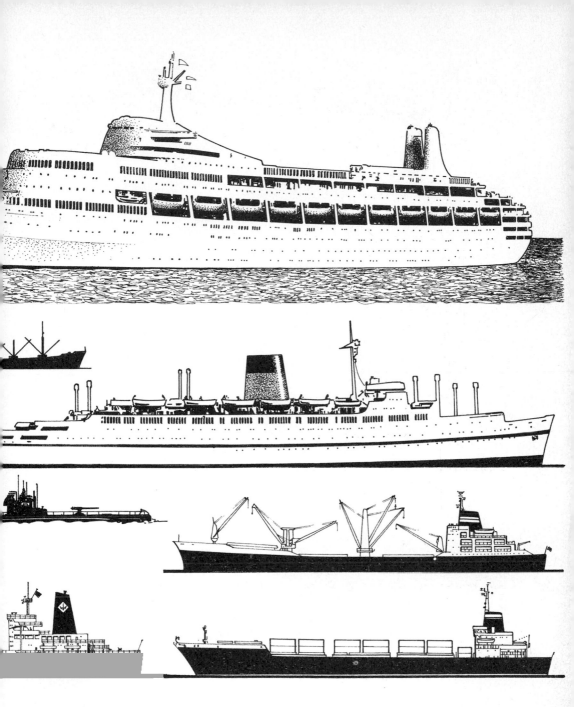

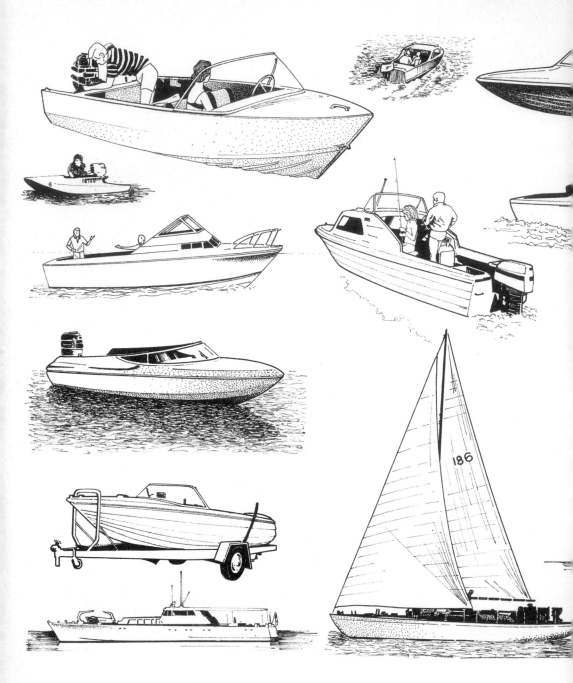

*Fig. 36  A few smaller vessels.*

These are some of the types of boats which can be seen around harbours, holiday resorts, lakes and rivers, and can add life and interest to any drawing where water figures in large quantities. As with the previous objects, it is easier to draw these boats by starting from a simple box and plotting the hull shapes around the centre line. One general rule worth mentioning is that ships and boats sit in the water, not on the water, and the drawing should take this into consideration.

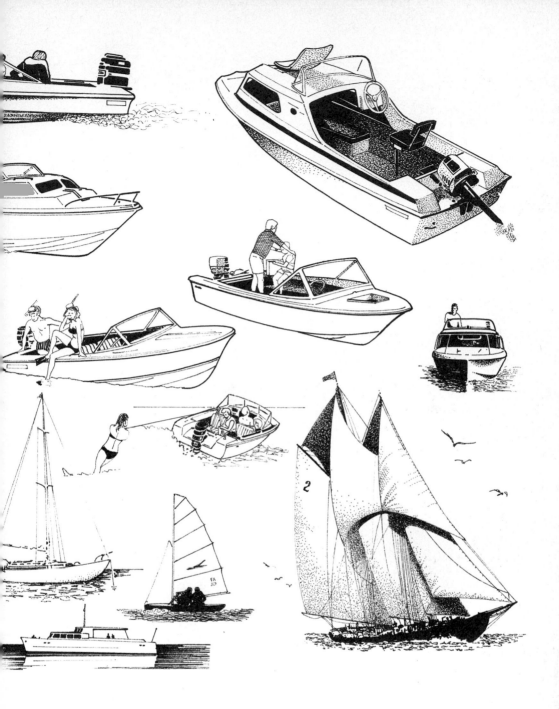

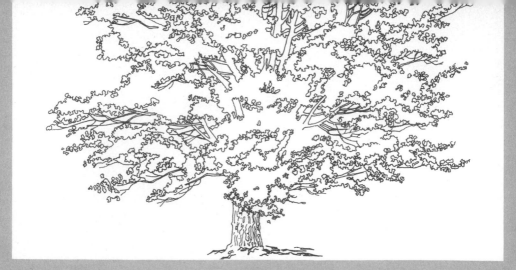

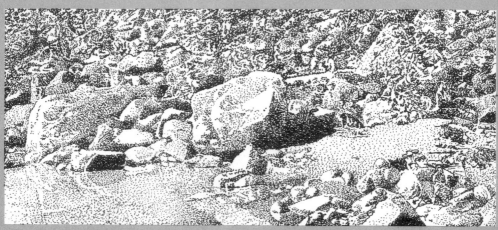

# 4    Drawing plants, rocks and water

Trees, more than motor cars, are endless in their variety, shape and size. Like cars, they are used in perspective drawing for many reasons, one of which could be that there is a tree or a group of trees growing on, in front of, or behind the site. In this case it is possible to observe the type and size of the existing trees and to draw them from 'life'. However, it is sometimes necessary or desirable to simplify or stylize trees to suit the type of drawing the draughtsman is doing or the materials and techniques in which he is working. With practice and experience it is possible to develop one's own styles with trees and to learn to use them to heighten the effect of the finished drawing.

A few rules in drawing trees are useful although, as in other things, it is easy to find exceptions. The most important thing to remember is that a tree grows out of the ground and is anchored to the ground firmly; any drawing of a tree that does not show this is seldom successful. Generally the widest part of a tree appears to be at the base where it meets the ground and the thinnest parts are the twigs on the ends of the branches. Between these extremes are a trunk and a series of limbs of diminishing sizes. The large drawing on p. 86 illustrates this point better than any description. Trees follow this principle with very few exceptions.

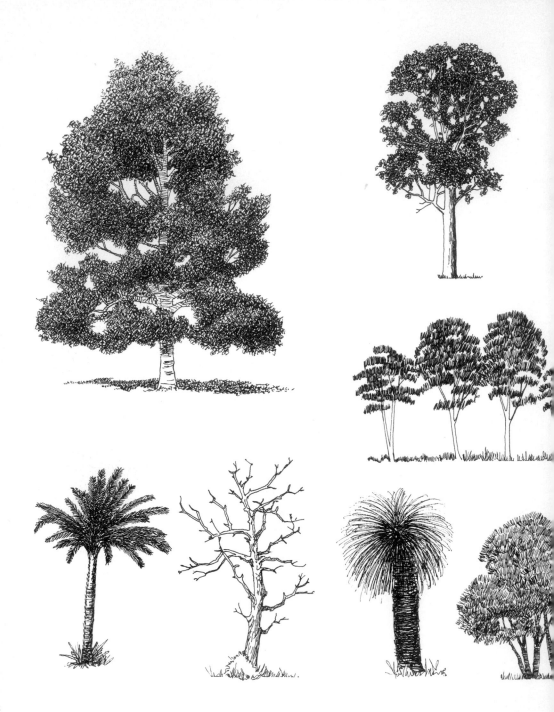

*Fig. 37  Hand-drawn trees
(some Australian trees).*

Figures 37 to 41 are not meant to show all types of trees as this would take a great deal of space, but should give a guide to a few of the more common types suitable for use in rendering and also a few methods which can be applied. There is an enormous number of styles in use and the student can vary those shown and add to them by use of his imagination.

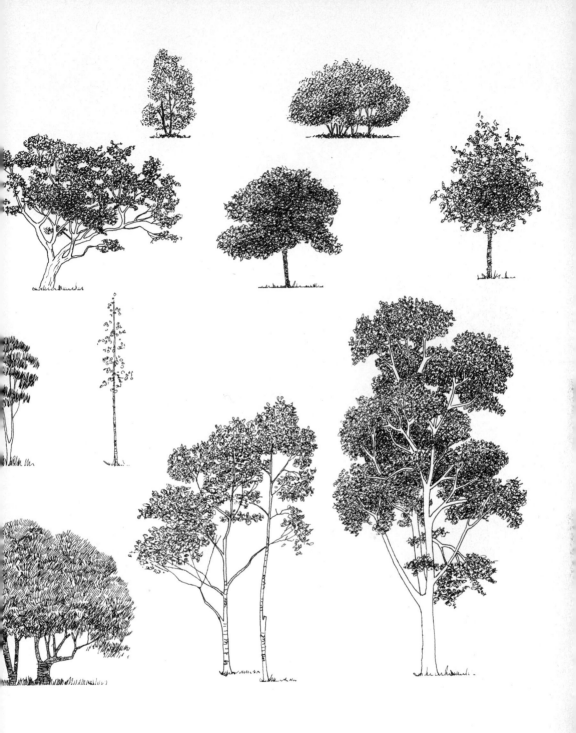

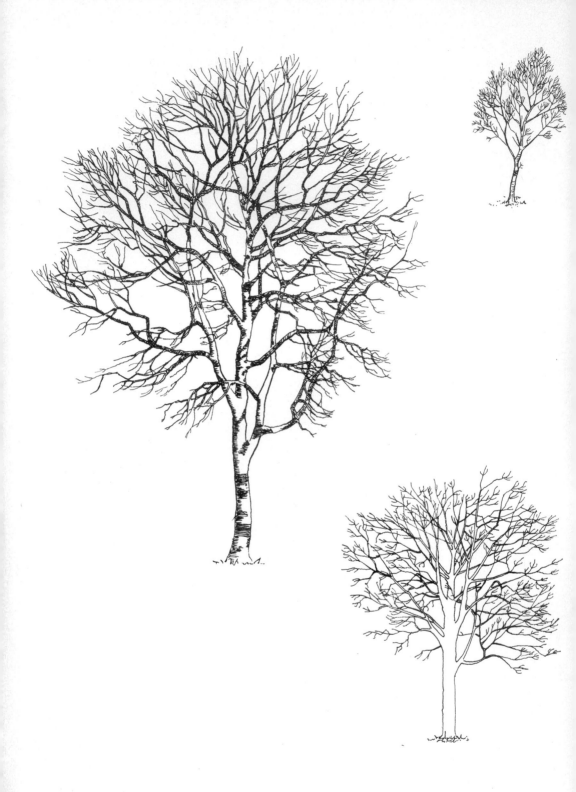

Fig. 38 Hand-drawn trees (ii).

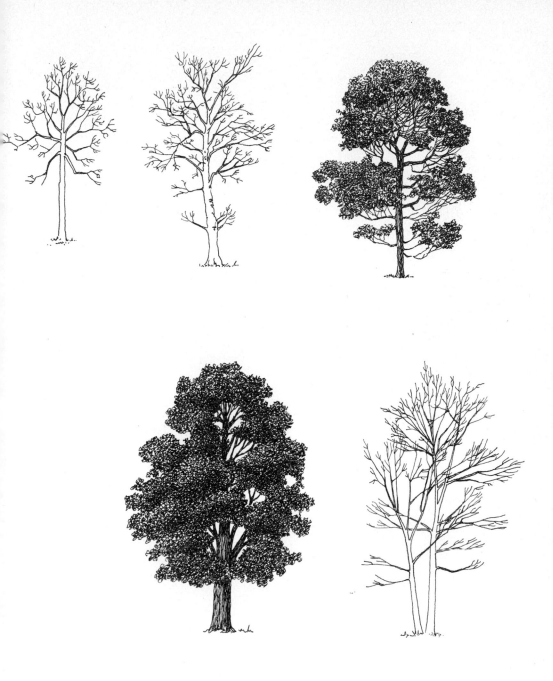

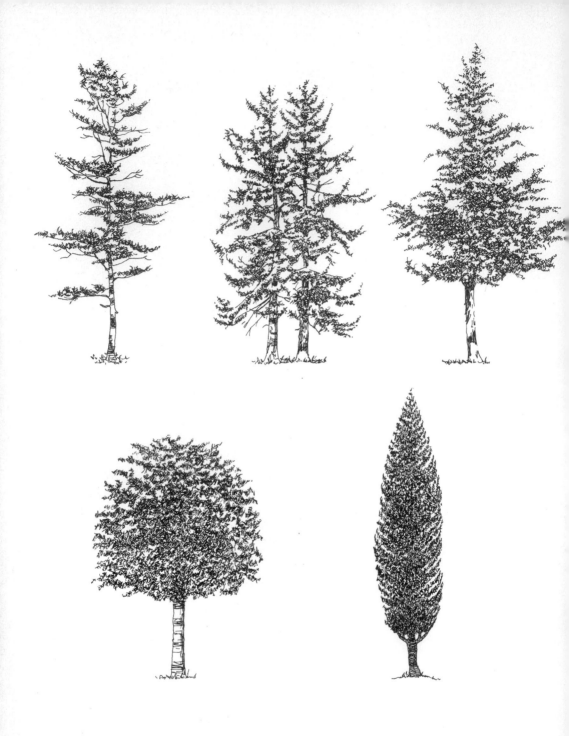

*Fig. 39  Hand-drawn trees (iii).*

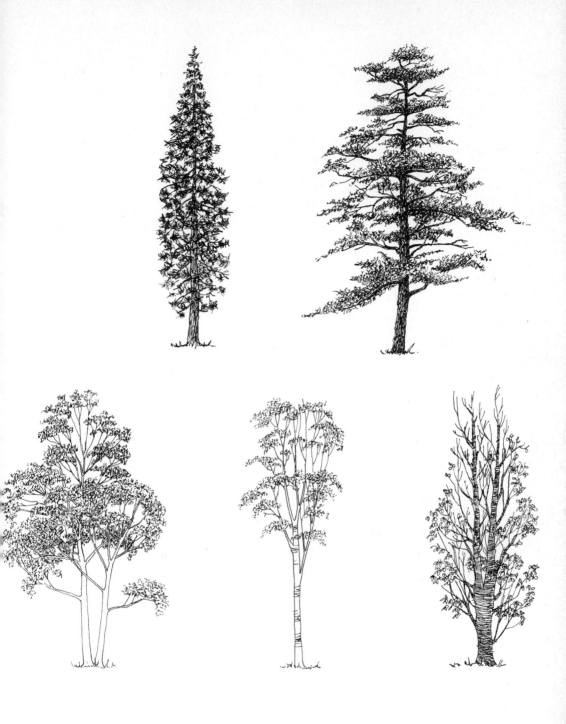

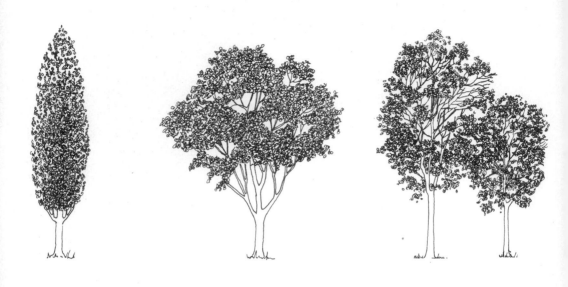

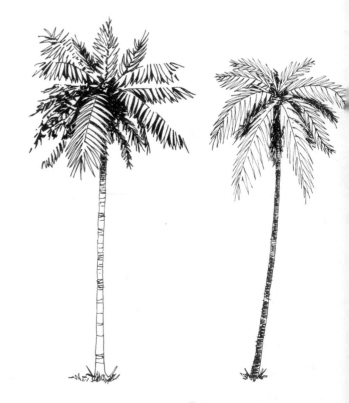

Fig. 40 Hand-drawn trees (iv)

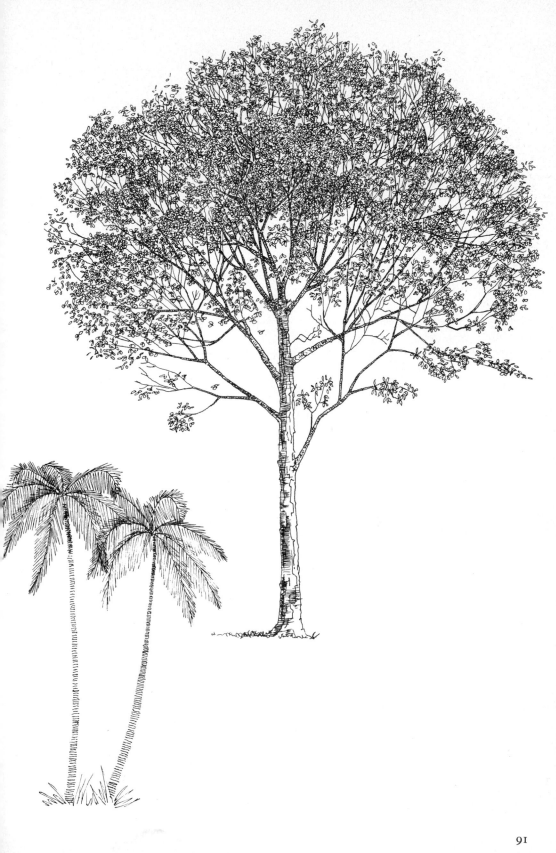

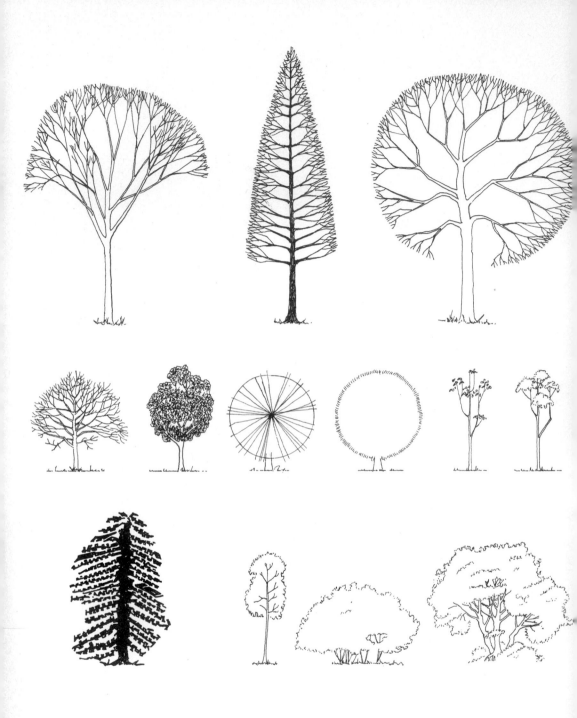

Fig. 41  Hand-drawn trees (v).

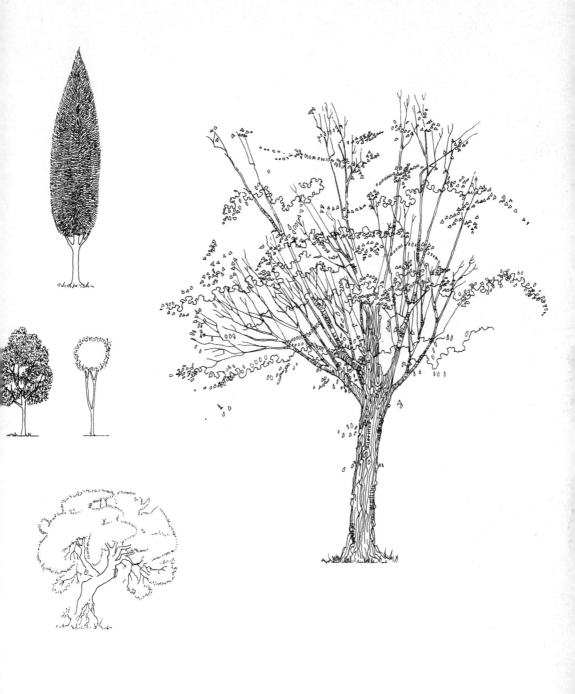

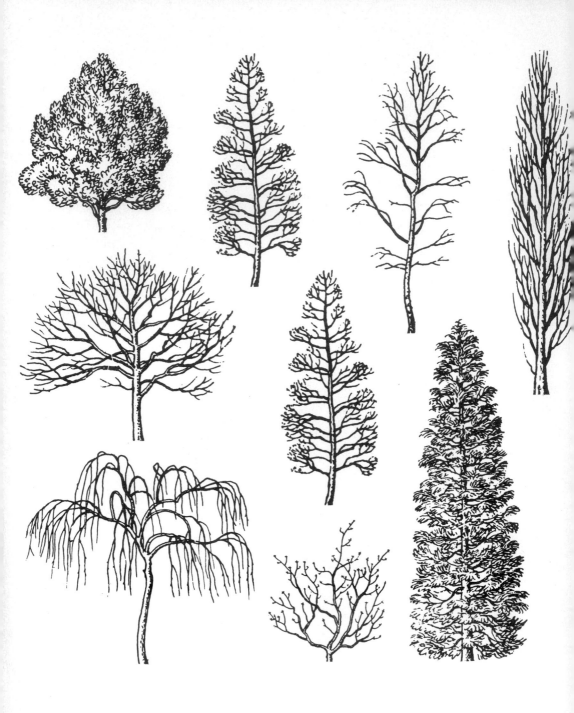

*Fig. 42 'Rub-down' trees by Letraset.*

As with the sheet on cars, only half the sheet is shown; the second half is exactly the same. All trees shown on sheet AS621 are drawn to a scale of 1 in. = 8 ft (1:100).

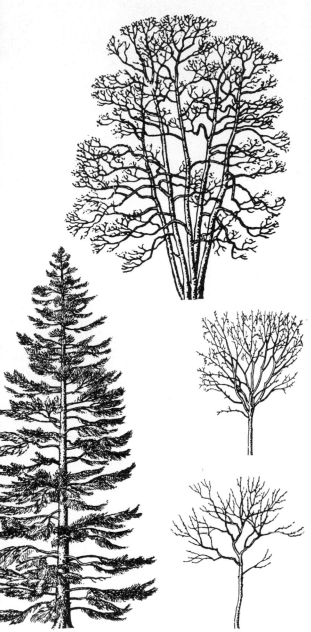

EACH SHEET CONTAINS TWO OF EACH TREE
SHOWN.
SHEET SIZE — 15″ x 10″
SHEETS ARE DESIGNED IN TWO IDENTICAL
HALVES   WHICH CAN BE CUT TO FACILITATE
STORAGE  AND HANDLING.

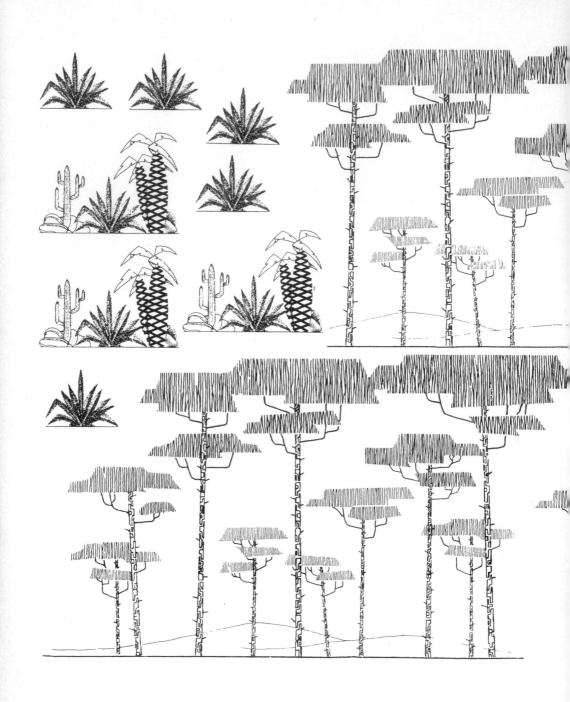

*Fig. 43 'Rub-down' trees by
Letter-Press.*

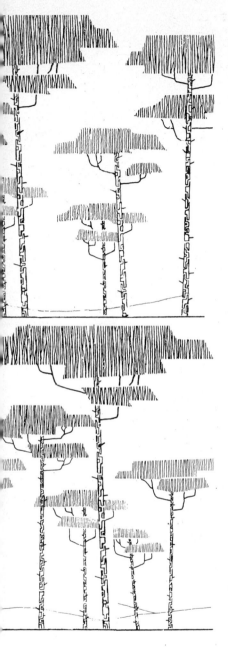

SHOWN ARE THE COMPLETE CONTENTS OF LETTER-PRESS
ARCHITECTURAL SYMBOL SHEET NO. 05.6030. (1 : 200).

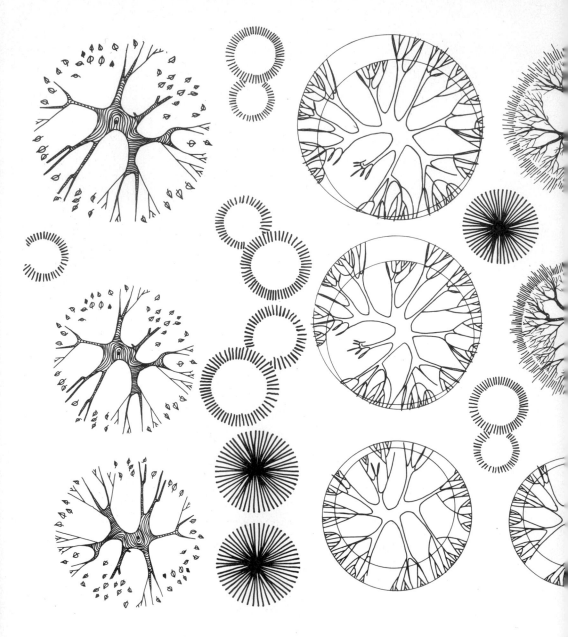

EXAMPLES OF TREES FROM LETTER-PRESS ARCHITECTURAL SHEE

*Fig. 44 'Rub-down' trees in
plan by Letter-Press.*

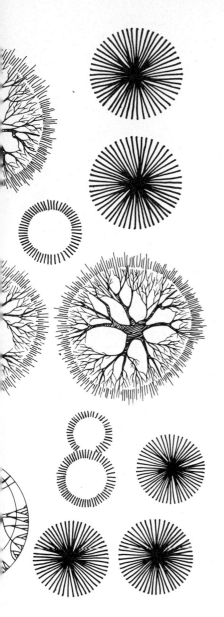

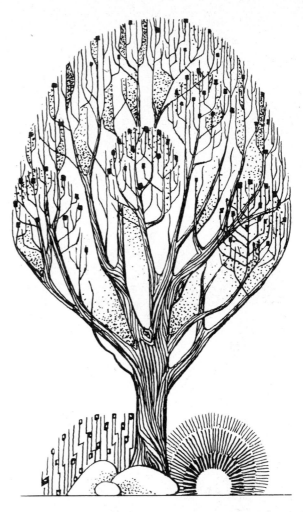

SEE PRECEDING PAGES FOR OTHER
EXAMPLES OF TREES FROM -
LETTER - PRESS ARCHITECTURAL
SHEETS.

05.6081    VEGETATION (PLAN)

*Fig. 45 'Rub-down' trees in plan by Letraset.*

As in previous examples, only half the complete sheet has been shown here. The other half of the sheet is identical, giving the draughtsman twice the quantity shown.

LETRASET ARCHITECTURAL SYMBOL SHEET
NO. AS 623 CONSISTS OF TWICE THE
QUANTITY SHOWN.

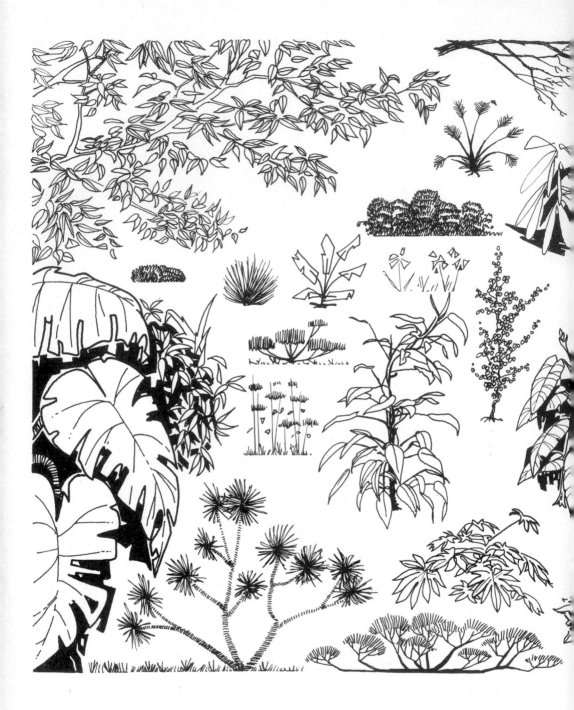

*Fig. 46 Drawing plants and shrubs.*

Figures 46–48 show some types of plants and shrubs. Like trees, plants are far too numerous to show even the main species, but the diagrams illustrate some useful plants for use in rendering. There are many more methods of drawing plants, and the student is advised to use the examples to develop his own style, and to use his own imagination and observation to produce convincing renderings.

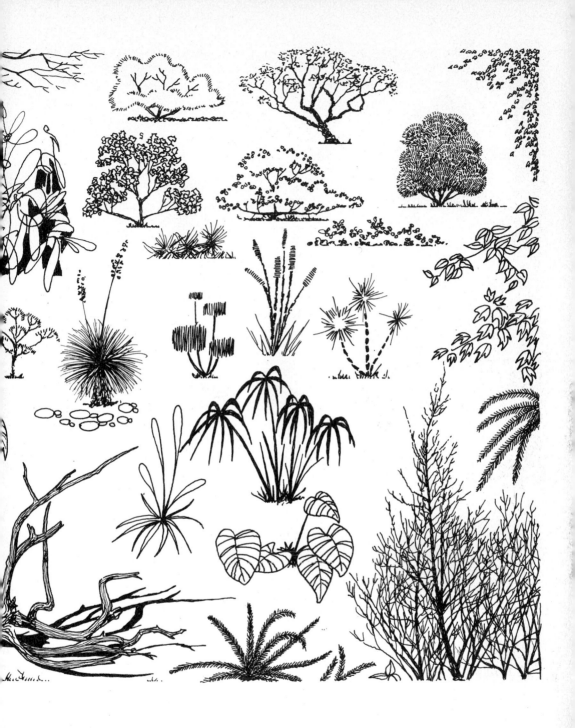

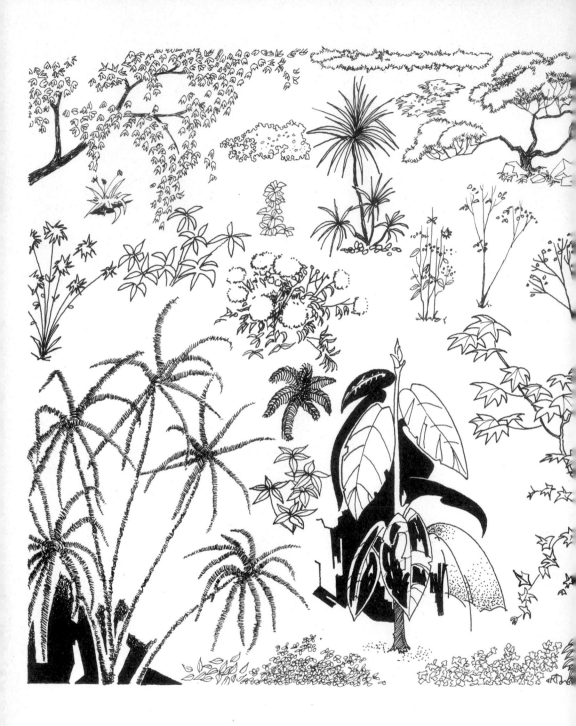

*Fig. 47  Drawing plants and shrubs.*

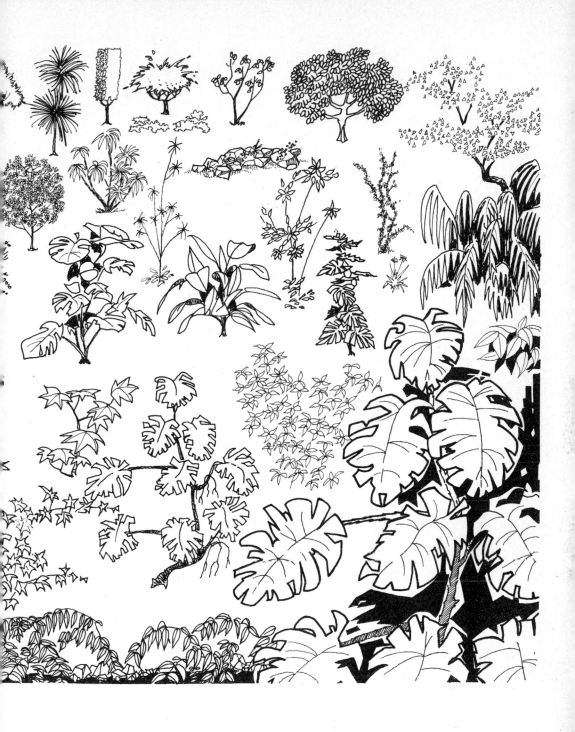

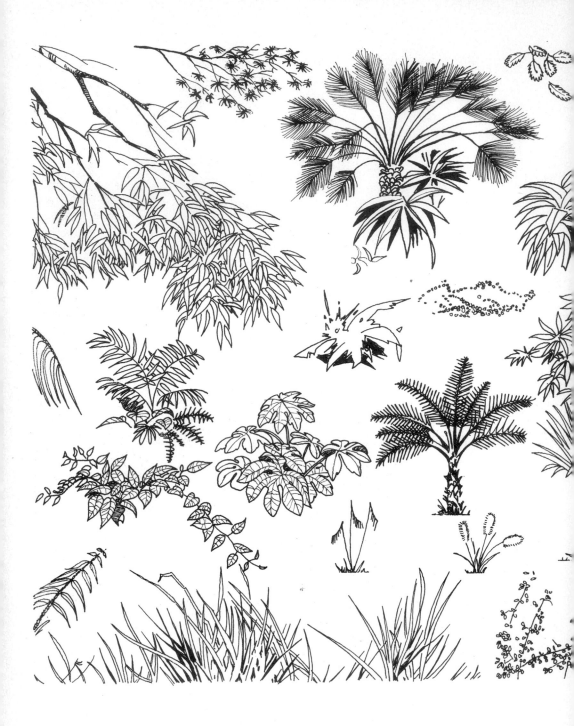

*Fig. 48 Drawing plants and
shrubs.*

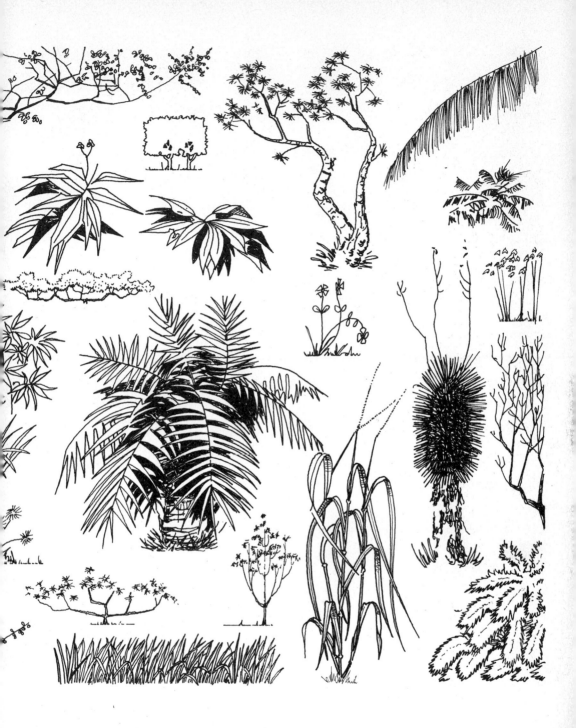

*Fig. 49 'Rub-down' hedges by Letter-Press.*

The possibilities of these should be obvious to the draughtsman with imagination.

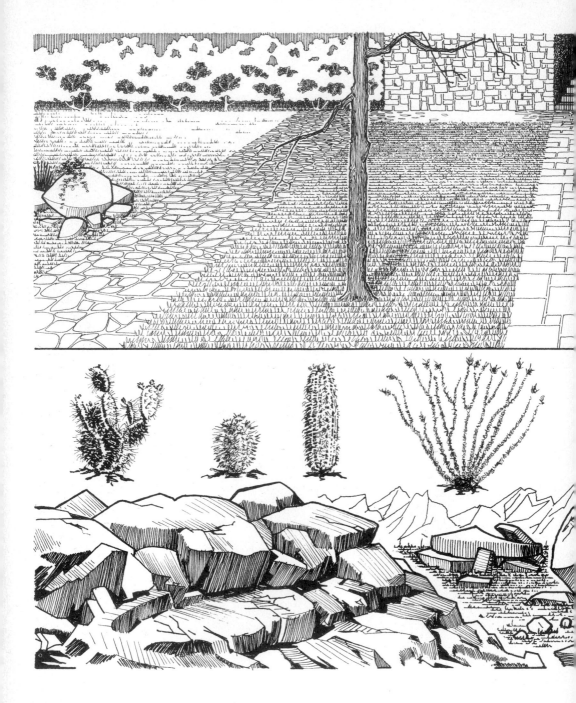

*Fig. 50 Drawing grass, paths, stone walls and rocks.*

Drawing grass, like drawing trees and shrubs, is a matter of selecting a technique which suits the draughtsman's own particular style. This figure suggests various ways of drawing lawns. Different types of stone paths and walls are also shown and the technique can be adapted to other forms of paths if required. Figure 50 also shows methods of rendering rocks

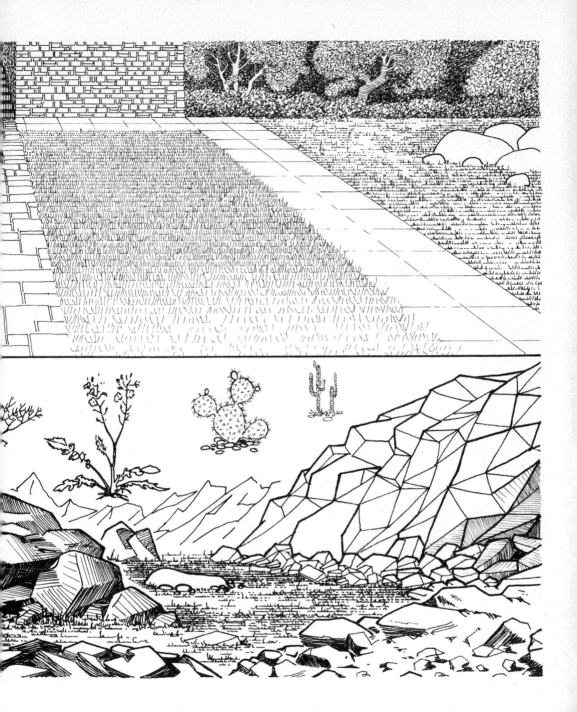

and some of the commoner cacti. Rocks are difficult to render successfully as they require a solid appearance, and also because they seldom have a regular shape, it is necessary to control carefully the use of shadows. Observation and practice will help in rendering rocks in a convincing fashion.

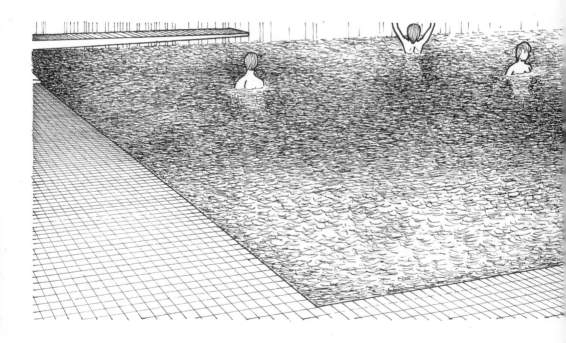

*Fig. 51 Four methods of
rendering water.*

The section on reflections should be thoroughly understood
before water is attempted. (See Fig. 12 (p. 33) for method of
setting up reflections.)

The main problem with water is to make it look wet. The
surface of the water is shiny and reflects, but in addition it is
often transparent, as is water in a calm swimming-pool.

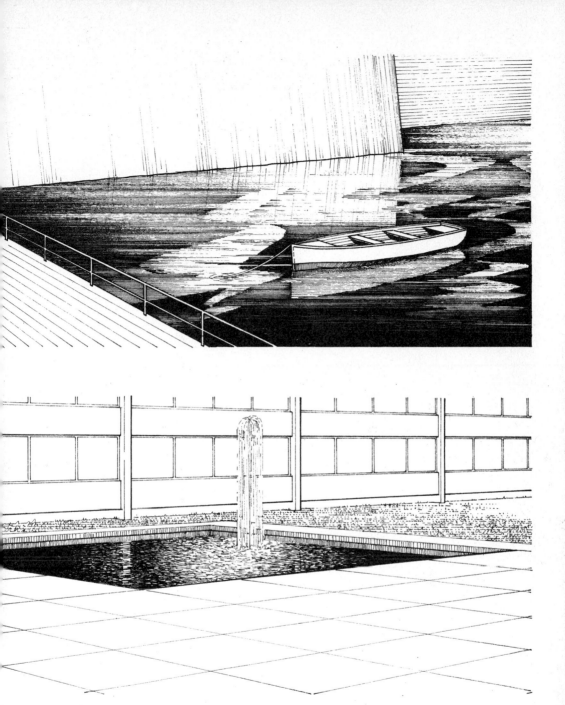

However, the aim is not to make a study of water as such but merely to use it as a 'prop'; for this purpose the four examples should explain themselves and cover most requirements met with in rendering. There are some very good books available on the subject if further study is necessary for special subjects.

# 5    Drawing people

Perhaps the most important 'prop' in rendering is the human
figure because it is used to give scale, atmosphere and anima-
tion to the subject. The human figure is the most difficult of
all props to draw and it should be understood that this
chapter is not meant to be a study in life drawing or even a
'how to': it is meant to give enough information to help the
renderer to understand the proportions of the human figure
and from this point construct his own people in his own
style, using whatever distortions may please him.

In the familiar classical formula the figure is $7\frac{1}{2}$ heads high.
Figure 53 (pp. 118–19) shows this in diagram form for the
male and the female figures, from the front, back and side.
The seated figure is also shown as a guide. The small figures
at the bottom of the sheet show a few practice figures which
may be helpful, and the student should produce his own until
he can draw convincing figures from any angle and in any
pose. Many renderers favour the elongated figures used by
fashion designers to achieve the required results, but before
attempting any form of distortion the student should be
conversant with the natural figure.

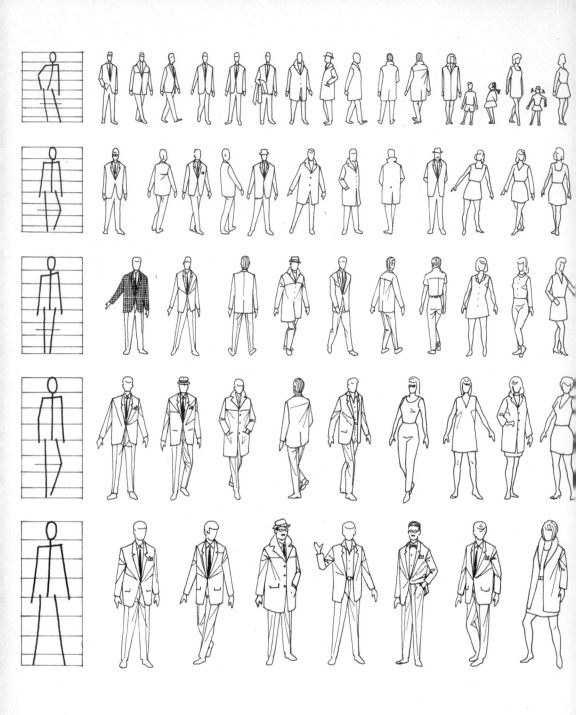

*Fig. 52 Examples of figures of various sizes.*

These will be helpful to those who have trouble in obtaining reasonable results.

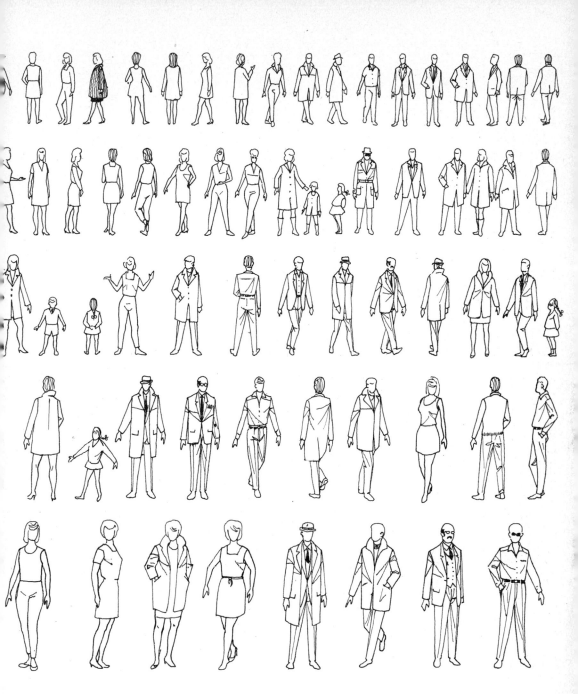

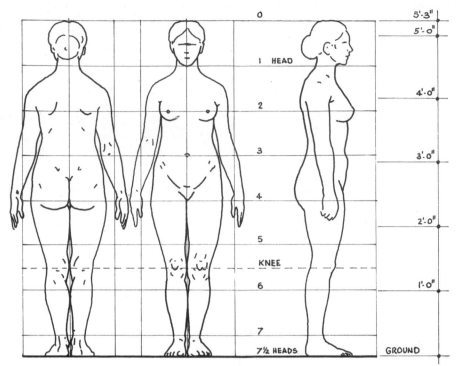

0    5'-3"
   5'-0"

1   HEAD

2    4'-0"

3    3'-0"

4

5    2'-0"

KNEE

6    1'-0"

7

7½ HEADS    GROUND

PROPORTIONS OF FEMALE FIGURE

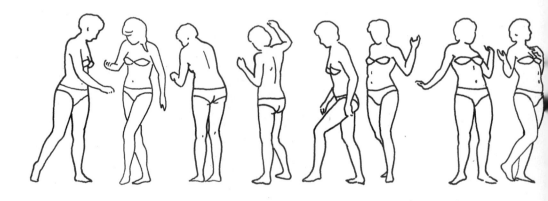

*Fig. 53  The human figure:*
*proportions.*

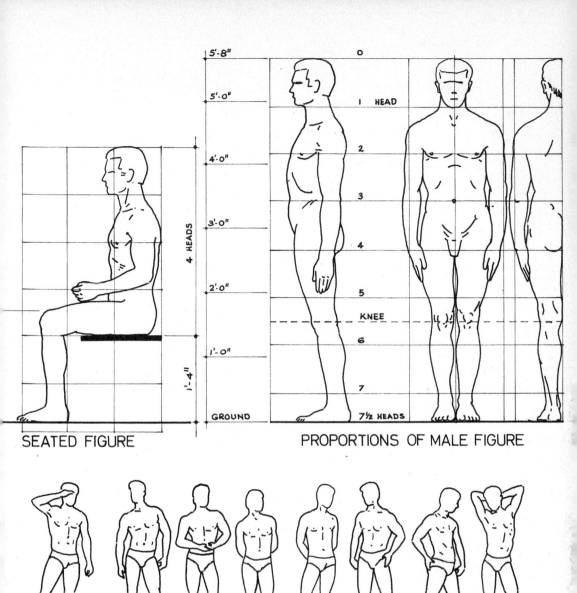

5'-8"
5'-0"
4'-0"
3'-0"
2'-0"
1'-0"
GROUND

4 HEADS

1'-4"

SEATED FIGURE

0
1   HEAD
2
3
4
5
KNEE
6
7
7½ HEADS

PROPORTIONS OF MALE FIGURE

eye level

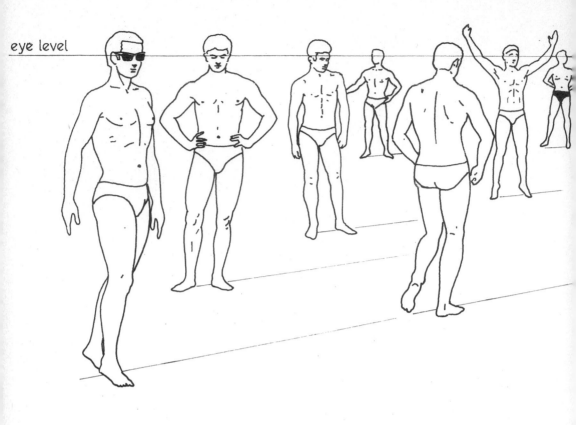

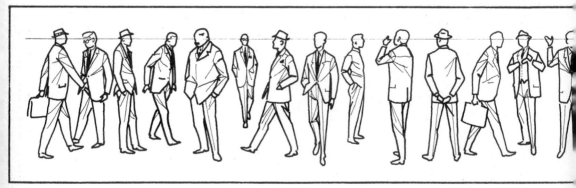

*Fig. 54 The male figure as seen by an observer on the same level.*

It will be seen that the eye-level of the observer and each of the figures coincides with the horizon. This is always the case when the observer stands on the same level as the figures observed.

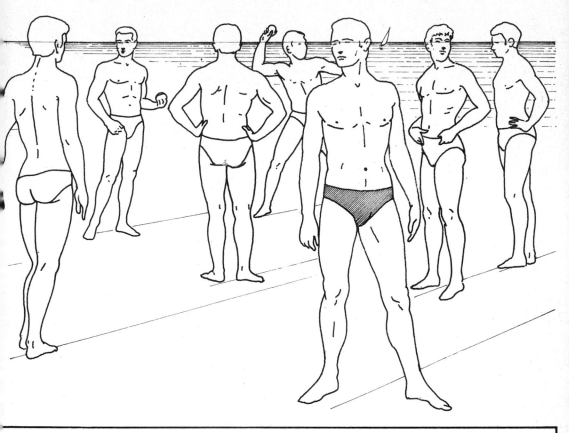

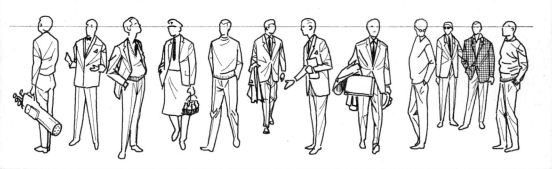

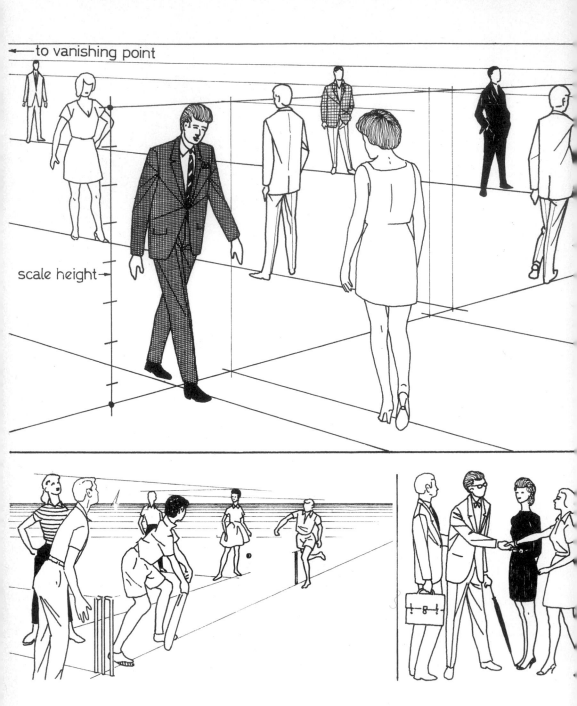

to vanishing point

scale height

*Fig. 55 The construction of figures in various positions on a plane below the observer.*

Note the method of setting up one figure correctly as a key figure, as has been previously shown in setting up perspectives (pp. 22–3). Using this key figure it is possible to set up other figures where they are needed, by projecting lines to the required positions.

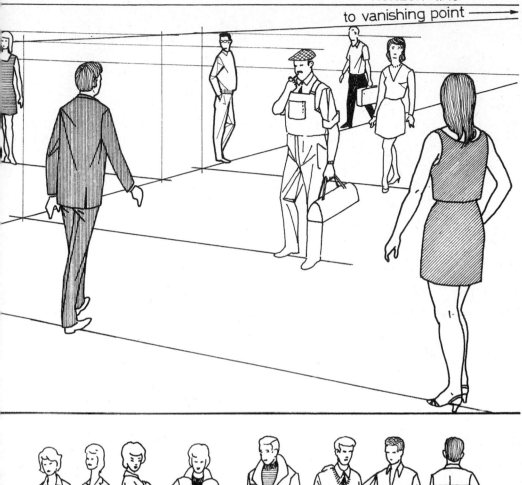

horizon line
to vanishing point ⟶

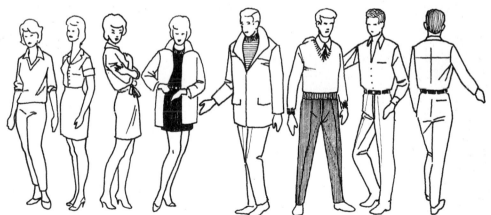

Figures 54 and 55 both have a row of examples across the bottom of the sheet to help the student with his own practice, using the information included in the sheet.

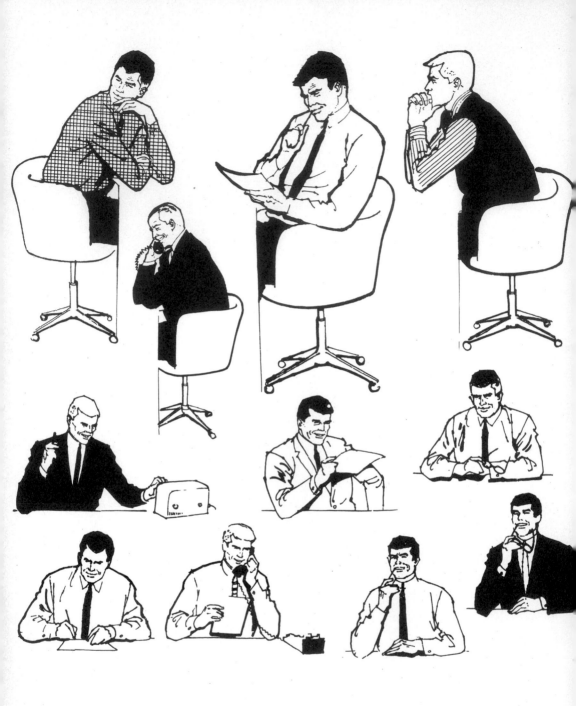

*Fig. 56 'Rub-down' figures by Letraset.*

This is one of the Letraset 'Art Sheets' which offer the renderer, both of architectural and interior subjects, as well as the advertising man and in fact anyone engaged in graphic works, an excellent supply of rub-down figures and groups of figures as well as parts of figures and backgrounds. (See also fig. 86, pp. 188–9.)

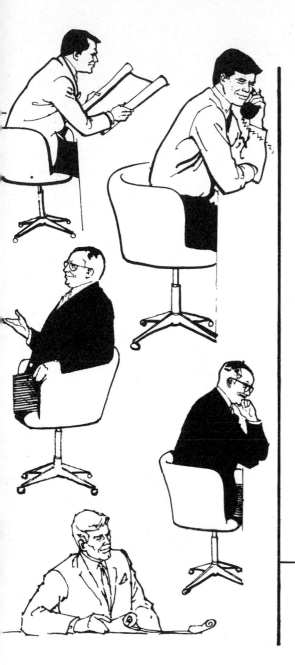

THERE ARE 40 SHEETS COMPRISING 600 COMPLETE DRAWINGS OF HEADS, HANDS, HALF-FIGURES AND FULL FIGURES OF MEN, WOMEN AND CHILDREN, AS WELL AS BACKGROUNDS IN THE ART SHEETS RANGE.

LETRASET ART SHEET DRAWINGS ARE RUBBED DOWN IN THE SAME WAY AS INSTANT LETTERING ( SEE FIG. 145. FOR FIXING INSTRUCTIONS).

SIZE OF ART SHEETS — 7 1/2" x 10"

ART SHEETS ARE DRAWN BY A LEADING FIGURE ARTIST, THEY CAN BE USED SINGLY OR GROUPED TO ILLUSTRATE MOST SOCIAL AND COMMERCIAL ACTIVITIES. THE CHARACTER, LINE WEIGHT AND PROPORTION OF THE DRAWINGS ARE CONSISTANT THROUGHOUT.

THE SEATED MALE FIGURES SHOWN IN THIS FIGURE ARE AS THEY ARE SET OUT ON LETRASET ART SHEET AA 22.

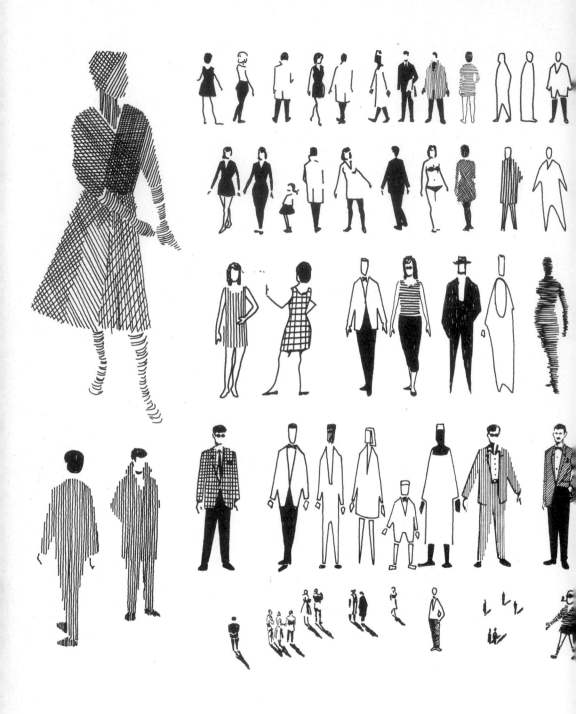

*Fig. 57 Figures – various types and styles.*

Figure 57 is a sheet of figure types which can be developed by the draughtsman to his own liking, and, as can be seen, the possible variations are almost endless.

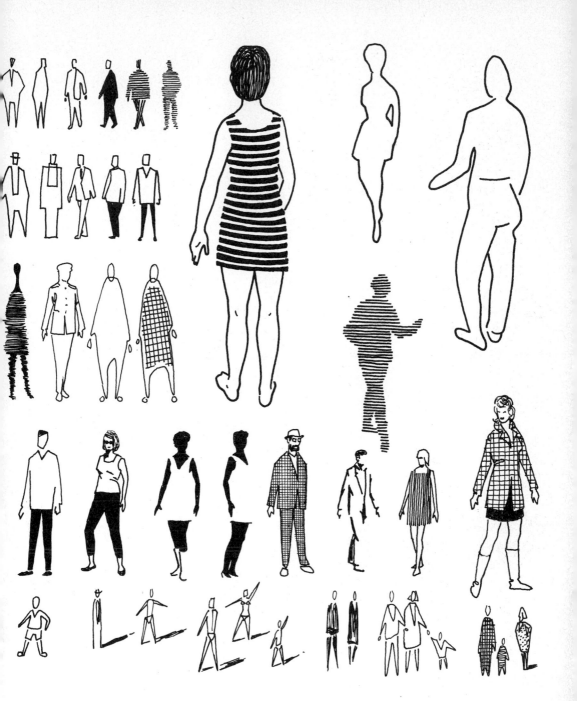

*Fig. 58 'Rub-down' figures by Letter-Press.*

Letraset and Letter-Press have produced sheets of rub-down people each sufficiently different from one another to give the draughtsman a choice of styles in which to work. An example from Letter-Press of particular interest to the architect is shown above.

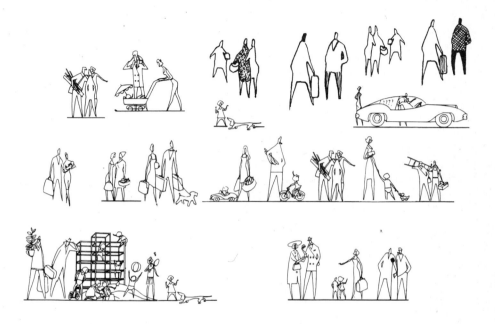

SHOWN ARE THE COMPLETE CONTENTS OF LETTER-PRESS ARCHITECTURAL SYMBOLS
SHEET NO. 05.5011. (1:100). THE LAYOUT OF THE SHEET HAS BEEN SLIGHTLY
CHANGED TO FIT THE PAGE SIZE OF THIS BOOK.
LETTER-PRESS ARCHITECTURAL SYMBOL SHEETS ARE SUPPLIED IN ONE SIZE ONLY..
17.5 × 25 cm. ( 8¼" × 9 7/8" approx.)

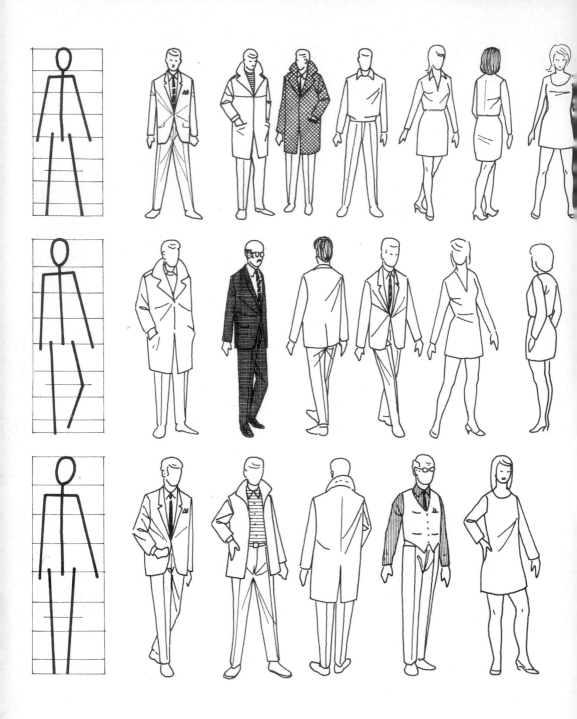

*Fig. 59 Examples of figures of various sizes.*

Finally fig. 59, continuing from fig. 52, shows more figures of larger sizes, which will help the student with his practice and may also be useful as a guide to those draughtsmen who experience difficulty with figure drawing.

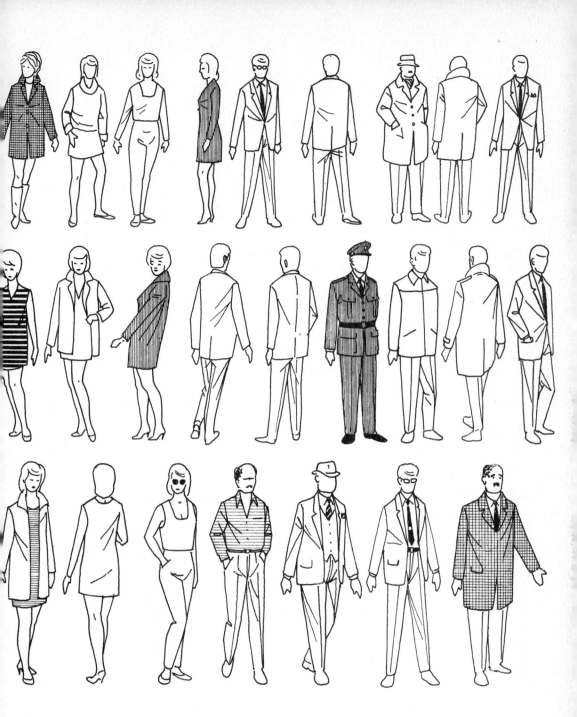

# 6 · Drawing furniture and fabrics

Chairs often look a great deal more difficult to draw than they are. As with other objects, it is essential first to have a plan and elevation of the chair to a scale suitable for the drawing to be made. Figure 60 (overleaf) shows the plan and elevations of a simple office chair and four perspective drawings of the chair from the same height and distance. Where necessary, a chair should be reduced to a simple box which contains the shape; from this it should be possible to draw any chair, simple or complicated.

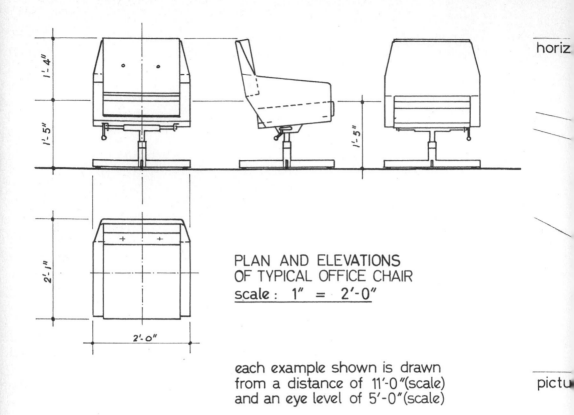

PLAN AND ELEVATIONS
OF TYPICAL OFFICE CHAIR
scale : 1″ = 2′-0″

each example shown is drawn
from a distance of 11′-0″(scale)
and an eye level of 5′-0″(scale)

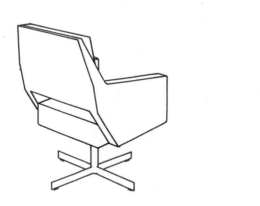

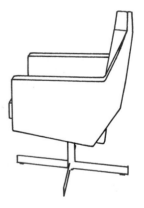

*Fig. 60 Plan and elevation of
typical office chair.*

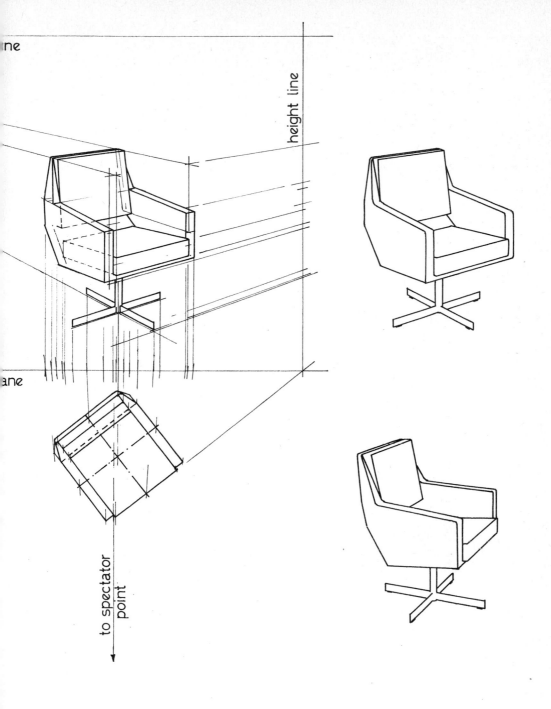

height line

to spectator
point

*Fig. 61 Chairs.*

*Fig. 62 Chairs.*

From figs. 61 and 62 it should be clear how each chair could be contained in a box for the purpose of drawing it. As a general rule, chairs should be kept simple in a rendering unless a specific type of chair is required, otherwise they can often consume a considerable amount of time without a very spectacular result; in addition they can increase the possibility of error, which can be costly when considerable amounts of drawing are involved, as is often the case.

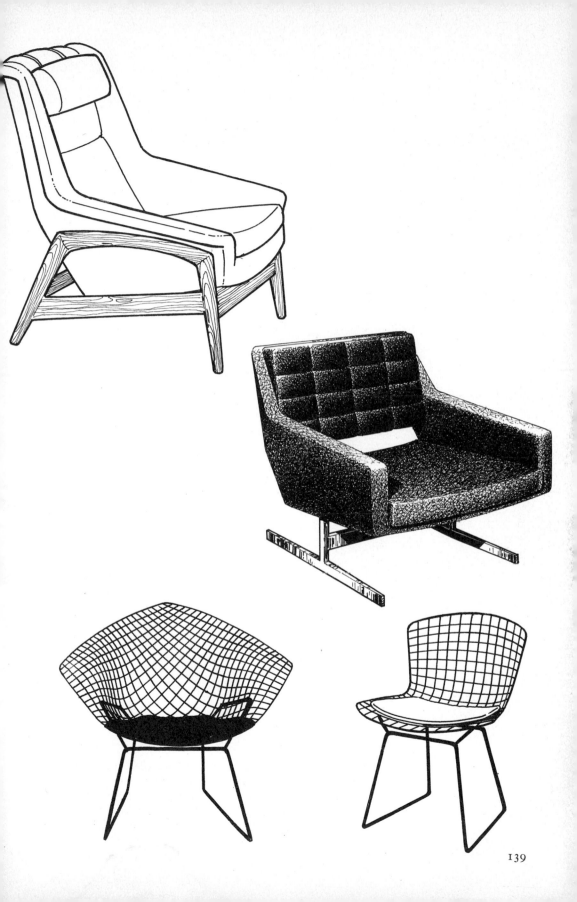

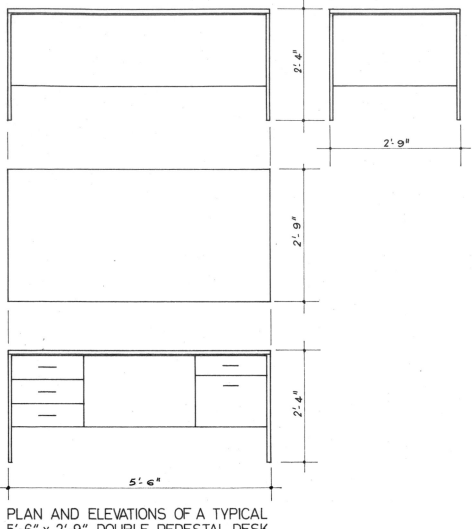

2'- 4"

2'- 9"

2'- 9"

2'- 4"

5'- 6"

PLAN AND ELEVATIONS OF A TYPICAL
5'-6" x 2'-9" DOUBLE PEDESTAL DESK

scale : 1" = 2'-0"

*Fig. 63 Office desk – plan and elevations.*

## DRAWING DESKS AND TABLES

Desks and tables are among the simpler objects to draw. Because of their size they are often prominent and therefore important in a rendering, and, if for no other reason, should be carefully constructed and drawn. It is probably their simplicity that often leads to carelessness in their rendering

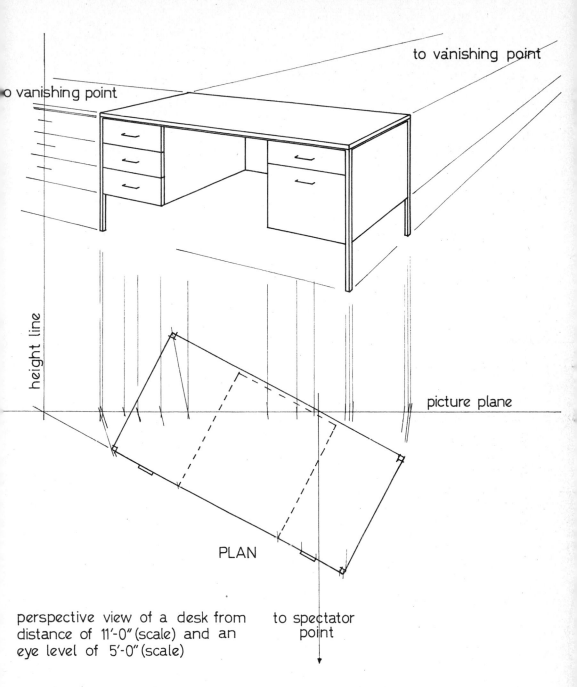

to vanishing point

o vanishing point

height line

picture plane

PLAN

perspective view of a desk from
distance of 11'-0" (scale) and an
eye level of 5'-0" (scale)

to spectator
point

with, sometimes, unfortunate results. A desk or table is
basically a box and should be treated as such; within this
box as much detail and style can be shown as is required.
Figure 63 shows the plan and elevations of a simple office
desk together with the setting-up and the resulting perspec-
tive of the desk. The objects shown in figs. 64 and 65 should
make it clear to the draughtsman that desks and tables are
simple objects to draw correctly.

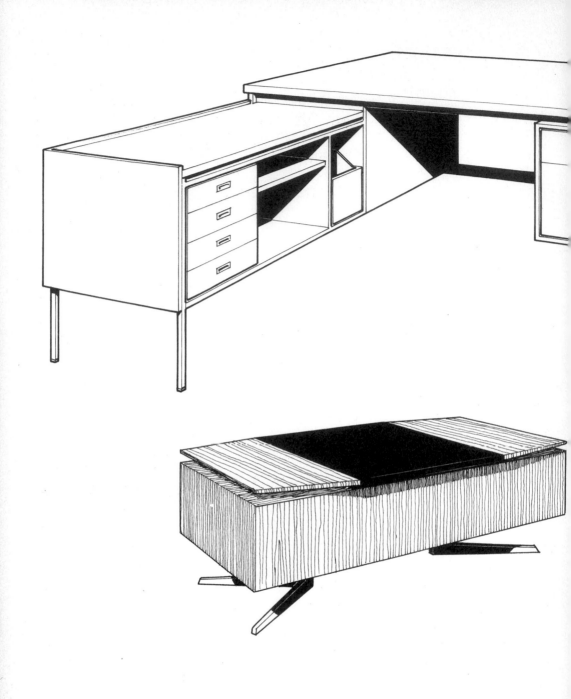

*Fig. 64 Desks in perspective.*

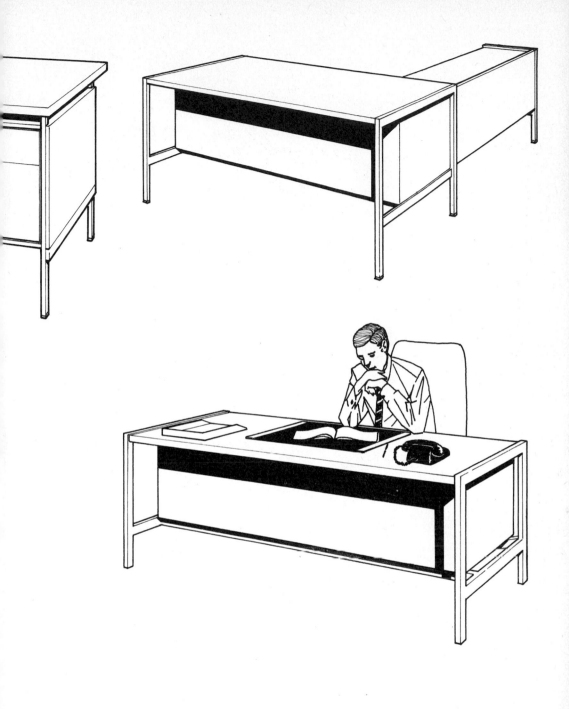

*Fig. 65  Tables in perspective.*

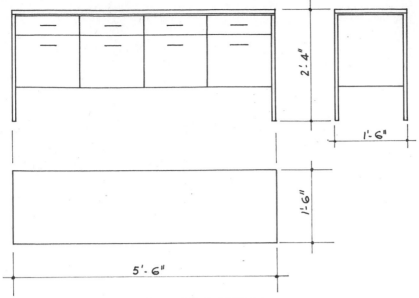

PLAN AND ELEVATIONS OF A TYPICAL
5'- 6" x 2'-9" OFFICE CREDENZA

scale : 1" = 2'-0"

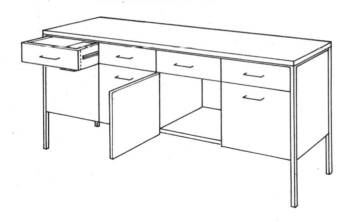

*Fig. 66 Credenza: plan,*
*elevations and perspectives*

DRAWING CREDENZAS, CUPBOARDS
AND FITTINGS

Credenzas, cupboards and fittings, like desks and tables, are simple boxes which can be varied in style and detail as required. Figure 66 shows a simple office credenza in plan and elevations through to the finished perspective drawings,

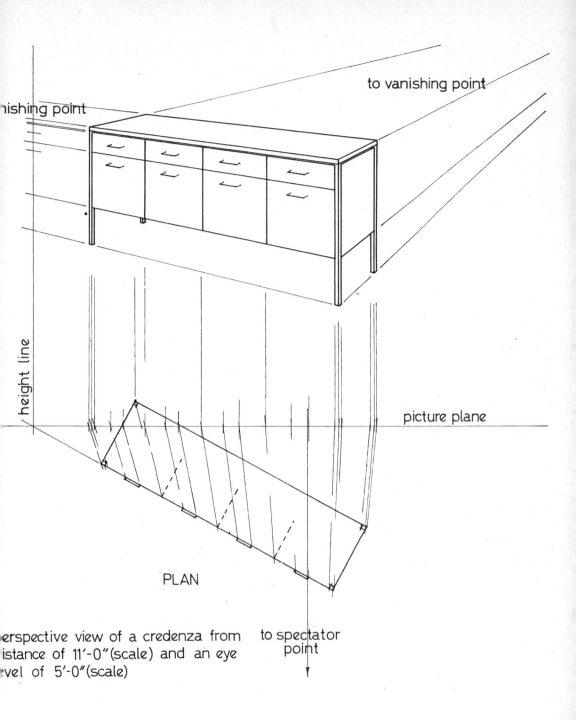

to vanishing point

vanishing point

to vanishing point

height line

picture plane

PLAN

perspective view of a credenza from
distance of 11'-0"(scale) and an eye
level of 5'-0"(scale)

to spectator
point

including one with a door and a drawer open. Figures 67
and 68 show a few further examples; again it should be
possible to see how each example shown can be related back
to its original box structure.

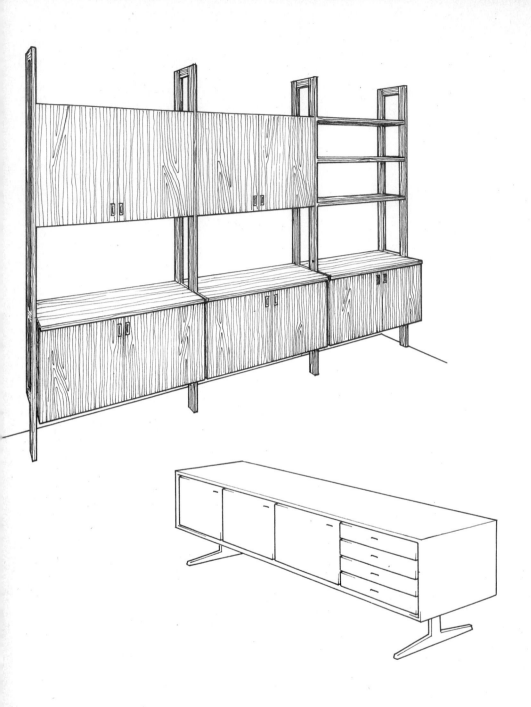

*Fig. 67  Cupboards and fittings.*

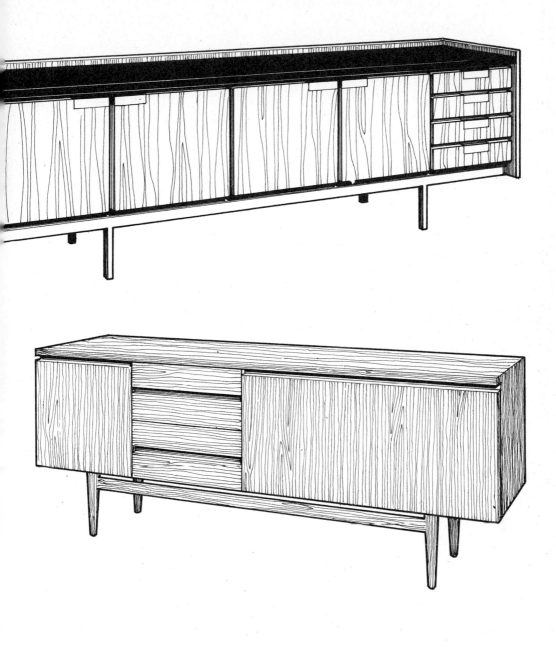

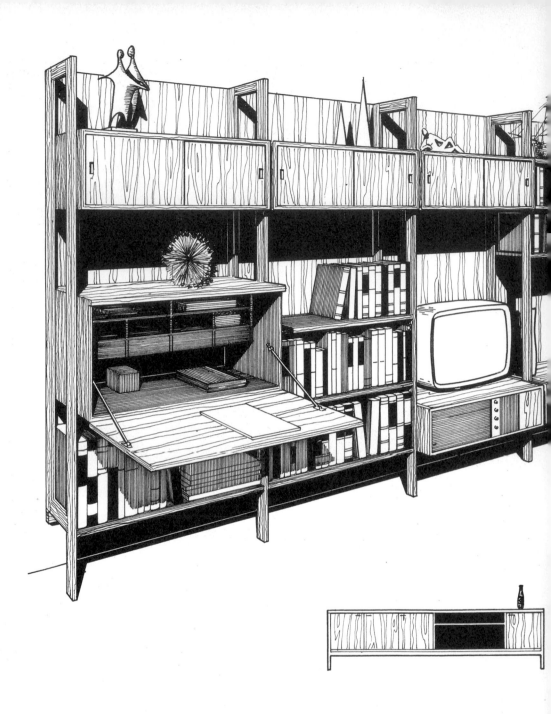

*Fig. 68 Cupboards and fittings.*

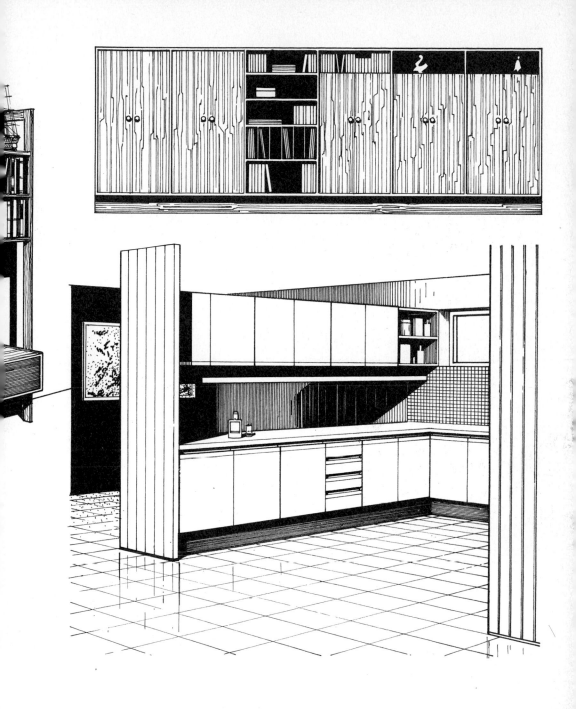

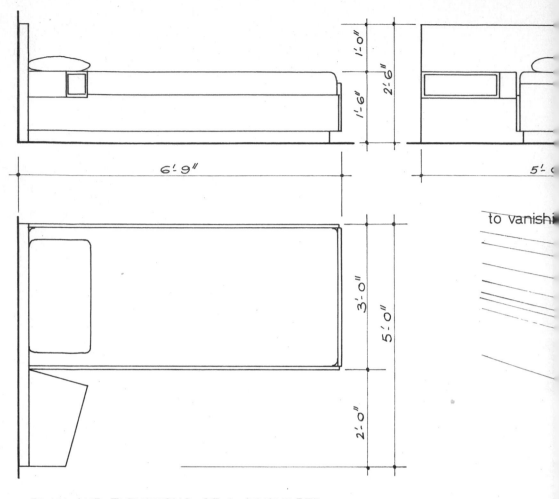

1'-0"

2'-6"

1'-6"

6'-9"

5'-

to vanishi

3'-0"

5'-0"

2'-0"

PLAN AND ELEVATIONS OF A SINGLE BED
scale : 1" = 2'-0"

picture pla

*Fig. 69 Single bed in plan,*
*elevation and perspective.*

DRAWING BEDS, WARDROBES AND
DRESSING-TABLES

Similarly, such pieces of furniture as a bed, a wardrobe or a
dressing-table are basically boxes and should be treated as
such. Figure 69 shows an example of a single bed and bed-
head drawn in plan and elevation as well as a perspective
drawing using the plan as previously described. Figure 70
shows four examples of beds with various methods of
drawing bedspreads, which, as can be seen, form an impor-
tant part of drawing beds.

perspective view of a single bed from
distance of 11'-0"(scale) and an eye
level of 5'-0"(scale)

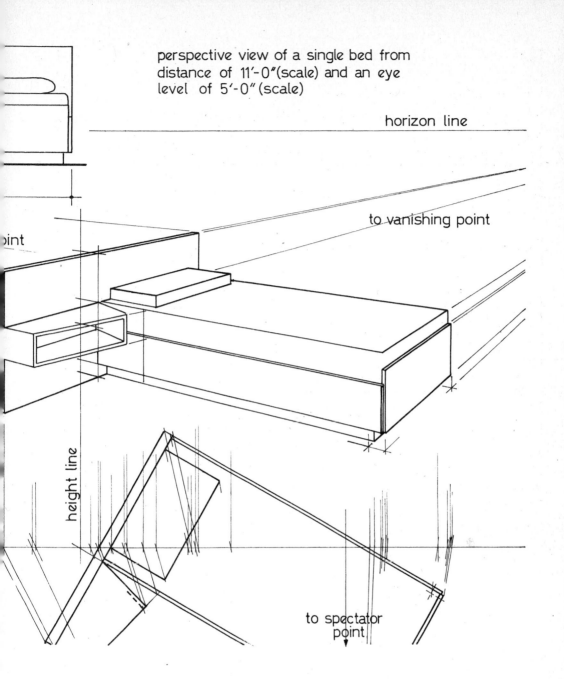

horizon line

to vanishing point

point

height line

to spectator
point

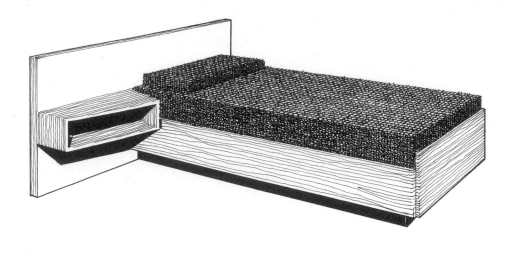

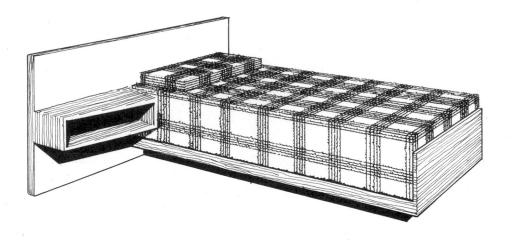

*Fig. 70  Beds in perspective.*

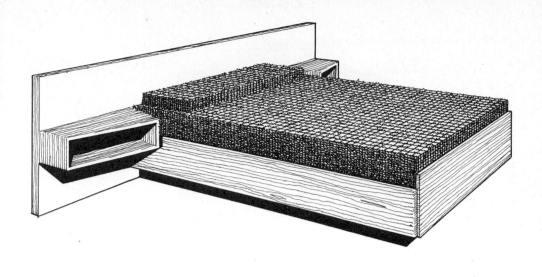

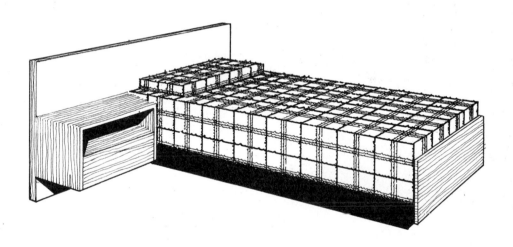

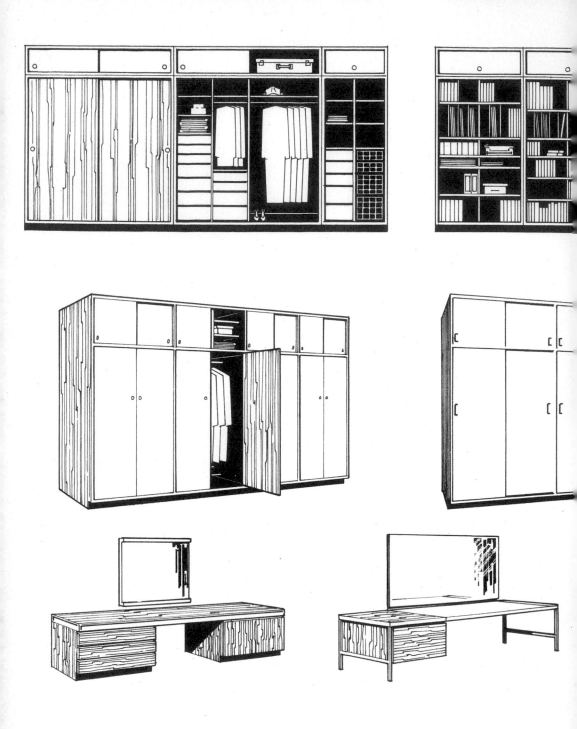

Fig. 71 Wardrobes and
dressing-tables.

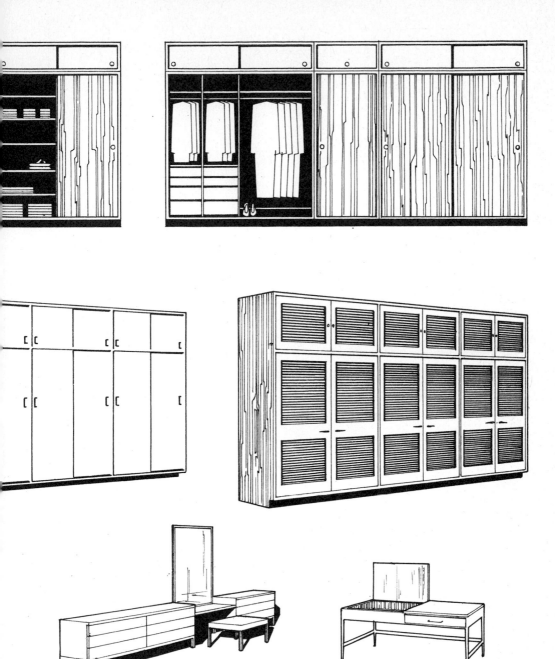

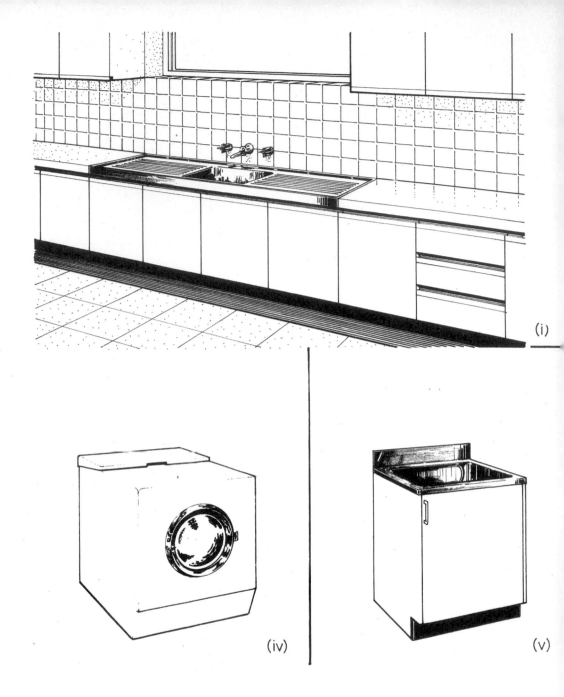

(i)

(iv)

(v)

*Fig. 72 Kitchen equipment.*

## DRAWING KITCHEN AND BATHROOM FITTINGS

The styling if not the function of kitchen and bathroom equipment may vary from year to year, but the over-all shapes and sizes remain fairly constant. The examples shown are of no specific make but should be of help when the draughtsman is faced with drawings which include some of these items.

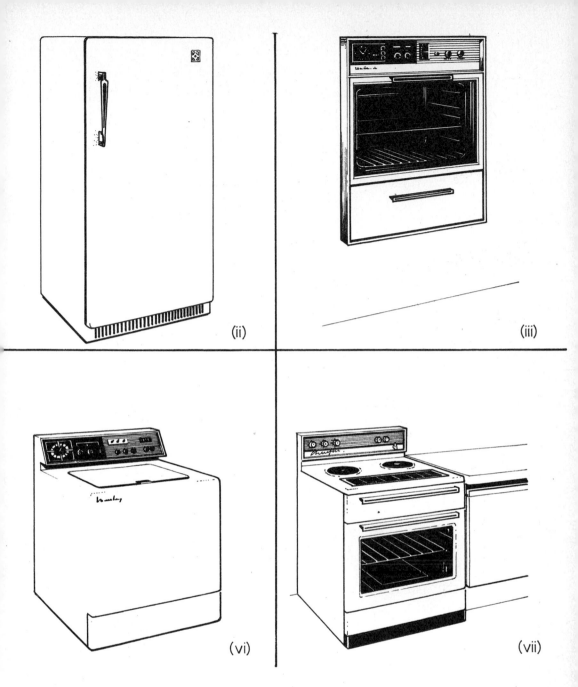

(ii)

(iii)

(vi)

(vii)

Figure 72 includes a sink, a stove or cooker, a refrigerator, a wall oven and a washing machine. These items should again be treated as simple boxes with special shapes contained within them; this makes even the most complicated shape fairly easy to draw.

Figure 73 includes a bath, a basin and a toilet. These too should have the box treatment, similar to kitchen equipment.

159

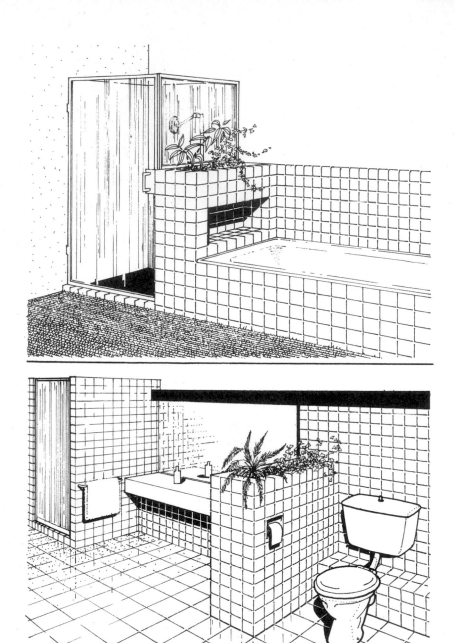

*Fig. 73  Bathroom equipment.*

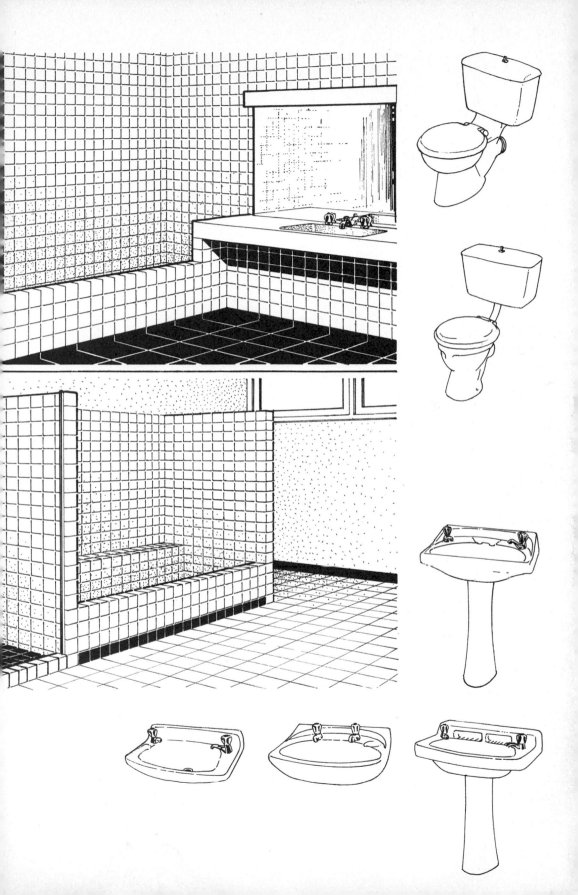

(i)            (ii)          (iii)

*Fig. 74 Fabrics, showing texture and drape.*

## DRAWING FABRICS

Figure 74 shows eight drawings of fabrics hung as drapes:

(i) using horizontal lines an equal distance apart and vertical lines of the same distance apart, except where the fabric is in shadow when they are drawn closer together;

(ii) using vertical lines of varying distances apart;

(iii) using a T-square to draw a series of small 'u's' (see p. 173), over which vertical lines are drawn to show the drape of the fabric;

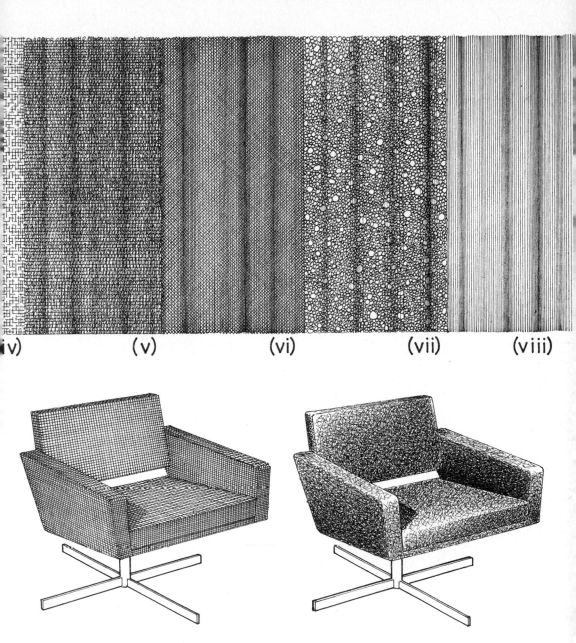

(iv) (v) (vi) (vii) (viii)

(iv) using vertical and horizontal 'dashed' lines, again closer together for the shading in the folds;

(v) as for (iii) using a T-square to draw a series of 'e's (see p. 173), over which are drawn vertical lines which come closer together to indicate the drape in the same way;

(vi) with diagonal lines in both directions, over which are drawn vertical lines as in previous examples;

(vii) using varying sizes of 'O's to build up the texture, with vertical lines to build up the drape;

(viii) using vertical lines only, more densely than (ii), but again showing the drape of the fabric as previously described.

4 DRAWER STEEL FILE CABINET

Examination of the three chairs will show that the first two are rendered in techniques similar to those used for the drapes, while the third effect is achieved by using short free-hand strokes in varying directions, gradually building up to the required strength of tone.

The examples shown in fig. 74 are by no means all or even most of the techniques which can be used to build up fabrics. As with most other objects the only limiting factors are time and imagination, and in some cases patience in building up the textures. Other examples of fabrics can be found in various parts of this book, so it is not intended to go further into the subject at this stage.

## DRAWING MISCELLANEOUS EQUIPMENT

It is not necessary to show more than a method of drawing some of these pieces of equipment. Like kitchen and bathroom equipment, they vary in design, shape and size from manufacturer to manufacturer and from year to year, so that it is always necessary to obtain the latest literature before attempting to show them accurately.

*Fig. 75 Various items of equipment in home and office.*

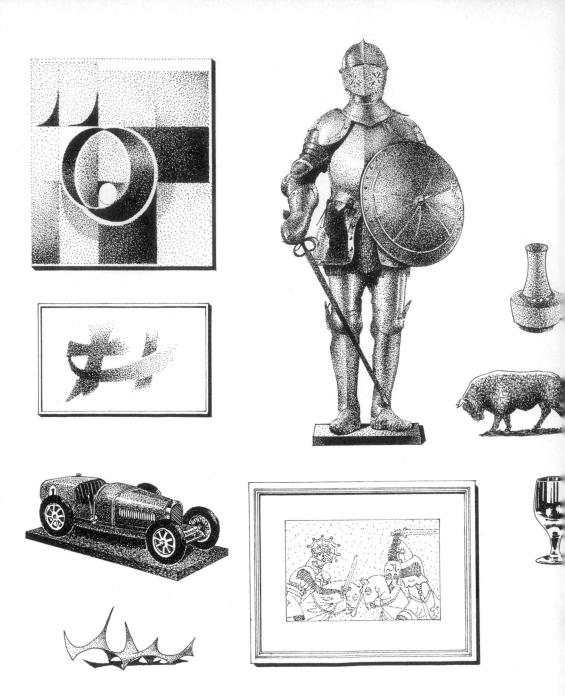

*Fig. 76 Some accessories and
ornaments for interior
perspectives.*

DRAWING ORNAMENTS AND PICTURES

Figures 76 and 77 show a few of the almost endless variety
of objects and pictures which the draughtsman can use when
drawing interior perspectives. Such details give a sense of
actuality and life to a drawing of an interior as they do in
reality. A room without ornaments and pictures may be
bare and uninteresting; the same is true of a drawing of an
interior.

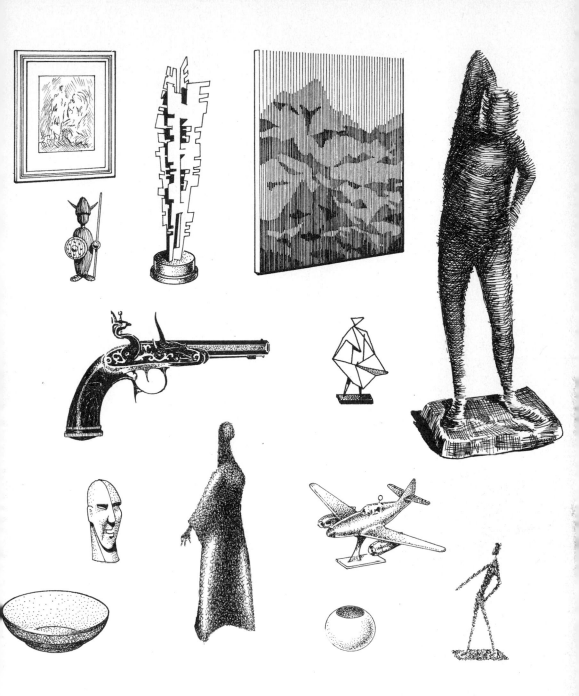

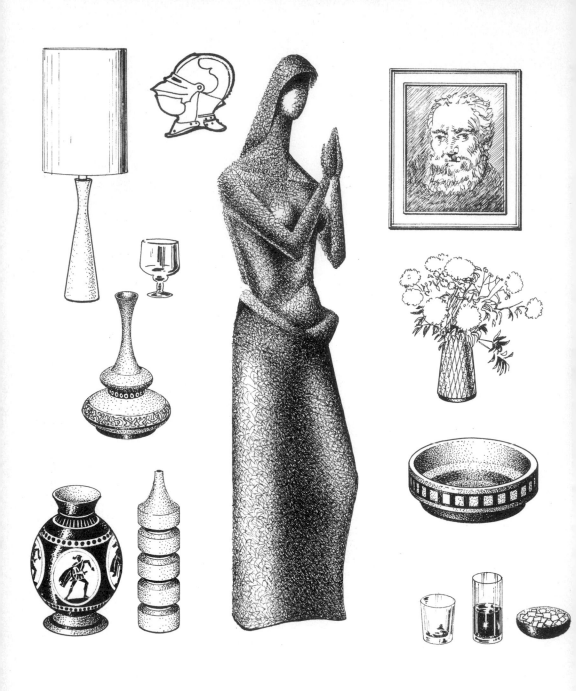

Fig. 77 Some accessories and
ornaments for interior
perspectives.

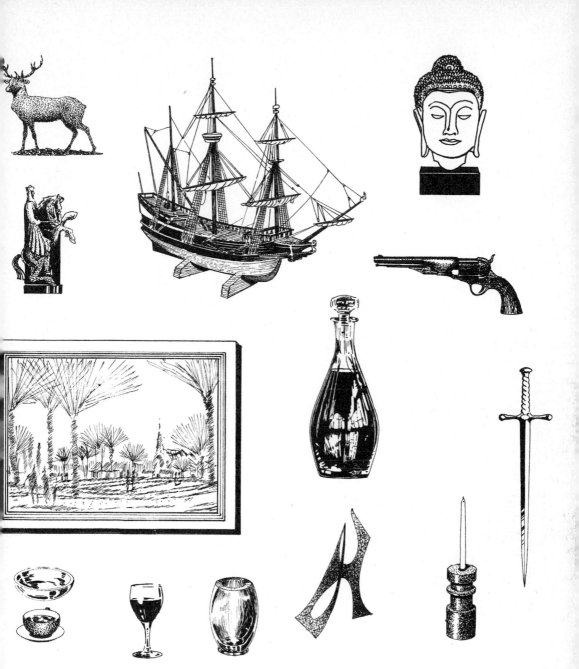

# 7 Techniques

This subject is vast, and as it cannot be fully covered in a work of this nature it is intended to cover only that part of the subject considered useful to the type of work with which this book is concerned.

The majority of the work shown is technical, or at least directed towards this end, therefore this chapter is based mainly on techniques using T-square and set square, and freehand drawing within this framework.

Equipment generally is discussed fully in the next chapter so it is sufficient to say at this stage that the examples shown in figs. 78–81 have been drawn generally with an 0.1-mm. Rotring 'Variant' drawing instrument.

Also shown is the range of line thicknesses available in Rotring 'Variant' drawing instruments. The use of different line thicknesses gives a large variety of tones and textures. Examples show line thicknesses of 0.1 mm., 0.2 mm., 0.4 mm. and 0.6 mm. used for dots and lines.

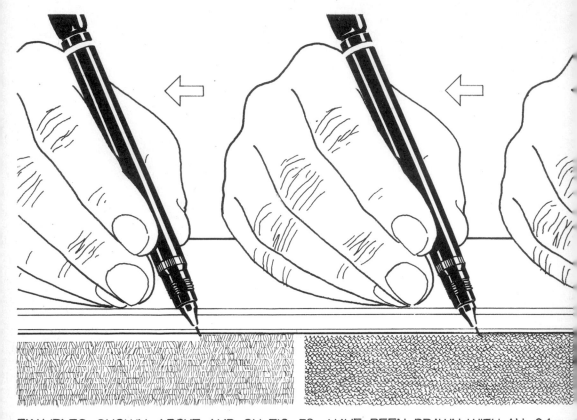

EXAMPLES SHOWN ABOVE AND ON FIG. 79 HAVE BEEN DRAWN WITH AN 0.1mm

LINE THICKNESSES AVAILABLE IN THE ROTRING VARIANT RANGE OF INSTRUMENT

| | |
|---|---|
| 0.1 mm | 0.15 mm |
| 0.2 mm | |
| 0.3 mm | |
| 0.4 mm | |
| 0.5 mm | |
| 0.6 mm | |
| 0.8 mm | |
| 1.2 mm | 1.0 mm |

Fig. 78 The method used to
draw various textures, using a
T-square with a Perspex edge.

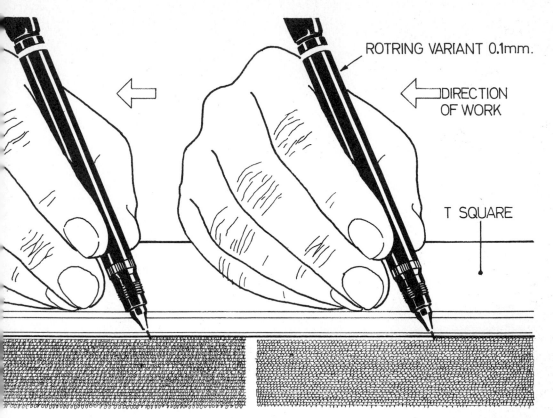

ROTRING VARIANT 0.1mm.

⬅DIRECTION
OF WORK

T SQUARE

'ROTRING' VARIANT INDIAN - INK DRAWING INSTRUMENT WITH 'ROTRING' INK.(BLACK)

| 0.1mm. | 0.2mm. | 0.4mm. | 0.6mm. |
|--------|--------|--------|--------|
|        |        |        |        |

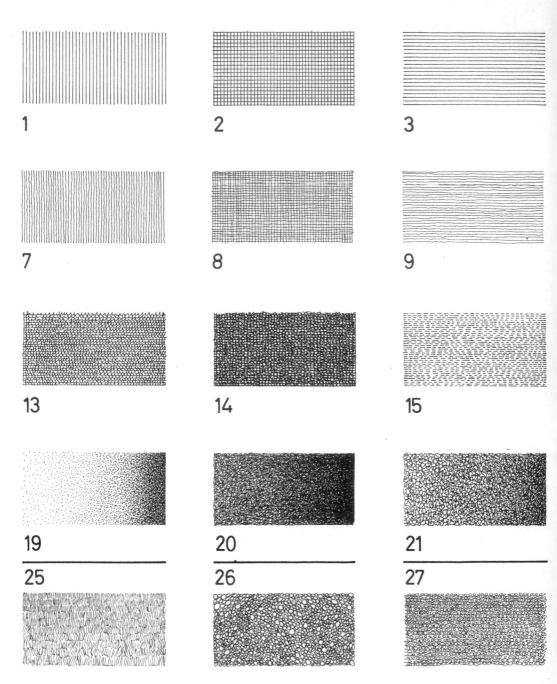

Fig. 79 Thirty different textures which can be achieved using an 0.1-mm. line thickness.

Examples 1–6 are drawn using a T-square and/or set square. Examples 7–12 are drawn freehand. Examples 13–18 are drawn using a T-square and/or a set square. Examples 19–28 are drawn freehand, and 29 and 30 are ruled, showing how shading can be achieved by using different spacing of lines. These are by no means all the textures which can be produced, as combinations and variations of those shown will produce endless possibilities.

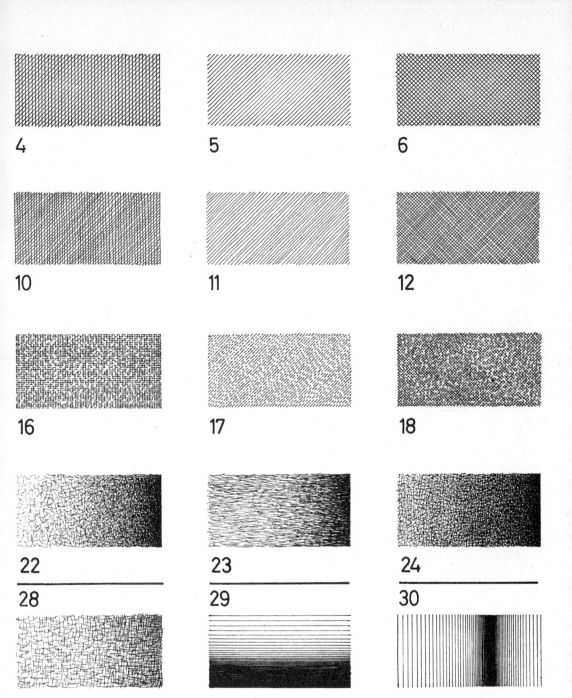

4

5

6

10

11

12

16

17

18

22

23

24

28

29

30

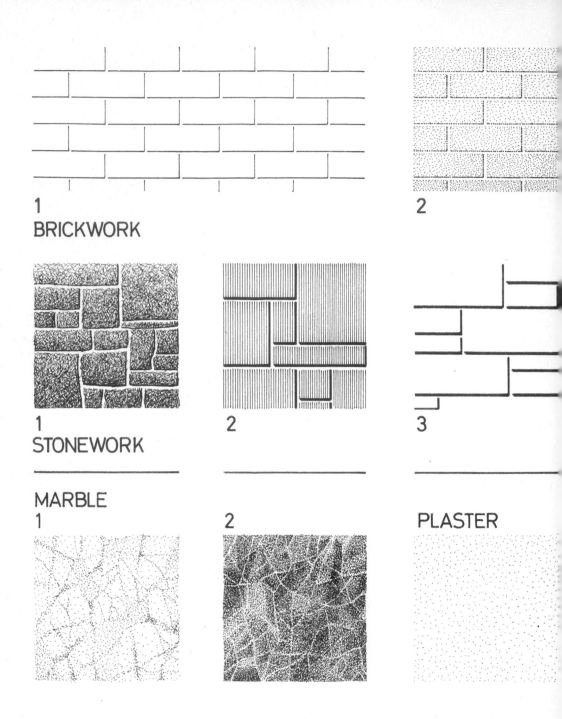

**BRICKWORK** 1 2

**STONEWORK** 1 2 3

**MARBLE** 1 2 **PLASTER**

*Fig. 80 A few possible techniques for showing various materials used in buildings.*

There is probably no limit to the different methods which can be used to achieve the desired results. The examples shown are meant as a guide only; the draughtsman will find his own method of representing materials, depending on the style or technique of the drawing.

**3**

**4**

**5**

**4**

**5**

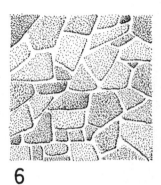

**6**

## TILES

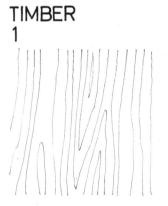

## TIMBER
**1**

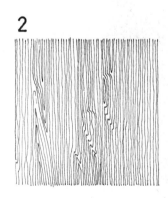

**2**

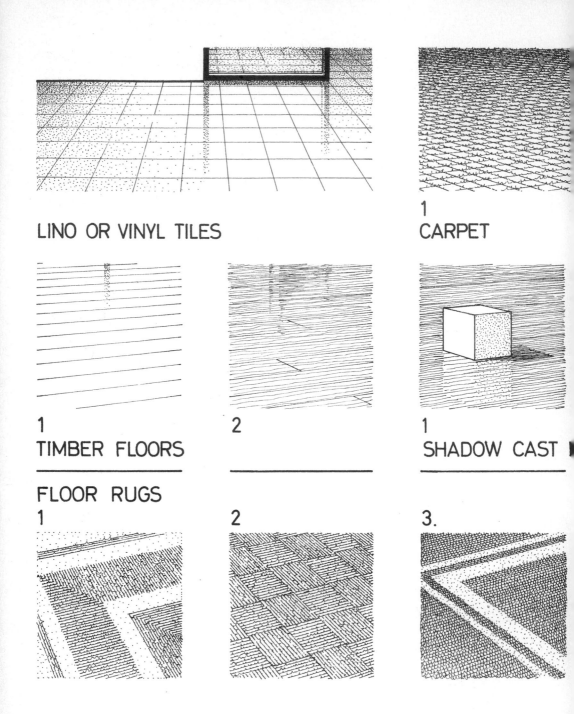

LINO OR VINYL TILES

1

CARPET

1

TIMBER FLOORS

2

1

SHADOW CAST

FLOOR RUGS

1

2

3.

*Fig. 81 Techniques for various types of floor finishes.*

These include shadows and reflections in some cases and, as is the case with many of these diagrams, little more need be said because most can be learnt from studying the drawings.

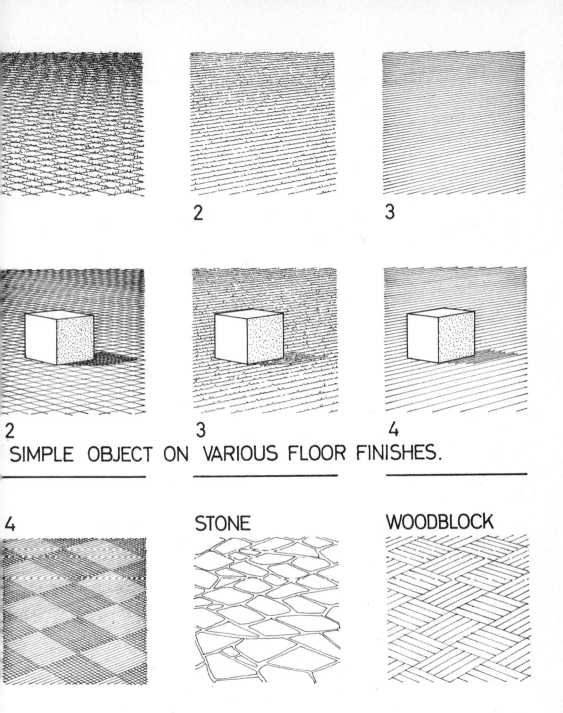

2

3

2

3

4

SIMPLE OBJECT ON VARIOUS FLOOR FINISHES.

4

STONE

WOODBLOCK

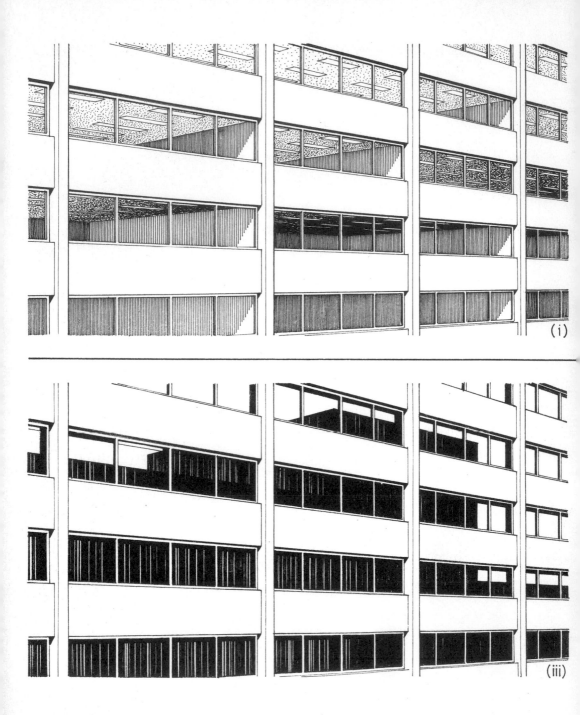

(i)

(iii)

*Fig. 82 Four typical, but different, methods of drawing windows in multi-floored buildings.*

Example *i* shows a method of using a transparent window to show the interior detail. Example *ii* is a semi-transparent window which combines a blacked-in window with lights shown inside the building. In example *iii* the windows reflect another building or group of buildings and there is no interior detail at all. This method can be one of the most convincing of all when done with care and can add a great

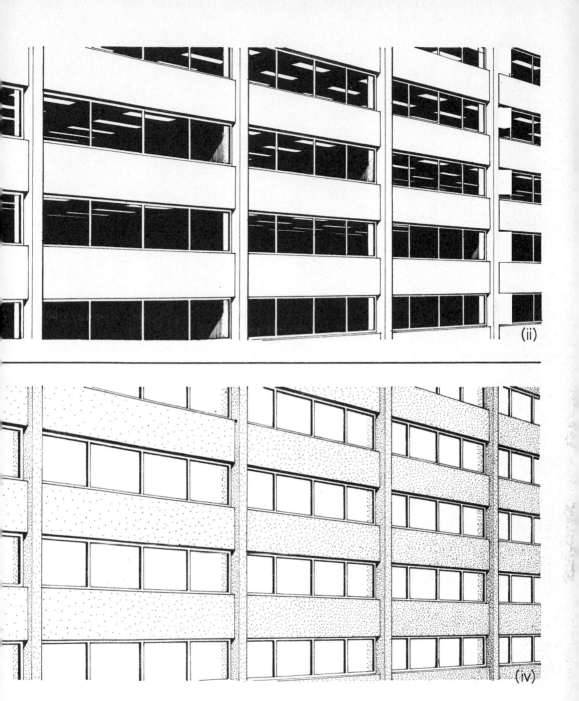

(ii)

(iv)

deal of interest to an otherwise undistinguished building. Example *iv* shows the windows left entirely plain and the work put into the surrounding materials to obtain yet another effect. This method should be used with care as it is useful only in special cases; it is usually better to use a graded tone from darker at the base of the building to the lightest tone at the top, as in later examples.

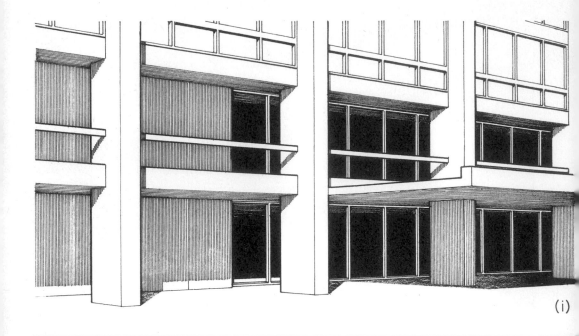

(i)

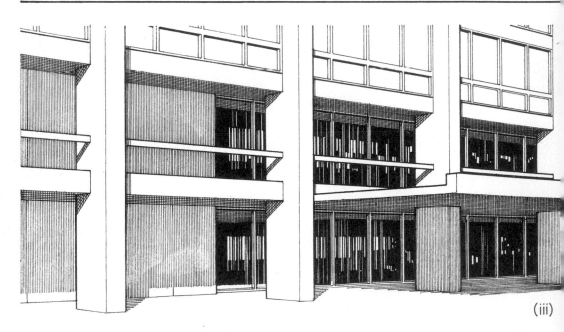

(iii)

*Fig. 83 Four ways of rendering shadows on the base of a building.*

Example *i* shows a method of shading using vertical lines on vertical surfaces and lines in perspective on horizontal surfaces. Example *ii* is the same building with freehand dots of varying density to show shadows on various surfaces. Example *iii* has shadows similar to example *i*, but in this case the horizontal surfaces have vertical lines as well as perspective lines. The windows also have reflections which

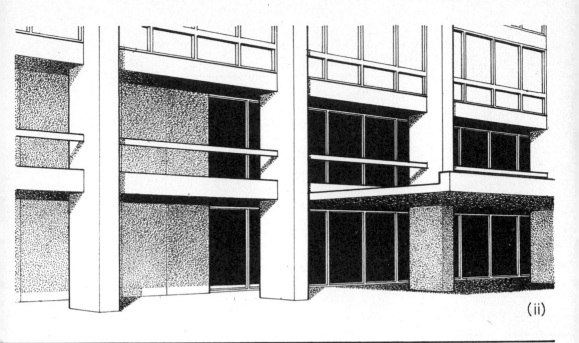

(ii)

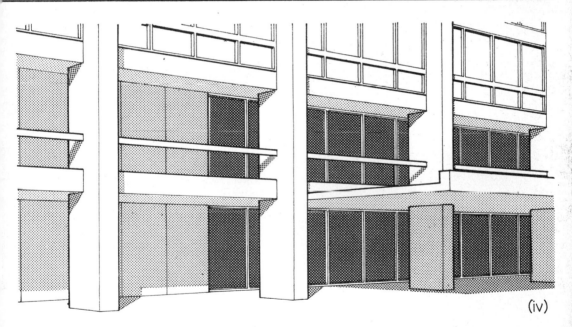

(iv)

add interest. Example *iv* is carried out with mechanical tones (adhesive screens) applied to the back of the sheet. (All examples have been drawn on 90 gm. tracing paper.) Combinations of these methods can be used effectively, as well as many other techniques which can be found by a little experimentation.

# LETRATONE SHADING TINTS

*Fig. 84  A simple freehand
drawing with mechanical tints.*

Shading on buildings and shadows thrown by the buildings
has been applied with Letratone shading tints, as set out in the
fixing instructions given beside the drawing. Again the best
results are achieved by working on the reverse side of the
tracing paper.

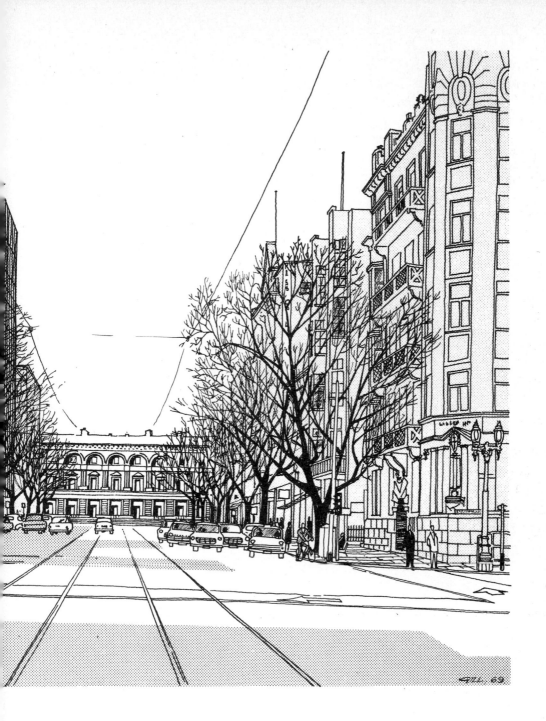

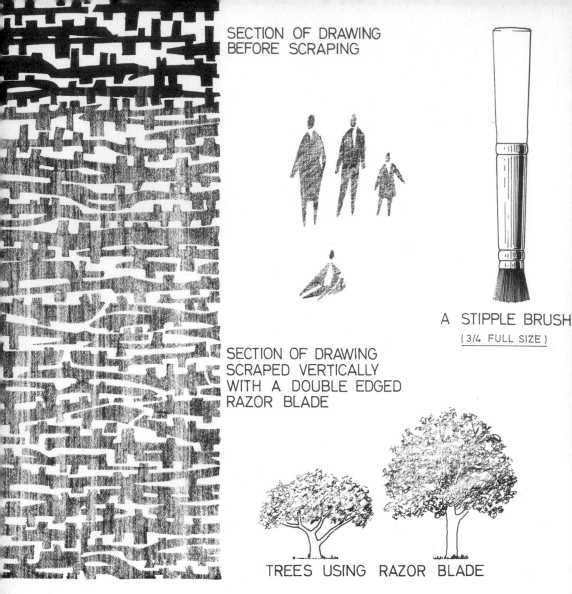

SECTION OF DRAWING
BEFORE SCRAPING

A STIPPLE BRUSH
(3/4 FULL SIZE)

SECTION OF DRAWING
SCRAPED VERTICALLY
WITH A DOUBLE EDGED
RAZOR BLADE

TREES USING RAZOR BLADE

*Fig. 85 The short-bristled stipple brush, which can be used to obtain many different textures.*

Experimentation is not only informative but can also be fun, as many effects can be found by accident. The usual way to use a stipple brush is to dip the bristles into a shallow container of Indian ink or watercolour, then, using a sheet of waste paper, remove the excess ink from the bristles, hold the brush vertically and dab on to the required area. It is often found that the use of masking media is required to obtain clean edges. The few simple examples shown in fig. 85 should be sufficient to encourage the student to purchase a stipple brush and go to work. In some cases it is useful to stop the spread of the brush by winding adhesive tape around the bristles about $\frac{1}{8}$ in. above their ends for this allows the draughtsman a tighter control of the texture. Most important is that the brush must be thoroughly cleaned when the work is completed; as with most brushes, warm water is excellent for the job.

PANEL SHOWING USE OF A STIPPLE BRUSH
AND PELIKAN INDIAN INK No. 17

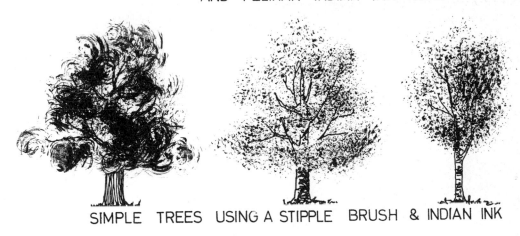

SIMPLE TREES USING A STIPPLE BRUSH & INDIAN INK

Also shown in fig. 85 is a method of breaking down solid blacks to various shades of grey by using an ordinary double-edged razor-blade. The blade should be held vertically above the paper and moved backwards and forwards lightly over the area to be treated, so that the entire length of the blade's sharpened edge contacts the paper evenly. When this is mastered with practice, it will be found that smaller areas of work can be treated by using only a small portion of the blade, but this should be attempted only with extreme caution as damage to the surface of the paper can easily be caused.

The few examples shown should be sufficient to show the possibilities of this method: the draughtsman should experiment for himself and find what is possible and desirable for him.

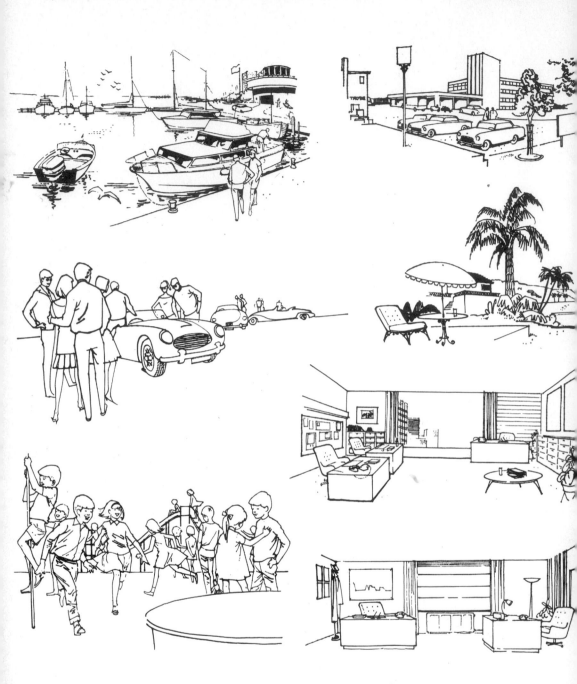

*Fig. 86 Typical Letraset 'Art Sheet'.*

There are some forty different sheets in the series, and as can be seen from this example and the other shown earlier in Chapter 5, 'Drawing People' (fig. 56, pp. 124–5), the character, line weight and proportion of the drawings are constant throughout. The 'Art Sheet' drawings are rubbed down in the same way as 'Instant Lettering', but care should be taken to read the fixing instructions thoroughly before using these sheets: careless handling can be costly and annoying. However, with care they can be used with excellent

# ART SHEETS

THERE ARE 40 SHEETS COMPRISING 600 COMPLETE DRAWINGS OF HEADS, HANDS, HALF-FIGURES AND FULL FIGURES OF MEN, WOMEN AND CHILDREN, AS WELL AS BACKGROUNDS IN THE ART SHEET RANGE.

LETRASET ART SHEET DRAWINGS ARE RUBBED DOWN IN THE SAME WAY AS INSTANT LETTERING. (SEE FIG. 145. FOR FIXING INSTRUCTIONS.)

SIZE OF ART SHEETS — 7½" x 10"

ART SHEETS ARE DRAWN BY A LEADING FIGURE ARTIST, THEY CAN BE USED SINGLY OR GROUPED TO ILLUSTRATE MOST SOCIAL AND COMMERCIAL ACTIVITIES. THE CHARACTER, LINE WEIGHT AND PROPORTION OF THE DRAWINGS ARE CONSTANT THROUGHOUT.

results and a considerable saving in time and money. When using 'Art Sheet' drawings or 'Instant Lettering' it is advisable to use a spray fixative supplied by Letraset which will enable dyeline or similar prints to be taken without the original drawing being damaged or removed by the heat of the printing machine.

*Fig. 87  A further aid for the draughtsman: Instantex 'rub-down' texture.*

In this range there are twenty different sheets which can be used individually or, if desired, in combinations to obtain many other individual textures and effects. Similar to the 'Art Sheet' drawings and 'Instant Lettering', Instantex should be sprayed with Letraset spray fixative when completed, to

## HOW TO USE INSTANTEX

HOLD OR TAPE THE TINT SHEET FIRMLY IN POSITION WHEN RUBBING DOWN. YOU CAN SEE THE TINT TRANSFERRING THROUGH THE SHEET, BUT IT IS BEST TO PEEL THE SHEET PARTLY BACK FROM TIME TO TIME TO CHECK PROGRESS.

RUB DOWN CAREFULLY BACKWARDS AND FOR-WARDS OVER WHOLE AREA WITH STEADILY INCREASING PRESSURE TO RELEASE THE TINT.

FOR ACCURATE POSITIONING OF THE DARKER TINTS USE A LIGHT BOX UNDER OR A TRAC-ING OVER.

INSTANTEX AVOIDS THE SHINY BUILD-UP OF NORMAL TINT SHEETS SO SEVERAL OVERLAYS CAN BE APPLIED. FURTHER TEXTURES CAN BE ACHIEVED BY OVERLAYING THE SAME TINT AT DIFFERENT ANGLES, OR COMBINING DIFFE-RENT ONES. THE VARIATIONS ARE PRACTICALLY LIMITLESS.

INTERESTING EFFECTS CAN BE ACHIEVED BY RUBB-ING DOWN AREAS OF TINT ON TO PAPER, THEN TRANSFERRING THE REMAINING TINT TO ART-WORK.

WHEN RUBBING DOWN HEAVIER 'LINKED' TINTS (1-11, 18 & 19) OUTLINE THE AREA FIRST WITH A BALL POINT PEN USING DOUBLE THE USUAL PRESSURE.

A BALL POINT PEN AND THE ROUND PLASTIC CAP PROVIDE THE MOST USEFUL GENERAL STYLUS. EXPERIMENT WILL PROVE WHAT IS BEST FOR A PARTICULAR REQUIREMENT.

SURPLUS LIGHT TINTS CAN BE REMOVED WITH A RUBBER. HEAVIER TINTS USE A RAZOR BLADE, SELLOTAPE OR PROCESS WHITE.

RANGE — 20 SHEETS

SHEET SIZE — 15" × 10"

allow for printing and handling, otherwise patterns can lift or become damaged, which again can be costly as well as annoying. Instantex can be most effective if used with care and attention to the fixing instructions, and can save a great deal of time and money.

Fig. 88 *The use of an air brush or spray gun to achieve varied effects.*

The example shown is a simple one, using masks of varying shapes and sizes to build up a pattern. The actual method of using a spray gun varies considerably, depending upon the results required and, in some cases, the gun used. The gun used for this example is a Japanese 'Holbein', an excellent piece of equipment for use in rendering (see fig. 164, pp. 352–3).

There are a number of other techniques available to the draughtsman such as spatter, which is often effective if somewhat messy, relying as it does on the use of an old toothbrush, flywire and other assorted materials. A great deal of care is needed to avoid a disastrous mess.

Other ways of obtaining effects such as using textured materials under the paper and then rubbing pencil over the

area, or the use of pencil dust and cotton-wool, can be effective in obtaining satisfactory results, but as this work is intended to cover only pen-and-ink rendering it is unnecessary to go into these subjects further.

From this point on it is intended to show various examples of drawings using one or more of the pen techniques previously described. In some cases more than one of the techniques have been used to obtain the required results. It would be superfluous to give long descriptions with each example: the drawings should be sufficient in themselves. The following drawings are included to demonstrate various techniques only and are not intended to show any specific building, the buildings being for the most part imaginary.

EAST ELEVATION

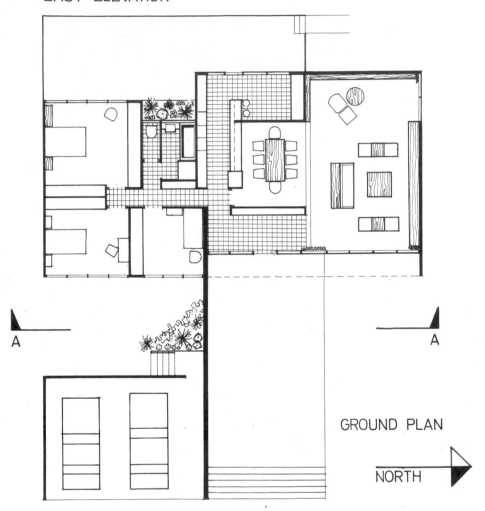

A                                              A

GROUND PLAN

NORTH

*Fig. 89 A typical plan and elevations of a small house.*

These have been prepared for 'selling' the design to the client, or for publication. The plan has been made more informative by the inclusion of furniture and fittings, a few shrubs and a floor texture. These additions eliminate the necessity of writing all over the plan to identify the various rooms, thus making it easier to reduce the size of the drawing, for

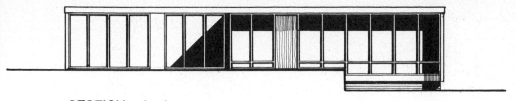

SECTION A-A

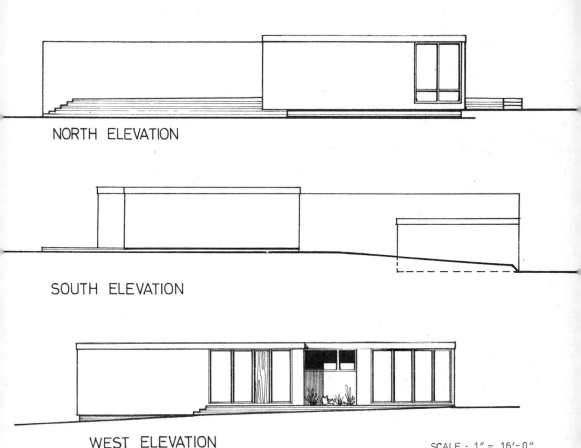

NORTH ELEVATION

SOUTH ELEVATION

WEST ELEVATION

SCALE : 1″ = 16′-0″

instance for reproduction in magazines. The elevations are helped by the addition of simple black shadows, which in this case, have been constructed at a 45° angle to the ground plane and to the picture plane. The same small house is used in fig. 90 to show the steps needed to obtain a one-point perspective of the entry and living-room area.

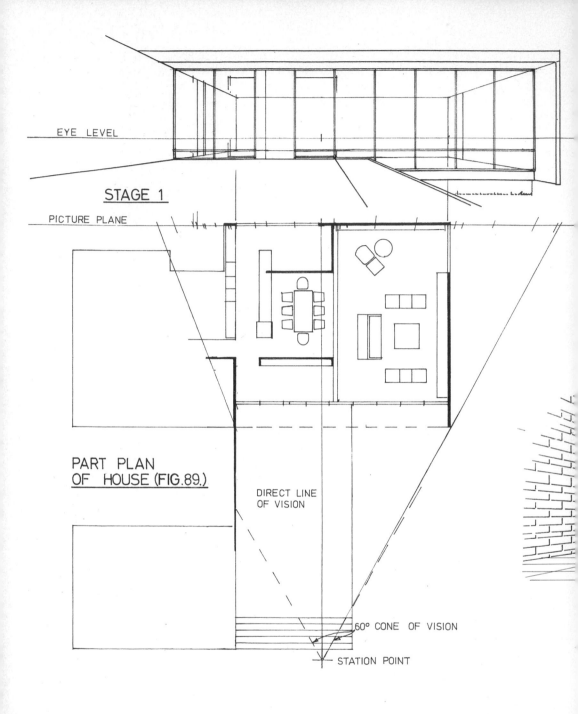

EYE LEVEL

STAGE 1

PICTURE PLANE

PART PLAN
OF HOUSE (FIG.89.)

DIRECT LINE
OF VISION

60° CONE OF VISION

← STATION POINT

*Fig. 90 One-point perspective*
*of the same house.*

After selecting the station point and setting up for the one-point perspective as previously described (p. 26), it is necessary to set up the main lines (stage 1). Stage 2 consists of locating details and main guide-lines as necessary. The finished drawing includes all the previous stages plus shadows, shrubs, grass, trees, stonework of the wall and textures in the interiors.

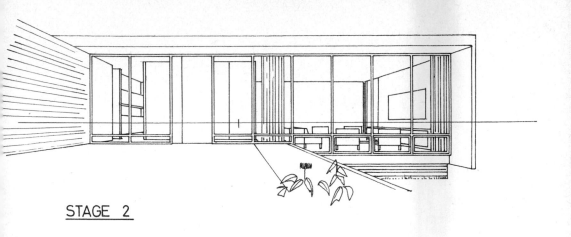

STAGE 2

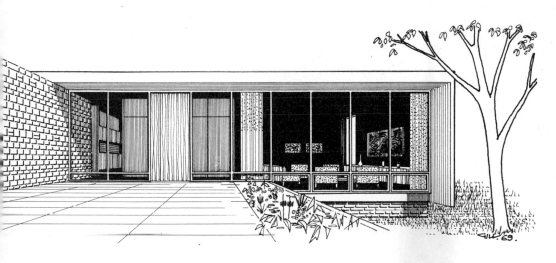

FINISHED ONE POINT PERSPECTIVE VIEW OF HOUSE

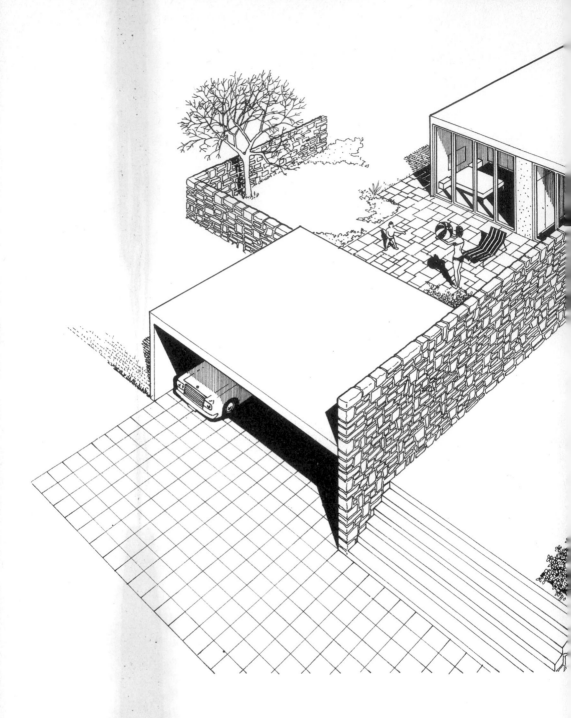

*Fig. 91 An aerial or bird's-eye view of the same house.*

This is an excellent way to show the shape and extent of the accommodation. This type of perspective drawing can also be useful in showing the building in relation to its site, to adjacent buildings and to its environment. In the example shown here the glimpses of the interiors are helpful in giving as much of the story as possible.

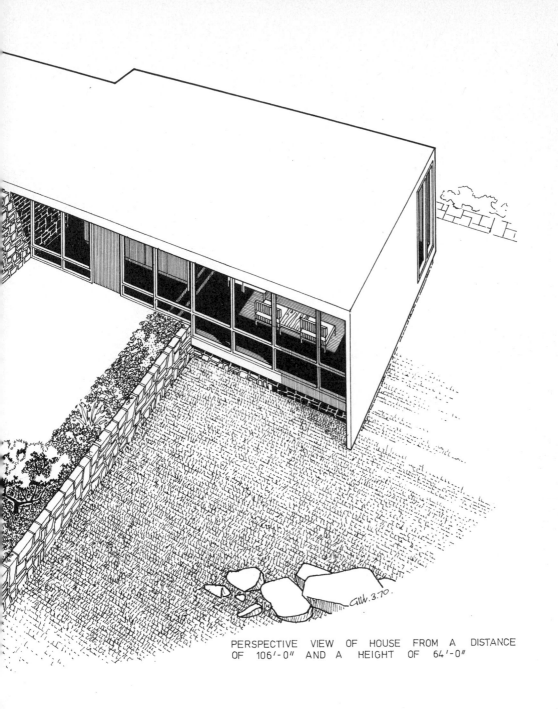

PERSPECTIVE VIEW OF HOUSE FROM A DISTANCE
OF 106'-0" AND A HEIGHT OF 64'-0"

Gill. 3.70.

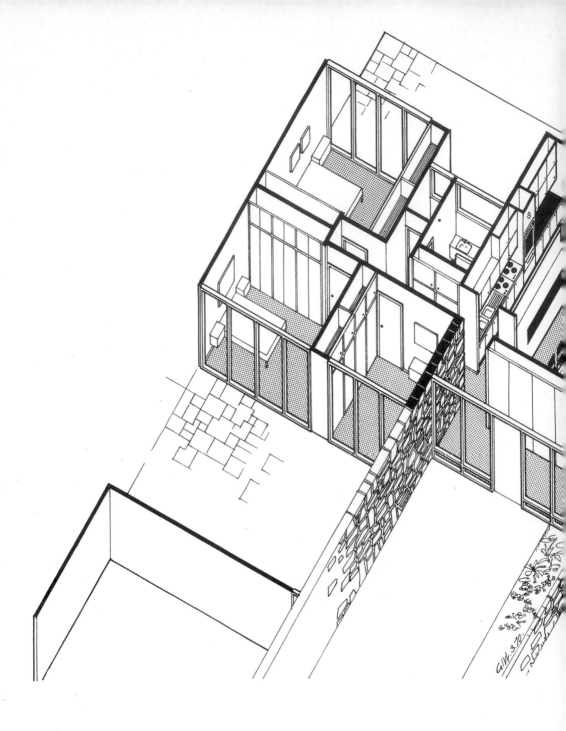

*Fig. 92 Another method of illustrating the same house.*

In this case a 60°/30° axonometric projection is used and the drawing is made with the roof removed so that the interior relationships can be seen clearly in three dimensions. This type of drawing is often useful in designing factories and offices because it enables the designer and the client to see clearly the work flows at various levels, which are sometimes

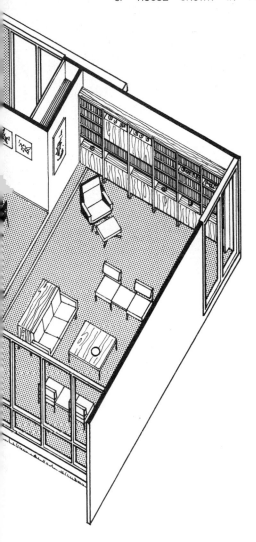

AXONOMETRIC PROJECTION (60°/30°)
OF HOUSE SHOWN IN FIG. 89

difficult to show on plans and elevations. This type of
illustration also enables measurements of heights as well as
plan dimensions to be taken from the actual drawing. By
using a tone on the floor areas it is possible to increase the
three-dimensional effect; by showing the furniture and
fittings a clear picture of the various rooms can be ascertained.

*Fig. 93 Apartment building (i).* This is used as a basis for the next four drawings. These four show different techniques applied to the one drawing and should be helpful to the student in assessing the value of the various styles.

GILL 3/70

*Fig. 94  Apartment building (ii).*  This shows the use of simple black shadows, ruled horizontal brick joints, plain windows where not in shadow and, generally, the elimination of top lines to the various projections. The surroundings are kept simple and in character with the main building. This type of drawing is very good for reproduction where reduction is necessary, and the final print is required for magazine, newspaper or similar publications.

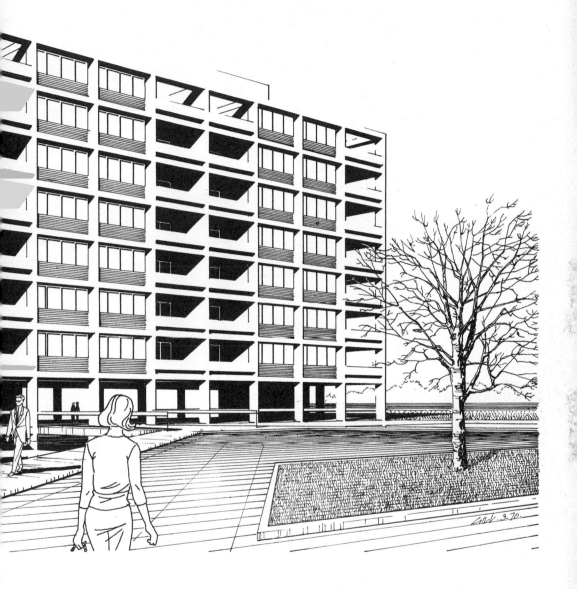

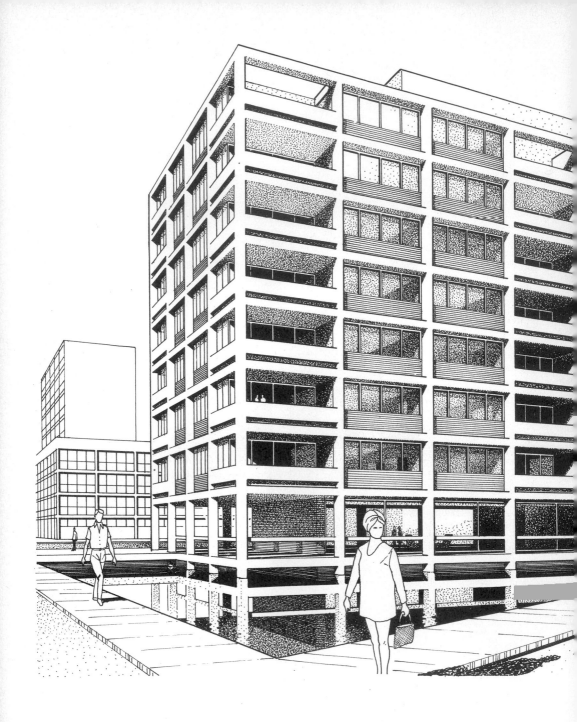

*Fig. 95 Apartment building (iii).*

Here freehand dots have been used to build up various tones from light grey at the top of the nearest corner of the building to the black shadows as the building recedes. This technique allows for simple detail in the areas of shadow and also detail in the windows which gives a transparency to them. Reflections of the sky and adjacent buildings are also possible which add interest. Again, the surrounding detail is kept

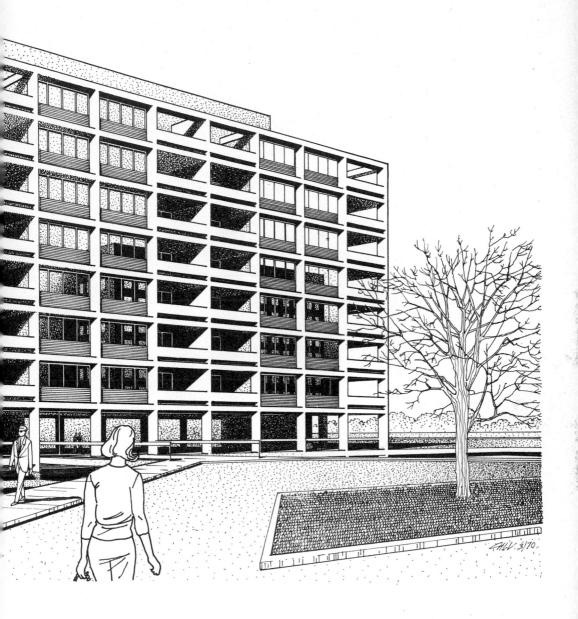

simple and in character with the main building. This type of
drawing reproduces well in magazines even when con-
siderably reduced but loses a great deal in reduction and
reproduction in newspapers.

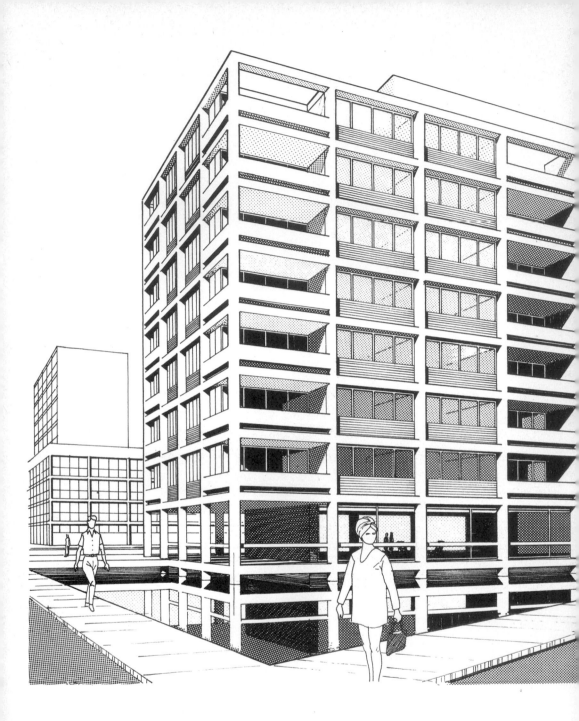

*Fig. 96 Apartment building (iv).*

This drawing uses adhesive screens consisting of mechanical dots from light grey through to almost black. The black areas have been done with pen and ink as the darker screens are difficult to use without a light table. Approximately eight different screens were used to produce this drawing, plus a special screen for the grass effect. The reproduction qualities of this type of drawing are similar to those of fig. 95.

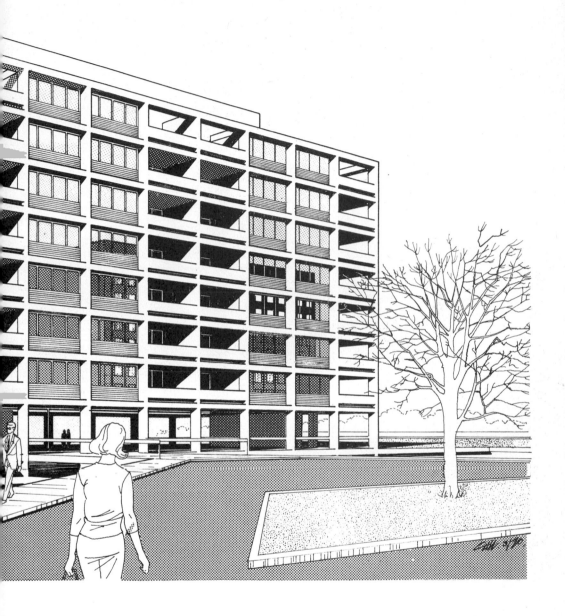

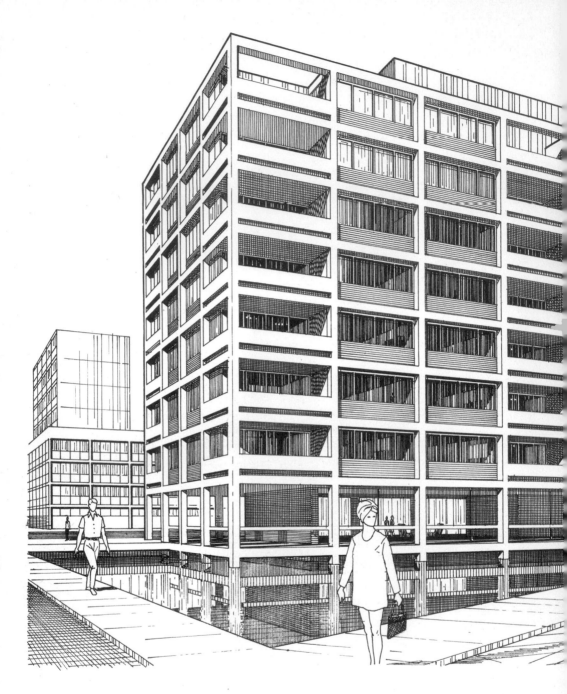

*Fig. 97 Apartment building (v).*

Here shadows and reflections have been built up with vertical and perspective lines, a technique which allows for a very large range of tones from white through to black, and also subtle variations between similar tones, which can be produced by simply varying the distance between the lines. (The fine lines in this example were ruled with an 0.1-mm. Rotring 'Variant', which was also used for the freehand dots in fig. 95.) This type of drawing reduces well for

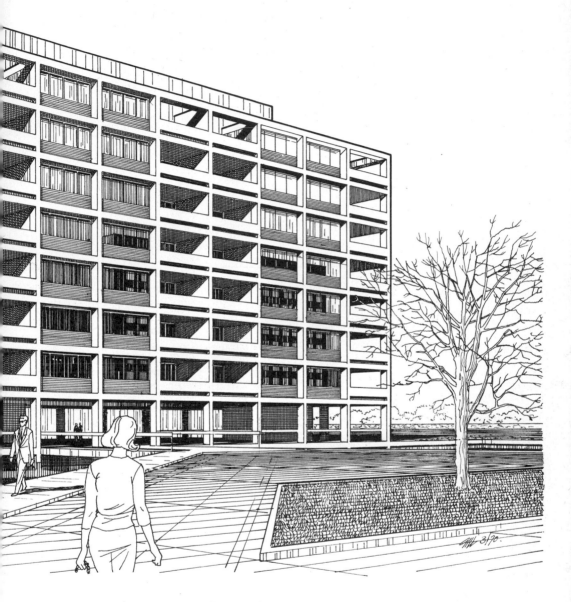

magazine reproduction and is still acceptable for newspaper
and similar publications.

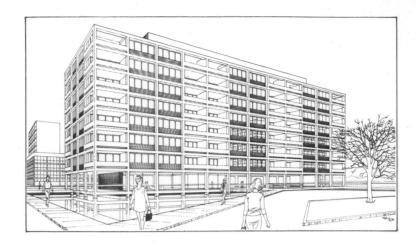

*Fig. 98 Apartment building: comparative reductions.*

From these five considerably reduced reproductions of the preceding five figures it is possible to compare the effect of reduction on each of the techniques shown. The student is advised to examine them carefully before deciding which type of drawing suits his purpose best.

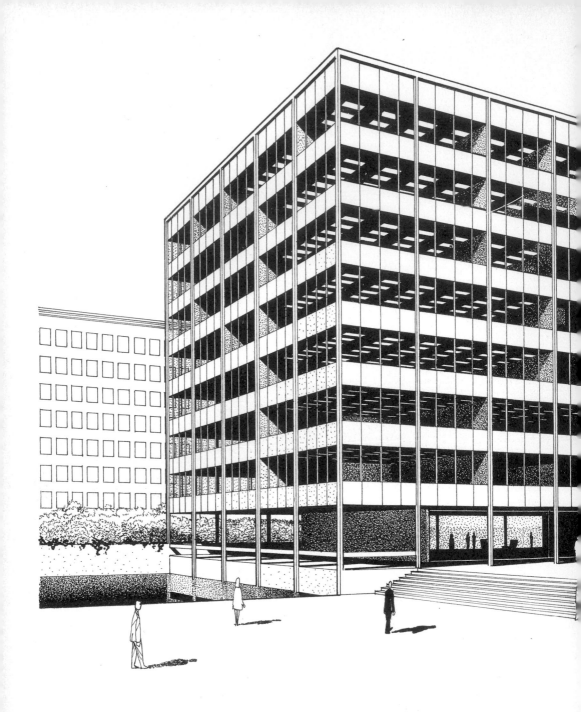

*Fig. 99 Office block.*

This has been treated to give the impression of other buildings and sky reflected in the window glass, as well as a glimpse of the interior of the building at its nearest point. The whole is intended to give life and interest to the drawing. Textures are built up by using freehand dots on a ruled perspective drawing.

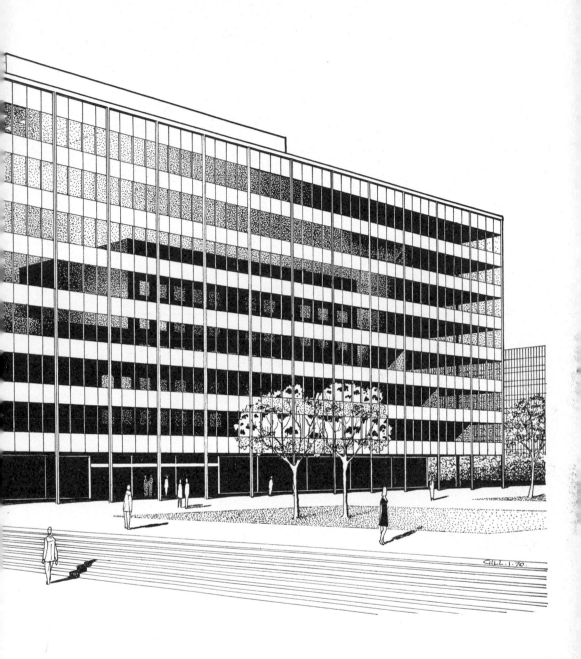

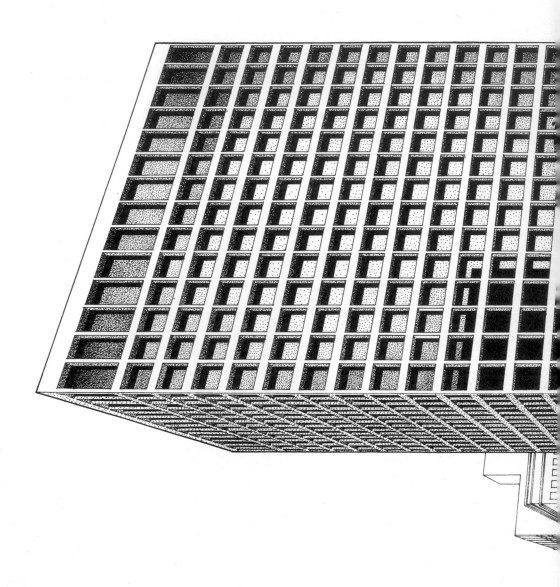

*Fig. 100 Office block.*

A larger building than the previous one, therefore it is shown to a smaller scale. In this case reflections of the sky and other buildings only are shown, using freehand dots to build up tones and textures. Dots are also used to build up the shadows.

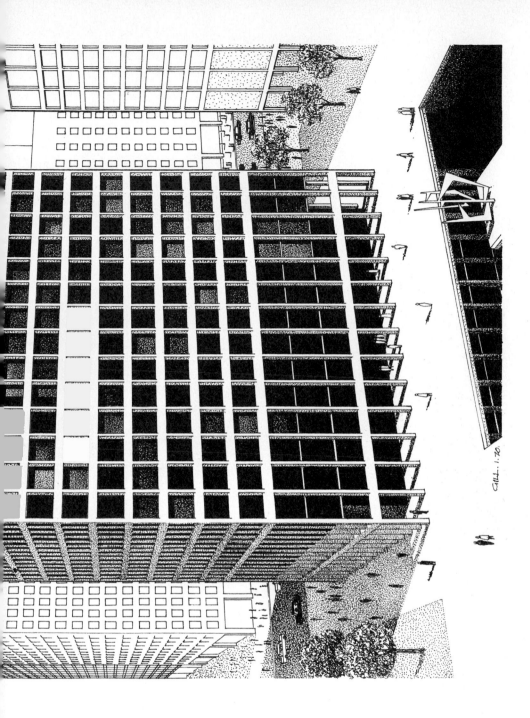

*Fig. 101 Commercial building.*   Here again, shadows and windows are ruled, dots in this case being used to denote material. Note the variation in tone of the end wall, which adds interest.

*Fig. 102 · Office block.*

This has been carried out entirely with freehand dots over a ruled drawing. The dark structure of the building requires careful handling so that it does not become flat and un-interesting. The tones on the windows also need careful handling so that they do not 'get lost', causing the building to lose definition. The glimpses of activity within the building help to liven up the drawing, a factor which should be watched in this type of building.

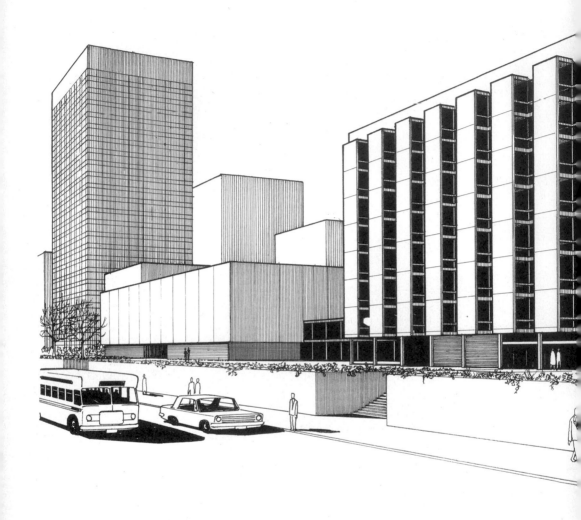

*Fig. 103  Commercial building.*   In this case windows have only a minimum of reflection shown. The shaded areas of the building are rendered with vertical lines ruled with an 0.1-mm. Pelikan 'Technos' pen. The shadows thrown by the building, cars and people are black.

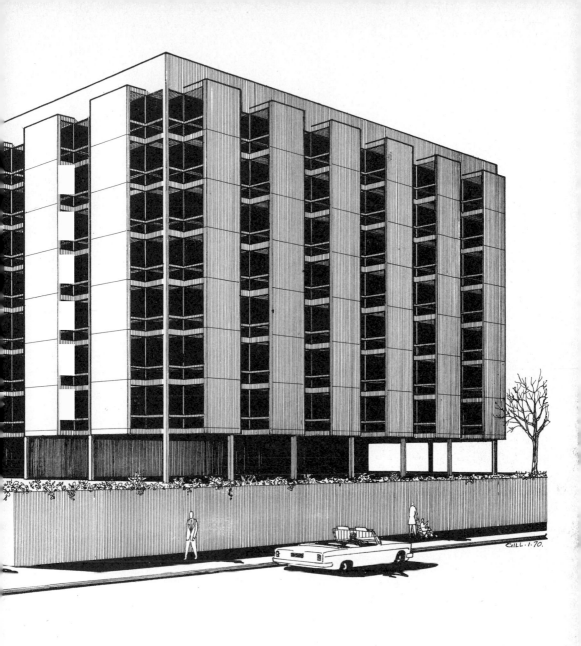

GILL·1·70.

223

*Fig. 104 A medium-sized city building.*

Over a ruled perspective drawing tones are built up using vertical and perspective lines, ruled with an 0.1-mm. Pelikan 'Technos' pen. The apparent transparency given to the drawing of the windows is helped by showing the lighting within the building and glimpses of detail through the outer corners.

GILL. 1.70.

225

*Fig. 105 An administration building.*

This figure uses 0.1-mm. vertical and perspective lines to build up tones, shades and shadows. In this case the shadows on the windows were drawn with an 0.2-mm. Rotring 'Variant' drawing instrument. As with most of the other figures in this chapter, an 0.4-mm. Rotring 'Variant' drawing instrument has been used to 'back line' the silhouette of the building. This method of outlining the building, and also the projections on the building, helps to create a

stronger third dimension to the drawing and is recommended
to the draughtsman, who should experiment with his own
drawings to see the advantages.

*Fig. 106 A large auditorium.*    This again uses vertical and perspective lines drawn with an 0.1-mm. Rotring 'Variant' drawing instrument for shade and shadows. The difficulty with this type of drawing is that a good deal of the building is in shade, which makes the definition of detail in the shaded areas very important. The use of perspective lines on sloping surfaces helps considerably. Locating the vanishing points, as previously described, greatly simplifies the drawing of these lines. Vertical and perspective lines similar to those used on the building are used to show the reflection of the building in the water in the foreground. The use of back lining can be seen to advantage in this example.

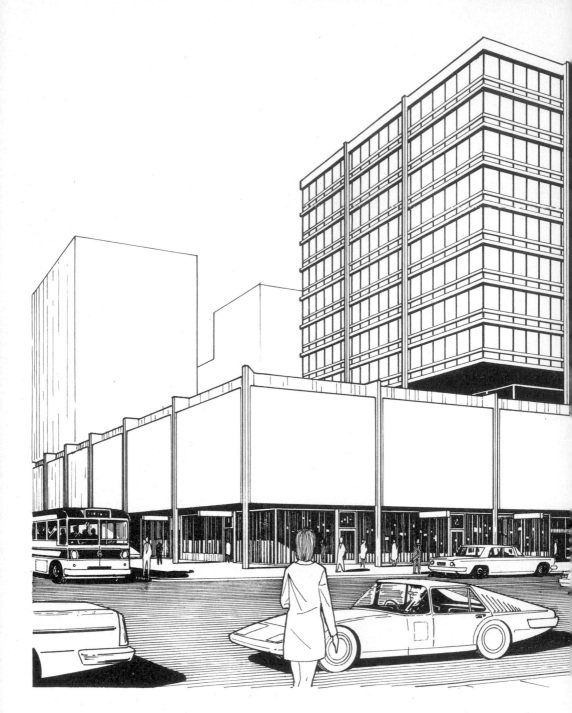

*Fig. 107 A city emporium.*

This drawing is meant to focus attention on the building at street level and therefore most of the detail is concentrated on the street and the display windows. The office block above the shopping area is left as a line drawing, without any shade or shadows, as a contrast to the lower area. Drawings of this type can be very useful when 'selling' an idea to the general public as opposed to designers and clients.

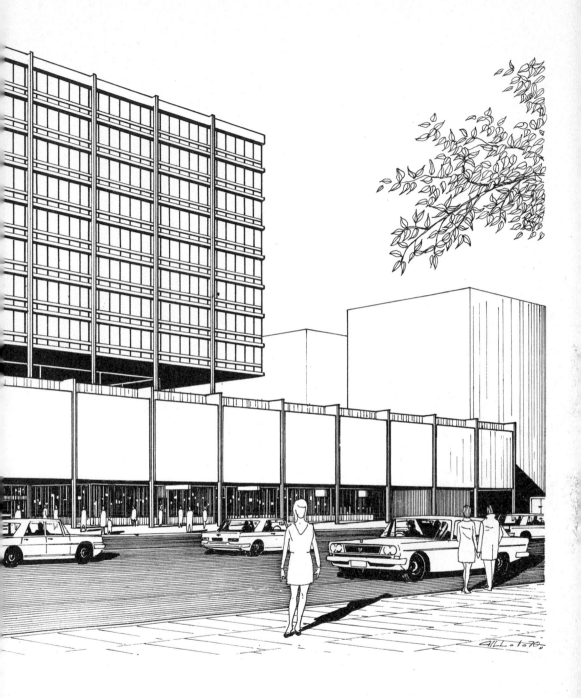

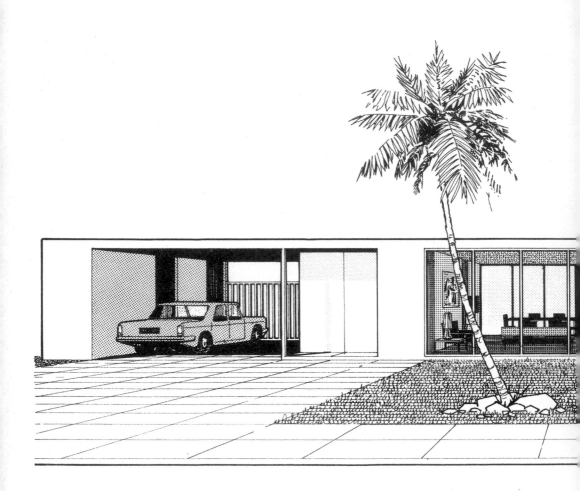

*Fig. 108 One-storey dwelling-house.*

This is a simple, quick one-point perspective of a house, using only two mechanical tints for shading and for the window areas. The surroundings have been kept to a minimum and the attention is focused on a very simply expressed building.

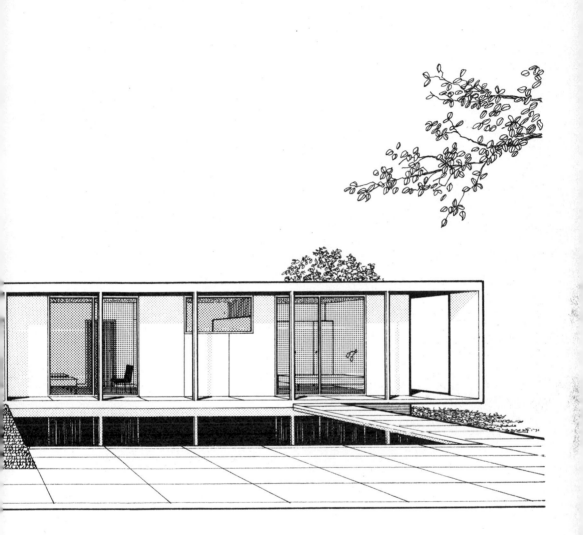

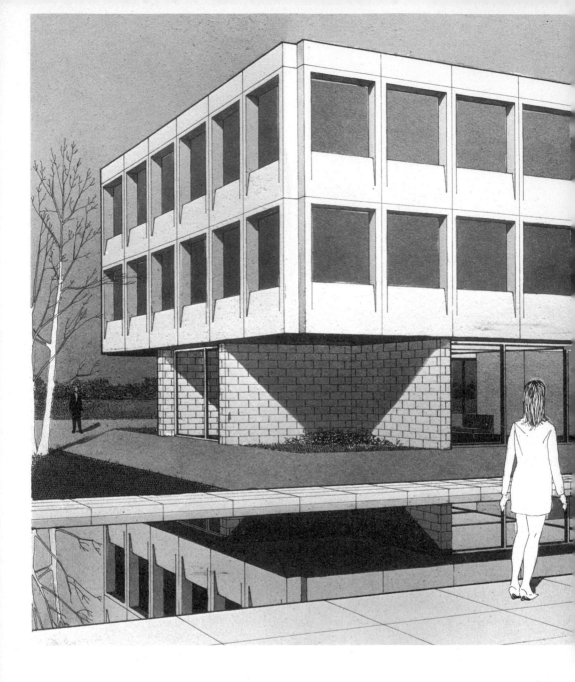

*Fig. 109 Rendering with an air brush.*

It is possible to increase or decrease the detail to suit the purpose, but in this case the rendering has been kept simple to show the use of the instrument with diluted Indian ink to produce a black-and-white rendering. Colours can be used with equal ease and success, and the methods and masking materials are the same in both cases. In the example shown, cut-out paper masks were used together with 'Mecanorm' liquid frisket, which is a neutral maskout liquid. This can be applied with a pen or brush on all drawing-paper surfaces and removed by peeling or rubbing.

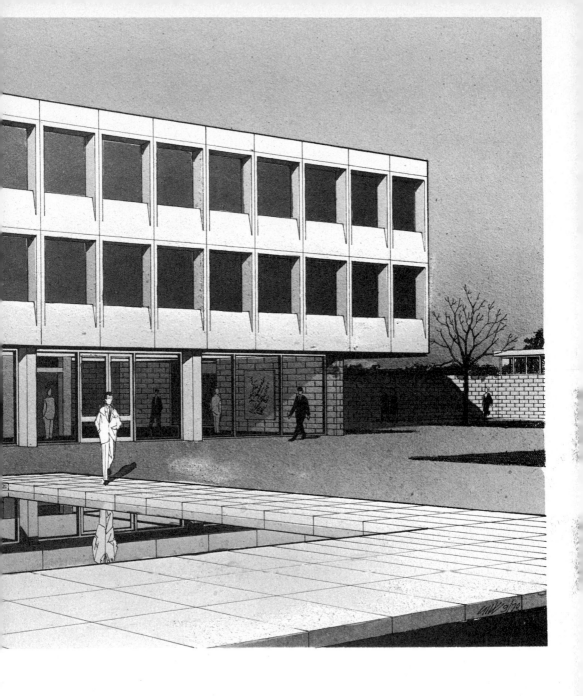

*Fig. 110 A simple exterior/
interior perspective.*

This figure shows how a perspective view can be more suitable to advertising than to the architectural or interior design rendering. However, this type of drawing can be very effective with a splash of strong colour in a strategic place.

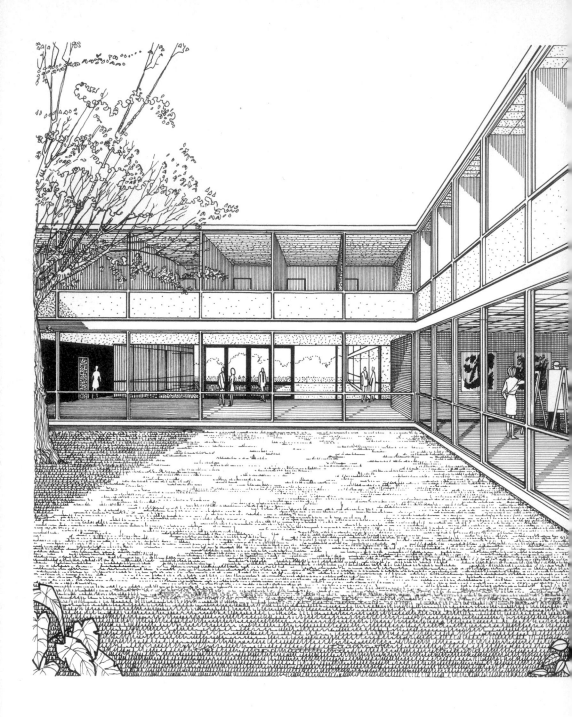

*Fig. 111 A typical exterior/ interior perspective rendering.*

In this one-point perspective it is possible to show the character of the exterior of the building while concentrating on the interior.

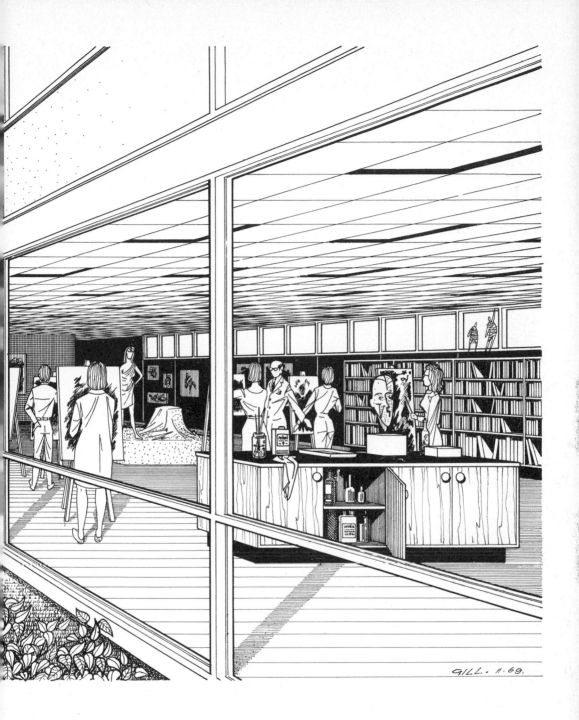

GILL. 11.69.

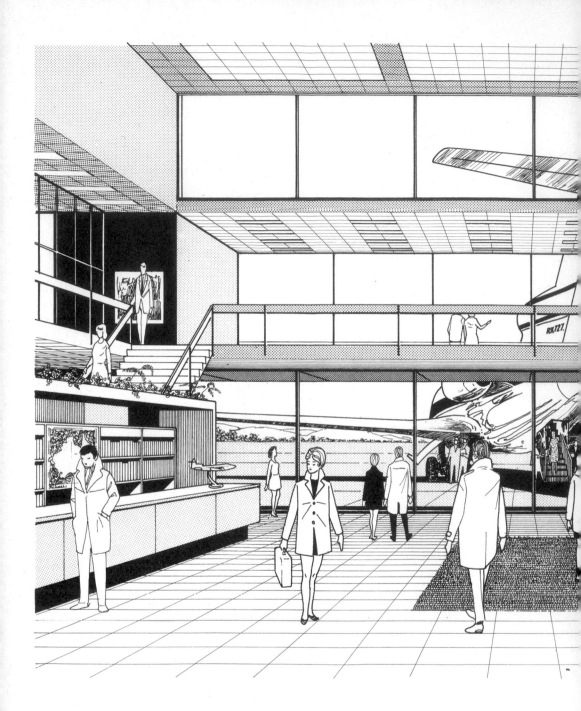

*Fig. 112  Interior of an airport.*   Through the windows a jet aircraft can be seen unloading. Again one-point perspective has been chosen for this drawing, which is generally ruled with mechanical tints used for the shades and shadows. The advantage of being able to see what is going on outside this area, plus the groups of people milling about, is that it leaves very little to the imagination as to what this building is all about.

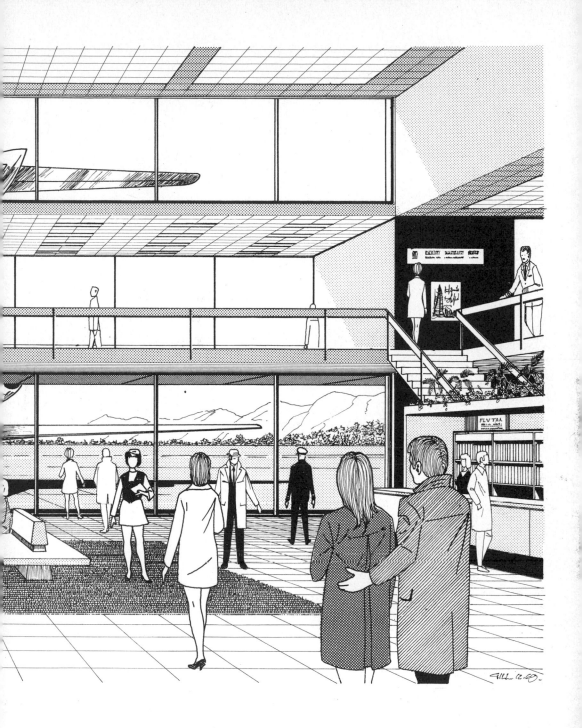

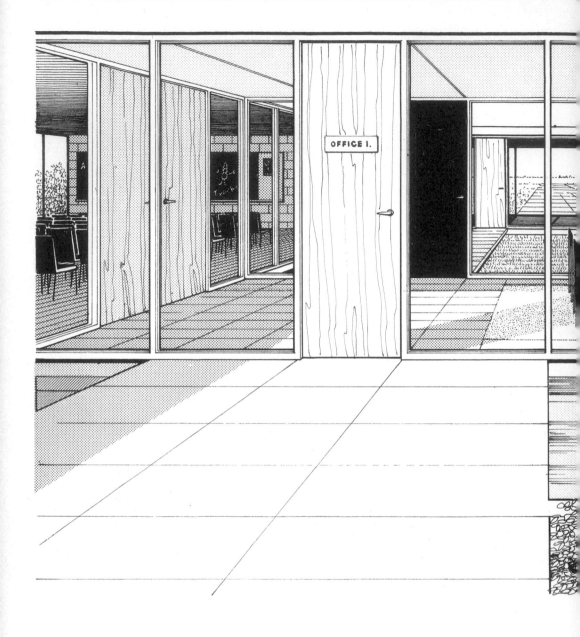

*Fig. 113 Exterior/interior
one-point perspective drawing.*

The drawing has been kept simple, and mechanical screens
have been used for shadows, as previously described, as well
as for carpet and water. This type of drawing can also be very
effective when simple blocks of colour are used sparingly.

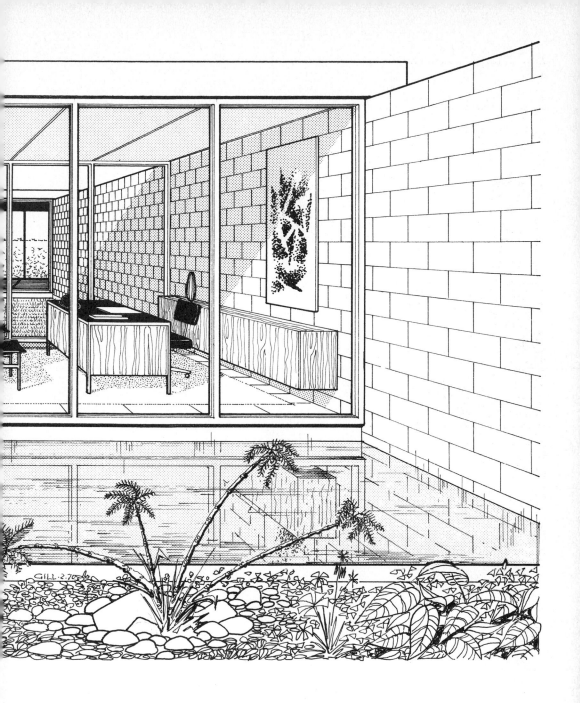

GILL·2·70

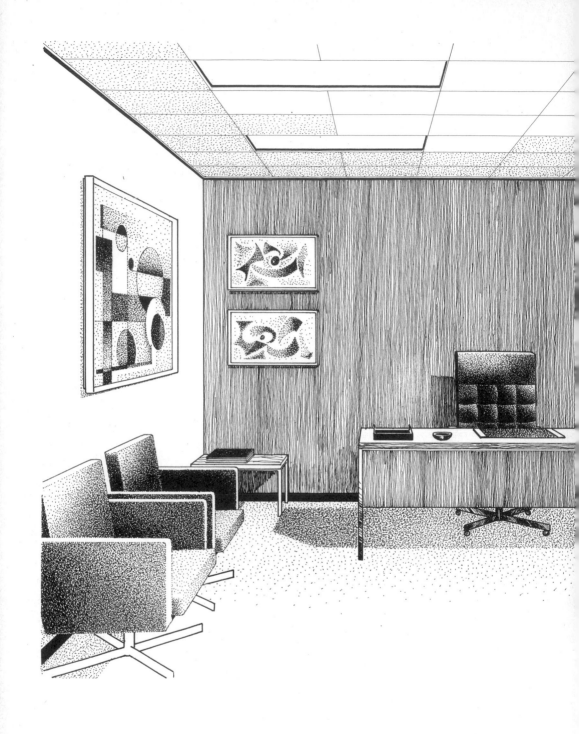

*Fig. 114 Executive office (i).*     A typical one-point perspective rendering combining ruled lines and dots with freehand lines for wood graining.

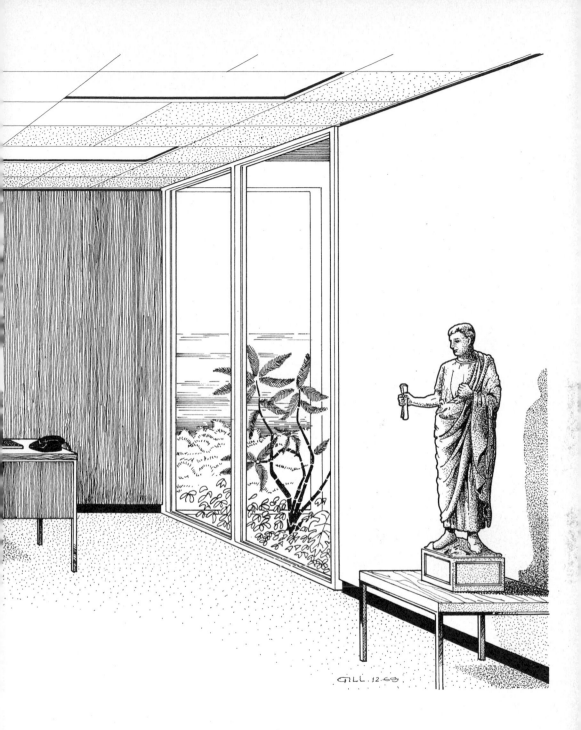

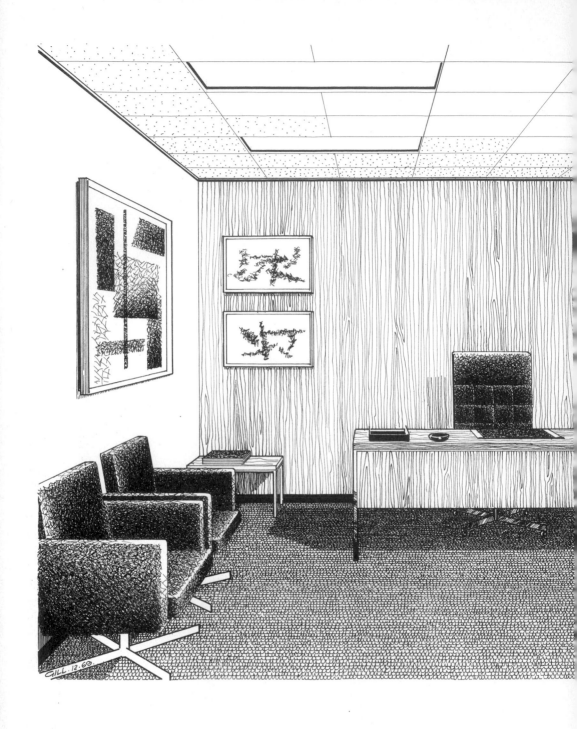

*Fig. 115 Executive office (ii).* The same office as the previous figure but with different treatments for the floor and chairs and a more open timber graining.

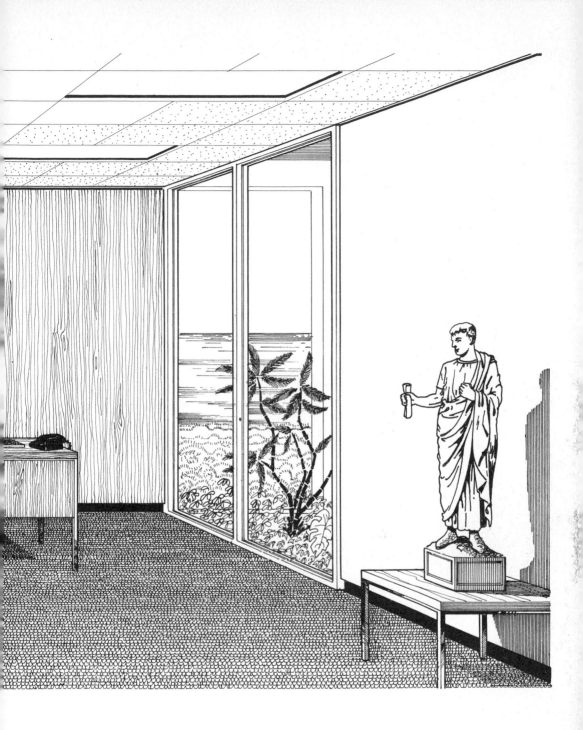

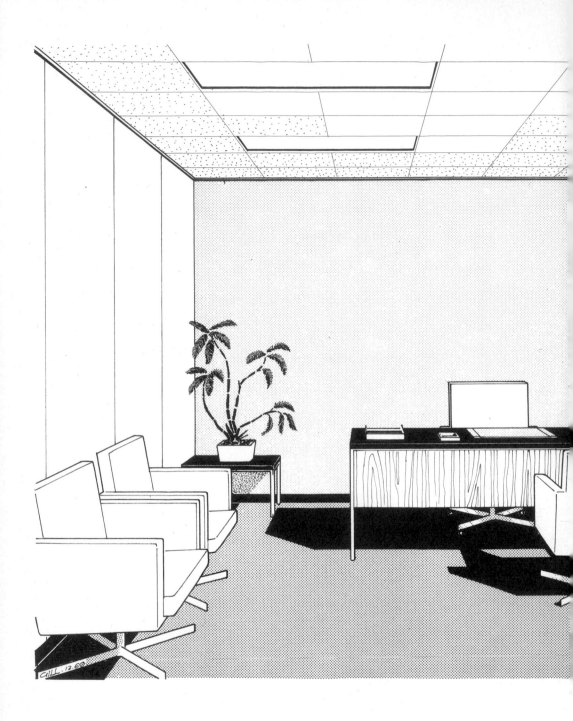

*Fig. 116 Executive office (iii).*

Again the techniques are different. The simple use of black shadows combined with Letratone mechanical tints for the floor and back wall give yet another effect which can be further varied by using other combinations of tints.

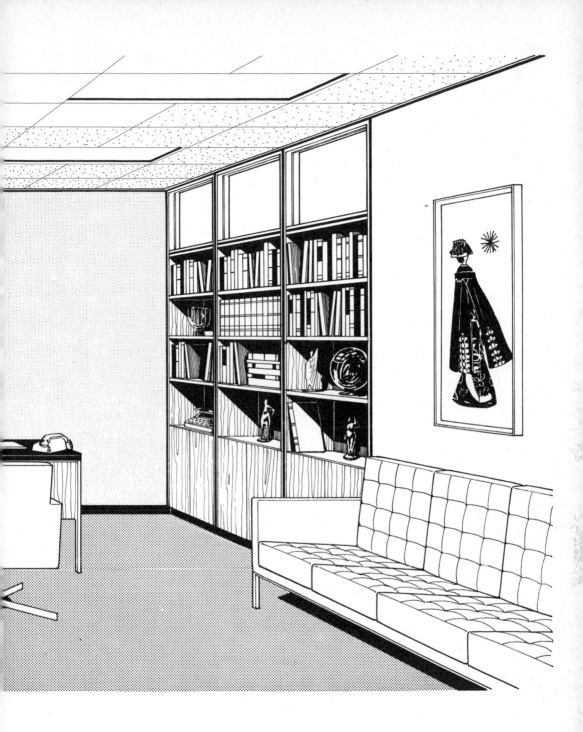

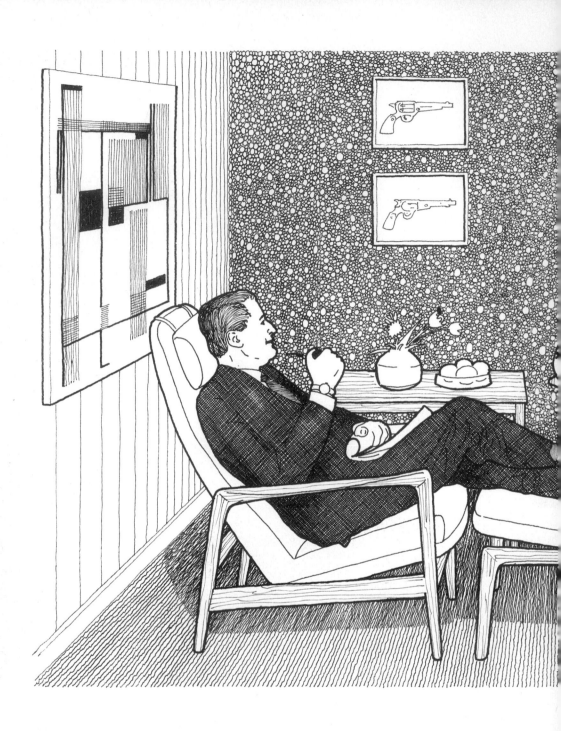

*Fig. 117 An example of freehand work in which all textures are hand–drawn.*

This type of drawing is perhaps more suitable to advertising than to interior design rendering. However, it can be effective and lends itself to the use of colour if required.

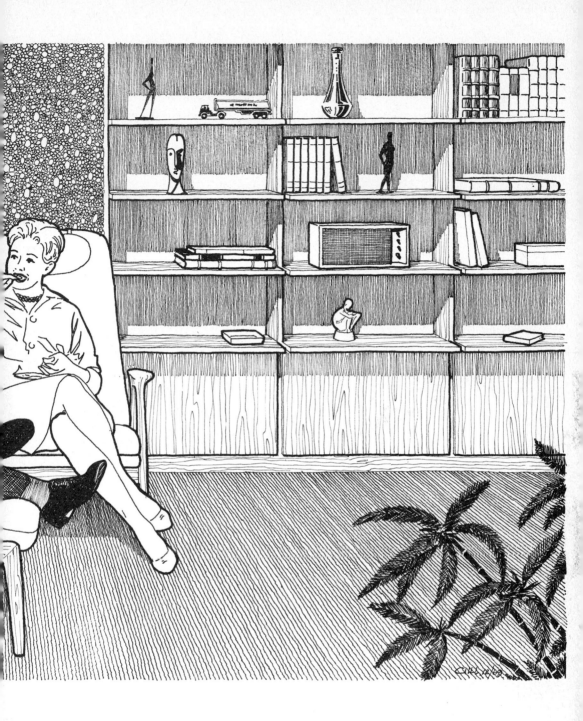

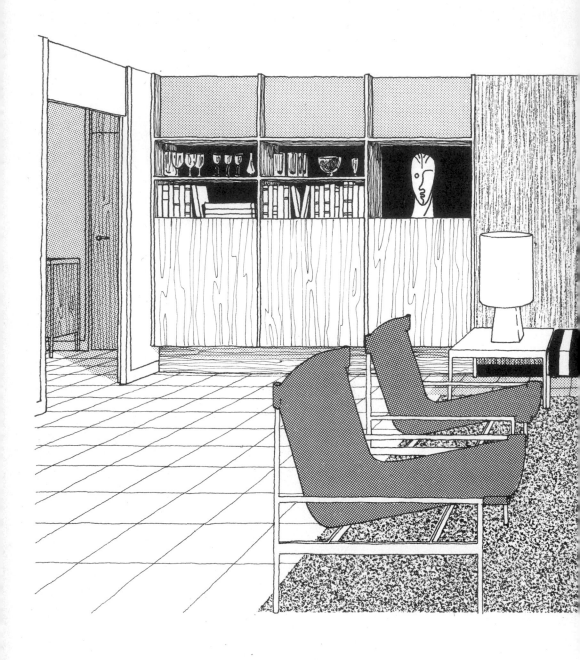

*Fig. 118 Freehand drawing with applied textures.*

Here the textures are applied with adhesive tints. These two examples of freehand drawings are done using Rotring 'Variant' drawing instruments of various sizes, over lightly ruled pencil set-ups.

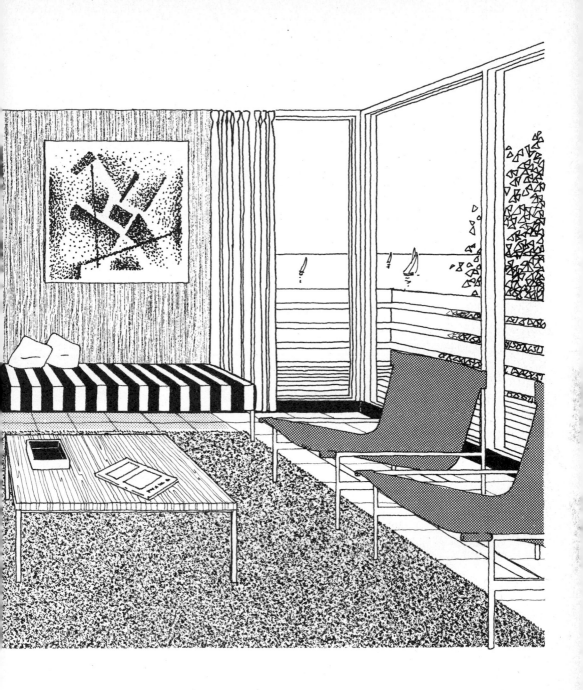

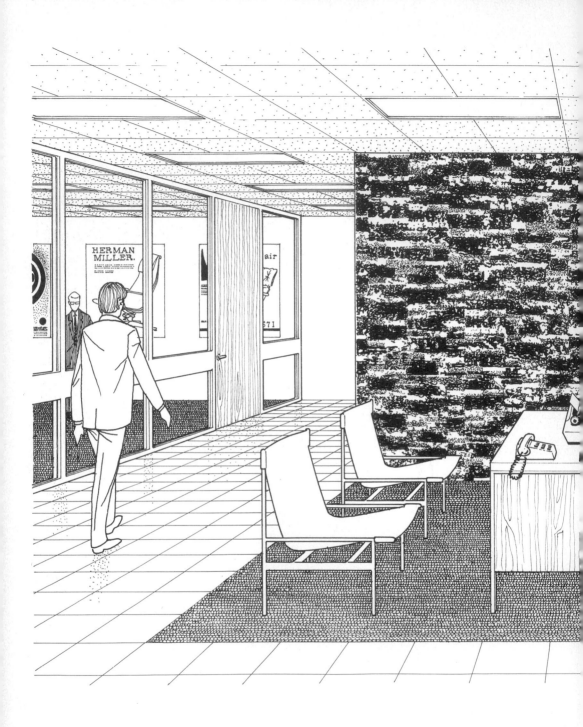

*Fig. 119 Office scene: reception area.*

This drawing shows a decorative treatment of the main wall area using freehand dots drawn with an 0.1-mm. and an 0.2-mm. Rotring 'Variant' drawing instrument. The rest of the drawing is kept fairly simple to accentuate the area on which the interest is to be focused.

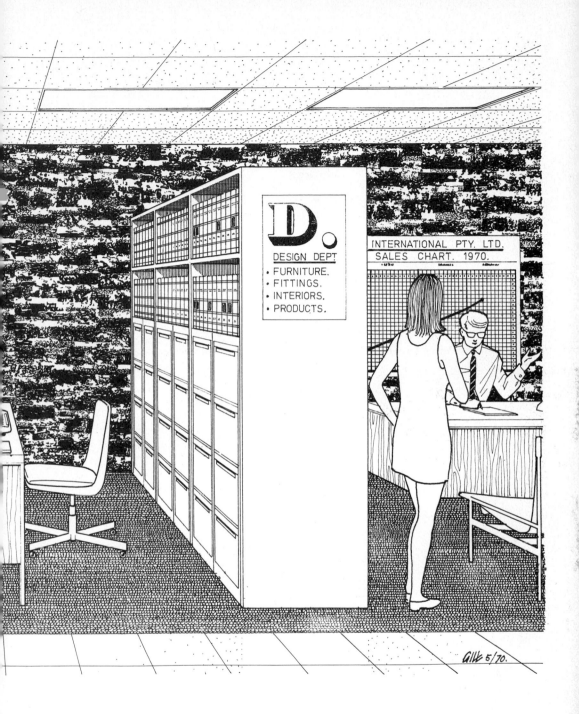

**D.**

DESIGN DEPT

• FURNITURE.
• FITTINGS.
• INTERIORS.
• PRODUCTS.

INTERNATIONAL PTY. LTD.
SALES CHART. 1970.

Gill 5/70.

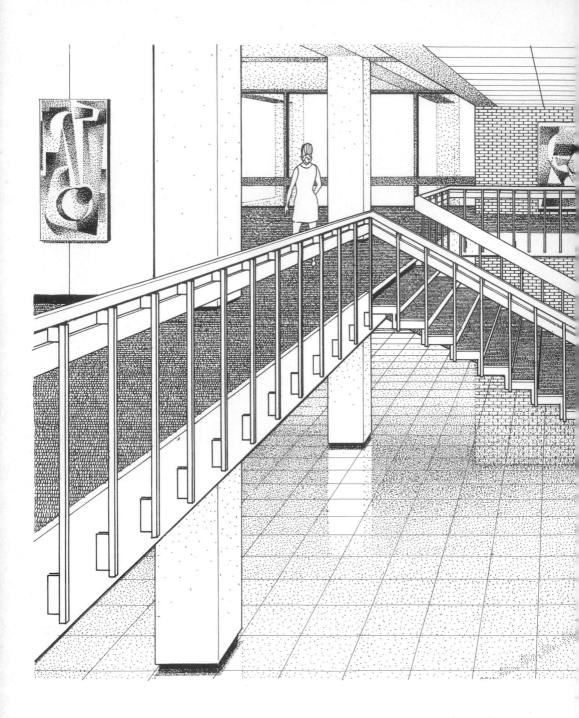

*Fig. 120  A more complex
interior rendering.*

This includes a staircase and two different floor levels. The
upper floor and the staircase are carpeted, the carpet being
drawn as described in fig. 78 (p. 173). The lower floor, of
vinyl tile, is drawn with ruled joints and freehand dots, which
are used to build up reflections and add to the interest of the
over-all drawing.

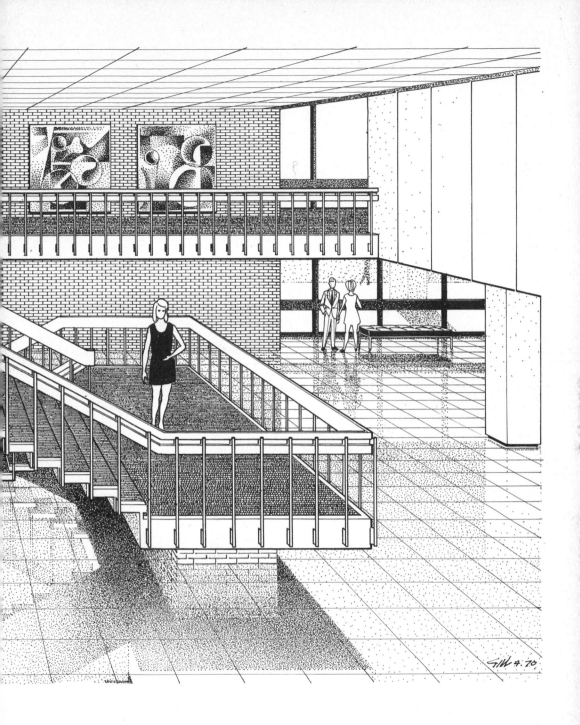

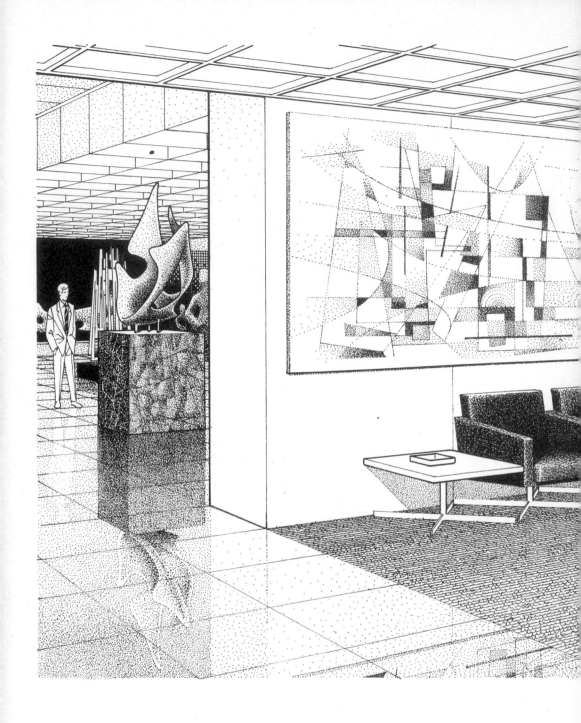

Fig. 121 An art gallery or
exhibition area.

A number of different finishes have been included, both
reflective and non-reflective, which add to the interest of the
over-all drawing.

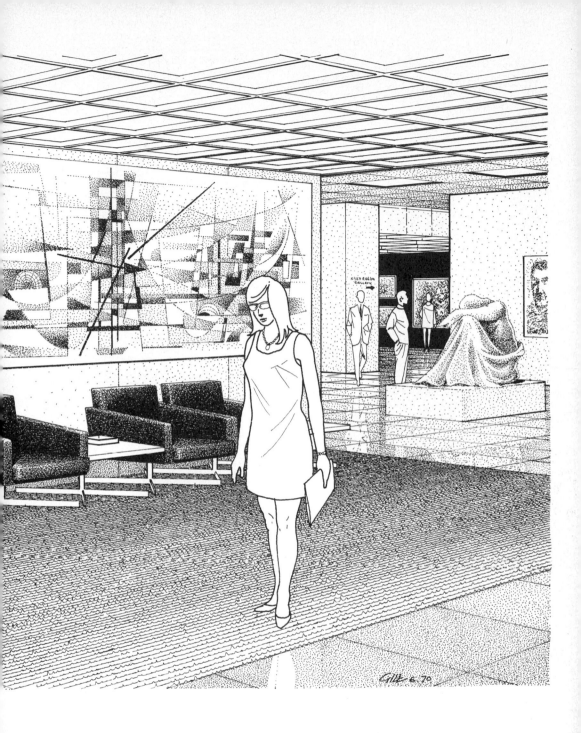

*Fig. 122 Townscape with overpass.*

This is an example of a perspective rendering a little away from the architectural and interior design subjects so far shown in this chapter. This type of drawing is often required by engineers and civic authorities when planning new freeways and bridges. The attention should not only be focused on the elevated roadway but one should also clearly show its relationship to its surroundings. Advantage can often be taken of the reflective qualities of the surface of the water in this type of drawing, which allows the underside detail of the bridge to be shown in an aerial view and in this way

gives more information than is normally expected in one drawing.

One of the most difficult problems faced in this type of work is the selection of the station point, as many considerations must be taken into account before a final decision can be made. This often involves a number of interested parties in addition to technical and aesthetic considerations. The draughtsman is advised to remain flexible during the discussions in order to achieve a result satisfactory to all.

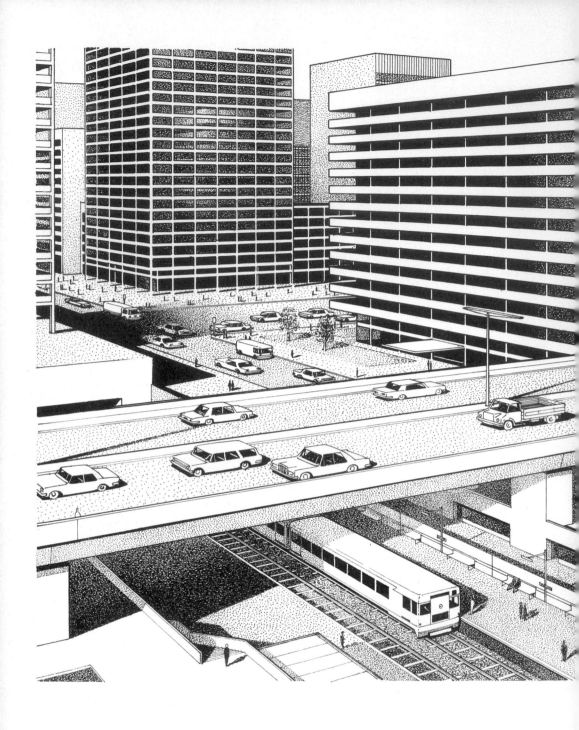

*Fig. 123 Townscape with overpass.*

A rendering similar to the last example, except that the shadows and textures are built up with freehand dots instead of the ruled lines and mechanical tints of fig. 122.

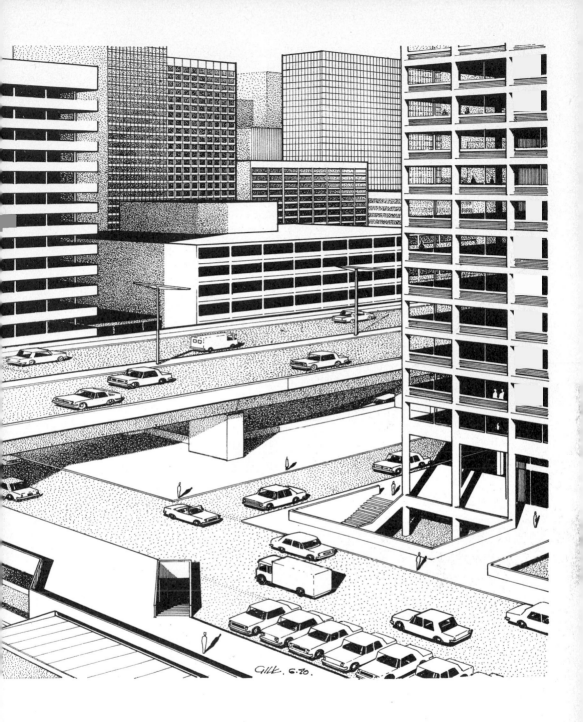

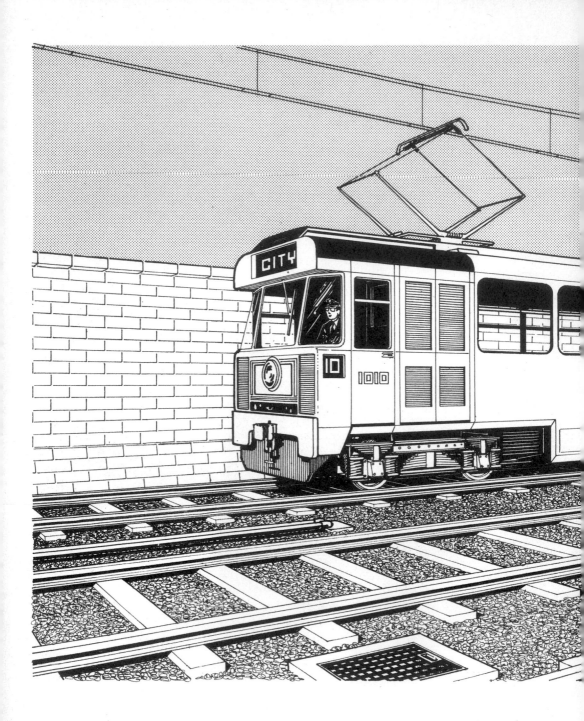

*Fig. 124 Electric passenger train of the inter–suburban type.*

This type of drawing shows hand-drawn textures and mechanical tones used together for special effects. In this case the road bed is drawn and the mechanical tone is used for the sky, the train being left untinted, which allows it to read clearly against the various tones around it.

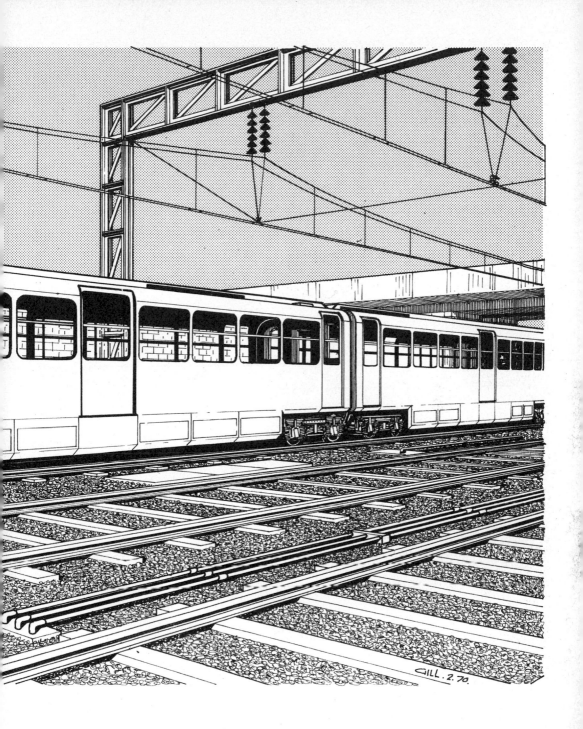

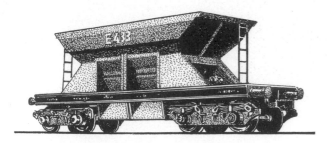
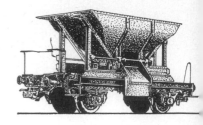

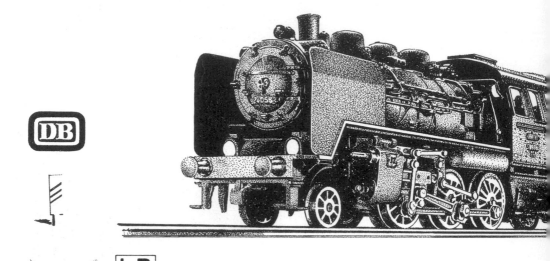

GERMAN FEDERAL RAILWAYS
AND ASSORTE

*Fig. 125 A group of railway subjects.*

Freehand dots have been used to build up tones. Railway locomotives of the older steam type make good practice subjects for the draughtsman as they have a great deal of detail and are generally black or some other dark colour, which means that in rendering they are exercises in controlling tone. Goods wagons are generally much easier to draw because of their simpler detail and lighter colour. It should, however, be noted that there are many types of railway goods wagons and a considerable variety of sizes in most railway systems. Information from the railway authorities is usually freely available to the draughtsman who has to include locomotives and goods or passenger cars in his drawing.

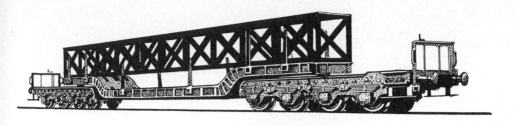

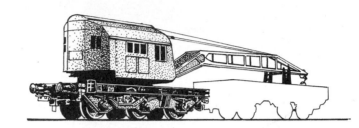

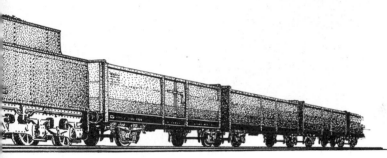

CLASS 24 – 2- 6- 0 LOCOMOTIVE

GOODS WAGONS

SIGNALS

GILL. 2.70.

*Fig. 126 A large jet plane being loaded.*

In this case the drawing has been made over a photograph, using freehand dots to build up the shape of the plane and to show shadows, reflections and highlights. The tarmac is an adhesive tone with the edges furthest away rubbed lightly with a razor-blade to eliminate the hard line. The tone was laid on the back of the tracing paper which meant that it was an easy matter to work on it without damaging the drawing.

# LOADING A BOEING 747 FREIGHTER (PAN AM)

5.69.

*Fig. 127 Rendering of machinery: Repco Model TC1A universal tool and cutter/grinder.*

This figure, too, was produced over a photograph, again using dots to build up detail and to show various types of finishes to metal parts. It was produced for an advertising brochure and, though it was done over a photograph, much more detail was built up from additional material supplied because in the photograph some details were in strong shadow. It is this clarity of detail which often makes a drawing more explicit than a photograph.

*Fig. 128 Diesel crawler: elevation and perspective drawing.*

This is another drawing produced over a photograph, using freehand dots to build up the detail. The technique of working over a photograph is common in technical illustrations of this type, which are usually produced for folders of technical information or other forms of advertising. The method is simple: over a clear photograph of the subject, to the size required, tracing paper is laid and the drawing is made on this using the chosen technique.

5'-0"

8'-2"

# INTERNATIONAL BTD-6 DIESEL CRAWLER

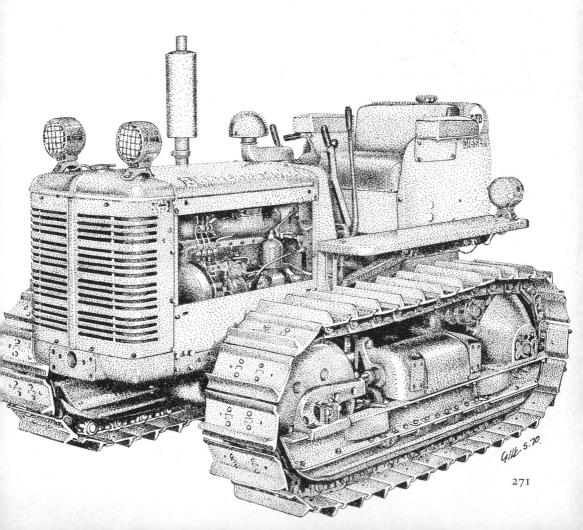

Gill. 5.70.

271

DETAIL FROM A BAS RELIEF
DEPICTING AN EPISODE
FROM THE HINDU EPIC,
THE RAMAYANA, WHICH WAS
CARVED OVER 1,000 YEARS
AGO IN A GALLERY OF THE
TEMPLE OF SHIVA, NEAR
DJAKARTA, INDONESIA

GILL. 7/6/68.

This is a slightly more complex drawing, showing the effect
of a thousand years of weathering on part of a bas-relief in
Indonesia, and demonstrates the possibility of reproducing
not only the form and modelling of the subject but also the
surface textures. This type of drawing should not be
attempted by the student until he has learned to control an
0.1-mm. Rotring 'Variant' drawing instrument and work at
considerable speed.

*Fig. 130  Rendering of stone
carving.*

Short freehand lines, moving in all directions, were used to
build up form and texture. As can be seen from the example,
a wide range of tones can be achieved by using this technique.

*Fig. 129  A piece of sculpture
(opposite).*

273

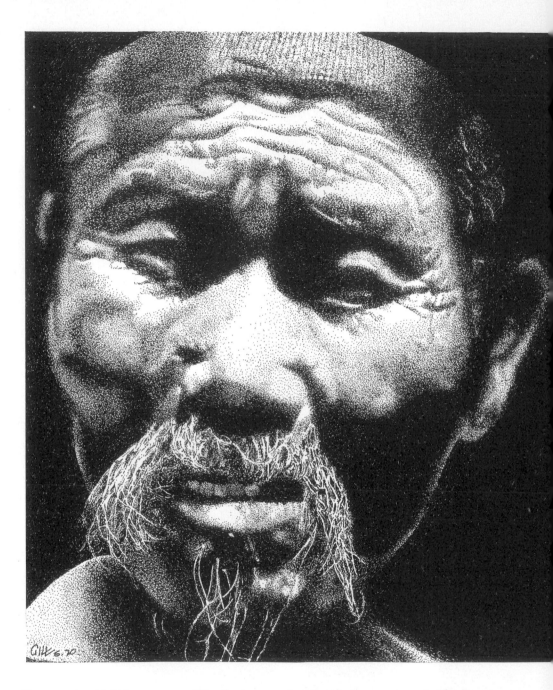

*Fig. 131 An old Chinese.*

The final example of technique was probably the most demanding in the whole chapter, if not the whole book.

Drawings of this type give considerable satisfaction when completed and do not differ a great deal in principle from other drawings in this chapter, as the draughtsman is still faced with the problem of light and shade, textures and reflections. Perhaps the greatest difference between this drawing and the earlier ones in this chapter is the greater

range of tones required and a greater control of these tones to obtain more subtle changes of surface direction than is usual in an architectural or interior rendering.

In conclusion, it should once again be pointed out that the drawings are intended to give the student of pen-and-ink rendering a helping hand in developing his own techniques and to act as a guide to the directions along which his experimentation can bring satisfactory results. However, there are no substitutes for observation and practice; a considerable amount of work must be done before competent results can be expected in this or any other method of rendering.

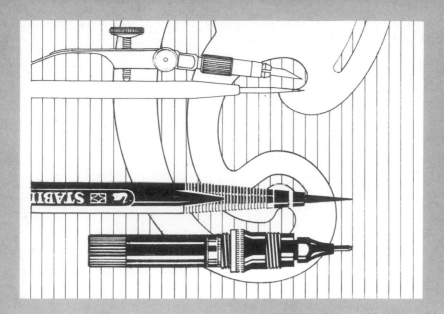

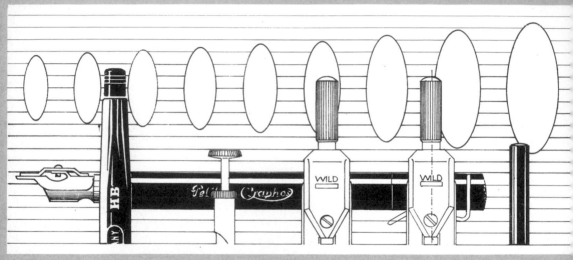

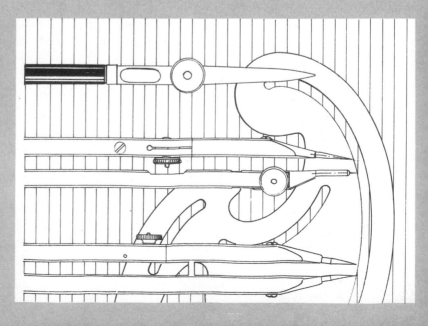

# 8 Equipment

The selection of equipment is a personal matter and the student should choose the equipment he or she finds most suitable to the hand, the job or the technique being used. The equipment shown in the following figures does not cover all the types and makes available on the market today, but has been limited to products from reliable manufacturers which the author has himself used. It should be pointed out that all the equipment shown is useful in some case or another, but it is not intended to give the impression that this is a list of requirements for pen-and-ink rendering.

In fig. 132 (overleaf) can be seen some of the essential equipment required, starting with an ebony-edged drawing board, for preference not less than 41 in. × 28 in.; a 42-in. Perspex-edged T-square, a 12-in. adjustable square-edged set square and a 12-in. or 18-in. scale rule. There are a number of reliable makes of these pieces of equipment on the market; one which has been found to retain a consistently high standard for T-squares, set squares and scale rules is 'Linex' from Denmark. Also shown are two large acrylic set squares, which make for ease of work on large projects where a 12-in. set square is too short. Usually only one of these is required and a 24-in. 60°/30° set square covers most needs. Another acrylic product which often makes for easier working is a 30-in. straight edge.

Essential for the draughtsman working in ink is an erasing shield which enables alterations to be made in confined spaces without damaging adjacent work. For general clean-up of drawings the Vinyl Artgum eraser is excellent, but for corrections to ink work a good ink eraser is necessary. The Laufer range from Germany cover most requirements of the draughtsman at reasonable cost, and have been found to be of excellent quality. A double-edged razor-blade is also a useful tool for erasing on tracing papers. It is scraped over the area to be erased, particularly when heavy work is to be altered. It is, however, necessary to rub over the scraped area with an ink eraser to flatten the surface of the paper before replacing work, and in some cases it is wise to 'bone' the area to obtain a satisfactory surface – that is to say to rub over the area with something like a scale rule or the end of a pen cap – in order to smooth a roughened surface.

The subject of pencils is always a difficult one to discuss as there are a large number of good makes on the market, each

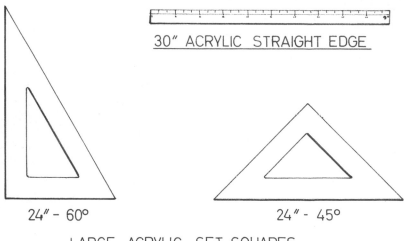

30" ACRYLIC STRAIGHT EDGE

24" - 60°         24" - 45°

LARGE ACRYLIC SET SQUARES

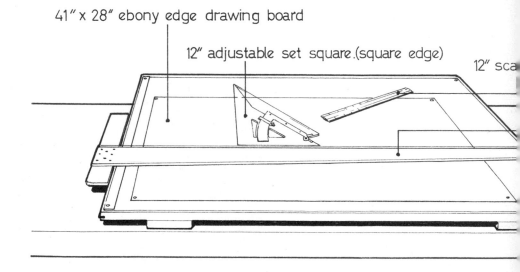

41" x 28" ebony edge drawing board

12" adjustable set square.(square edge)

12" sca

*Fig. 132 Basic equipment.*

in a number of types. The pencil shown is a Stabilo 8-9 'Repeater', which is described in detail in fig. 141 (p. 302). The Fedra 4900 lead-sharpener, which clamps on to the board, will put a clean draughting point on a clutch pencil every time with a minimum amount of effort and mess, and because of this it is thoroughly recommended to all users of clutch pencils. The ever popular 'Stanley' all-purpose knife has also proven over the years to be the draughtsman's friend

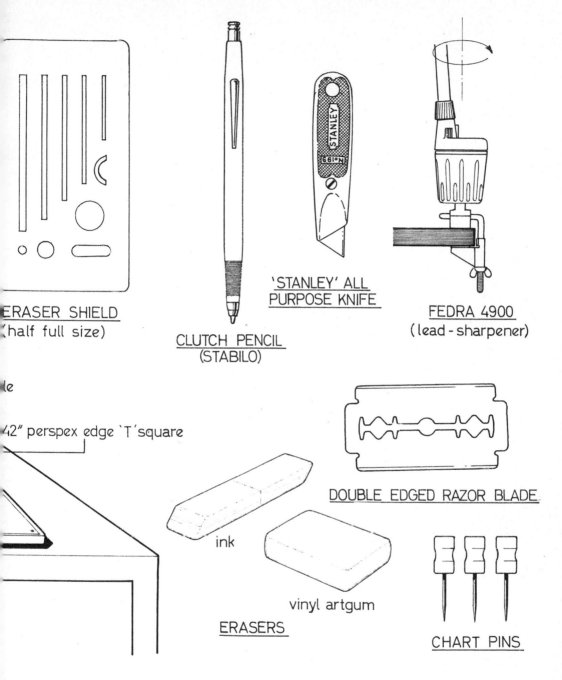

ERASER SHIELD
(half full size)

CLUTCH PENCIL
(STABILO)

'STANLEY' ALL
PURPOSE KNIFE

FEDRA 4900
(lead-sharpener)

42" perspex edge 'T' square

DOUBLE EDGED RAZOR BLADE

ink

vinyl artgum

ERASERS

CHART PINS

and in everything from pencil sharpening to paper and card cutting it has few equals. Last, but very useful, are a few chart pins of sturdy manufacture and, for preference, in bright colours. These pins are used to locate vanishing points when drawing perspectives, and save a great deal of time when drawing lines which converge to those vanishing points. They are also useful for station points, and in fact any point to which lines converge.

DRAWING PEN

DROP COMPASS

MEDIUM
DRAWING PEN

EXTENSION BAR

SWEDISH
DRAWING PEN

LARGE COMPASS
INTERCHANGEABLE
ATTACHMENT TYPE

WILD   RZ 3

## MAHO  PC 39.  PROPORTIONAL  DIVIDERS

( DIVIDERS SHOWN HALF FULL SIZE )

( BEAM  100 c

## MAHO   No. 36/100.  ALUMINIUM

(COMPASS  SHOWN  HALF  FULL SIZE )

*Fig. 133  A set of precision drawing instruments.*

These will cover most requirements the draughtsman is likely to meet under normal circumstances. The set shown is manufactured in Switzerland by Wild Heerbrugg Ltd: a similar set has been in constant use by the author over the last ten years. Other makers of precision instruments of very high standard are Kern, also from Switzerland, and Maho and Riefler from Germany.

Figure 133 also shows a pair of proportional dividers from Maho (PC39) which are solidly made and beautifully finished. This instrument is very useful when it is necessary,

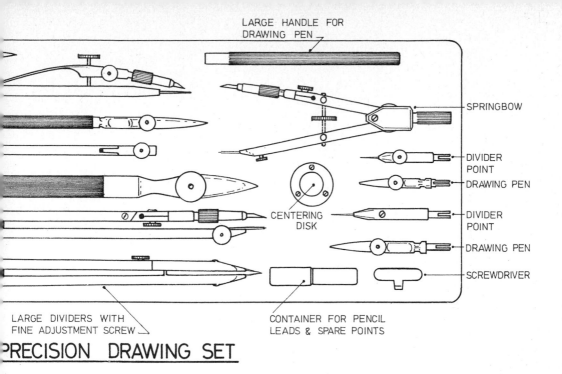

LARGE HANDLE FOR
DRAWING PEN

SPRINGBOW

DIVIDER POINT

DRAWING PEN

DIVIDER POINT

DRAWING PEN

SCREWDRIVER

CENTERING
DISK

LARGE DIVIDERS WITH
FINE ADJUSTMENT SCREW

CONTAINER FOR PENCIL
LEADS & SPARE POINTS

## PRECISION DRAWING SET

## BEAM COMPASS

as often occurs in perspective drawing, to decrease or increase a scale. The pivot is adjustable and one arm is engraved with numbers against which the pivot may be set to give any ratio from 2 to 10. Other ratios may be found by trial and error.

Another useful piece of equipment from Maho is the No. 36/100 aluminium beam compass, supplied complete with 100-cm. beam and sliding attachments with locking screws and fine-adjustment wheels, centring, pencil and pen fittings – another solidly constructed and well-finished instrument.

HOLDER USED
BOTH ENDS

POCKET CLIP

ROTRING `VARIANT'          RAPIDOGRAPH

| VARIANT RAPIDOGRAPH FOLIOGRAPH MICRONORM | VARIANT LINE THICKNESSES | RAPIDOGRAPH LINE THICKNESSES | VARIOSCRIPT LINE THICKNESSES |
|---|---|---|---|
| | 0.1  mm. | 0.1  mm. | 0.1  mm. |
| | 0.15 mm. | 0.15 mm. | 0.2  mm. |
| | 0.2  mm. | 0.2  mm. | 0.3  mm. |
| | 0.3  mm. | 0.3  mm. | 0.4  mm. |
| | 0.4  mm. | 0.4  mm. | 0.5  mm. |
| | 0.5  mm. | 0.5  mm. | 0.6  mm. |
| | 0.6  mm. | 0.6  mm. | 0.7  mm. |
| | 0.8  mm. | 0.8  mm. | 0.8  mm. |
| STEPPED POINT OF TUBE TO PREVENT UNDERRUNNING OF INK WHEN RULING | 1.0  mm. | 1.0  mm. | 1.0  mm. |
| | 1.2  mm. | 1.2  mm. | 1.2  mm. |
| | | | 1.4  mm. |

*Fig. 134 Rotring Indian ink drawing instruments.*

The introduction of this range from West Germany in the late 1950s has opened up to the draughtsman many possibilities in the field of technique and has generally speeded up work previously consuming much time. The illustrations show five different types of drawing instruments, and the table below the illustrations shows the sizes available in each type. The 'Variant' and the 'Rapidograph' both use the same drawing head. The 'Variant' consists of a series of interchangeable drawing elements complete with ink reservoir. The 'Rapidograph' has a pocket clip and is filled like a piston-filling fountain pen. Both instruments are suitable for draw-

JOINTED PART

SAPPHIRE POINT

VARIOSCRIPT          FOLIOGRAPH     MICRONORM. m̅.

| | VARIOSCRIPT<br>FOR USE WITH LETTERING GUIDES | FOLIOGRAPH<br>LINE THICKNESSES | MICRONORM<br>LINE THICKNESSES |
|---|---|---|---|
| .6 mm.<br>.0 mm. | | 0.15 mm.<br>0.2 mm.<br>0.3 mm.<br>0.4 mm.<br>0.5 mm.<br>0.6 mm.<br>0.8 mm.<br>1.2 mm. | 0.13 mm.<br>0.18 mm.<br>0.25 mm.<br>0.35 mm.<br>0.5 mm.<br>0.7 mm.<br>1.0 mm.<br>1.4 mm.<br>2.0 mm. |

FLAT GROUND TUBE POINT

ing according to the internationally accepted West German standard DIN (Deutsche Industrie-Norm) 15, series 2. The 'Varioscript' is designed for stencil lettering (DIN16, 17, series 2, DIN1451). Unlike the other drawing instruments, the 'Varioscript' has a flat-ground tube point which is not suitable nor designed for ruling. A hinged joint is available to allow an unimpeded view of the drawing point and adjustment to any position of the hand. The following table shows the relationship between the pen size and the appropriate lettering stencil:

| Order no. | Colour code | Height of characters (mm.) | |
|---|---|---|---|
| 1201 | red | 1.4, | 1.6 |
| 1202 | white | 2.0, | 2.5 |
| 1203 | yellow | 3.0, | 3.5 |
| 1204 | grey | 4 | |
| 1205 | brown | 5 | |
| 1206 | beige | 6 | |
| 1207 | blue | 7 | |
| 1208 | green | 8 | |
| 1210 | orange | 10 | |
| 1212 | caramel | 12 | |
| 1214 | old pink | 14 | |
| 1216 | light green | 16 | |
| 1220 | light grey | 20 | |

Lettering stencils according to DIN1451, series 2, suitable for 'Varioscript' are made of yellow low-reflection and low-shadow material. The lettering stencils are available in the following types and sizes:

| Order no. | | Height of characters (mm.) |
|---|---|---|
| Upright | Oblique | |
| 5700 | 5800 | 1.4 |
| 5701 | 5801 | 1.6 |
| 5702 | 5802 | 2 |
| 5725 | 5825 | 2.5 |
| 5703 | 5803 | 3 |
| 5735 | 5835 | 3.5 |
| 5704 | 5804 | 4 |
| 5705 | 5805 | 5 |
| 5706 | 5806 | 6 |
| 5707 | 5807 | 7 |
| 5708 | 5808 | 8 |
| 5710 | 5810 | 10 |
| 5712 | 5812 | 12 |
| 5714 | 5814 | 14 |
| 5716 | 5816 | 16 |
| 5720 | 5820 | 20 |

See fig. 142 (p. 305) for more detailed information on lettering stencils, including the new 'Micronorm' range.

The 'Foliograph' Indian ink drawing instrument is specially designed for drawing on plastic films with film-dissolving (etching) drawing ink. The great abrasiveness of the polyester film (approximately six hundred times higher than that of tracing paper) has been overcome by the unusually hard sapphire drawing point which is considerably more expensive than other instruments, but has an almost unlimited life. All parts coming into contact with the film-surface dissolving ink are made of acetate-proof material. It should be noted that the 'Foliograph' can be filled with either the film-surface dissolving special Indian ink or with water-soluble Indian ink. The 'Foliograph' can be used equally well

on plastic drawing film, tracing paper or heavy drawing paper. Except for the grey colour of the components, it is similar in appearance to the 'Variant'. Line thicknesses are in accordance with German Industrial Standard DIN15, series 2.

The 'Micronorm' Indian ink drawing instrument is a comparatively new range complying with the new German Industrial Standards DIN15, 16 and 17 – preferred series 1. The Indian ink drawing instrument marked with an $\overline{m}$ offers decisive advantages for all kinds of technical draughting, including the special draughting technique required for microfilming.

The gradation of the standardized drawing sizes is met by the new arrangement of a series of line thicknesses and lettering heights with a step increment of $1 : \sqrt{2}$. To every instrument in the range (except 0.13 mm.) is apportioned a suitable stencil for medium-thick lettering (thickness of line $\frac{1}{10} \times$ height) and thin lettering (thickness of line $\frac{1}{14} \times$ height). The 'Micronorm' range is coloured a dark wine-red and is colour-coded for instant recognition, as are the 'Variant', 'Rapidograph' and 'Varioscript'. The colour code ring is repeated on each lettering stencil to eliminate all possibility of error.

The following table shows the relationship between the pen size and the appropriate lettering stencils according to DIN15, 16 and 17, preferred series 1:

| Line thickness (mm.) | Colour code | Medium-thick lettering $\frac{1}{10}h$ Upright | Oblique |
|---|---|---|---|
| 0.13 | violet | – | – |
| 0.18 | red | 5418 – 1.8 mm. | 5518 – 1.8 mm. |
| 0.25 | white | 5425 – 2.5 mm. | 5525 – 2.5 mm. |
| 0.35 | yellow | 5435 – 3.5 mm. | 5535 – 3.5 mm. |
| 0.5 | brown | 5405 – 5.0 mm. | 5505 – 5.0 mm. |
| 0·7 | blue | 5407 – 7.0 mm. | 5507 – 7.0 mm. |
| 1.0 | orange | 5410 – 10.0 mm. | 5510 – 10.0 mm. |
| 1.4 | green | 5414 – 14.0 mm. | 5514 – 14.0 mm. |
| 2.0 | light grey | 5420 – 20.0 mm. | 5520 – 20.0 mm. |

| Line thickness (mm.) | Colour code | Thin lettering $\frac{1}{14}h$ Upright | Oblique |
|---|---|---|---|
| 0.13 | violet | – | – |
| 0.18 | red | 5475 – 2.5 mm. | 5575 – 2.5 mm. |
| 0.25 | white | 5485 – 3.5 mm. | 5585 – 3.5 mm. |
| 0.35 | yellow | 5455 – 5.0 mm. | 5555 – 5.0 mm. |
| 0.5 | brown | 5457 – 7.0 mm. | 5557 – 7.0 mm. |
| 0.7 | blue | 5460 – 10.0 mm. | 5560 – 10.0 mm. |
| 1.0 | orange | 5464 – 14.0 mm. | 5564 – 14.0 mm. |
| 1.4 | green | 5470 – 20.0 mm. | 5570 – 20.0 mm. |
| 2.0 | light grey | – | – |

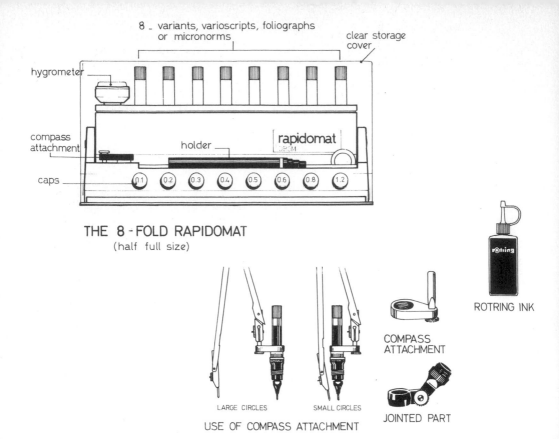

8 _ variants, varioscripts, foliographs or micronorms

clear storage cover

hygrometer

compass attachment

holder

rapidomat

caps

0.1 0.2 0.3 0.4 0.5 0.6 0.8 1.2

**THE 8 - FOLD RAPIDOMAT**
(half full size)

ROTRING INK

COMPASS ATTACHMENT

LARGE CIRCLES    SMALL CIRCLES

USE OF COMPASS ATTACHMENT

JOINTED PART

*Fig. 135  Accessories and component parts.*

There are a number of useful accessories available for use with the various types of drawing instruments, including compass attachments for 'Rapidograph', 'Variant', 'Varioscript', 'Foliograph' and 'Micronorm' with various peg diameters to suit most precision drawing instruments. Also available is a joint centre for Riefler series A round system, a jointed compass attachment for Riefler Sinus compass, a pump compass attachment and a joint for the holder.

Each drawing instrument is packed with a cone key, a sheet of blotting-paper for cleaning and a sheet of instructions on filling, cleaning and ink. Replacement cones are available for all types of instruments, allowing for considerable saving when replacement is necessary because of damage or breakage. A number of the accessories available are shown in fig. 135, among them the 'Rapidomat', which is a worthwhile investment for the draughtsman using 'Variant', 'Varioscript', 'Foliograph' or 'Micronorm'. The 'Rapidomat' solves an old problem: the drying up of drawing ink. The principle is simple and reliable: the ink is prevented by humidity from drying up. The two sizes of 'Rapidomat', eight-fold and four-fold, can each be supplied with or without a hygrometer. This shows accurately the humidity content of the utensil, and thus indicates when it needs refilling with water. The 'Rapidomat' can be used as a table utensil, as shown, or it can be fixed to the drawing board by

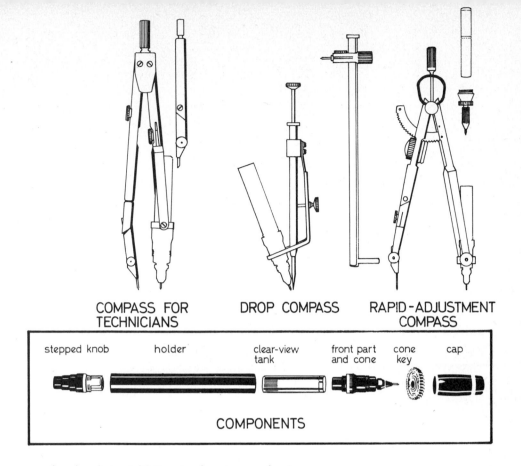

COMPASS FOR TECHNICIANS          DROP COMPASS          RAPID-ADJUSTMENT COMPASS

| stepped knob | holder | clear-view tank | front part and cone | cone key | cap |
|---|---|---|---|---|---|

COMPONENTS

means of a bracket. Additional advantages of using a 'Rapidomat' are that drawing instruments can be kept in order of line thickness, which is clearly seen; the instruments are ready for instant use, as it is not necessary to waste time removing caps; and, as a bonus, the ink level in each instrument is clearly visible. The eight-fold 'Rapidomat' table design is fitted with a drawer at either end of the base for Indian ink and accessories. Generally, this piece of equipment is a necessity for the busy draughtsman using any of the Rotring range of drawing instruments and will repay, in time saved, many times the original cost of obtaining it.

Figure 135 also shows three compasses developed specially for Rotring Indian ink drawing instruments. For use, screw in the required Indian ink drawing instrument ('Variant', 'Foliograph' or 'Micronorm') to the compass, which is then ready for use. It is possible to screw on the cap without removing the instrument from the compass, during delays in work. The technician's compass, which has a built-in telescopic arm, is suitable for drawing circles up to 500 mm. diameter and is supplied with a lead insert for design work. The drop compass has its centre of gravity lying on the middle axis and is capable of drawing a circle as small as 0.7 mm. external diameter. As with the technician's compass, the drawing instrument can be screwed directly into the compass and the cap can be screwed on without removing

the instrument. The rapid-adjustment compass has all the advantages of the previous compasses as well as a rather ingenious, rapid and fine adjustment by means of a screw, which provides a secure lock for the compass when in use. The compass is supplied complete with an extension bar, a lead insert and a pen box. This compass is capable of drawing circles up to 520 mm. diameter.

Finally it should be pointed out that, besides the well-known plastic bottles of Rotring Indian ink, drawing-ink cartridges are available for all Rotring Indian ink drawing instruments of the interchangeable system. (With 'Folio-graph', cartridges can be used when drawing with water-soluble Indian ink.)

*Fig. 136 The Pelikan 'Graphos' fountain pen (opposite).*

This pen is specially designed for use with normal black drawing ink and Scribtol calligraphy drawing ink, and is simple in operation. The fountain pen is filled with drawing ink which then flows freely and evenly from the nib. The nibs are easily interchangeable and are available in a variety of widths and types for most purposes (the table in fig. 136 shows the complete range and uses). The upper blade of each nib can be rotated sideways, which makes it easier to keep the nib clean. Of special importance is the width of the ruling nibs, which ensures absolute precision and trouble-free working, while the thickness of the line remains uniform throughout. Similarly, the narrow width of the round nibs makes it possible to write round-end lines with a uniformity unattainable with any other nib.

By means of the 'Graphos' compass clip, the complete pen can be used in compasses. To prepare the 'Graphos' for use, unscrew the cap and screw it on to the other end for balance. Remove the feed, fill the barrel, insert the feed, attach the nib, and the 'Graphos' is ready for work. After use remove the nib, screw the cap on tightly so that the ink will not dry out, and clean the nib thoroughly. The ink feeds are available in three kinds:

No. 1 – flowing sparingly
No. 2 – medium flow
No. 3 – freely flowing

Trial and error is the best way to decide which of the feeds will suit the draughtsman and the job he is engaged on.

Besides the compass clip shown in the figure, there are a number of useful accessories for use with the 'Graphos' pen. A small sponge box with viscose sponge for moistening tips of nibs is available, and also a stand (Stand 4 G) which keeps the nib moist when the busy draughtsman is interrupted for a short while. In general, the 'Graphos' is an excellent piece of equipment and, particularly when used with Type A ruling nibs, has few equals in quality of line produced, apart from the older type of ruling pen.

| NIB | TYPE | KIND | WIDTH AVAILABLE (in mm.) |
|---|---|---|---|
| | A | RULING NIBS for FINE LINES | 0.1 , 0.12 , 0.16 , 0.2 , 0.25 , 0.3 , 0.4 , 0.5 , 0.6. |
| | T | RULING NIBS for BROAD LINES | 0.8 , 1.0 , 1.25 , 1.6 , 2.5 , 4.0 , 6.4 , 10.0. |
| | S | DRAWING NIBS FOR FREEHAND DRAWING AND SKETCHING | B. = soft. HB. = medium hard. H. = hard. K. = extra hard. |
| | R | TUBULAR NIBS FOR USE WITH LETTERING GUIDES | 0.3 , 0.4 , 0.5 , 0.6 , 0.7 , 0.8 , 1.0 , 1.25 , 1.5 , 1.75 , 2.0 , 2.5 , 3.0. |
| | O | ROUND NIBS FOR FREEHAND LETTERING AND SKETCHING | 0.2 , 0.3 , 0.4 , 0.5 , 0.6 , 0.7 , 0.8 , 1.0 , 1.25 , 1.6 , 2.0 , 2.5 , 3.2 , 5.0. |
| | N | RIGHT HAND SLANT NIBS for OBLIQUE LINES | 0.8 , 1.25 , 2.0 , 2.5 , 3.2 , 4.0 , 5.0. |
| | Z | LEFT HAND SLANT NIBS for OBLIQUE LINES | 0.8 , 1.25 , 2.0 , 3.2 , 5.0. |

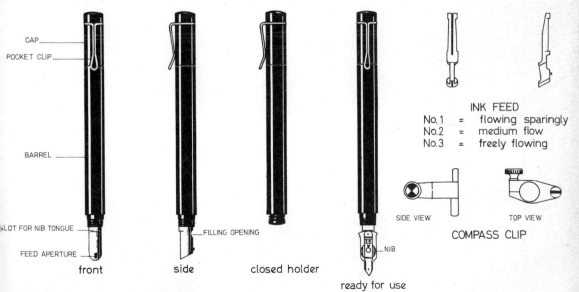

CAP
POCKET CLIP
BARREL
SLOT FOR NIB TONGUE
FEED APERTURE
front

side

FILLING OPENING
closed holder

NIB
ready for use

INK FEED
No.1 = flowing sparingly
No.2 = medium flow
No.3 = freely flowing

SIDE VIEW          TOP VIEW

COMPASS CLIP

THE 'PELIKAN' GRAPHOS FOUNTAIN PEN

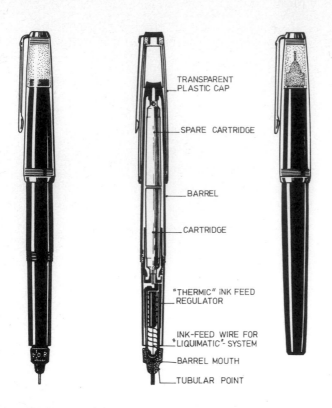

TRANSPARENT
PLASTIC CAP

SPARE CARTRIDGE

BARREL

CARTRIDGE

"THERMIC" INK FEED
REGULATOR

INK-FEED WIRE FOR
"LIQUIMATIC"- SYSTEM

BARREL MOUTH

TUBULAR POINT

COMPASS CLIP

# THE PELIKAN TECHNOS DRAWING INK FOUNTAIN PEN

| B-POINTS<br>RULING | D-POINTS<br>LETTERING GUIDES | $\overline{m}$-POINTS<br>MICROFILM | C-POINTS<br>FREEHAND |
|---|---|---|---|
| 0.1  mm. | 0.3  mm. | 0.13 mm. | 0.3  mm. |
| 0.2  mm. | 0.4  mm. | 0.18 mm. | 0.4  mm. |
| 0.3  mm. | 0.5  mm. | 0.25 mm. | 0.5  mm. |
| 0.4  mm. | 0.6  mm. | ————— | 0.6  mm. |
| 0.5  mm. | 0.7  mm. | 0.18 mm. | |
| 0.6  mm. | 0.8  mm. | 0.25 mm. | |
| 0.8  mm. | 1.0  mm. | 0.35 mm. | |
| 1.0  mm. | 1.2  mm. | 0.5  mm. | |
| 1.2  mm. | 1.4  mm. | 0.7  mm. | |
| 1.4  mm. | 1.7  mm. | 1.0  mm. | |
| 1.7  mm. | 2.0  mm. | 1.4  mm. | |
| 2.0  mm. | 2.5  mm. | 2.0  mm. | |
| 2.5  mm. | | | |
| DARK BLUE | DARK GREEN | MULTICOLOUR | LIGHT GREY |

INK CARTRIDGE    EXCHANGING POINTS    INTERCHANGEABLE POINTS FOR TECHNOS    CLEANER    SEALING CAP    BELLOWS

Another Pelikan product, the 'Technos' works on a different system from other drawing instruments of this type, and has what is known as a 'liquimatic' system. The spring-loaded ink-feed wire keeps the nozzle of the point clear at all times, retracting instantly into the barrel. 'Technos' can never scratch the surface, whether ruling or lettering. The thermic ink-feed regulator ensures uniform ink flow to the point. This enables the draughtsman to work at top speed with sharp, continuous, unbroken lines. Bladed points of 0.1, 0.16 and 0.2 mm. width (4, 6 and 8 thousandths of an inch) ensure the finest hairlines of exact width, rivalling the 'Graphos' in quality of line produced.

The interchangeable points are quickly and easily exchanged without staining the fingers. The cleaning and unblocking accessories (above) are excellent, and most effective in use.

Refilling the pen with a new cartridge is simple, speedy and clean; a spare cartridge is always kept in the barrel of the pen, and without it the pen cannot function. The pen is fitted with an airtight cap, and an additional sealing liner in the cap prevents ink drying inside the nozzle. The transparent cap gives instant identification of the code marking of the point fitted to the pen. Also available is a protective cap to use during interruptions when the pen is fitted to a compass with the 'Technos' compass clip. A comprehensive range of points (nibs) is available (see the table opposite), including a range of $\overline{m}$ points for microfilm techniques in keeping with German Industrial Standards.

Development of this range makes it possible to draw and letter with a single point, saving both time and money. Technical drawings stored on microfilm, when re-enlarged to original size, can now be corrected and up-dated without difficulty. The range includes three-bladed points (B-points) for associated ruling work, and, as will be seen from the table, these overlap the range of tubular points.

*Fig. 137  The 'Technos' drawing ink fountain pen.*

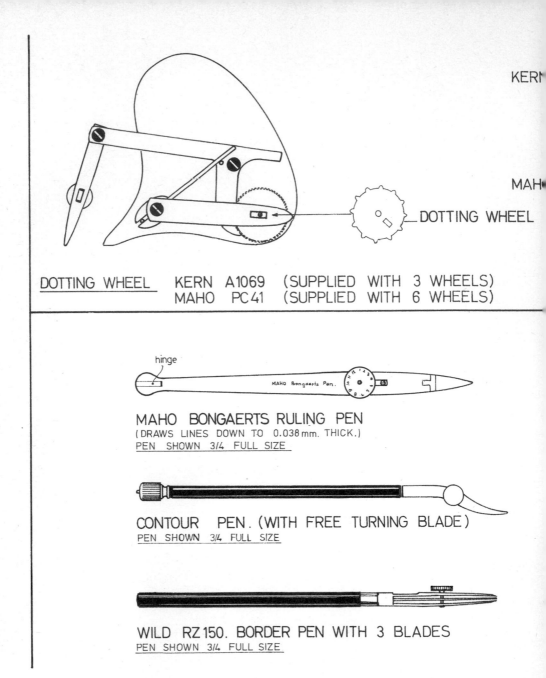

DOTTING WHEEL

DOTTING WHEEL    KERN  A1069   (SUPPLIED  WITH  3  WHEELS)
                 MAHO  PC41    (SUPPLIED  WITH  6  WHEELS)

hinge

MAHO  BONGAERTS  RULING  PEN
(DRAWS  LINES  DOWN  TO  0.038 mm. THICK.)
PEN  SHOWN  3/4  FULL  SIZE

CONTOUR   PEN. (WITH  FREE  TURNING  BLADE )
PEN  SHOWN  3/4  FULL  SIZE

WILD  RZ 150.  BORDER  PEN  WITH  3  BLADES
PEN  SHOWN  3/4  FULL  SIZE

*Fig. 138 Pens for special jobs.*

The most intricate of all pens must be the special pen for ruling dotted lines of various types, known as the 'dotting wheel'. The example shown here is from Kern of Switzerland (No. A1069) and is supplied with three wheels (thirty-two patterns of wheels are available). These wheels are interchangeable and produce the three types of dotted lines shown; twenty-nine others can be provided if wanted. The second dotting wheel illustrated is identical to the Kern: this

## EXAMPLES USING THE VARIOUS WHEELS

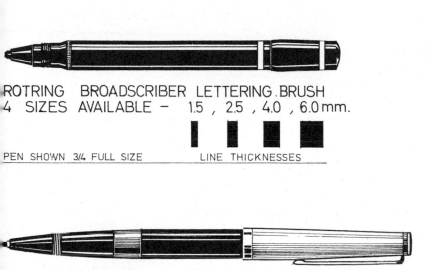

ROTRING  BROADSCRIBER  LETTERING.BRUSH
4  SIZES  AVAILABLE  –    1.5 , 2.5 , 4.0 , 6.0 mm.

PEN SHOWN 3/4 FULL SIZE         LINE  THICKNESSES

STABILO  FIBRE-TIP  PEN
4  COLOURS  AVAILABLE   (BLACK , BLUE , RED & GREEN)
PEN SHOWN 3/4 FULL SIZE

CROW QUILL PEN
PEN SHOWN 1/2 FULL SIZE

is the Maho PC41, which is supplied with six interchange-
able dotting wheels and produces the six types of dotted lines
shown. These instruments are used with a T-square or set
square and are fitted with a normal double-bladed ruling
pen, which is raised and lowered as the dotting wheel is
drawn along the ruling edge.

The Maho Bongaerts ruling pen is a beautifully designed
and constructed instrument which is a pleasure to use. It is

capable of ruling consistent lines down to 0.038 mm. thick, and holds an unusually large ink supply.

The contour pen with free-turning blade is one of the many pens available of this type. As with other precision drawing instruments, Wild, Kern, Maho and Riefler are reliable names, all of which are recommended. The contour pen is constructed so that the free-turning blade (similar to the normal bladed ruling pen) can trail when drawing lines which are constantly changing direction, e.g. contour lines on maps.

Another useful pen is the Wild RZ150 border pen with three blades. This pen is designed for ruling borders where a thick line is required and sufficient ink to allow for a reasonable length of line to be drawn without refilling. The three blades help considerably in regulating the ink flow and the quality of the line produced.

The range of Rotring 'Broadscriber' lettering brushes is a useful addition to the draughtsman's kit. These brushes come in four sizes: 1.5, 2.5, 4.0 and 6.0 mm. In addition to the lettering for which they were designed, the brushes are helpful in drawing thick lines, blacking-in and many other little jobs constantly facing the draughtsman during the course of his work.

The 'Stabilo' fibre-tip pen shown in fig. 138 is, like the 'Broadscriber', a useful instrument for a number of jobs when nothing else seems to do the job. It is most suitable for quick sketching, and some very interesting effects can be obtained when it is used in conjunction with colour.

Last is the old and faithful crow quill pen. Although great progress has been made over the last few years, no one has yet produced a substitute for this versatile nib, which can still be used to draw a finer freehand line than any other instrument used by the author to date. The crow quill is not the easiest nib to use, but with practice very satisfying results can be achieved.

Generally, the pens shown in fig. 138 are for special projects, but having some or any of them available makes the draughtsman's work easier, and in some cases improves its standard. There are other special pens available, such as the double-curve pen and the railroad pen, which have not been shown here, but when exact parallel lines are required, either ruled or freehand, or for any other unusual need, the draughtsman is advised to contact one of the precision instrument manufacturers.

Of the most readily available makes of top-grade inks, perhaps the best-known name is Pelikan; many professionals have used Indian ink produced by this company from the time they started their training, and they have not found it necessary to change their brand.

Rotring Indian inks are comparative newcomers to the field but have shown themselves to be of top quality. They are designed expressly for use with Rotring Indian ink drawing instruments. General information is given on both products in fig. 139 (overleaf), including cleaning fluids for Indian ink instruments.

Not shown on the figures are the inks and cleaning fluids specially developed for plastic drawing films, but before describing them it is necessary to know a little about these films and their uses.

The development of plastics has gone so far that only an expert is capable today of clearly distinguishing between them. At present no end can be seen to this rapid development. Plastics in the form of films have for some time been used as drawing carriers. These drawing films vary greatly in their chemical composition and their surface properties. Because they are made to meet the respective requirements of the technical draughtsman, very important problems have arisen for drawing technique and equipment.

Firstly, the advantages of drawing films over tracing paper are numerous. Films have extraordinary dimensional stability. They are waterproof, insensitive to many acids and are to a large degree microbe-resistant. They have a long life, do not yellow and have a high folding and tearing strength. The plastic films have a particular advantage wherever dimensionally stable and durable original drawings are required, as for instance in the vehicle and aeroplane industries, shipbuilding, in electrical and manufacturing industries, and especially in cartography and in surveying.

There are, however, two substantial disadvantages: the relatively high price and the usually very high abrasive effect of the drawing film (which is approximately six hundred times higher than that of tracing paper). Drawing points are worn down in a disproportionately short time when normal drawing instruments are used. The Rotring 'Foliograph' (p. 284) with its sapphire drawing point has been produced to overcome this disadvantage.

There are three main drawing film bases on the market at the present time: PVC, polyester, and polycarbonate. These materials can be relatively easily distinguished by the layman. PVC will, as a rule, splinter when knocked strongly against an edge. Polyester is not dissolved by normal surface-dissolving Indian inks. It is difficult to ignite and does not continue to burn. Polycarbonate can in most cases be distinguished from PVC and polyester in that, while it can be surface-dissolved, it resists impact stresses.

As it is very difficult to work with Indian ink or pencil on natural, i.e. very smooth, surfaces, the surfaces of the films

*Fig. 139 Drawing inks (overleaf).*

295

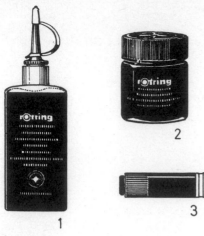

TURN BOTTLE UP-SIDE-DOWN – INSERT FILLS. TURN BOTTLE BACK TO NORMAL POSITION. UNSCREW CAP AND FILL PEN, THE INSERT ENSURES THAT THE LAST DROP OF INK IN THE BOTTLE WILL BE USED.
COLOURS : BLACK , BLUE , YELLOW , RED , GREEN AND BROWN.
ROTRING BLACK INDIAN INK LIKE PELIKAN SPECIAL BLACK (SHADE 50) IS ESPECIALLY SUITABLE FOR DRAWING INK FOUNTAIN PENS WITH TUBULAR NIBS.
THIS INK GIVES A SATISFACTORY DYELINE REPRODUCTION. THE COLOURED INKS ARE OPAQUE AND GIVE A CLEAR BLACK AND WHITE COPY PRINT WITH SHARP CONTRASTS.

## ROTRING DRAWING INKS

### PELIKAN PEN CLEANER

PUT NIBS OR TUBULAR POINTS INTO THE CONTAINER (1). THEN CLOSE FIRMLY AND TURN UPSIDE-DOWN. LET PEN CLEANER OPERATE (2).

FOR CLEANING ENCRUSTED DRAWING INK FOUNTAIN PENS PUT THEM INTO THE TUBE (3+4).

THE PELIKAN PEN CLEANER CAN BE USED FOR ALL TYPES AND MAKES OF DRAWING INSTRUMENTS USING INDIAN-INK.

THE PELIKAN PEN CLEANER IS NOT SUITABLE FOR INSTRUMENTS USING SURFACE ETCHING INKS OR ANY FORM OF DRAWING FILM INDIAN-INK.

ROTRING CLEANER (FOR INSTRUMENTS USING INDIAN-INK)

*Fig. 139 Drawing inks.*

are given some mechanical roughening, dulling or chemical coating. At present only a few firms manufacture so-called 'carrier films', and they supply them to a large number of processing plants which undertake the appropriate surface treatment. Because of the technical difficulty of the subsequent treatment it does not seem as yet safe to assume that a uniform quality standard can be maintained everywhere. It can sometimes happen that one make and type of film is subject to continual variations of properties, which become noticeable when one draws on it with Indian ink or pencil.

Various film cleaning and preparation media, and also special Indian inks, have been developed to meet the differing requirements as regards the films and their applications.

## PELIKAN DRAWING INKS

PELIKAN DRAWING INKS ARE AVAILABLE IN 16 TRANSPARENT AND 9 COVERING SHADES. ALL FLOW READILY AND ARE WATERPROOF. LINES DO NOT RUN OR SPREAD, WILL RESIST ERASING WITH A SOFT RUBBER, BUT CAN READILY BE REMOVED WITH A HARD ERASER OR OTHER MEDIUM.

BLACK - (SHADE 17) THE DEEP BLACK COLOUR AND OUTSTANDING COVER POWER OF THIS INK MAKES IT IDEAL FOR BLACK AND WHITE DRAWING OF ALL KINDS AND GIVES PERFECT DYELINE REPRODUCTION. IT IS SPECIALLY RECOMMENDED FOR WORK WITH DRAWING PEN, BRUSH AND THE GRAPHOS FOUNTAIN PEN. FOR ART WORK, IT IS READILY DILUTED WITH RAIN WATER, DISTILLED OR BOILED WATER TO GIVE A RANGE OF SHADES UP TO THE LIGHTEST GREY.

BLACK-SPECIAL FOR TUBULAR NIBS ( SHADE 50) FLOWS WITH EXTRA EASE. ITS CON-SISTENCY AND DRYING PROPERTIES WERE SPECIALLY FORMULATED FOR RELIABLE, TROUBLE-FREE WORKING WITH TUBULAR NIBS OF ANY DESIGN. THIS INK IS NOT AS DENSE AS SHADE 17 BUT YIELDS SATISFACTORY DYELINE REPRODUCTION.

COLOURED, TRANSPARENT DRAWING INKS ( SHADES 1 – 16 , 18) EASY - FLOWING AND DURABLE, THEY CAN BE INTERMIXED AT WILL AND ARE SUITABLE FOR DILUTION WITH RAIN WATER, DISTILLED OR BOILED WATER.

COLOURED, OPAQUE DRAWING INKS, SUITABLE FOR DYELINE PRINTING ( SHADES 51 - 56) ALL OPAQUE INKS ARE SUITABLE FOR USE IN DRAWING INK FOUNTAIN PENS WITH TUBULAR NIBS. THESE COLOURS ARE SUITABLE FOR DYELINE REPRODUCTION AND ART WORK WHICH MUST REMAIN FAST TO LIGHT. SHADES CAN BE MIXED & DILUTED.

COLOURS : 1 - SCARLET . 2 - CARMINE . 3 - VERMILION . 4 - ORANGE . 5 - YELLOW. 6 - LIGHT GREEN . 7 - DEEP GREEN . 8 – COBALT BLUE . 9 - ULTRAMARINE . 10 - PRUSSIAN BLUE . 11 - RED VIOLET . 12 - BLUE VIOLET . 13 - SIENNA . 14 - BURNT SIENNA . 15 - SEPIA. 16 - GREY. 17 - BLACK . 18 - WHITE . SPECIALS - 50 - BLACK. 51 - RED. 52 - YELLOW. 53 - GREEN. 54 - BLUE . 55 - VIOLET . 56 - BROWN.

Most drawing films can be cleaned, especially of grease and eventually also of moisture with *cleaning petrol. Alcohol* has a similar action to that of cleaning petrol. The *FK cleaner* of Messrs Günther Wagner, the Pelikan makers, is a special cleaning medium for films.

When one of these three media is used, it is necessary first to check carefully that the coating of the film to be treated is sufficiently resistant.

Messrs Günther Wagner's *cleaning powder 333* is a chalk-like powder which frees the film of grease and other con-taminations. Care must be taken to remove the powder from the drawing carrier after use as thoroughly as possible if difficulties during drawing are to be avoided. The *PK*

*preparation* of the same firm is a wax-like liquid which improves the absorbing capacity of some films (polycarbonate) for Indian ink.

The question of which Indian ink to use on drawing film is unfortunately difficult to answer as it depends decisively upon the demands made of the drawing itself, i.e. of the result. For this reason and as a matter of principle the first question to answer is: 'Is the application of film surface-dissolving Indian ink necessary or is the use of water-soluble Indian ink sufficient?' When this question has been answered, the chief factors to be considered are: the adhesive capacity of the Indian inks to be used; the outline sharpness of the lines drawn; the resistance to smudging of the Indian ink to be applied; the heliographic printing capacity of the result; the ease of correction.

If the questions are put in the sequence recommended here, the number of Indian inks that need to be tested is considerably reduced. In other words, if a result as smudgeproof and waterproof as possible is required, film surface-dissolving Indian inks generally available are Messrs Günther Wagner's K-Indian ink and Rotring film Indian ink. These inks can at present be used only in the 'Foliograph' Indian ink drawing instrument and the Pelikan 'Graphos' HK (with vulcanite cap). Care should be taken not to clean either of these instruments under any circumstances with water, because these Indian inks clot if combined with water. Only the solvent recommended by the manufacturer of the Indian ink may be used for cleaning.

The disadvantage of these Indian inks should, however, not be underrated. As they bind very closely with the drawing carrier, it is relatively difficult to make corrections. The use of ink solvents as a liquid correction medium is possible only to a limited extent as in most cases this causes the destruction of the film coating. If a fully waterproof result is not required, then, besides normal drawing inks (on a water base), a number of special film Indian inks on a water base may be used, e.g. the types T, TT, TN and C from Messrs Günther Wagner. A sufficiently waterproof result is obtained in most cases with normal drawing inks on a water base. When they are used, neither the film nor its coating has its surface dissolved and therefore corrections are relatively easy.

It can be seen that it is impossible to make fundamental recommendations in this complex question of drawing on plastic film. It is necessary to find out the most reliable result by specific tests.

| ISO – A SERIES OF TRIMMED SIZES | | | | | |
|---|---|---|---|---|---|
| | millimetres | | | inches | |
| A 0 | 1,189 | x | 841 | 46·81 x | 33·11 |
| A 1 | 841 | x | 594 | 33·11 x | 23·39 |
| A 2 | 594 | x | 420 | 23·39 x | 16·54 |
| A 3 | 420 | x | 297 | 16·54 x | 11·69 |
| A 4 | 297 | x | 210 | 11·69 x | 8·27 |
| A 5 | 210 | x | 148 | 8·27 x | 5·83 |
| A 6 | 148 | x | 105 | 5·83 x | 4·13 |
| A 7 | 105 | x | 74 | 4·13 x | 2·91 |
| A 8 | 74 | x | 52 | 2·91 x | 2·05 |
| A 9 | 52 | x | 37 | 2·05 x | 1·46 |
| A 10 | 37 | x | 26 | 1·46 x | 1·02 |

THE NORMAL SUBDIVISION OF A0 SHEET

These are based on the German system of classification. International sizes are also known by the following names: International Standards Organization sizes (ISO); 'A' sizes (from the A series shown here); DIN sizes (from Deutsche Industrie-Norm); metric paper sizes; and International Standard paper sizes (ISPS range).

The international sizes comprise A, B and C series. In each series the shape of the basic size and all normal subdivisions

*Fig. 140 International paper sizes (continued overleaf).*

299

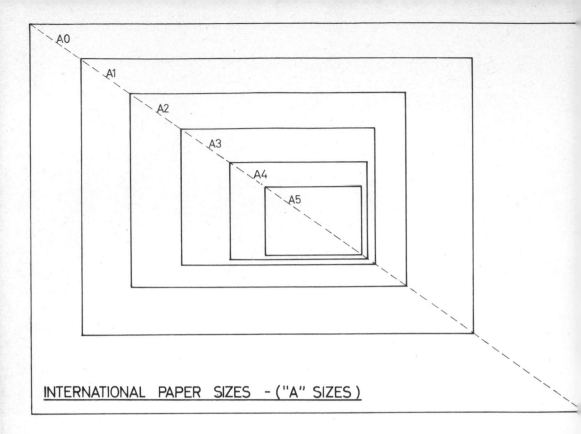

INTERNATIONAL PAPER SIZES - ("A" SIZES)

Fig. 140 International paper
sizes (continued).

is the same, so that the sides of the sheets are always in propor-
tion $1 : \sqrt{2}$ ($1 : 1.414$ approx.).

The A series is the main series within the international
range of sizes. The basic size is A0 (1,189 mm. × 841 mm.),
which occupies an area of 1 sq. m. The letter A is used to
precede a number when describing all sizes within this
standard. Half A0 is A1; half A1 is A2, etc. (see detail in fig.
140). For sizes larger than A0 the number precedes the letter;
2A is therefore twice the size of A0. The letter 'L' after the
designation indicates that the upright dimension of the page
is the shorter (e.g. A4L means the sheet is used horizontally
instead of vertically). The A series is used for printing and
stationery as well as for drawing-paper sizes.

The B series is based on the size B0 (1,414 mm. × 1,000
mm.), and the normal subdivisions provide sizes between the
A subdivisions; thus, B2 is midway between A1 and A2, etc.
The B sizes were originally intended for envelopes and
posters, but because a better progression can be obtained by
using both A and B ranges, B sizes are also used for paper.
B sizes are, however, not suitable for stationery because
envelopes are not available in the international range.

C series sizes, based on the size C0 (1,297 mm. × 917 mm.),
fall between the A and B sizes and are used solely for
envelopes.

Conversion to international sizes has obvious advantages
besides filing and storage. According to a report of the sub-
committee of the International Standards Organization,

meeting in Paris in March 1958, twenty-six countries had already adopted the A series and seventeen countries had adopted it as a national standard. Western European countries using international sizes include Germany, Belgium, Holland, Italy, Denmark, Austria, Spain, Portugal, Switzerland, Norway, Sweden and Finland.

The standard sizes are trimmed sizes, so the sizes of all finished work remain constant regardless of printer or publisher. There are no fixed trim sizes in the traditional British sizes, and 'foolscap folio' may vary from 13 in. × 8 in. to $13\frac{1}{8}$ in. × $8\frac{1}{8}$ in., $13\frac{1}{4}$ in. × $8\frac{1}{4}$ in. or $13\frac{1}{8}$ in. × $8\frac{1}{4}$ in.

Generally the introduction of standard paper sizes, together with the standardization of line thicknesses and lettering stencils (fig. 142), should simplify the draughtsman's job as well as ease the strain on his pocket. A further advantage of the introduction of these standards will be seen when microfilming technical drawings for storage and subsequent re-enlargement. The new gradation of line widths in the progressive ratio $1:\sqrt{2}$, the same as the gradation for international paper sizes, makes it possible to effect corrections and additions according to standards with reproductions in any of the international paper sizes. The same applies to the lettering stencils.

We speak of the 'lead' pencil, although the lead is now a ceramic containing graphite. When natural graphite was discovered in the sixteenth century, it was thought to be a sort of lead and was called 'blacklead'. Drawing sticks, hewn from slabs of raw graphite, were messy to use and were sometimes wound with string or rags or held in a form of tweezers. It is recorded that in the year 1659 a carpenter, Hanns Baumann, glued his leads between two slats of wood, making the first pencil as we know it today.

Pencils and pencil sharpeners are inseparable and should be thought of in this way. The best pencil badly sharpened will give nothing but trouble. The pencils shown overleaf are the Stabilo range from Germany, a consistently high grade of pencil of many types to cover most requirements the draughtsman is likely to meet. There are a number of good makes of pencil on the market and everyone will have their own likes and dislikes. The pencils shown are all in current use by the author and have been found to confirm the makers' claims. A particular favourite is the Stabilo 8-9 'Repeater' which is light and comfortable to use, triangular in section and feeds lead out $\frac{1}{10}$ in. only at a time. Combined with the Stabilo 'Micro' refill leads the 'Repeater' gives first-class results. The 'Micro' refill leads are available in all grades from 7B to 9H. The 'Repeater' will take leads from 3B to 9H (2-mm. diameter leads), but a clutch pencil

POCKET CLUTCH LEAD
SHARPENER.(DUX·3250E)

DUX RECEPTACLE PENCIL SHARPENER
( 3307 N.)

'DUX' VARIABLE PRECISION
PENCIL SHARPENER

SOLID BRASS CONSTRUCTION WITH
REPLACEABLE BLADE. SHARPENER
IS SUPPLIED WITH A LEATHER
CASE FOR CARRYING IN THE POCKET.

1 . . . BLUNTED POINT FOR NORMAL COLOUR PENCILS

2 . . . NORMAL POINT FOR BLACKLEAD AND
COPY PENCILS

3 . . . FINEST POINT ESPECIALLY FOR DRAWING PENCILS

*Fig. 141 Pencils and pencil
sharpeners.*

capable of taking 3.15-mm. diameter leads is required for
4B to 7B. The 'Micro' leads are suitable for drawing on
plastic films, glass, polished metal etc.

The Stabilograph 8-5C is another type of mechanical
pencil which feeds out an 0.5-mm. drawing lead which does
not need sharpening. Refill leads are available in five degrees
as shown. The Stabilo coloured clutch pencil is available in
twelve shaft colours and thirty colours of Stabilo leads. Like
the other two clutch pencils, it is made of durable plastic,
light in weight. The triangular section fits the three fingers

## THE STABILO 8-9 REPEATER

WITH BUILT-IN SHARPENER. POCKET CLIP OR
DEGREE MARK OPTIONAL.
FEEDS LEAD 1/10" ONLY AT A TIME. THE LEAD
CANNOT FALL OUT.

## STABILO 'MICRO' REFILL LEADS

AVAILABLE IN ALL GRADES FROM 7B – 9H.
THE 8-9 REPEATER WILL TAKE LEADS FROM
9H TO 3B (2mm. ∅). 4B TO 7B (3·15 mm. ∅)
REQUIRE A DIFFERENT CLUTCH PENCIL.
MICRO LEADS ARE SUITABLE FOR DRAWING ON
PLASTIC FILMS, GLASS, POLISHED METAL, ETC.

## THE STABILOGRAPH 8 – 5C

MECHANICAL PENCIL WITH 0.5 mm DRAWING
LEAD. MICRO REFILL LEADS ARE AVAILABLE
IN 5 DEGREES 8105/ H B, H, 2H, 3H, 4H.

## THE STABILO COLOURED CLUTCH PENCIL

STABILO COLOURED LEADS ARE AVAILABLE IN 30 SHADES
( PLUS GOLD AND SILVER ).

## STABILO SERIES 8000, 'MICRO' DRAWING PENCILS

AVAILABLE :

10H, 9H, 8H, 7H, 6H, 5H, 4H, 3H, 2H, H, F, – HB, B, 2B, 3B, 4B, 5B, 6B, 7B, 8B.

holding the pencil, and does not roll off the table readily.
Not shown is the range of thin-lead coloured pencils,
which are available in several shades as well as gold and silver.

Last is shown the Stabilo Series 8000 'Micro' drawing pen-
cil, which is available in a range of twenty degrees from 8B to
10H. It is worth testing these pencils as it has been found that
a harder pencil than usual can be used and still give a good
reproducible line when photo-printed. All pencils and
leads shown are suitable for drawing on plastic films. Already
mentioned on p. 279 is the Fedra 4900 lead-sharpener for

clutch pencil leads, which is favoured by many architects and draughtsmen. Another type of lead-sharpener for use with clutch pencils is the tiny pocket clutch lead sharpener from Dux (No. 3250E). This sharpener will put a draughtsman's point on the lead and can be carried in the pocket when the cover is closed without danger of lead particles soiling the pocket. This unit is very efficient and is obtainable for a modest price.

Two of the large range of pencil sharpeners from Dux are shown in fig. 141; these are the Dux receptacle pencil sharpener (No. 3307N) and the Dux variable precision pencil sharpener. The first has a plastic container for catching wood shavings and will put a good usable point on a pencil. The variable sharpener is a solid brass sharpener with replaceable blades and is supplied in a leather case. There are three settings, which give a blunted point for coloured pencils, a normal point for blacklead and copy pencils and a fine point for drawing pencils. Both sharpeners give a good point and are recommended.

Not shown but also available are a number of good electric pencil sharpeners. One very good machine is the Elm Electric pencil sharpener V.7. It is fully automatic, well designed and simple to operate, gives a first-class result and is thoroughly recommended where such a machine is required.

*Fig. 142 Lettering stencils.*

The current trend towards standardization has been previously described; the Rotring 'Micronorm' $\overline{m}$ range of lettering stencils is used as an example to explain the system of standardization. There are a number of good makes of lettering stencils on the market, including 'Nestler', 'Linex' and 'Standardgraph', all of which are clean cut and produce first-class results when combined with the various pens available. It can be clearly seen that the recent introduction of this new standard will save the draughtsman a considerable amount of money and time as only one drawing instrument is required for both drawing and lettering. Another improvement is the colour-coding system: the drawing instrument and the lettering stencil both carry the same colour ring, and this makes for speed and accuracy in working.

The stencils are made of yellow low-reflection and low-shadow material with aluminium non-skid edge strips. Each stencil has a complete range of upper- and lower-case letters, numbers and symbols as shown on p. 306. The table shows the line thickness and the size of the letters produced by the stencils in the $\frac{1}{10}h$ and the $\frac{1}{14}h$ upright characters. (Oblique letters of the same height are not shown.) 'Micronorm' stencils have been used for lettering on various figures throughout this book and have proved most satisfactory over a sustained period.

Art. 5418 **rotring** 1,8 / 0,18 mm

ÄᴈCDÊGHJKLMÑÖ.PRSTÜVWXYZ I 1234567₀°90,°/

## `ROTRING´ MICRONORM m̅ LETTERING STENCIL No.5418

THE MICRONORM m̅ INDIAN-INK DRAWING
INSTRUMENTS ARE GRADED IN LINE THICK-
NESS AND LETTERING HEIGHT STEPS OF
$1 : \sqrt{2}$ ( $1 : 1.41$) LIKE THE DIN –
(GERMAN INDUSTRIAL STANDARD) DRAWING
SIZES.

THE SAME `DRAWING INSTRUMENT´ CAN BE
USED FOR DRAFTING AND STENCIL-LETTER-
ING.
FOR LINEAR DRAFTING ACCORDING TO THE
DIN 15 PREFERRED SERIES 1 IN 9 LINE
THICKNESS OF 0.13 – 2 mm.

THE TUBULAR POINTS ARE STEPPED TO
PREVENT THE INK FROM RUNNING UNDER
THE DRAWING RULERS.

A WRITING ANGLE OF APPROXIMATELY 90°
SHOULD BE AIMED AT , AS OTHERWISE NO
CONTINUOUS STANDARDISED LINE THICK—
NESSES CAN BE OBTAINED.

FOR STENCIL-LETTERING ACCORDING TO THE
DIN 16/17 PREFERED SERIES 1 IN 8 LETT—
ERING HEIGHTS OF 1.8 – 20 mm.

LINE THICKNESS IN MEDIUM—THICK LETT-
ERING 1/10 h , IN THIN LETTERING 1/14 h.

NOTE: COLOUR MARKING ON DRAWING
INSTRUMENT AND LETTERING STENCIL
SHOULD AGREE.

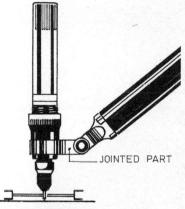

—— JOINTED PART

LETTERING.

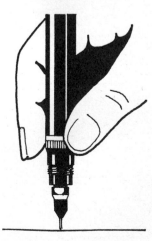

RULING

| LINE THICKNESS. | MEDIUM THICK. (1/10 h.) | THIN. (1/14 h.) |
|---|---|---|
| 0.18 ———————— | ABCDEFGHIJ*ABCDEFGHIJ* | ABCDEFGHI *ABCDEFGHI* |
| 0.25 ———————— | ABCDEFGI*ABCDEFGI* | ABCDEFGI*A3CDEFG* |
| 0.35 ———————— | ABCDEF*ABCDEI* | ABCDEF*ABCDEF* |
| 0.5 ———————— | ABCD*ABCD* | ABCDI*ABCC* |
| 0.7 ———————— | ABC*ABC* | ABC*ABC* |
| 1.0 ———————— | AB*AБ* | AB*AБ* |
| 1.4 ———————— | AEA*ι* | AEA*ι* |
| 2.0 ———————— | AA | |

NOTE :– DRAWING INSTRUMENT 0.13 mm. NOT SHOWN AS IT IS ONLY FOR RULING & DRAWING

Fig. 142 Lettering stencils
(continued).

Another method of lettering is with the scriber and template, of which there are a number of different makes on the market, one of the best of these being the 'Leroy' by the Keuffel & Esser Co. of the United States of America. Figure 143 (overleaf) shows the 'Leroy' equipment and also a few examples of the results which can be obtained with very little experience.

There are three essential steps for scriber lettering:

1   Select a template from the large number of types and sizes available. (There are many styles and sizes of alphabets, as well as graphic symbols, and templates can also be made specially to individual requirements.) The template is laid along the T-square or straight-edge.
2   Choose the type of pen (reservoir or standard) with the width that best suits the job in hand. Set the pen in the socket on the upper arm of the scriber. For pencil lettering the 'Leroy 020' pencil or the 'Leroy' lead clutch, that holds any regular draughting lead, are both available. Both pens and pencils work with the 'Leroy' scribers.
3   Set the tail pin of the scriber in the straight-guide groove of the template. With the tracer pin of the scriber simply trace the engraved letters on the template. The pen or pencil reproduces the letter or symbol in full view above the template.

'Leroy' templates are made of three layers of special plastic material, thick and heavy enough to resist warping and distortion. The outside layers are white and the middle layer is black, laminated for extra strength and stability. The characters are engraved right through the outer white layer to the black middle layer, so that they stand out in sharp permanent black-on-white contrast. Each letter, number and symbol is engraved complete and can be drawn without shifting the template. 'Leroy' templates have uniform base lines, which means that templates can be changed or turned over for the characters on the back, and the same line of lettering can be continued without having to move the straight-edge. The distance from the bottom of the letters to the lower edge of the template is uniform throughout all standard and nearly all other lettering templates in the 'Leroy' range. The templates have a groove on both sides in which the 'anchoring' tail pin of the scriber rides. Each template has a scale on the lower edge to allow for quick, accurate locating or spacing of any line of lettering. Templates generally have upper-case letters on one side and lower-case letters and numbers on the other, which means that only one template is required for each size and style of lettering. (There is a catalogue which gives the full range of templates and accessories.)

Two types of pen are available to fit the 'Leroy' scriber: the reservoir pen and the standard pen. The reservoir pen is a cartridge type and, like other pens of this type, has many

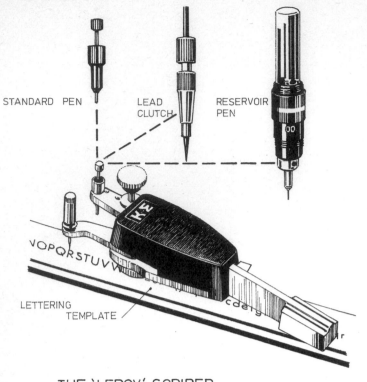

| PEN SIZE | | LINE WIDTH. (in) |
|---|---|---|
| 0000 | — | .008 |
| 000 | • — | .010 |
| 00 | • — | .013. |
| 0 | • — | .017 |
| 1 | • — | .021 |
| 2 | • — | .026 |
| 3 | • — | .035 |
| 4 | • — | .043 |
| 5 | • — | .055 |
| 6 | • — | .067 |
| 7 | • ▬ | .083 |
| 8 | • ▬ | .098 |
| 9 | ▬ | .125 |
| 10 | • ▬ | .150 |
| 12 | ▬ | .200 |
| 14 | ▬ | .250 |

STANDARD PEN    LEAD CLUTCH    RESERVOIR PEN

LETTERING TEMPLATE

## THE 'LEROY' SCRIBER

LEROY TEMPLATES ARE AVAILABLE IN A LARGE VARIETY OF STYLES (APPROX. 30) AND SIZES OF LETTERING, AS WELL AS IN A RANGE OF GRAPHICAL SYMBOLS.

LEROY SCRIBERS ARE AVAILABLE IN THREE TYPES. THERE IS THE FIXED, OR NON-ADJUSTABLE TYPE FOR VERTICAL LETTERING ONLY. THE ADJUSTABLE TYPE PRODUCES CHARACTERS EITHER VERTICAL OR SLANTING AT ANY ANGLE UP TO 22 DEGREES FROM THE SAME TEMPLATE.
THE THIRD TYPE PERMITS VARIATION OF THE HEIGHT AND SLANT OF LETTERS AND NUMERALS.
( 5 DIFFERENT SCRIBERS ARE AVAILABLE IN THE ABOVE TYPES).

LEROY PENS ARE AVAILABLE IN TWO TYPES - STANDARD LETTERING PEN AND RESERVOIR LETTERING PEN. STANDARD LETTERING PENS ARE AVAILABLE IN 16 SIZES FROM 0000 TO 14.
RESERVOIR LETTERING PENS ARE AVAILABLE IN 13 SIZES FROM 000 TO 14. (SEE TABLE OF PEN SIZES),

ALSO AVAILABLE A PENCIL & A LEAD CLUTCH FOR PENCIL LETTERING.

• AVAILABLE ALSO IN RESERVOIR LETTERING PEN

KEUFFEL & ESSER CO.

𝕬𝕭𝕮𝕯𝕰𝕱

*ABCDEF*

*Fig. 143 The 'Leroy' scriber.*

advantages. These pens are available in thirteen point sizes from 000 to 14. The 'Leroy' standard pens were designed to handle small lettering jobs. The finest (0000 to 1) have stainless steel tips and the very fine stainless steel wire of the 'cleaner' is reinforced for about half its length by stainless steel tubing inserted into the body. The standard pens are available in a wide range of sizes (0000 to 14).

The 'Leroy 020' pencil is a mechanical pencil feeding out an 0.02-in. diameter lead which does not need sharpening. The 'Leroy' lead clutch is for lettering jobs requiring lead

| TEMPLATE SIZE | PEN SIZE | | | | | | | | | | | |
|---|---|---|---|---|---|---|---|---|---|---|---|---|
| | 0000 | 000 | 00 | 0 | 1 | 2 | 3 | 4 | 5 | 6 | 7 | 8 |
| 50 | A● | | | | | | | | | | | |
| 60 | A● | A | B | C | | | | | | | | |
| 80 | A | A● | B | C | | | | | | | | |
| 100 | | A | A● | B | C | D | | | | | | |
| 120 | | A | B | C● | D | E | | | | | | |
| 140 | | A | B | C | D● | E | F | | | | | |
| 175 | | A | B | C | D | E● | F | G | | | | |
| 200 | | A | B | C | D | E | F● | G | H | | | |
| 240 | | A | B | C | D | E | F● | G | H | | | |
| 290 | | | B | C | D | E | F | G● | H | K | | |
| 350 | | | B | C | D | E | F | G● | H | K | | |
| 425 | | | B | C | D | E | F | G | H● | K | L | |
| 500. | | | B | C | D | E | F | G | H● | K | L | M |

CHART SHOWING WIDE RANGE OF LETTERING PRODUCED BY COMBINING VARIOUS TEMPLATES & PENS.
● INDICATES RECOMMENDED COMBINATIONS OF TEMPLATES AND PENS FOR BEST RESULTS.

(EXAMPLES OF LEROY TEMPLATES.)

sizes other than 0.02 in. There are three types of 'Leroy' scribers available. There is the fixed, or non-adjustable, type for lettering only. The second, the adjustable type, produces characters either vertical or slanting, at any angle up to $22\frac{1}{2}°$, from the same template. A simple adjustment of the tracer arm requires only the loosening and retightening of a thumb nut. The third type permits variation of the height and slant of letters and numerals.

A large range of accessories is also available for the 'Leroy' scriber lettering system.

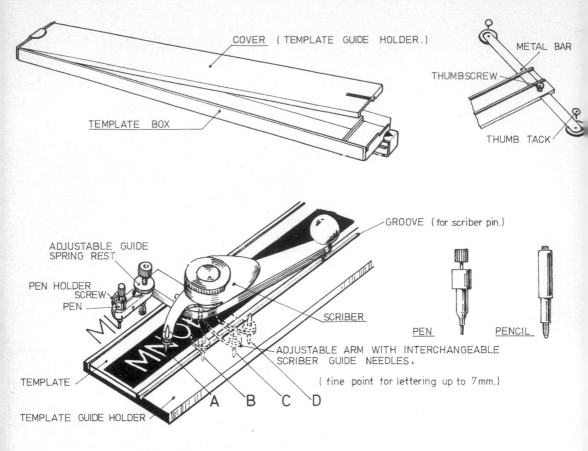

COVER ( TEMPLATE GUIDE HOLDER.)

METAL BAR

THUMBSCREW

TEMPLATE BOX

THUMB TACK

GROOVE ( for scriber pin.)

ADJUSTABLE GUIDE
SPRING REST

PEN HOLDER
SCREW

PEN

SCRIBER

PEN

PENCIL

ADJUSTABLE ARM WITH INTERCHANGEABLE
SCRIBER GUIDE NEEDLES.

TEMPLATE

( fine point for lettering up to 7mm.)

TEMPLATE GUIDE HOLDER

A    B    C    D

# THE TECNOSTYL COPIOGRAPH LETTERING SET

THE COVER OF THE TEMPLATE BOX WHEN REMOVED FROM THE BOX AND TURNED UPSIDE DOWN IS USED AS THE TEMPLATE GUIDE HOLDER. THE TEMPLATE GUIDE HOLDER CAN BE USED WITH A T-SQUARE, PARALLEL EDGE, DRAFTING MACHINE OR STRAIGHT EDGE. INCLUDED IN THE BOX IS ALSO A METAL BAR WHICH CAN BE FITTED TO THE TEMPLATE GUIDE HOLDER WITH THE THUMB SCREW PROVIDED. THE METAL BAR HAS HOLES AT EACH END WITH PLASTIC THUMB TACK HOLDERS FITTED TO USE WHEN A STRAIGHT EDGE IS NOT AVAILABLE. THE SCRIBER IS CONSTRUCTED TO TAKE A PENCIL LEAD HOLDER AND A VARIETY OF PEN SIZES ( SIZES – 00 , 0 , 1 , 2 & 3 ). THE SCRIBER CAN BE SET TO FOUR POSITIONS TO ALLOW FOR VERTICAL OR THREE DIFFERENT ANGLES OF SLOPING LETTERING TO BE DONE FROM EACH TEMPLATE. THE COMPLETE RANGE OF TEMPLATES IS SHOWN IN THE ADJACENT TABLE.

THE TECNOSTYL COPIOGRAPH LETTERING SET IS A SIMPLE AND CHEAPER SCRIBER SET BUT WITH CARE CAN BE USED SIMPLY AND SHOULD GIVE SATISFACTORY RESULTS.

*Fig. 144 The 'Tecnostyl Copiograph' lettering set.*

While this – a much simpler and cheaper piece of equipment from Italy – is not shown as a competitor of the much larger range of the professional 'Leroy' lettering equipment it has a place in its own right as a simple form of lettering scriber for the draughtsman whose occasional requirements do not justify the outlay required for the 'Leroy'. As with the 'Leroy', the lettering on the figure was done after very little practice; the 'Tecnostyl' was simple to use, and with a little more practice first-class results can be expected.

| TEMPLATE SIZE | POSITIONS OF SCRIBER NEEDLE ARM | | | |
|---|---|---|---|---|
| | POSITION A | POSITION B | POSITION C | POSITION D |
| 2·5mm. | ABCDEFGHIJK | ABCDEFGHIJK | ABCDEFGHIJK | ABCDEFGHIJ |
| 3mm. | ABCDEFGHI | ABCDEFGHI | ABCDEFGH, | ABCDEFG. |
| 3·5mm. | ABCDEFG | ABCDEFG | ABCDEFG | ABCDEF( |
| 4mm. | ABCDEF | ABCDEF | ABCDEF | ABCDE+ |
| 5.mm. | ABCDEI | ABCDEI | ABCDEi | ABCDE |
| 6mm. | ABCDI | ABCDI | ABCDI | ABCI |
| 7mm. | ABCI | ABCI | ABCI | ABCI |
| 10mm. | ABC | ABC | ABC | ABC |

,ABCDEFGHIJKLMNOP,QRSTUVWXYZ&

abcdefghijklmnopqrstuvwxyz,(%)≡

CONTENTS OF EACH
TEMPLATE GUIDE

0123456789

*Letraset*

It is impossible to reproduce here more than a small fraction of the type faces and sizes available in this range, which covers various language frequencies (French, English, German, Spanish and Scandinavian), music symbols, sheets of French accents, international traffic signs, hand-drawn faces, borders, rules, asterisks, dotted rules, road transport symbols and numerals. Also included in the Letraset range are Greek, Hebrew, Cyrillic and Arabic characters in various type faces. Letraset sheets feature Spacematic letter-spacing, which makes for well-spaced lettering even in the hands of an amateur. The complete range is shown in the Letraset catalogue, which also includes all the Graphic Art products, some of which are mentioned elsewhere in this book.

Letraset instant letters are dry transfer letters which are printed on a plastic sheet and, when rubbed over with a ball-point pen, can be transferred to the surface of the art-work in a fraction of the time required to produce the letters by hand, so that even a comparatively inexperienced draughtsman can obtain professional results at a fraction of the cost of other methods. Instant lettering can be applied to any smooth surface – paper, board, plastic, metal, glass, acetate and even linen and silk. The letters are formed of a tough, pliable ink film which is highly resistant to cracking even when applied to rough surfaces. Letraset can be projected or photographically 'blown up' without significant loss of definition. In case of error in setting, it can be removed by eraser or adhesive tape.

The general method of fixing is shown in fig. 145, but for special uses another method is adopted, which is called the 'Pre-release technique'. This can be used on difficult surfaces (e.g. rough metal, tracing linen, delicate tissue paper).

1  Hold the sheet away from the surface, and rub *lightly* over the letter with a ball-point pen until it appears to turn completely grey (pre-released).

2  Place it in position on the artwork and press it off with a finger.

3  Cover it with protective tissue and burnish hard.

The blue backing tissue is silicone-coated to prevent letters accidentally transferring to it. It should always be placed under the sheet when using 'Instant Lettering', clear of the letters being transferred but protecting other letters from accidental transfer. Replace it after use to prevent dirt and dust from adhering to the sheet. 'Instant Lettering' should not be used on drawings to be dyeline copied unless it is protected with 'Letracote' or '101' spray fixatives. 'Letracote Matt' dries in a few minutes, and ink and pencil additions can be made over sprayed areas. 'Letracote' is also useful in protecting lettering from abrasion. 'Instant Lettering' sheets should be stored flat and away from heat and humidity.

<!-- Letter specimen sheet, left column -->
```
EEEE E
EEFGH
HIIIJLLM:
u u v w q y : : ;
o o £ $ & ? !! ( ) = :
i o o u u - n p ;
I I I J L L M N ; ;
E E E E F G H H I I I I J L L M N ;
R R S S S T T T T U U V W X Y ;
R R S S S T T T T U U V W Z Y ;
: $ ? & ! £ $ ? & ! ( ) : ; a a a b c d d
3 4 5 5 6 7 7 8 9 0 0 0 £ s % — : : : :
i 2 2 3 4 5 5 6 7 7 8 9 0 0 0 £ s % + : : :
+ : :
U U V W 1 1 1 2 2 3 4 5 5 6 7 7 8 9 0 0 0 £ s % : : :
+ : : :
```

## FIXING INSTRUCTIONS

REMOVE BLUE BACKING AND PLACE INSTANT LETTERING SHEET ON YOUR SURFACE CLOSE UP TO THE WORKING POSITION.

SELECT A LETTER AND POSITION IT BY REGISTERING ITS PRINTED GUIDE LINE WITH EITHER A RULED LINE ON YOUR SURFACE OR ON EDGE OF THE BLUE BACKING.

SHADE RIGHT ACROSS THE LETTER FROM TOP TO BOTTOM WITH A BALL POINT PEN USING MODERATE PRESSURE TAKING CARE NOT TO PRESS ON ANY OTHER LETTER WITH THE PEN OR THE HAND UNLESS THESE ARE OVER THE BLUE BACKING TO WHICH IT WILL NOT TRANSFER.

LIFT AWAY INSTANT LETTERING SHEET SLOWLY AND REPEAT THE TRANSFER PROCEDURE UNTIL SETTING IS COMPLETE AND FINALLY PLACE BLUE BACKING OVER THE SETTING AND SHADE ALL LETTERS TO FIX THEM.

IN CASE OF ERROR, PLACE A SMALL PIECE OF ADHESIVE TAPE GENTLY ON LETTER, PRESS ALL OVER THE LETTER ONLY WITH THE PEN AND LIFT AWAY TAPE AND LETTER.

THE LETTERS ARE SHARPLY DEFINED, OF REPRODUCTION QUALITY, AND ARE ARRANGED ON THE FONT SYSTEM GIVING MORE OF THE LETTERS IN MOST FREQUENT USE.

SHEET SIZE — 15" x 10"

ALL SHEETS ARE PRINTED IN BLACK AND WHITE. SOME SHEETS ARE AVAILABLE IN RED BLUE AND YELLOW.
A FEW SHEETS ARE AVAILABLE IN GOLD.

Fig. 145 *A selection of rub-down letters from Letraset.*

Fig. 146 Samples of 'rub-down'
lettering by Letter-Press.

This is a 'fun' sheet using types from the large range of
'Instant Lettering' by Letter-Press. They supply good clean
letters of very high quality and, as previously described,
these easily give first-class results. Letter-Press, like Letraset,
have a large selection which is shown fully in their current
illustrated catalogue together with the full range of graphic
effects.

This concludes the various ways of producing lettering, and no doubt the experienced draughtsman will have long ago settled on his own favourite method or combination of methods, but it will be seen that each method has its advantage over the others. The student is advised to keep an open mind on the subject until he has had the opportunity of trying them all out for himself.

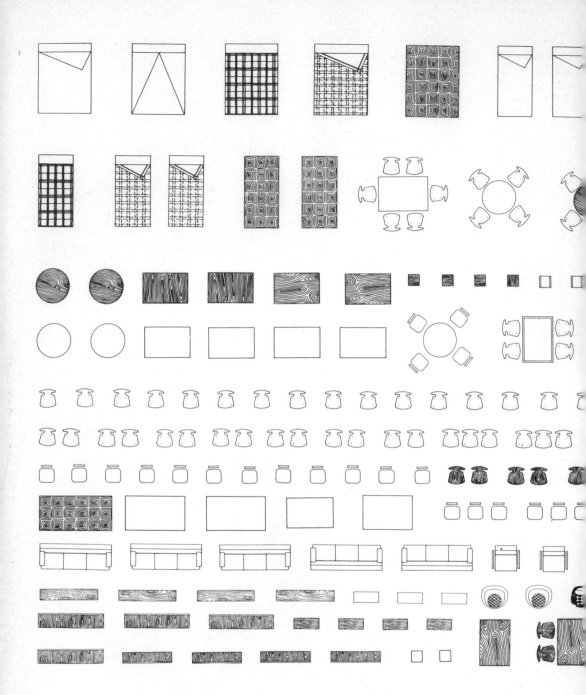

*Fig. 147 Furniture symbols by Letter-Press.*

These drawings are in the form of rub-down symbols, similar to 'Instant Lettering' and used in the same way. Directions for use are shown on the figure. Only a part of the sheet has been shown, but the wide variety of pieces of furniture and groups of furniture on the sheet can be seen. This sheet is another useful time- and money-saver.

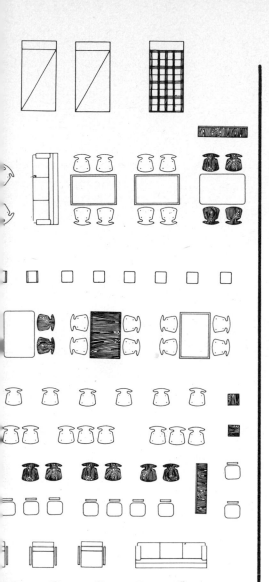

## DIRECTIONS FOR USE

REMOVE THE BACKING SHEET AND PLACE LETTER-PRESS ON SURFACE OF ARTWORK. BURNISH THE WHOLE SURFACE OF THE ITEM TO BE TRANSF-ERRED WITH A LETTER-PRESS SPATULA, A BALL POINT PEN OR SIMILAR HARD TOOL.

AFTER LIFTING AWAY SLOWLY THE LETTER-PRESS SHEET, THE ITEM IS THEN TRANSFERRED FROM THE SHEET TO THE ARTWORK.

FOR BETTER ADHESION, PLACE THE BACKING SHEET OVER THE SETTING AND BURNISH.

A WIDE CHOICE OF MODERN SYMBOLS AND DRAWINGS FOR ARCHITECTS ARE AVAILABLE. CONTAINED IN THE 44 SHEET RANGE OF ARCH-ITECTURAL ELEMENTS ARE DRAWINGS OF PLUM-BING FITTINGS, FURNITURE, KITCHEN ELEMENTS, WORDS, CARS, HUMAN FIGURES, TREES, ETC..

ALL LETTER-PRESS SYMBOLS ARE HEAT RESISTANT IN DIAZO MACHINES.

LETTER-PRESS ARCHITECTURAL SHEETS ARE IN TWO SIZES

SIZE – A        25·5  x  35 cm.  (10″ x  14″)
SIZE – B        32.   x  40 cm.  (12¾″  15¾″)

THE SIZE INDICATION (A OR B) IS PLACED IN FRONT OF EVERY REFERENCE NUMBER.

## ARC-1051  FURNITURE.

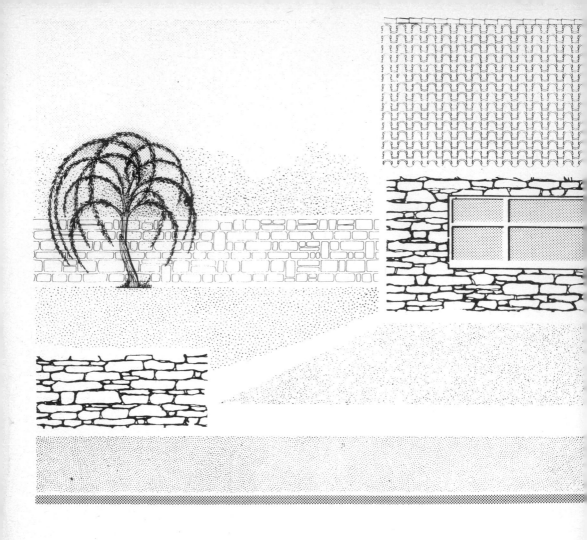

*Fig. 148  Some Normatone screens.*

This is another 'fun' sheet, this time made up of adhesive screens from the Normatone range; it is in no way intended to indicate their whole range, which comprises some three hundred-odd patterns including mechanical tones. Twelve different sheets have been used, with figures, trees and shrubs from the range of 'rub-down' architectural sheets. The adhesive screens include materials as well as patterns of dots and lines etc.; they are useful in many types of work, but are of particular help to the draughtsman engaged in rendering architectural subjects and interiors as can be seen in Chapter 7, 'Techniques'.

ADHESIVE SCREENS FROM THE NORMATONE° RANGE

THE SELECTED RANGE OF NORMATONE SCREENS IS SUITABLE
FOR MOST VARIOUS ILLUSTRATION WORKS, ADVERTISING ,
EDITION , INDUSTRIAL DRAFTING , ARCHITECTURE , MAPPING
WORK , DECORATION , ETC...

TECHNICAL DATA

THIN GAUGE TRANSPARENT ACETATE , MATT FINISH.
'BALANCED' ADHESIVE : CAN BE POSITIONED AND REMOVED
EASILY , HIGH RESISTANCE IN DIAZO MACHINES.
SIZE OF PRINTED AREA – 20 x 30 cm AND 43 x 55 cm.
( IN A SELECTION OF 27 PATTERNS ).

FIXING INSTRUCTIONS

USING A SPECIAL CUTTING TOOL OR SHARP KNIFE, CUT
A SECTION OF SCREEN SLIGHTLY LARGER THAN REQUIRED.
CARE SHOULD BE TAKEN NOT TO CUT THROUGH THE
BACKING SHEET.  PLACE IN POSITION ON ART-WORK
SMOOTHING LIGHTLY WITH FINGER TO HOLD IN PLACE.
REMOVE EXCESS SCREEN BY CUTTING WITH KNIFE OR
TOOL OR BY SCRAPING WITH BLADE OR KNIFE.
(PATTERNS CAN ALSO BE REMOVED WITH A MECHAN-
ICAL ERASER ).
COVER SCREEN WITH PAPER AND BURNISH HARD
WITH THE SPECIAL SPATULA (LETTER-PRESS) FOR
FIRM ADHESION.

RANGE CONSISTS OF SOME 323 SHEETS. SEE CATALOGUE.

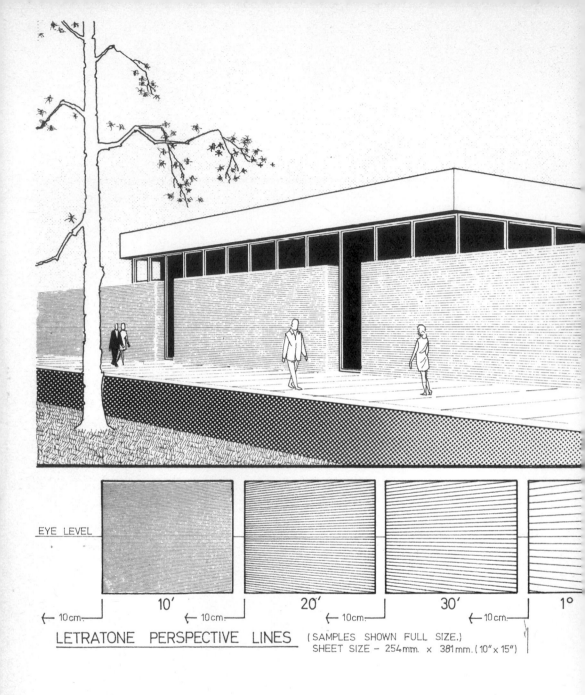

EYE LEVEL

10'    20'    30'    1°

← 10 cm →    ← 10 cm →    ← 10 cm →    ← 10 cm →

LETRATONE PERSPECTIVE LINES (SAMPLES SHOWN FULL SIZE.)
SHEET SIZE – 254 mm. × 381 mm. (10" × 15")

*Fig. 149 Letratone perspective lines.*

A comparatively new product from Letraset, these new patterns consist of sheets of perspective lines radiating from a given vanishing point. There are seven sheets in the range with lines drawn at 5', 10', 20' and 30' intervals and also at 1° intervals. The 10' and 20' sheets are designed to be used in pairs and to facilitate this are set up 10 cm. and 40 cm. from the vanishing point. The 30' and 1° sheets are set up 10 cm. from the vanishing point and the 5' one is 40 cm. from the

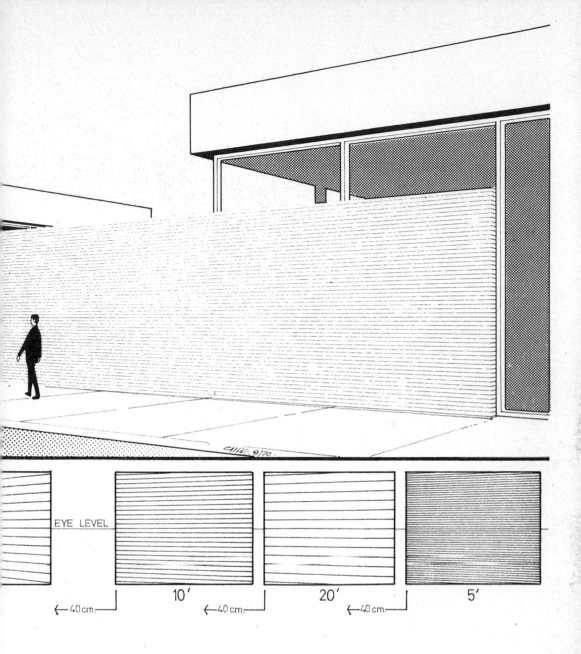

EYE LEVEL

←─40cm─→    10′    ←─40cm─→    20′    ←─40cm─→    5′

METHOD OF APPLYING LETRATONE PERSPECTIVE LINES IS
THE SAME AS FOR ALL OTHER ADHESIVE SCREENS.

vanishing point. These sheets of perspective lines reduce the
need for tedious repetitive line work on drawings. As can be
seen from the simple example shown, these sheets are easy
to use and are much more versatile than may be at first
thought. One thing that should be remembered is that when
buying these sheets, two of each type of sheet should be
purchased whenever a change of direction is required – as,
for instance, at the ends of the walls in fig. 149.

*LINEX* 1151
DENMARK.

LINEX No.1151 1:100 HOUSE FURNISHING TEMPLATE     (FULL SIZE)

$1\frac{3}{8}$

1

LINEX No.1164. ONE QUADRANT OF ELLIPSE TEMPLATE  (35°–16'.)
(FULL SIZE)

*Fig. 150 Templates.*

Templates help the draughtsman to save time and acquire accuracy when working with circles, curves and ellipses. There are a large number of makes on the market but unfortunately they vary considerably in quality and accuracy. It is important that a template is cut smoothly as any bump or hollow will be magnified when drawing from it. The furniture template, the circle template and the two ellipse templates, from Linex of Denmark, are accurate, and are recommended. The French curve is the small curve from the Burmester set by Radiant of Germany. The set

LINEX No. 1155  ELLIPSE TEMPLATE
(HALF FULL SIZE)

LINEX No. 1117  CIRCLE TEMPLATE
(HALF FULL SIZE)

AN EXAMPLE OF ONE OF THE MANY
CURVES AVAILABLE
(FULL SIZE)

consists of three templates of various sizes and though its
price is very modest, it is accurate and of excellent quality.

Among the most useful accessories for use with templates
are the 'Linex' edge strips, which are available in pairs 25 cm.
(10 in.) long and can be fitted to all templates with straight
edges. These edge strips make working in ink from templates
a much easier and safer business.

## SANITARY INSTALLATION TEMPLATE FROM STANDARDGRAPH (I)

TWO TYPES OF SANITARY INSTALLATION TEMPLATE ARE AVAILABLE IN THIS RANGE , No. I . IS SHOWN ABOVE AND No. II. (NOT SHOWN). TEMPLATE No. II COVERS COPPERS , ELECTRIC AND GAS STOVES WASH FOUNTAINS , DRINKING FOUNTAINS, COAL AND GAS GEYSERS , ELECTRIC HOT WATER TANKS , BATH TUBS , FITTINGS ETC..

BOTH TEMPLATES ARE AVAILABLE IN TWO SIZES - SCALE 1 : 100 AND 1 : 50 ( AS SHOWN ABOVE).

THE TWO TEMPLATES SHOWN ARE FROM THE LARGE STANDARDGRAPH RANGE INCLUDING CURVES SYMBOL TEMPLATES , LETTERING STENCILS AND A RANGE OF PENS.

*Fig. 151 Two templates from the Standardgraph range.*

This includes lettering guides, French curves and templates such as the two very useful ones shown. They are supplied complete with an identification sheet covering every cut-out; this is often helpful to the draughtsman. The Standardgraph range is also of high standard and is recommended. (Templates are available with fillets for ink work.)

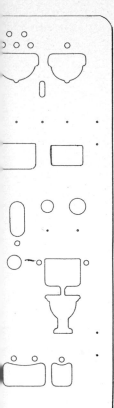

# FURNITURE TEMPLATE FROM STANDARDGRAPH

( AVAILABLE IN VARIOUS SCALES 1:200, 1:100, 1:50.)

ARCHITEKT
1 : 100

STANDARDGRAPH
No. 342

(TEMPLATES SHOWN FULL SIZE.)

ELLIPSEN.

Kurvenlineal
nach
Ing. F. Hahn

cos

sin

KURVOGRAPH

PARABELN

# KURVOGRAPH No.120

## FRENCH-CURVES TEMPLATE BY STANDARDGRAPH

THE "KURVOGRAPH" IS A NOVEL TYPE OF FRENCH-CURVES DRAFTING TEMPLATE WHICH LENDS ITSELF TO A WIDE VARIETY OF APPLICATIONS. IT CONTAINS CUT-OUTS OF ELLIPSES AS WELL AS OF PARABOLIC, HYPER-BOLIC, SINE AND COSINE CURVATURES.

THE COMPACT DESIGN OF THE TEMPLATE INS-URES RIGIDITY AND CONVENIENT WORKING. THE SIZES OF THE INDIVIDUAL CURVES HAVE BEEN ADAPTED TO RECOGNIZED THEORETICAL AND PRACTICAL STANDARDS. THANKS TO MATHEMATICAL PRECISION OF ITS CURVE CONFIGURATIONS, THE TEMPLATE IS A USEFUL DRAFTING AID FOR INSTRUCTION PURPOSES. THE TEMPLATE AFFORDS THE STUDENT BETTER INSIGHT INTO, AND FEEL OF THE CURVE CONFIGUR-ATIONS OF CONIC SECTION.

MATERIAL : CLEAR PLASTIC.

This extraordinarily compact template is one of the most valued drawing aids in the author's kit and has been his most-used template over the last ten years or so. The variety of uses to which it has been put seems unlimited, and because of this it is thoroughly recommended to the draughtsman.

*Fig. 152 The Standardgraph 'Kurvograph' No. 120.*

327

LINEX 790 DENMARK

# LINEX 790 ISOMETRIC PROTRACTOR
## MEASURES ANGLES IN THE 3 ISOMETRIC PLANES
## AND INDICATES PROJECTION ANGLES FOR ELLIPSES.
### ( PROTRACTOR SHOWN FULL SIZE )

*Fig. 153 The 'Linex 790' isometric protractor.*

Isometric drawing is becoming more and more popular both for planning and construction drawings and for instructions for use and catalogue illustrations. The advantage is a realistic drawing showing all three dimensions in the same picture, thus avoiding separate pictures of sections and side views. 'Isometric' signifies equality of measure (see p. 12): all measures for height, width and length are depicted in true size. The horizontal lines of the object are depicted under 30°, the object being turned 45° about a vertical axis and inclined 35° 16′ forwards compared to normal projection.

The protractor consists of a 19-cm. circular protractor seen in isometric projection. The ellipse protractor thus produced is encircled on the lower half by half a hexagon, which makes the protractor easier to place in the correct direction of axis by supporting one side of the hexagon on a

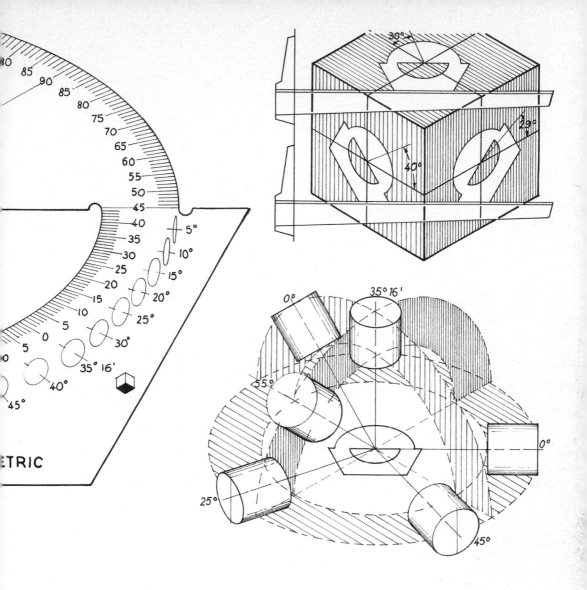

draughting machine ruler or T-square. In order to facilitate the marking of angles, the graduated arc on the lower half has been placed around a half-elliptic cut-out. The upper half-elliptic part is provided with zero points and guide lines in the isometric axis directions, and between the axes it is divided 0° to 30° and back to 0°. The half hexagon further facilitates the placing of the protractor on the three isometric main planes: when using the horizontal or XY plane, place the protractor with the middle edge at the bottom, and when using it on the right-hand or XZ plane, tilt the protractor to the left so that the left edge is turned downwards. On the edges are imprinted isometric cubes, the side at which one is working being dark, thus clearly showing the correct placing. Moreover, the protractor is provided with indications of circle projections for different directions of angles,

WITH A PENCIL IN ONE OF THE HOLES A LINE IS DRAWN SLIDING THE SET SQUARE ALONG A RULER. THE THREE ROWS OF HOLES IN THE CENTRE ARE FOR HATCHING. THE FOUR-HOLE-GROUPS GIVE GUIDELINES FOR LETTERS IN THE MENTIONED HEIGHTS 2-15 mm, HEIGHT OF SMALL LETTERS IS 2/3 OF THE CAPITALS. INCLINATIONS OF 68° AND 75° ARE GIVEN. MATERIAL: 1·5 mm. (0.06″) GREEN-TRANSPARENT, SUPERFLEXIBLE RINO.

# LINEX LETTERING SET SQUARE (METRIC)
## FOR HATCHING AND DRAWING GUIDE LINES FOR LETTERING

in the shape of ellipses from 5° to 55°. These ellipses are used to draw circles in a plane at right angles to a given axis direction which is to be found on the protractor. If the axis direction is 0° or 90° from the right-hand side (XZ plane), this produces 35° 16′ ellipses on the other two isometric planes. If a circle is to be drawn on a plane at 45° to YZ, the ellipses will be 55° up and 0° down.

## LINEX PARALLELOGRAPH
### FOR LETTERING AND HATCHING

WITH A PENCIL IN ONE OF THE HOLES IN THE DISK A LINE IS DRAWN SLIDING
THE PARALLELOGRAPH ALONG A RULER. THE DISTANCE BETWEEN THE PARALLEL
LINES CAN BE ADJUSTED BY TURNING THE DISK. THE HOLES IN THE CENTRE
ARE FOR HATCHING, THE OTHER HOLES ARE FOR GUIDELINES FOR LETTERING.
HEIGHT OF SMALL CHARACTERS IS ON THE LEFT 3/5 AND ON THE RIGHT 2/3
OF CAPITALS. INCLINATIONS OF 68° AND 75° ARE GIVEN.
MATERIAL: 2 mm. (0.08") GREEN-TRANSPARENT, SUPERFLEXIBLE RINO.

The first drawing shows a 'Linex' lettering set square (metric), and the second shows a 'Linex' parallelograph, which is a little more complex but will enable the draughtsman to adjust the instrument to suit his own requirements. The method of using both instruments is clearly shown in the figure.

*Fig. 154 Two templates for use in lettering and hatching.*

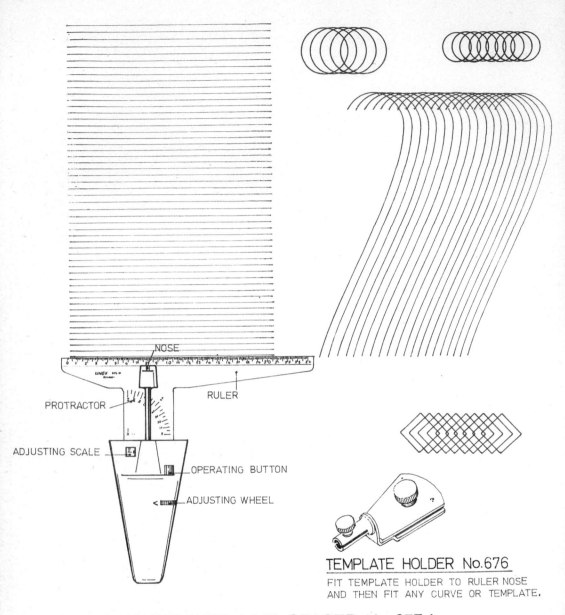

NOSE

PROTRACTOR

RULER

ADJUSTING SCALE

OPERATING BUTTON

ADJUSTING WHEEL

TEMPLATE HOLDER No.676
FIT TEMPLATE HOLDER TO RULER NOSE
AND THEN FIT ANY CURVE OR TEMPLATE.

LINEX AUTOMATIC LINE SPACER No.6751

Fig. 155  *Two instruments for hatching.*

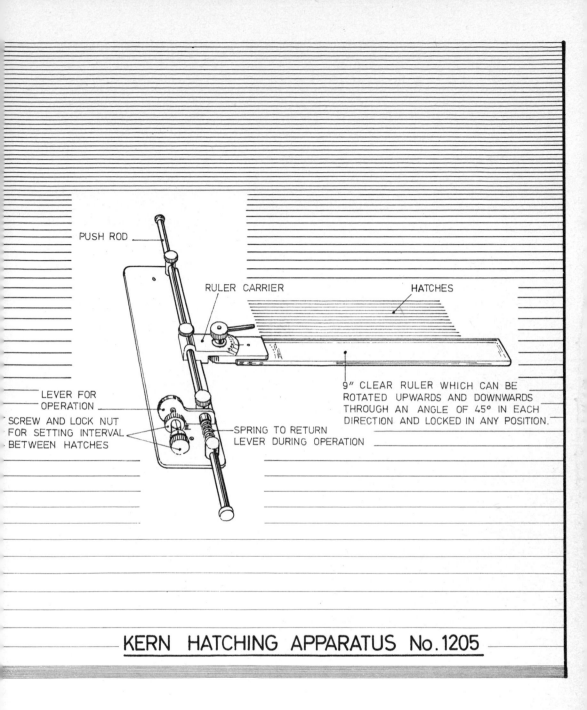

PUSH ROD

RULER CARRIER

HATCHES

LEVER FOR OPERATION

SCREW AND LOCK NUT FOR SETTING INTERVAL BETWEEN HATCHES

SPRING TO RETURN LEVER DURING OPERATION

9" CLEAR RULER WHICH CAN BE ROTATED UPWARDS AND DOWNWARDS THROUGH AN ANGLE OF 45° IN EACH DIRECTION AND LOCKED IN ANY POSITION.

## KERN HATCHING APPARATUS No. 1205

The instruments shown in fig. 155 are sufficiently different to make both of them of use to the draughtsman. The Kern hatching apparatus No. 1205 is the more expensive of the two and is solidly constructed. It has a Perspex ruler, which can be rotated upwards and downwards through an angle of 45° in each direction and locked in any position desired.

*Instructions for use.* Loosen the screws holding the ruler carrier, push the rod to its full extent from the end with lever operation. Slide the ruler carrier to the lever operation end and lock with the screw. The interval between the hatches is set with the graduated screw, and the lock nut locks the mechanism. (One revolution of the graduated screw from 0 to 0 corresponds to an interval of 1 mm. = 0.039 in.) When hatching, the left thumb is placed against the head of the graduated screw and an even pressure is applied with the forefinger to the lever for operation until it comes up against the screw. In this way the push rod and the ruler carrier are displaced downwards through the distance that has been set. On letting go with the forefinger the lever returns to its original position under the action of the spring and the operation can be repeated.

The hatches surrounding the drawing show some of the possibilities of this instrument. The top section has been drawn with the instrument set as described. The gradual variation of the distance between the lines as they proceed down the page is achieved by turning the graduated screw one division for each line. Alterations to the setting of the instrument can be made without moving the instrument, and in fact with one hand only.

Also shown in fig. 155 is the 'Linex' automatic line spacer No. 675 1. This is considerably cheaper than the Kern instrument and although without some of the advantages of the Kern it performs well and is simple to use. The housing is made of shatterproof plastic material and has a ruler of clear acrylic with tracing edge and divisions. The ruler moves at the pressure of a button and the instrument lies firmly on the paper when in use, held in position by rubber plates. Any interval between 0 and 6 mm. (approx. $\frac{1}{4}$ in.) can be obtained. The 'Linex' line spacer, however, has one advantage over the Kern instrument and that is the template holder 676, with which any ruler, template or curve can be fitted to the instrument for pattern hatching. A few examples from various templates are shown around the drawing of the instrument. This attachment gives endless possibilities for experiment with unusual and interesting patterns.

*Instructions for use.* When the ruler is pulled out to its furthest position the black adjusting scale is visible and its zero-mark is then covered by the red index line of the magnifier. Adjustment of the apparatus may be made continuously for any hatching interval between 0 and 6 mm. For example: adjust on $1\frac{1}{2}$ mm. Turn the wheel entirely to the left (zero-position) but not so hard that the wheel

locks. Hold the automatic apparatus in the left hand, with the forefinger on the button, and keep it pressed down all the time while the wheel is turned to the right with the right thumb until the adjusting scale indicates $1\frac{1}{2}$ mm. Thereupon the ruler is moved $1\frac{1}{2}$ mm. ($\frac{3}{32}$ in.) each time the button is pressed. When the end of the instrument's range is reached, press the ruler firmly against the paper, raise the housing of the apparatus and pull it back ready to continue with the hatching uninterrupted.

The Centrolinead (fig. 156), developed especially for perspective drawing, enables the draughtsman to work with vanishing points which are a considerable distance away from the drawing, thus simplifying the job considerably. The instrument is calibrated for distances up to 300 in. (i.e. 300 in. from the centre line of vision).

It is intended to give only a brief description of the use of the Centrolinead here as an instruction book is included with each instrument.

Place the blade of the Centrolinead along a line, such as the horizon line, or any other line that is known to pass through the vanishing point. The head or arms of the instrument should be as near as possible to the left-hand side of the board. (Scales A and B are for a vanishing point opposite the arms; C and D are for a vanishing point on the same side as the arms.)

To set up the Centrolinead for a vanishing point on the left-hand side, measure the distance between VP1 and the centre line of vision (in this case 85 in.). With the instrument in position as previously described, measure the distance between the zero mark of scales A and B and VP1 (in this case 70 in.). As a check, measure the distance between the zero mark of scales A and B and the centre line of vision (in this case 15 in.). These dimensions should add up to the total distance between VP1 and the centre line of vision (85 in.).

With the blade still on the horizon line (in this case) insert pins in the board against mark 70 on scales A and B. The instrument can now be moved against these pins, and lines drawn along it will converge to VP1. If the distance between the zero mark of scales A and B and VP1 is greater than the highest practical number on these scales, then the scales on the inner edges can be used up to approximately 350 in. When using the inner scales the procedure is exactly the same except that the zero mark of the inner scale is used.

The method for setting up the Centrolinead for vanishing points on the right-hand side is as follows. Measure the distance between VP2 and the centre line of vision (in this case 70 in.). Measure the distance between the centre line of vision and the zero mark of scales C and D (20 in.). Add these two dimensions together (90 in.). With the instrument in position as previously described (with the blade on the

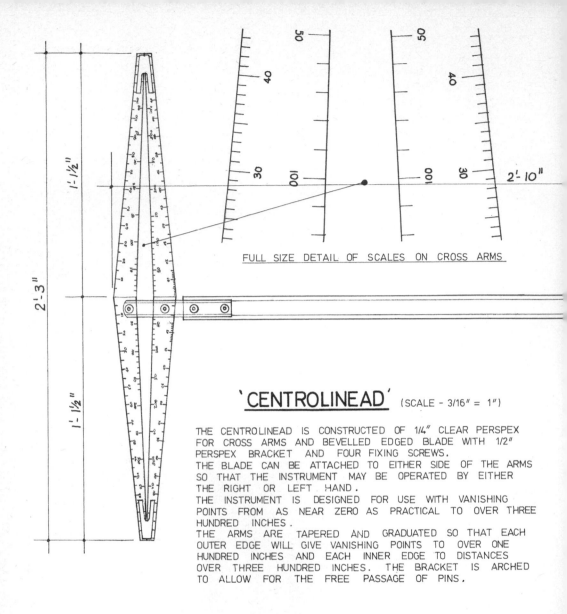

FULL SIZE DETAIL OF SCALES ON CROSS ARMS

`CENTROLINEAD` (SCALE - 3/16″ = 1″)

THE CENTROLINEAD IS CONSTRUCTED OF 1/4″ CLEAR PERSPEX
FOR CROSS ARMS AND BEVELLED EDGED BLADE WITH 1/2″
PERSPEX BRACKET AND FOUR FIXING SCREWS.
THE BLADE CAN BE ATTACHED TO EITHER SIDE OF THE ARMS
SO THAT THE INSTRUMENT MAY BE OPERATED BY EITHER
THE RIGHT OR LEFT HAND.
THE INSTRUMENT IS DESIGNED FOR USE WITH VANISHING
POINTS FROM AS NEAR ZERO AS PRACTICAL TO OVER THREE
HUNDRED INCHES.
THE ARMS ARE TAPERED AND GRADUATED SO THAT EACH
OUTER EDGE WILL GIVE VANISHING POINTS TO OVER ONE
HUNDRED INCHES AND EACH INNER EDGE TO DISTANCES
OVER THREE HUNDRED INCHES. THE BRACKET IS ARCHED
TO ALLOW FOR THE FREE PASSAGE OF PINS.

THE CENTROLINEAD SHOWN IS MANUFACTURED BY W. H. HARLING LTD. MOORGATE. LONDON.

*Fig. 156 Centrolinead.*

horizon line) insert pins in the board against mark 90 on
scales C and D. The instrument can now be moved against
these pins, and lines drawn along it will converge to VP2.
As with scales A and B, if the distance between the zero mark
of scales C and D and VP2 is greater than the highest
practical number on these scales, the figures on the inside
edges of these scales can be used.

This instrument is very efficient and should cover at a
moderate cost all the needs of the draughtsman engaged in
perspective drawing.

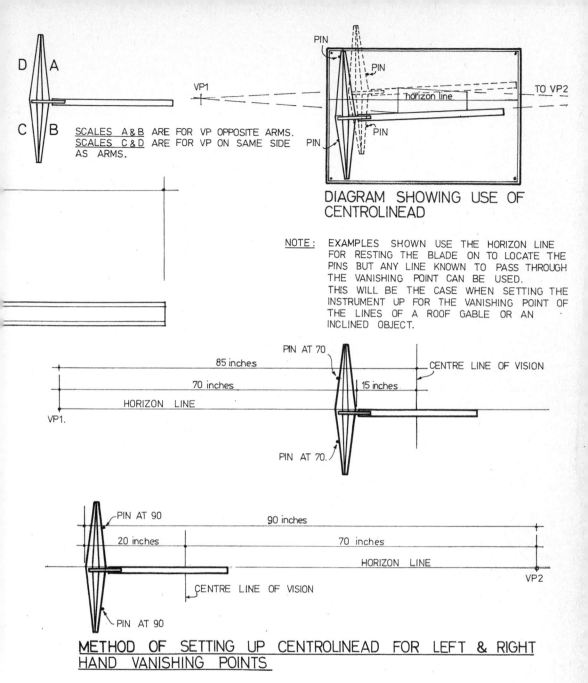

SCALES A & B ARE FOR VP OPPOSITE ARMS.
SCALES C & D ARE FOR VP ON SAME SIDE
AS ARMS.

## DIAGRAM SHOWING USE OF CENTROLINEAD

NOTE: EXAMPLES SHOWN USE THE HORIZON LINE
FOR RESTING THE BLADE ON TO LOCATE THE
PINS BUT ANY LINE KNOWN TO PASS THROUGH
THE VANISHING POINT CAN BE USED.
THIS WILL BE THE CASE WHEN SETTING THE
INSTRUMENT UP FOR THE VANISHING POINT OF
THE LINES OF A ROOF GABLE OR AN
INCLINED OBJECT.

## METHOD OF SETTING UP CENTROLINEAD FOR LEFT & RIGHT HAND VANISHING POINTS

TRANSPARENT EDGE

K&E 57 2817-18
KEUFFEL & ESSER CO.

COPPER WIRE

MINIMUM RADIUS 3 INCHES

This is available in four lengths: 12 in., 18 in., 24 in. and 30 in. Curve rules solve the problems of ruling a smooth curve through any given set of points. They lie flat on the board and are easy to use; they can be bent to fit a contour to a 3-in. radius and will hold this position without support. The clear plastic ruling edge stands away from the board to allow for ink work. The flexible curve rule is strong and durable and is not subject to permanent sets. The Keuffel & Esser rule is one of the best on the market and is recommended to the draughtsman.

TRANSPARENT EDGE

Fig. 157 Flexible curve rule
from the Keuffel & Esser Co.

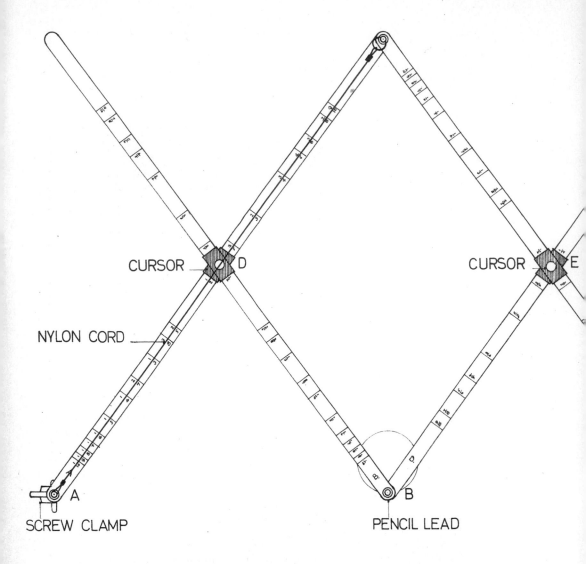

CURSOR D

NYLON CORD

CURSOR E

A
SCREW CLAMP

B
PENCIL LEAD

## NESTLER No. 2495 - 24″ PANTOGRAPH
### PANTOGRAPH SHOWN SET FOR 1/2 REDUCTION

*Fig. 158 A simple and inexpensive pantograph.*

This instrument consists of 24-in. wooden bars with the various ratios engraved on each arm and a metal slide movement setting for reduction and enlarging. There are a number of very good pantographs on the market, such as the Maho 7200 (not shown), which includes a cable release, magnifier and pen attachment; the specialist should make his selection from this type of instrument, but for the draughtsman who has only occasional use for a pantograph the Nestler is simple and accurate.

**TRACER**

# INSTRUCTIONS FOR USE

A PANTOGRAPH IS USED FOR ENLARGING AND REDUCING OF DRAWINGS, PLANS, PATTERNS, ETC.

IT IS FIXED BY THE SCREW CLAMP AT POINT A ON THE LEFTHAND SIDE OF DRAWING BOARD.

IN ORDER TO ENLARGE A DRAWING PUT THE CURSORS D AND E AT THE CORRESPOND- ING MARKS ENGRAVED ON THE BARS, THE TRACER IN POINT B AND THE LEAD POINT IN C. THE LEFT HAND FOLLOWS THE ORIGINAL DRAWING WITH TRACER B, WHILST THE RIGHT HAND PUTS SLIGHT PRESSURE ON THE LEAD POINT IN C THUS OBTAINING THE ENLARGEMENT.

FOR REDUCTION CHANGE TRACER FROM B TO C AND LEAD POINT FROM C TO B, AND PROCEED INVERSELY.

THE FOLLOWING TABLES GIVE THE RATIOS MARKED ON THE BARS.

| MARKS. | $\frac{1}{10}$ | $\frac{1}{8}$ | $\frac{1}{7}$ | $\frac{1}{6}$ | $\frac{1}{5}$ | $\frac{1}{4}$ | $\frac{2}{7}$ | $\frac{1}{3}$ | $\frac{3}{8}$ | $\frac{2}{5}$ | $\frac{1}{2}$ | $\frac{3}{5}$ | $\frac{2}{3}$ | $\frac{3}{4}$ | $\frac{4}{5}$ | $\frac{5}{6}$ | $\frac{7}{8}$ | $\frac{9}{10}$ |
|---|---|---|---|---|---|---|---|---|---|---|---|---|---|---|---|---|---|---|
| ENLARGEMENT. | 10 | 8 | 7 | 6 | 5 | 4 | 3½ | 3 | 2⅔ | 2½ | 2 | 1⅔ | 1½ | 1⅓ | 1¼ | 1⅕ | 1⅐ | 1⅑ |
| REDUCTION. | $\frac{1}{10}$ | $\frac{1}{8}$ | $\frac{1}{7}$ | $\frac{1}{6}$ | $\frac{1}{5}$ | $\frac{1}{4}$ | $\frac{2}{7}$ | $\frac{1}{3}$ | $\frac{3}{8}$ | $\frac{2}{5}$ | $\frac{1}{2}$ | $\frac{3}{5}$ | $\frac{2}{3}$ | $\frac{3}{4}$ | $\frac{4}{5}$ | $\frac{5}{6}$ | $\frac{7}{8}$ | $\frac{9}{10}$ |

A SMALLER VERSION OF THIS PANTOGRAPH IS AVAILABLE WITH 16" BARS (NESTLER No.2490)

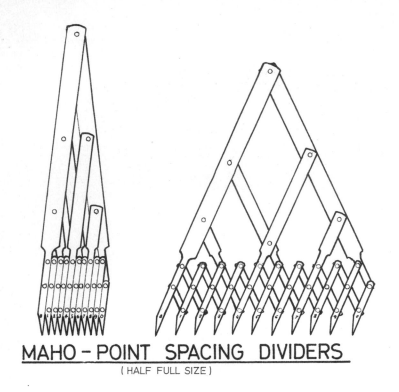

# MAHO – POINT SPACING DIVIDERS

( HALF FULL SIZE )

# 12" ROLLING PARALLEL RULER (K&E)

*Fig. 159 Dividers, parallel rulers and ellipsograph.*

This figure shows four instruments of which at least two are unusual. Both are from the Maho range (Germany). The first is the Maho point spacing dividers, an instrument which comes in two sizes, the smaller of the two being shown here at half size. With this instrument it is possible to divide a line into up to ten equal parts (maximum length of line 9 in.). The second of these Maho instruments is the ellipsograph (PC45-DRP). The special advantages of this instrument consist in the fact that it is located directly above the drawing plane and that it remains immovable in the fixed position by means of a firm foot in connection with a bracket. By adjustment of the scales on the two square cross-arms, any

# MAHO – ELLIPSOGRAPH   ( PC 45 - DRP)

# 12″ LINEX – PARALLEL RULER  (ACRYLIC)

shape and size of ellipse may be determined by moving the sleeves mounted on them. The tracing of the ellipse is effected by turning the button on the upper part of the instrument. By one turn the entire ellipse is traced. Instructions for use are included with each instrument, which makes its manipulation simple and easily intelligible. The PC45 size 1 traces figures with a longitudinal section of up to 350 mm.

Two examples of parallel rulers are shown in fig. 159, the first of these being the rolling parallel ruler made by Keuffel & Esser Co. (564192). This instrument is sturdily constructed to assure accuracy of motion; these heavy brass

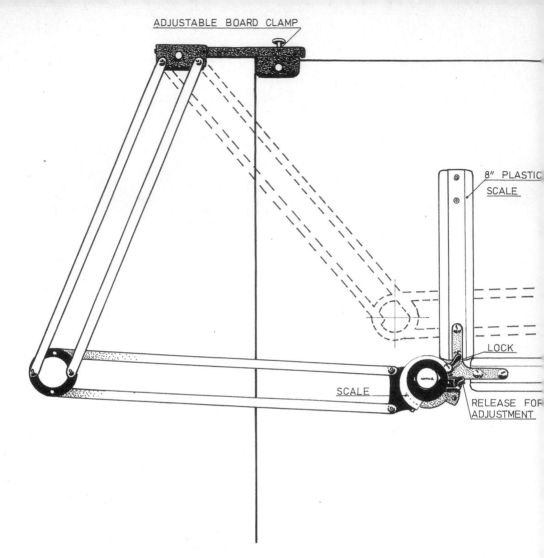

ADJUSTABLE BOARD CLAMP

8" PLASTIC
SCALE

LOCK

SCALE

RELEASE FOR
ADJUSTMENT

rolling parallel rulers are used for map measuring and as a drawing aid in making parallel lines. Knurled rollers assure maintenance of whatever angle the ruler is set at. The metal guard over the axle is shaped to form a convenient handle. This parallel ruler is available in either 12-in. or 18-in. lengths.

The second parallel ruler in fig. 159 is a 12-in. 'Linex' parallel ruler (standard). This instrument has bevels on all working sides and all the metal parts are of nickel-plated brass. Springs built into the bearings secure a pleasant motion, and prop-discs on the underside prevent sliding and soiling the paper. The rulers are made of clear acrylic and are available with or without protractor markings. The 'Linex' parallel ruler is available in four sizes: 12 in., 15 in., 18 in. and 21 in.

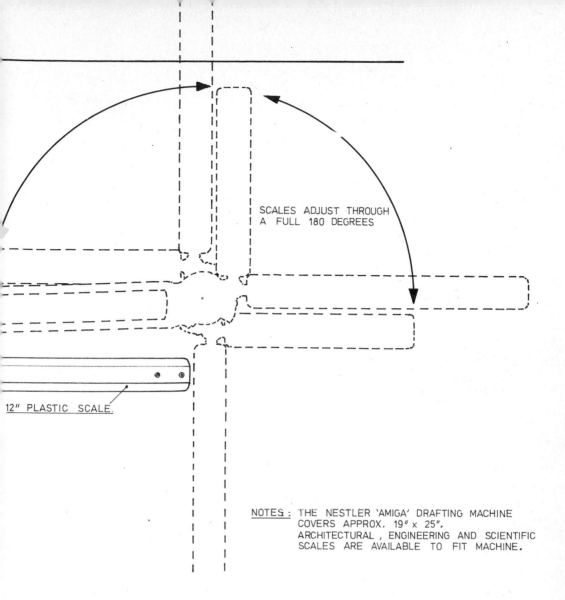

SCALES ADJUST THROUGH
A FULL 180 DEGREES

12" PLASTIC SCALE.

NOTES : THE NESTLER 'AMIGA' DRAFTING MACHINE
COVERS APPROX. 19" x 25".
ARCHITECTURAL , ENGINEERING AND SCIENTIFIC
SCALES ARE AVAILABLE TO FIT MACHINE.

This is one of the smaller types in the large range of draughting machines made by this company. The 'Amiga' is supplied with one 8-in. scale and one 12-in. scale in any one of three types: model A, full and half-size inch mechanicals, 32nd divisions; model B, $\frac{1}{8}$ in. $\frac{1}{4}$ in., $\frac{1}{2}$ in., 1 in. to the foot, for architects; model C, millimetres on one side, inking edge other side, for scientists.

The draughting machine is used instead of a T-square and set square or parallel rule and has many advantages over these for much of the draughtsman's work. They are quick, accurate and easy to use, and are favoured by engineers and some architects. The 'Amiga' draughting machine can be fastened to any drawing board with a screw clamp and is simple to set for working. It is easily removed and stored in a specially designed carrying case which is supplied with every machine.

*Fig. 160 The Nestler 'Amiga' draughting machine.*

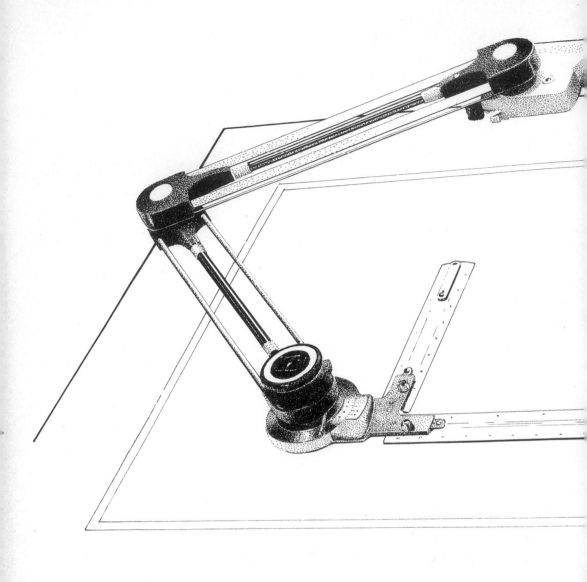

*Fig. 161 'Max' Plan-Master.*

This machine is designed for use on a slanting board, and has a built-in balance adjustment device which can be tensioned to suit the user. This means that when working on a sloping surface (up to 30°) the machine can be placed anywhere on the board and will not slip down. Because of the tension mechanism it is easy and light in operation. The 'Max' Plan-Master PM-19AS11 is an instrument with a high degree of accuracy, is of high quality and is recommended to the draughtsman who requires a machine for use on a sloping board.

THE 'MAX' PLAN-MASTER IS DESIGNED FOR USE ON
DRAFTING BOARDS UP TO 30° SLOPE . IT IS MOST
SUITABLE FOR USE ON DRAFTING BOARDS OF 900 mm.
x  1200 mm. ( 35.4" x 47.3") AND CAN BE USED FOR
UP TO  A1. SIZE DRAWINGS .

BY THE ADOPTION OF CAMS AND COIL SPRINGS , THIS
INSTRUMENT IS ALWAYS WELL BALANCED REGARDLESS
OF THE SPOT WHERE IT IS USED. AND NO EXCESS-
IVE  LOAD  IS  IMPOSED  ON  ANY  PART  OF  THE
INSTRUMENT  THEREBY  REDUCING  THE  RESISTIVE
FORCE  BY  A  WIDE  MARGIN .
THE  BALANCE  ADJUSTMENT  DEVICE  IS  BUILT IN THE
VICE  PORTION  OF  THIS  INSTRUMENT  WHICH  ELIMIN-
ATES  THE  NECESSITY  OF  A  COUNTER - WEIGHT.

SCOPE   OF   DRAWING    —    900 mm. x  1,200 mm .

LENGTH  OF  SCALES.    —    300 mm. x   200 mm.

LENGTH  OF  ARMS.    —    480 mm. x  2

NET  WEIGHT.    —    3.8 Kg.

THE  'MAX'  PLAN -MASTER  PM - 19 AS II  IS  THE
PRODUCT  OF   MAX  CO., LTD. , TOKYO. , JAPAN.

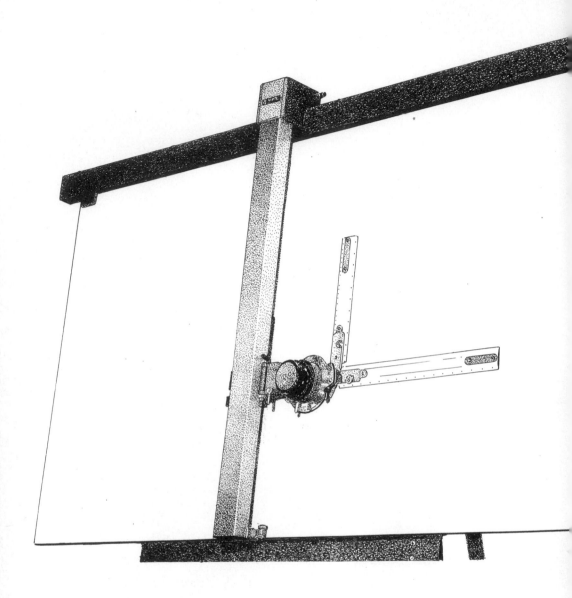

*Fig. 162 The Kent 'Classic' track type draughting machine.*

This is slightly more complex than the 'Amiga' but has similar advantages. It is quick, accurate and easy to use and can be fastened to any drawing board with two screw clamps. The vertical bar is fitted with a positive locking device which makes for ease of use. The Kent 'Classic' is an instrument of high quality and is recommended to the draughtsman.

# KENT 'CLASSIC' DRAFTING MACHINE

## MOUNTING INSTRUCTIONS

TWO CLAMPS MOUNT HORIZONTAL RAIL TO BOARD.
TAKE OUT SCREW LOCKING THE COUNTERWEIGHT, ADJUST
THE WHEEL HEIGHT AT THE BOTTOM OF VERTICAL RAIL.
ATTACH THE HEAD TO VERTICAL RAIL, INSERT A PAIR
OF SCALES.
THE DRAFTING MACHINE IS READY FOR USE.

## FEATURES

FINGER TIP POSITIVE CONTROL LOCK IS OPERATED ON
VERTICAL RAIL.
CARRIAGES RUN ON FOUR PRECISION MACHINED WHEELS.
DRAFTING HEAD COUNTERWEIGHT RUNS ON FOUR MACHINED
WHEELS, HAS BUILT IN TRAVEL LOCK TO PROTECT
AGAINST SHIPPING DAMAGE.
CLOSED BOX SECTION EXTRUDED ALLOY RAILS ASSURE
RIGIDITY. VERTICAL RAIL HAS VAST ADJUSTMENT TO VARY
BOARD HEIGHTS UP AND DOWN.
DRAFTING HEAD FEATURES – NO-SLIP SCALE CHUCK LOCKS,
360° HEAD WITH 60 MINUTE VERNIER, 15° AUTOMATIC
SNAP INDEX, FREE WHEEL ANY ANGLE LOCK LEVER AND
BASE LINE MECHANICAL "RETURN TO ZERO LOCK".
VERTICAL RAIL CAN SWING UP FROM DRAWING BOARD
FREELY TO AN ANGLE OF 125°.
RUBBER BUMPERS PROVIDE FOR VERTICAL AND HORIZONTAL
LIMIT STOPS.

[ KENT 'CLASSIC' IS A JAPANESE PRODUCT.]

TOP

# INSTRUCTIONS FOR ASSEMBLY
# THE KENT PARALLEL MOTION UNIT

1.    MOUNT THE TWO METAL GUIDE RUNNERS AT EACH CORNER AT THE TOP FACE OF THE BOARD. PLACE THE GUIDE RUNNER WITH THE CLAMP SCREW AT THE RIGHT HAND SIDE, SO THAT THE WIRES WHEN FITTED ROUND THE PULLEY ARE ABOUT 1/4" IN FROM THE EDGE OF THE BOARD.

2.    PLACE THE STRAIGHTEDGE FLAT ON THE BOARD UP AGAINST THE TWO BRACKETS AND PLACE THE WIRES WITH THE SPRING ROUND THE PULLEYS, KEEPING THE TENSION SPRING IN THE CENTRE OF THE BOARD.

3.    DRAW THE TWO ENDS OF THE WIRE DOWN TO THE LOWER EDGE OF THE BOARD AND SECURE IN PLACE WITH THE NYLON OVERIDES WHICH ARE PLACED WITH THE SMALL LIP RESTING ON THE EDGE OF THE BOARD.    SECURE THE WIRES WITH THE SCREWS AND WASHERS PROVIDED SO THAT THE WIRES ARE RUNNING APPROXIMATELY 1/4" FROM THE SIDES OF THE BOARD. LOCK THE WIRE IN POSITION AT THE CLAMP FITTING ON THE TOP RIGHT HAND GUIDE MOUNTING.

4.    FIX THE TWO SLIDE GUIDES IN PLACE BY LOOSENING THE TWO SCREWS AT EACH END OF THE STRAIGHTEDGE AND INSERT THE SQUARE SECTION INTO THE RECESS AND TIGHTEN UP THE SCREWS.

---

KENT PARALLEL MOTION UNITS ARE AVAILABLE IN THE FOLLOWING FOUR SIZES:

Nº 32.    (IMPERIAL SIZE BOARD) ———— 32"
Nº 42.    (DOUBLE ELEPHANT SIZE BOARD) — 42"
Nº 54.    (ANTIQUARIAN SIZE BOARD) ———— 54"
Nº 60.    (HAMBURG SIZE BOARD) ———— 60"

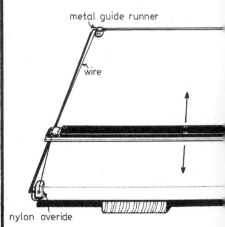

metal guide runner

wire

nylon overide

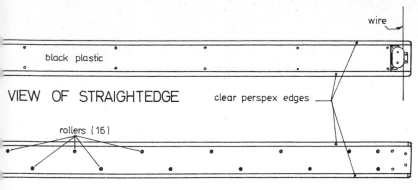

## VIEW OF STRAIGHTEDGE

wire

black plastic

clear perspex edges

rollers (16)

## UNDERSIDE VIEW OF STRAIGHTEDGE

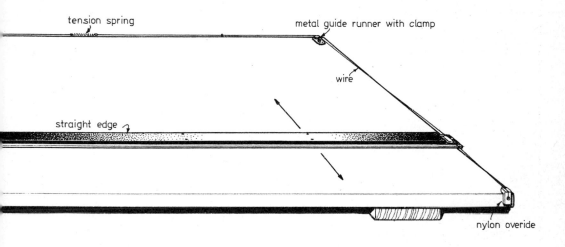

tension spring

metal guide runner with clamp

wire

straight edge

nylon overide

This is a type of instrument that has a number of advantages over the T-square. It remains parallel at all times and can be moved up and down the board freely, and once the parallel motion unit is positioned it remains fixed until moved, leaving the draughtsman with both hands free. The instrument moves freely on rollers fitted to its underside and is simple to fit.

*Fig. 163 The Kent parallel motion unit (42-in.).*

# OPERATION OF HAND-PIECE

CONNECT THE VALVE TO THE AIR-HOSE WHICH IS IN TURN CONNECTED TO EITHER A BOTTLE OF COMPRESSED AIR OR A SMALL COMPRESSOR. IF A BOTTLE OF COMPRESSED AIR IS USED THE AIR-PRESSURE SHOULD BE ADJUSTED TO KEEP IT WITHIN 2 – 3.5 kg/cm.$^2$
WHEN THE CONTROL LEVER IS PRESSED DOWN ONLY AIR IS BLOWN THRU' THE INSTRU-MENT. TO SPRAY PIGMENT THE CONTROL LEVER IS PRESSED DOWN AND DRAWN BACK SIMULTANEOUSLY. THE FURTHER BACK THE CONTROL LEVER IS DRAWN BACK THE GREATER THE QUANTITY OF PIGMENT DELIVERED TO THE WORKING SURFACE.
WHEN THE INSTRUMENT IS HELD CLOSE TO THE PAPER A VERY FINE LINE CAN BE DRAWN. THE FURTHER BACK FROM THE WORKING SURFACE THE INSTRUMENT IS MOVED THE THICKER THE LINE BECOMES. TO SPRAY LARGER AREAS IT IS NECESSARY TO MOVE FURTHER FROM THE WORKING SURFACE AND DRAW THE CONTROL LEVER BACK AS FAR AS IT WILL GO. IT IS ESSENTIAL TO KEEP THE INSTRUMENT MOVING WHILE SPRAYING IF PUDDLES ARE TO BE AVOIDED.
IN CASE OF AIR ESCAPING INTO CUP DUE TO THE INSTRUMENT BEING USED OVER A LONG PERIOD IT IS NECESSARY TO TIGHTEN THE PACKING PUSH FROM BOTH SIDES GENTLY. IF NOT TIGHTENED EVENLY THE NEEDLE WILL LEAN TO ONE SIDE OR THE OTHER WHICH WILL CAUSE THE INSTRUMENT TO MALFUNCTION. THE PACKING PUSH SHOULD BE OILED AT LEAST ONCE A MONTH.

# CLEANING

IT IS IMPORTANT TO CLEAN THE HAND-PIECE THOROUGHLY AT THE CONCLUSION OF EACH PART OF THE WORK. POUR WATER INTO THE CUP AND REMOVE THE PIGMENT ENTIRELY BY REPEATING 2 OR 3 TIMES.
AT THE COMPLETION OF THE WORK TAKE OFF THE CAP AND TURN THE NEEDLE CAP TO THE LEFT IN ORDER TO LOOSEN IT AND REMOVE THE NEEDLE. THE NEEDLE SHOULD BE CAREFULLY WIPED WITH A SOFT CLOTH IN ORDER TO REMOVE ALL TRACES OF PIGMENT. THE NEEDLE SHOULD BE HANDLED WITH EXTREME CARE AS IT IS EASILY DAMAGED.
AFTER THE NEEDLE CAP AND THE NOZZLE CAP ARE REMOVED THE INSIDE OF THE BODY OF THE INSTRUMENT SHOULD BE THOROUGHLY WIPED CLEAN.
THE INSTRUMENT SHOULD BE RE-ASSEMBLED WITH CARE IN THE SEQUENCE SHOWN IN THE INSTRUCTIONS INCLUDED WITH EACH HAND-PIECE TO AVOID BENDING THE NEEDLE.

THE INSTRUMENT SHOWN IS ONE OF A RANGE OF AIRBRUSHES AVAILABE FROM THIS JAPANESE COMPANY. THE RANGE IS MADE UP OF DIFFERENT SIZES OF INSTRUMENT FOR DIFFERENT TYPES OF WORK. THE INSTRUMENT SHOWN IS CONSIDERED TO BE THE MODEL BEST SUITED TO THE TYPE OF WORK INCLUDED ELSEWHERE IN THIS BOOK.

*Fig. 164 Air brush.*

When mastered, the air brush can add a great deal to the quality of the draughtsman's work. The cost of the equipment may place it beyond the reach of the student, but to the professional this can be justified fairly easily if only for the increased scope it gives. Air brushes are fairly simple to use and a great deal can be learned by use and experiment. The student is advised to look at the work of Helmut Jacoby, in whose architectural renderings the possibilities of this

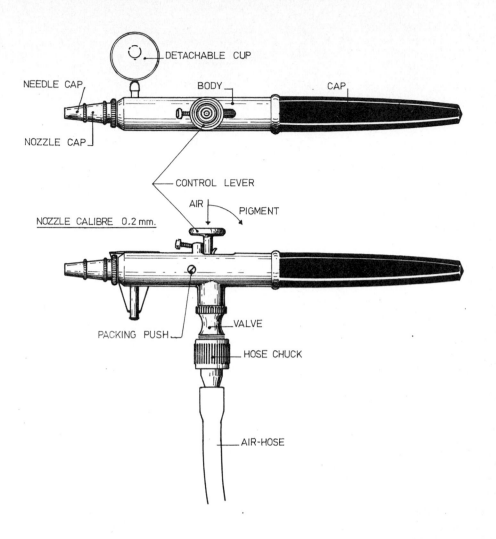

DETACHABLE CUP

NEEDLE CAP

NOZZLE CAP

BODY

CAP

CONTROL LEVER

AIR    PIGMENT

NOZZLE CALIBRE 0.2 mm.

PACKING PUSH

VALVE

HOSE CHUCK

AIR-HOSE

# THE 'HOLBEIN' NEO-HOHMI 45011 AIRBRUSH

( HAND PIECE SHOWN 3/4 FULL SIZE.)

instrument can be seen. It is of course important in other fields as well, but we need not go further into this here as there are two or three good books on the subject of the air brush and its use listed in the bibliography on p. 364.

As with other instruments shown in this chapter there are a number of good reliable makes of air brushes available on the market: the 'Holbein' air brush shown here is the instrument used by the author.

FRONT ELEVATION

PLAN

*Fig. 165  Pen cleaner.*

The Rotring ultrasonic pen cleaner is of more use to the office where a large number of draughtsmen are employed; the light table (fig. 166), on the other hand, is a very useful piece of equipment to anyone tracing or using adhesive screens, 'Instantex' or similar products.

The pen cleaner, while it is designed for use with Rotring drawing instruments and accessories, can be used for all types and makes of such equipment. It has the advantage, when used with the Rotring drawing instrument, that the whole piece can be placed in the cleaner and it will be cleaned

INSTRUCTIONS FOR THE CLEANING OF TECHNICAL
DRAWING INSTRUMENTS

1. FILL STAINLESS STEEL BATH UP TO 3 CM.
OR 1 1/4 INCHES WITH TAP WATER.

2. ALSO FILL THE CLEANING CONTAINER (GLASS
INSERT) TO 2/3 RDS. FULL WITH TAP WATER
AND DETERGENT.

3. ACCORDING TO HOW DIRTY THE INSTRUMENT
IS, SET THE TIMER. ON FIRST SIGNS OF A
DRAWING INSTRUMENT BECOMING DIRTY OR
CLOGGED IMMERSE IN GLASS CONTAINER FOR
1 MINUTE. FOR MORE ENCRUSTED DRAWING
INSTRUMENTS SET THE TIMER FOR A LONGER
PERIOD.

4. REMOVE DRAWING INSTRUMENT FROM FLUID
BY HOLDING POINT DOWNWARDS TO AVOID THAT
THE CLEANING FLUID GETS INTO THE AIR
CHANNEL. DRY HEAD THOROUGHLY AND DRY
AIR CHANNEL WITH BLOTTING PAPER.

N.B. FOR NORMAL CLEANING IT IS NOT NECESS-
ARY TO DISMANTLE A DRAWING INSTRUMENT.

ATTENTION :

IF DRAWING INSTRUMENT IS COMPLETELY CLOGGED,
SEPARATE INK RESERVOIR FROM THE FRONT
PART AND UNSCREW CONE AND SUBMERGE ON
SIEVE INTO CLEANING FLUID. DRY EACH
PART SEPARATELY.

WHEN CLEANING A FOLIOGRAPH DRAWING
INSTRUMENT, THAT HAS BEEN FILLED WITH
SPECIAL FILM INK OR ACID INKS, THEN
EXCHANGE THE TAP WATER IN THE CLEANING
CONTAINER ( GLASS INSERT ) WITH 'ROTRING'
SOLUTION FOR FILM INK. HERE IT WOULD
BE SUFFICIENT IF THE DRAWING INSTRUMENT
PARTS ARE JUST COVERED WITH SOLUTION.

(THE ABOVE IS A TRANSLATION OF THE
INSTRUCTIONS IN GERMAN SHOWN ON
THE TOP OF THE ROTRING ULTRASONIC
CLEANER ).

satisfactorily, unless it is badly clogged or dried out, when it
should be dismantled and the parts placed in the cleaner.

There are a number of ultrasonic cleaners marketed by
reputable manufacturers: the Rotring is an excellent machine
and performed very well when used by the author.

OPAL GLASS

41"

28"

36"

SWITCHES

# A 41"x 28" LIGHT TABLE

THE LIGHT TABLE SHOWN IS THE SAME SIZE AS THE DRAWING
BOARD RECOMMENDED AND SHOWN IN FIG. 132. THIS CAN BE AN
ADVANTAGE WHEN THE LIGHT TABLE IS REQUIRED FOR PERSPECTIVE
DRAWING. THE WORKING SURFACE IS OPAL GLASS FITTED TO
THE TOP OF A BOX WHICH CONTAINS FLUORESCENT LIGHTING
TUBES. THE NUMBER AND SIZE OF LIGHTING TUBES TOGETHER
WITH THE SOPHISTICATION OF THE ELECTRICAL EQUIPMENT VARIES
BUT THE PRINCIPLE REMAINS THE SAME IN ALL COMMERCIALLY
AVAILABLE LIGHT TABLES.

*Fig. 166 Light table.*

The light table shown in fig. 166, specially made by a local firm, is simply a sheet of diffusing glass with a light source below it. When the drawing is placed on the illuminated glass the added transparency makes for easier working conditions. The size of the light table and the exact form it takes are matters of preference, and no doubt vary from manufacturer to manufacturer, but the principle remains the same. Many makeshift light tables are no doubt in use and doing a satisfactory job, which is probably why this item is hard to find in many catalogues of drawing office supplies.

SPUN GLASS REFILL

## RUSH FYBRGLASS ERASER

DIRECTIONS FOR USE:
USE LIGHT BRUSHING STROKES. LET ERASER DO THE WORK.
DO NOT PRESS HARD AS WITH ORDINARY RUBBER ERASER.
SOME INKS TEND TO SMUDGE. IF THEY DO, CLEAN UP
WITH ORDINARY PENCIL ERASER.
FYBRGLASS WORKS BEST ON HARD FINISHED PAPERS.
REFILL IS SPUN GLASS. DO NOT TOUCH END WITH FINGERS.
A LITTLE PIECE OF GLASS IN FINGER , IS HARMLESS BUT
ANNOYING.   AFTER ERASING, BLOW OR BRUSH PARTICLES
OFF PAPER.  LEAVES PAPER SMOOTH AND CLEAN.
(SCALE : 3/4 FULL SIZE)

FLINT PAPER HELD FIRMLY
BY A SPRING

## THE PLASTIC PENCIL POINTER          (SCALE : 1/2 FULL SIZE)

FROM KEUFFEL & ESSER CO. U.S.A.
THE PLASTIC PENCIL POINTER IS REFILLABLE AND IS SUPPLIED
WITH 36 SHEETS OF FLINT PAPER. REFILLS OF FLINT PAPER
OR EMERY PAPER ARE AVAILABLE IN PACKAGES OF 12 SHEETS.

## TERRY'S BOARD CLIPS.

CLIP IS MADE OF SPRING STEEL AND IS
USED TO HOLD PAPER OR CARD ONTO
A DRAWING BOARD OR SIMILAR.

(SCALE : APPROX. HALF FULL SIZE.)

The items shown here, while not strictly necessary, may
nevertheless be useful. The first is a fibreglass eraser from
Rush. This is a good, reliable and handy instrument which, if
used according to the instructions, will give excellent results.
The fibreglass brush is easily replaceable and a spare brush is
supplied with each instrument. New brushes are always

*Fig. 167 Miscellaneous
equipment.*

FIG.1

FIG.11

THE KEUFFEL & ESSER CO.
58 0800 — PAPER CUTTER

ANY STANDARD DOUBLE BLADE
MAY BE USED.
(INSTRUMENT SHOWN 1/2 FULL SIZE.)

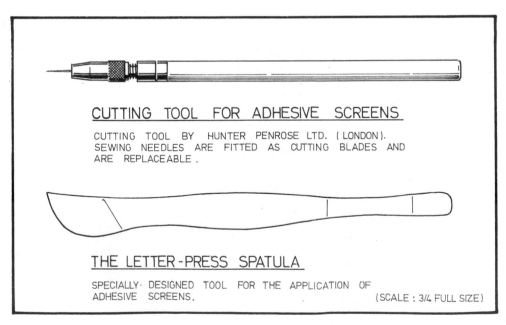

## CUTTING TOOL FOR ADHESIVE SCREENS

CUTTING TOOL BY HUNTER PENROSE LTD. (LONDON).
SEWING NEEDLES ARE FITTED AS CUTTING BLADES AND
ARE REPLACEABLE.

## THE LETTER-PRESS SPATULA

SPECIALLY- DESIGNED TOOL FOR THE APPLICATION OF
ADHESIVE SCREENS.                    (SCALE : 3/4 FULL SIZE)

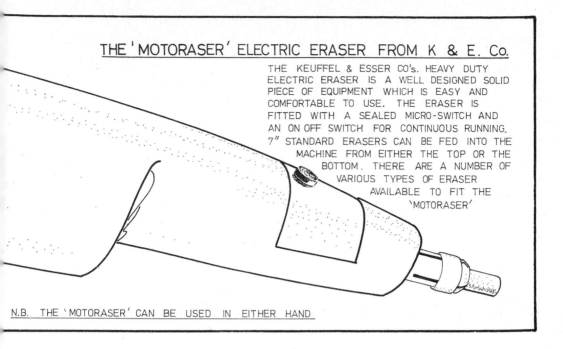

## THE 'MOTORASER' ELECTRIC ERASER FROM K & E. Co.

THE KEUFFEL & ESSER CO's. HEAVY DUTY
ELECTRIC ERASER IS A WELL DESIGNED SOLID
PIECE OF EQUIPMENT WHICH IS EASY AND
COMFORTABLE TO USE. THE ERASER IS
FITTED WITH A SEALED MICRO-SWITCH AND
AN ON OFF SWITCH FOR CONTINUOUS RUNNING.
7″ STANDARD ERASERS CAN BE FED INTO THE
MACHINE FROM EITHER THE TOP OR THE
BOTTOM. THERE ARE A NUMBER OF
VARIOUS TYPES OF ERASER
AVAILABLE TO FIT THE
'MOTORASER'

N.B. THE 'MOTORASER' CAN BE USED IN EITHER HAND

available from the local supplier. Care should be taken when using fibreglass erasers not to get glass particles in the skin as these can be painful and difficult to remove. Always blow the particles from the working surface or brush them away with a brush before proceeding with the work. It has been found by experience that a light rub with an ink eraser over the area treated with a fibreglass eraser when working on tracing paper will give an excellent result in preparing the surface for reworking.

The refillable pencil pointer (p. 357) is a piece of equipment found hanging on the end of many draughtsmen's boards. It is used for either retouching the point or putting a fine draughting point on a pencil, depending on the sharpening method used. The example shown is a de luxe model when compared with many in use, but has the advantage of cleanliness.

The board clip (p. 357) is of advantage when it is not possible or desirable to pin work to the board or use adhesive tape. The Terry board clip has an extended top to allow the clip, when slid on to the edge of the board, to grip the work and hold it firmly.

The cutting tool for adhesive screens is a useful instrument which was purchased many years ago from Hunter Penrose Ltd in London, and has proved to be one of the best instruments of its type. There are a number of cutting instruments available but most of them have a fixed needle point which, when it becomes dull, is thrown away and a new one purchased. This type of instrument is suitable for cutting most adhesive screens, but for colour screens a

*Fig. 168 Miscellaneous equipment.*

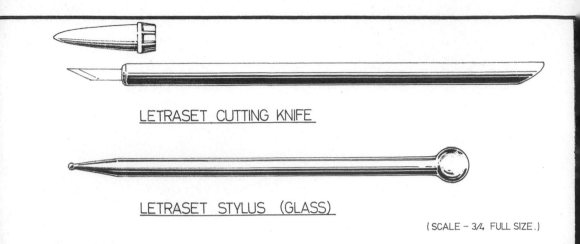

## LETRASET CUTTING KNIFE

## LETRASET STYLUS (GLASS)

(SCALE – 3/4 FULL SIZE.)

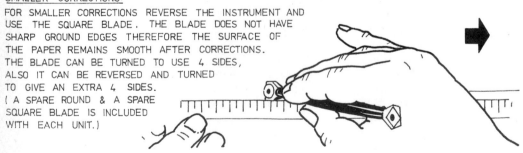

## DAHLE '2910' DRAWING INK PLANER.

(APPROX. FULL SIZE.)

THE DRAWING INK PLANER IS EQUIPPED WITH TWO BLADES. THE ROUND BLADE IS FOR ALL KINDS OF LINE CORRECTIONS. THE SQUARE BLADE IS FOR SMALL CORRECTIONS.

### CORRECTIONS OF LINES

PLACE SHOULDER OF ROUND BLADE END AGAINST RULING EDGE AND WITH SLIGHT PRESSURE MOVE THE PLANER TO THE RIGHT. THE ROUND BLADE SHAVES OFF THE DRAWING INK AND SMOOTHS THE SURFACE OF THE PAPER AT THE SAME TIME. FOR FURTHER SMOOTHING RETURN THE PLANER USING SLIGHT PRESSURE TO THE STARTING POINT. THE BLADE CAN BE ROTATED AND REVERSED AS FOR THE '2900'.

### SMALLER CORRECTIONS

FOR SMALLER CORRECTIONS REVERSE THE INSTRUMENT AND
USE THE SQUARE BLADE. THE BLADE DOES NOT HAVE
SHARP GROUND EDGES THEREFORE THE SURFACE OF
THE PAPER REMAINS SMOOTH AFTER CORRECTIONS.
THE BLADE CAN BE TURNED TO USE 4 SIDES,
ALSO IT CAN BE REVERSED AND TURNED
TO GIVE AN EXTRA 4 SIDES.
( A SPARE ROUND & A SPARE
SQUARE BLADE IS INCLUDED
WITH EACH UNIT. )

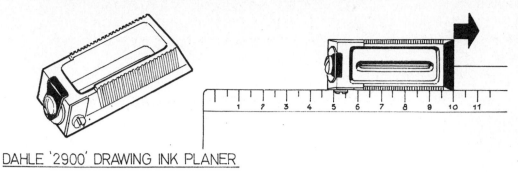

## DAHLE '2900' DRAWING INK PLANER
### (APPROX 3/4 FULL SIZE)

THE DRAWING INK PLANER IS EQUIPPED WITH TWO BLADES. THE ROUND BLADE ON THE FRONT IS SUITED FOR ALL CORRECTIONS OF LINES. THE SIDE BLADE IS FOR SMALLER CORRECTIONS.

### CORRECTIONS OF LINES

THE PLANER IS USED WITH THE LONG SIDE AGAINST A T-SQUARE, SET-SQUARE OR RULER SO THAT THE LINE TO BE ERASED IS VISIBLE IN THE CENTRE OF THE APERTURE IN THE BASE OF THE PLANER. THE BLACK ARROW ON THE ROUND BLADE SHOWS THE ERASING POINT. PRESS THE PLANER SLIGHTLY ON THE PAPER AND MOVE IT IN THE DIRECTION OF THE ARROW (SEE DIAGRAM). TO SMOOTH THE SURFACE OF THE PAPER AFTER ERASING MOVE PLANER BACK UNDER SLIGHT PRESSURE TO THE STARTING POINT.

AS EACH PART OF THE ROUND BLADE BECOMES BLUNT TURN IT SLIGHTLY TO BRING A FRESH PART INTO CONTACT WITH THE PAPER. WHEN THE WHOLE OF THE BLADE HAS BEEN USED THE BLADE CAN BE REVERSED AND USED AS PREVIOUSLY DESCRIBED. (EXTRA BLADES ARE INCLUDED WITH EACH UNIT.)

### SMALLER CORRECTIONS

FOR SMALL CORRECTIONS USE SQUARE BLADE. LIFT THE PLANER SLIGHTLY SO THE SIDE BLADE ONLY IS IN CONTACT WITH THE PAPER. THE BLADE CAN BE TURNED TWICE.

sharp craft knife is advised; a good knife (fig. 169, opposite) is supplied by Letraset for this purpose.

The spatula from Letter-Press (p. 358) is another useful and inexpensive aid when working with rub-down and adhesive materials.

Keuffel & Esser Co.'s paper cutter solves the draughtsman's problem of cutting paper and card: it is simple and safe to use and produces excellent results.

The electric eraser, one of the many available, is from the large range of equipment available from Keuffel & Esser Co. It has a number of features which recommend it to the draughtsman requiring a reliable, tough instrument of this type. The 'Motoraser' takes a standard 7-in. eraser and there are various types of erasers available to fit it. These instruments are a 'must' when a great deal of alteration is required as they save time and in many cases are more accurate than hand rubbing with an ordinary eraser.

It can be seen that there is a large selection of equipment available to the draughtsman. It varies in quality, cost and usefulness but, as previously stated, the equipment shown in this chapter has been limited to that of which the author has had personal knowledge. This is *not* intended to be a complete list of the only good equipment in the various fields covered, nor is it intended to infer anything more than has been said about the specific equipment shown.

*Fig. 169 Letraset aids and drawing ink planers.*

# Acknowledgments

The author wishes to express his appreciation to the companies whose products are illustrated and discussed in this book. Without access to this information and the help of these companies and their Australian representatives the task of providing reliable information about equipment would have been virtually impossible.

To the following people the author wishes to express his special appreciation for their highly valued aid in the writing of this book:

To Reg Jones, Director of Jasco Pty Ltd, for the considerable time and effort which, together with his advice, have been available constantly.

To Miss Rhonnie O'Grady, Art Department, Robertson & Mullens Pty Ltd, for her encouragement, help and advice over a period of many years.

To Jim Mornard, Victorian Manager, Letraset Australia Pty Ltd, for his personal help and advice together with the considerable assistance given by the company he represents.

To Mr A. G. Barker of A. G. Barker & Associates (Pty) Ltd, for his time and that of his representatives in providing information and help.

To Mr Michael A. Dortheimer of Michael A. Dortheimer (Pty) Ltd, for his help and advice.

To Mr R.J. Dennis, Victorian Sales Manager, Wild (Australia) Pty Ltd, for his help in supplying information.

To Tom Pickford and Dick Hamerton, Directors of Ponsford Newman and Benson Limited for their help and advice.

To Bryan Keegan, W. & G. Dean Pty Ltd, for his help and that of his firm in providing use of special equipment.

To Pan American World Airways Inc., International Harvester Co. of Australia Pty Ltd, Repco Ltd, and others who have allowed me to produce drawings based on information and illustrations obtained from these companies.

To Riepe-Werk (Rotring) of Hamburg, Germany, for advice and information about drawing on plastic films (pp. 295–8).

To the many friends and colleagues who have helped with criticism and advice.

To Anke Gill whose patience and understanding while typing the manuscript were greatly appreciated.

# Bibliography

ATKIN, W.W., R. Corbelletti and V.R. Fiore: *Pencil Techniques in Modern Design*. New York, 1953.

BLOMFIELD, Sir Reginald: *Architectural Drawing and Draughtsmen*. London, 1912.

D'AMELIO, Joseph: *Perspective Drawing Handbook*. New York, 1964.

DOBIN, Jay: *Perspective, A New System for Designers*. New York, 1957.

GIESECKE, Frederick E., Alva Mitchell and Henry C. Spencer: *Technical Drawing*. New York, 1936.

HALSE, Albert: *Architectural Rendering*. New York, 1960.

HAMM, Jack: *Drawing the Head and Figure*. London, 1969.

HOLLIS, H.F.: *Teach Yourself Perspective Drawing*. London, 1955.

HULL, Joseph W.: *Perspective Drawing, Freehand and Mechanical*. Berkeley and Los Angeles, 1950.

JACOBY, Helmut: *Architectural Drawings*. London, 1965.

JACOBY, Helmut: *New Architectural Drawings*. London, 1969.

JACOBY, Helmut: *New Techniques of Architectural Rendering*. London, 1971.

LOOMIS, Andrew: *Three-Dimensional Drawing*. London, 1963.

LOOMIS, Andrew: *Figure Drawing for All It's Worth*. New York, 1943.

MARTIN, C. Leslie: *Design Graphics*. New York, 1962.

MAURELLO, S. Ralph: *Commercial Art Techniques*. New York, 1952.

MAURELLO, S. Ralph: *The Complete Airbrush Book*. New York, 1954.

MORGAN, Sherley W.: *Architectural Drawing. Perspective, Light and Shadow Rendering*. New York, 1950.

MUYBRIDGE, Eadweard: *The Human Figure in Motion*. London, 1901.

NORLING, Ernest R.: *Perspective Made Easy*. New York, 1939.

NORTON, Dora M.: *Freehand Perspective*. London and Melbourne, 1965.

SCHAARWÄCHTER, Georg: *Perspective for the Architect*. London, 1967.

STUDIO DRAWING BOOKS:
*Drawing for Pleasure* by Start Walter (1962).
*Drawing Buildings* by Richard Downer (1962).
*Drawing Ships* by John Worsley (1962).
*Drawing Cars* by John Raynes (1964).
*Drawing Figures* by John Raynes (1965).
*Drawing Perspective* by Hugh Chevins (1966).
*Drawing Nudes* by Paul d'Aguilar (1966).
*Pen and Ink Drawing* by Faith Jaques (1964).
*Drawing People in Action* by Nigel Lambourne (1961).

WATSON, Ernest W.: *How to Use Creative Perspective*. New York, 1955.

# Index